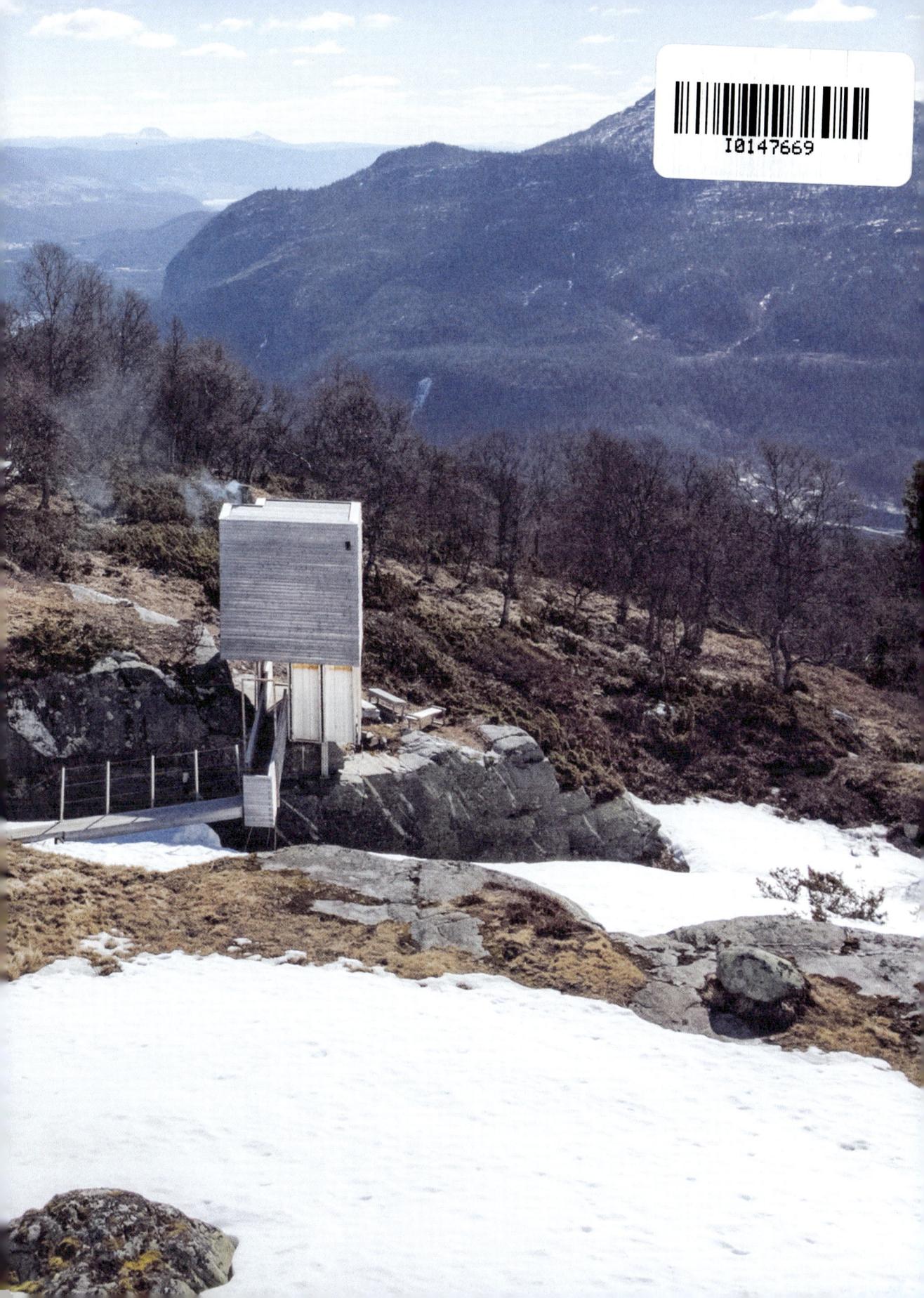

SAUNA

THE POWER OF DEEP HEAT

EMMA O'KELLY

PHOTOGRAPHS BY MAIJA ASTIKAINEN

WELBECK
BALANCE

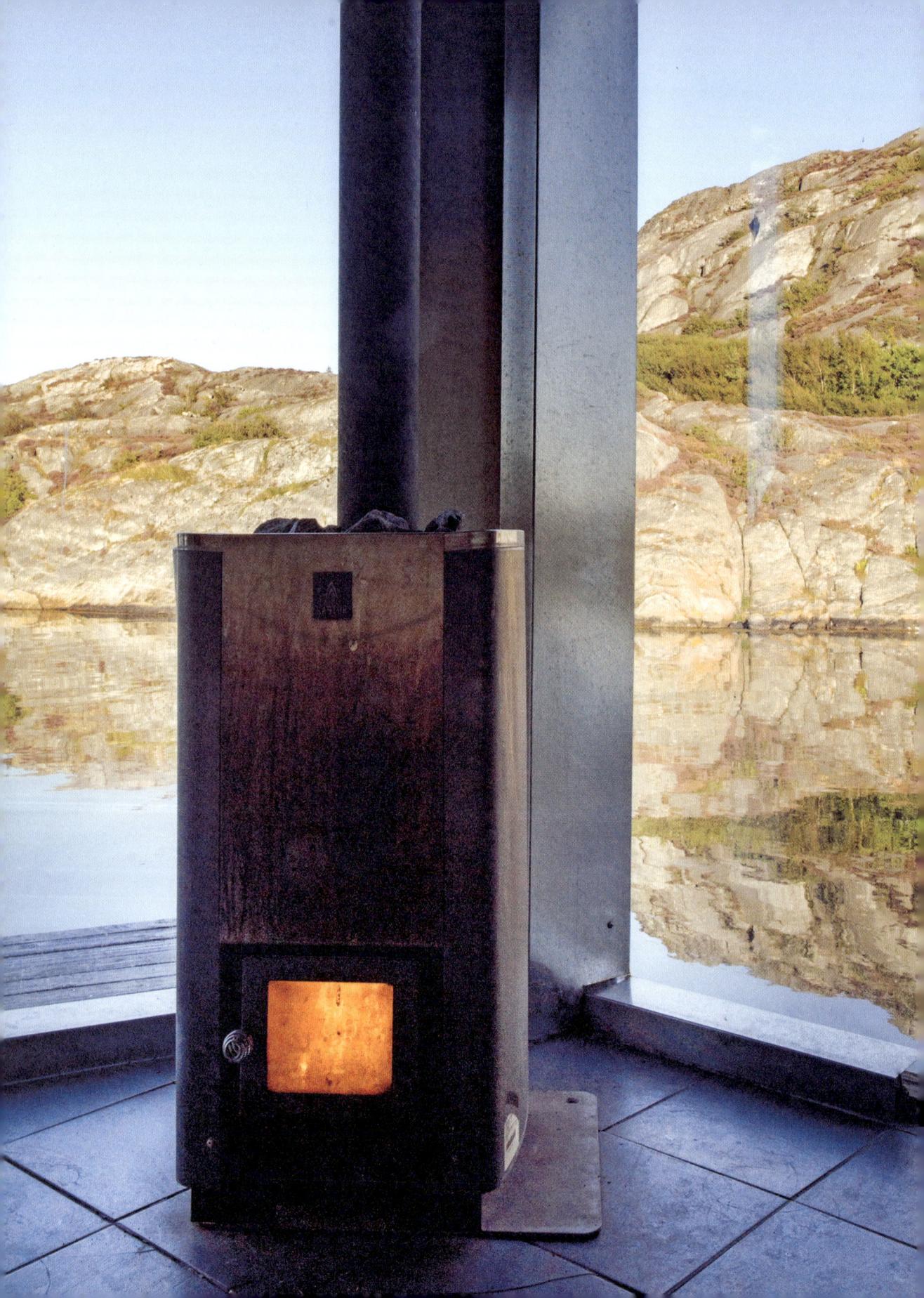

Opposite: Björholmens Marina sauna near Gothenburg, Sweden.

Published in 2023 by Welbeck Balance
Part of Welbeck Publishing Group
www.welbeckpublishing.com

Design and layout © Welbeck Non-Fiction Ltd 2023
Text © Emma O'Kelly 2023
Photography © Maija Astikainen

A CIP catalogue record for this book is available from the British Library.

ISBN
Hardback – 978-1-80129-242-9

Design by stevewilliamscreative.com
Printed in Heshan, China by Leo Paper Group

10 9 8 7 6 5 4 3 2 1

FSC
www.fsc.org

MIX
Paper | Supporting
responsible forestry
FSC® C020056

Note/Disclaimer
Welbeck Balance encourages diversity and different viewpoints.
However, all views, thoughts, and opinions expressed in this book are the author's own and
are not necessarily representative of Welbeck Publishing Group as an organization. All material in this book
is set out in good faith for general guidance; Welbeck Publishing Group makes no representations or
warranties of any kind, express or implied, with respect to the accuracy, completeness, suitability or currency
of the contents of this book, and specifically disclaims, to the extent permitted by law, any implied
warranties of merchantability or fitness for a particular purpose and any injury, illness, damage, death,
liability or loss incurred, directly or indirectly from the use or application of any of the information
contained in this book. This book is not intended to replace expert medical or psychiatric advice.
It is intended for informational purposes only and for your own personal use and guidance.
It is not intended to diagnose, treat or act as a substitute for professional medical advice.
The author and the publisher are not medical practitioners nor counsellors, and professional
advice should be sought before embarking on any health-related programme.

Picture credits
All images by Maija Astikainen, except for:
Page 5 (right): Lisa Linder
Page 145: Holmes Garden Photos/Alamy Stock Photo
Page 179: Timo Syrjänen/Finnish Heritage Agency
Page 220: National Museums Northern Ireland/Mary Evans

About the Author & Photographer

MAIJA ASTIKAINEN's work has been published in the *Financial Times*, *Konfekt* magazine and *Les Echos Week-End*. She works for Finland's biggest travel magazine *Mundo* and has photographed several travel guides.

Maija is a sauna enthusiast and wild swimmer. Her first sauna memories are at the old wood-burning sauna in the garden of her grandma's house. A must-have condition of getting her own house in Helsinki was that it should have its own wood-burning sauna. Which it does.

Before one of her many work trips, she throws her tent sauna in the back of the camper van and steams wherever she goes. Her New Year's Eve "sauna village" party in her back garden has become one hot ticket.

EMMA O'KELLY grew up on a farm in the British countryside where there was never a sauna in sight. She now lives in London and writes for the likes of the *Telegraph*, the *Financial Times* and *Condé Nast Traveller,* and is a long-term contributing editor at *Wallpaper* magazine.

Over the years, she has carried out many design and travel assignments in Scandinavia, and it was during a work trip to Finland in 2016 that she discovered the joys of a real sauna.

Emma swims all year round in Hampstead Ladies Pond and Parliament Hill Lido. She's happy to see that a good sweat can now be found closer to home, thanks to the new sauna scene taking shape in the UK – especially on its beaches. She is currently building a sauna in her back garden.

For Mark and Mikko – our sauna partners-in-crime

For A, T and L – young bathers in the making

And for the Van – our reliable carriage and trusted getaway

Contents

Foreword

Emma O'Kelly's journey of discovery into the world of sauna and sweat-bathing culture is a testament to the transformative power of a humble tradition that has been around for centuries.

As a veteran in the field of sweat-bathing culture, I have been documenting this ancient tradition for nearly half a century, inspired by my Norwegian father who instilled in me a love for the *badstue* – the Norwegian version of the Finnish sauna. I was lucky to have been exposed to a place where family and friends gathered to bond and cleanse themselves, not just physically, but also mentally and emotionally. I believe you will be hard-pressed to find another human activity that combines the physical, social and spiritual under one roof.

Sauna is a fascinating and healthful practice, which has been as ubiquitous throughout history as the baking of bread and the squeezing of the grape. In my book *Sweat* (Capra 1978), I showcased the incredible culture and history of sweat bathing; at the time, many of these practices were on the brink of extinction. Almost 45 years since its publication, the world is once again waking up to incredible power and beauty of the sauna. More recently, *Sweat* has been made into a seven-part documentary, *Perfect Sweat*; this has given me a front-row seat into the dramatic revival of sweat-bathing culture. In our rapidly changing world, the growing need for physical, social and spiritual wellness is inspiring people to look for alternative lifestyles, and the sauna/sweat bath fits this yearning.

I have been privileged to meet many of the leaders of the sauna/sweat bath revival who are profiled and interviewed by Emma in this book. Emma's approach is one of curiosity, and – along with Maija's sumptuous photography – the result is a deep understanding of this ancient tradition and its role in our modern world.

This book is a celebration of a cultural resurgence and a reminder of the power of connecting with nature and something larger than ourselves. It's a tonic for my heart – I hope you enjoy it as much as I did.

Mikkel Aaland, author
www.mikkelaaland.com

Introduction

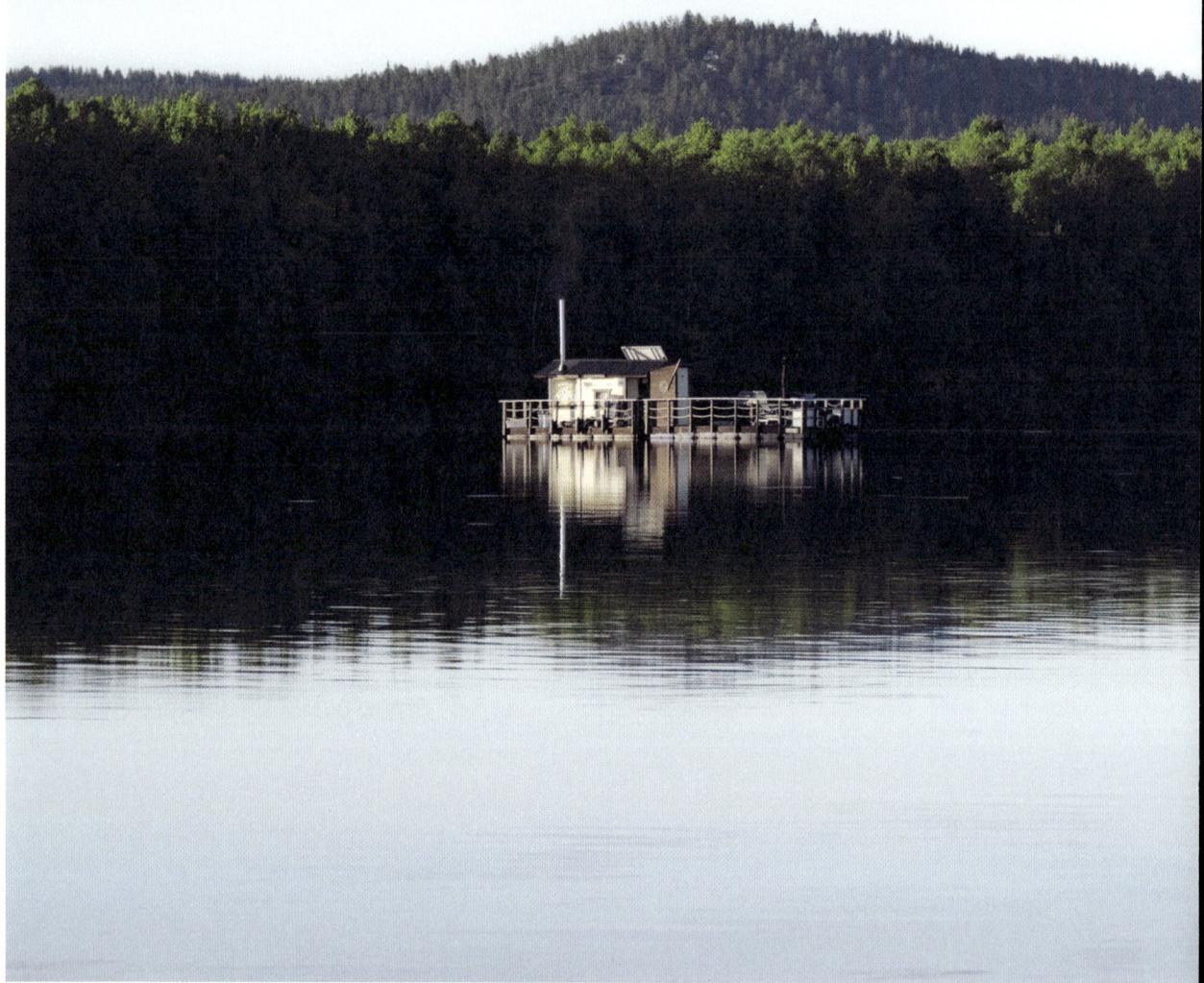

I was never a big fan of the sauna. Tucked away as an afterthought in the corner, it was always the least appealing option of many a London gym. The dry heat left me with lizard-crisp skin and I felt claustrophobic in the small, confined space. I would always opt for the gentle, moist heat of the steam room instead.

Then came this book, originally conceived with Maija as an art project about Scandinavian saunas. From car windows on work trips to Finland, Sweden and Norway, I had fallen in love with those ox-blood red huts, chuffing smoke in improbable locations. Who, I wondered, on this raw edge of nature, would build and use such places? I hadn't thought too much about what happened inside them. Because I didn't really know.

Previous: Saana floating sauna in Rovaniemi, Finland.
Opposite: Private sauna on the archipelago, southern Finland.

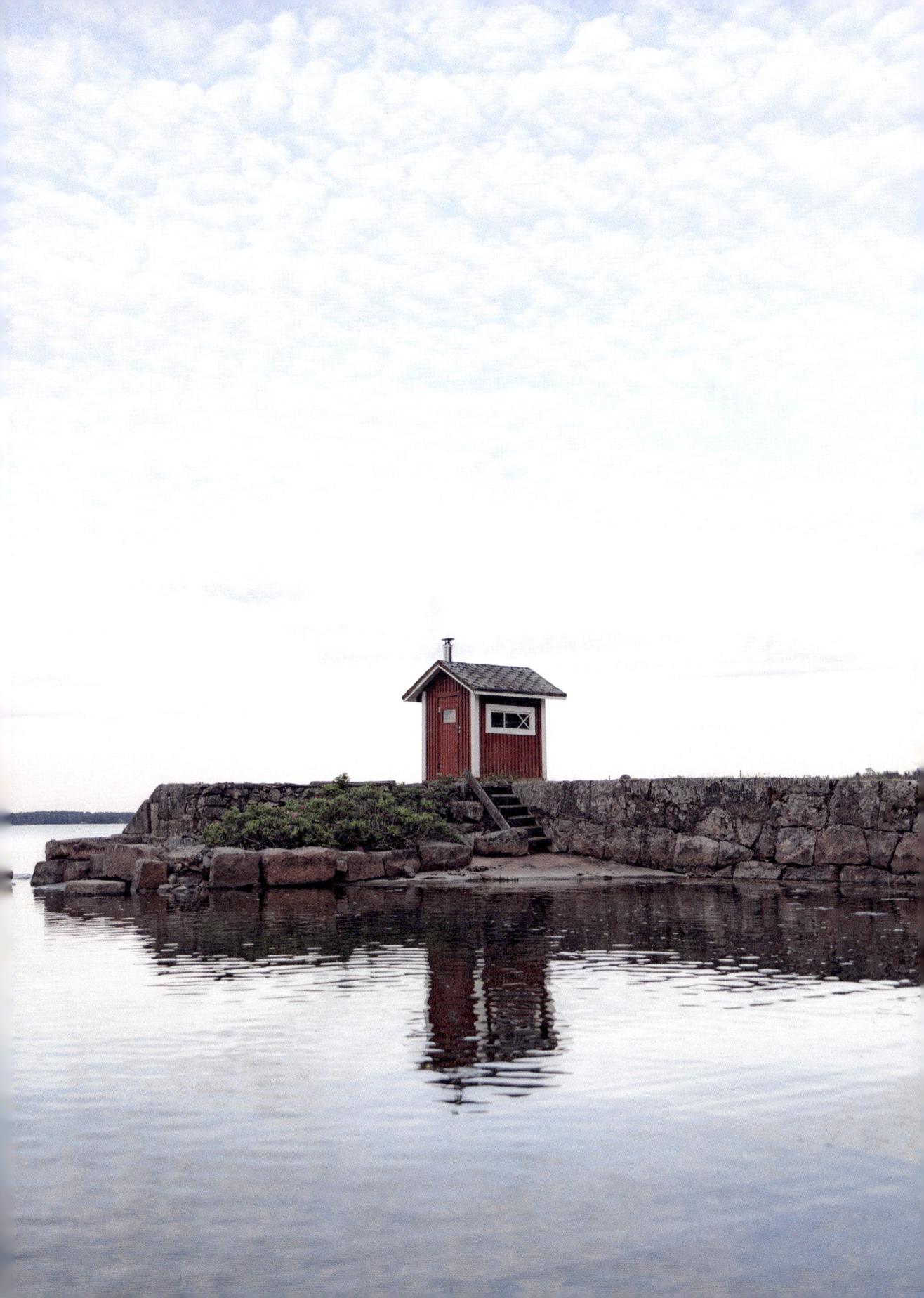

My first "research mission" was at the Community Sauna Baths in Hackney, London, a complex of Finnish-style saunas and a melting pot of sweat-bathing ideas from around the globe. I stayed too long cooling off in a barrel of icy water, after having lost track of time talking to the Baths' enthusiastic founders. I felt dizzy and nauseous and had to stand in the sauna in all my clothes and my coat to properly warm up. This threw me. How could I write a book about sauna culture if I couldn't take the heat (or cold!)? What would Maija, who's Finnish and a sauna pro, make of me scrambling for the exit in a sweaty panic? How would my interviewees respond if I kept leaving the sauna every few minutes to cool off?

As a veteran winter swimmer, my body is used to the cold. Plunging into sub-zero waters is an adrenaline rush and a high like no other. It's addictive and life-affirming, and helps me manage anxiety and stress. Sauna bathers say the same thing about the heat. Why? Well, scientists say regular saunas help lower blood pressure, reduce the risk of cardiovascular disease and dementia, boost immunity and help with fatigue, depression and more (see Chapter 1). Putting our bodies through the thermo-regulatory ping-pong that is sauna followed by cold rinse, sauna followed by cold rinse, is extremely good for us – and it's not as challenging as cold-water swimming on its own. There's a reason why sauna-loving nations, such as Finland, Sweden and Norway, jostle for the top spots in the annual *United Nations World Happiness Report* every year.

My journey began in Finland because Maija is Finnish and because "sauna" is a Finnish word – although not entirely a Finnish invention (see Chapter 5) – and it didn't take long to find new sauna movements everywhere. Often, sauna-lovers go hand-in-hand with the growing tribes of cold-water swimmers that have rediscovered lakes, rivers and seas from the UK to North America, but not always. In cities such as London, Copenhagen and Oslo, we came across Portakabins, army trucks and all sorts of contraptions pitched up on parking lots, derelict docks and shady scrublands being used as saunas. We sweated in horseboxes on cold British beaches, on rafts on Norwegian lakes, in tree houses in Finnish forests; and we were soon wishing we had the skills to build our own, so we could pull up, fire up and roast whenever we got the urge.

We drove more than 10,000 kilometres in Maija's trusted camper van, through the vast reaches of Sweden, Finland and Norway, where distances between hamlets, or not-even-hamlets, are huge. On windswept archipelagos, we sought out bathhouses with not a soul in sight, serviced by an honesty box and a stack of logs. In front of autumn seas, we tuned in to nature in its purest form and marvelled at setting suns, eagles, seals and the odd swimming deer. In the winter wilderness of Lapland, we stumbled into ice saunas welded onto frozen lakes, rolled in the snow and jumped into ice holes. In spring, we dipped into semi-thawed waterfalls, dodging chunks of ice. We threw ourselves off boats and rafts and sauna rooftops into warm summer waters.

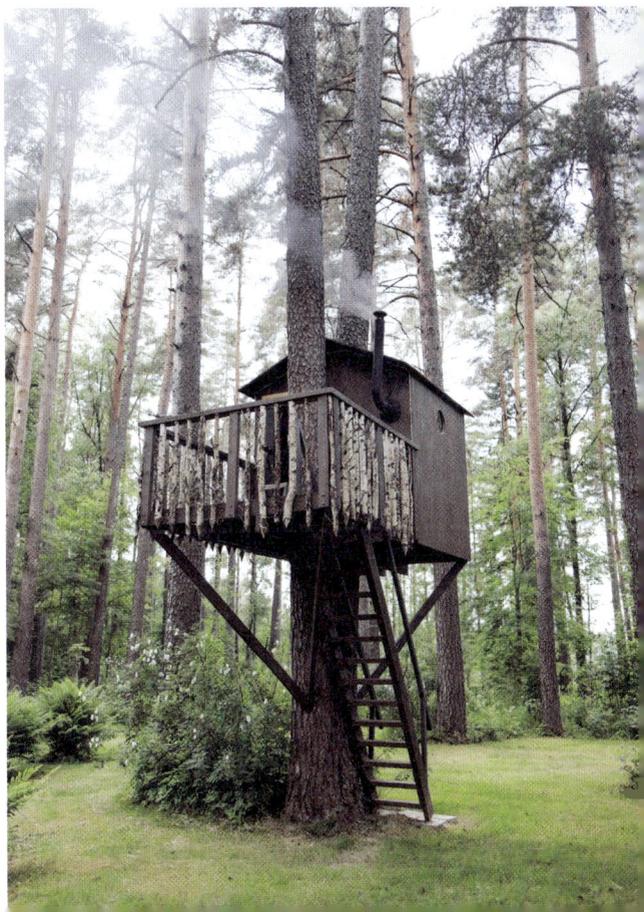

Treehouse sauna at Urpolan Kartano Manor sauna village, Finland.

We met bathers of every age, background and occupation. In Helsinki, we were serenaded by amateur musicians playing saws – yes, saws; in Estonia, pagan artists whisked us with birch branches. We met shamans, hipsters, office workers, heavily pregnant women, toddlers, babies, and old timers who were born in the sauna, and shared beer, vodka, sausages and stories with them all.

My lack of sauna etiquette meant I learned the hard way. I was politely asked to be quiet by a naked bather holding an egg timer; told off in Tallinn by mealy-mouthed babushkas for using the wrong water buckets or the wrong whisks (bunched young tree twigs with leaves for massage), and for putting on a swimsuit. Thanks to "sauna brain" – that spaced-out, floaty feeling that a session in the steam brings on – I lost towels, bikinis, water bottles, pens and sunglasses. Sometimes, I had to be naked with strangers; this, like the heat, got easier over time. I started to mind less my lumps and bumps and scars and wrinkles, and took comfort that everyone else has them too.

As Maija and I clocked up the kilometres, things began to change. I learned to tolerate the heat for a little bit longer every time, and to brace myself without panicking whenever a fellow bather poured water on the rocks. In most of the countries we visited, a sauna is not a proper sauna unless you can pour water on the rocks. Ask any sauna fan. The steam adds a new dimension, both physically and spiritually. Known by its Finnish name *löyly*, (pronounced low-loo), it means spirit, or soul, and has a life of its own. You could say that it is the protagonist of this book.

By the end of the journey – my baptism of fire – I felt able to distinguish between a good, bad and mediocre sauna. Over 50 saunas made the grade for this book, and after every single one, we felt restored, invigorated and happy to be alive.

And now, I have become obsessed. Addicted. As I scrub myself down at the end of each sauna, I wonder how long I will have to wait until my next. We hope, that, through the pages of this book, you will too.

Opposite: Traditional-style private sauna in eastern Finland.

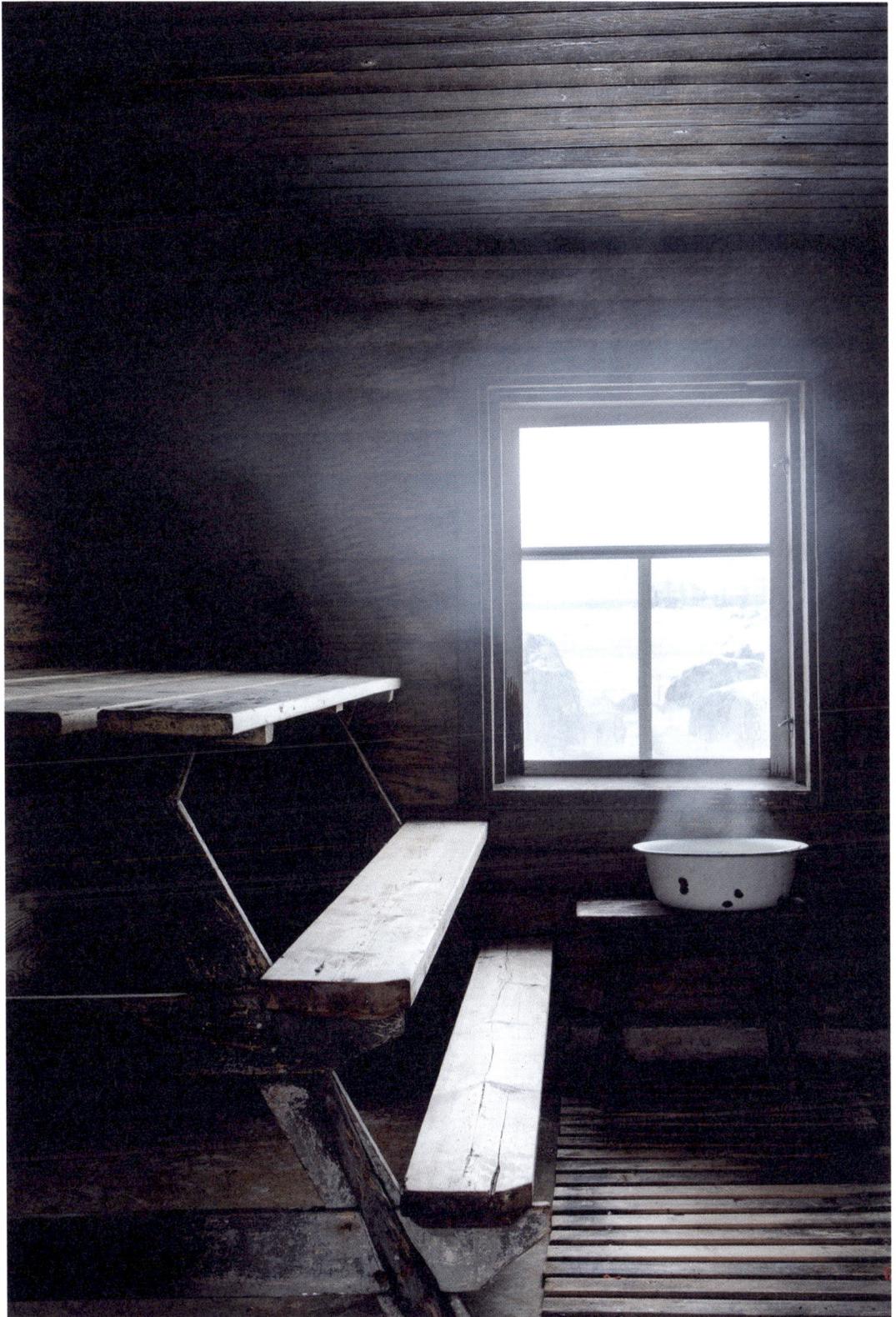

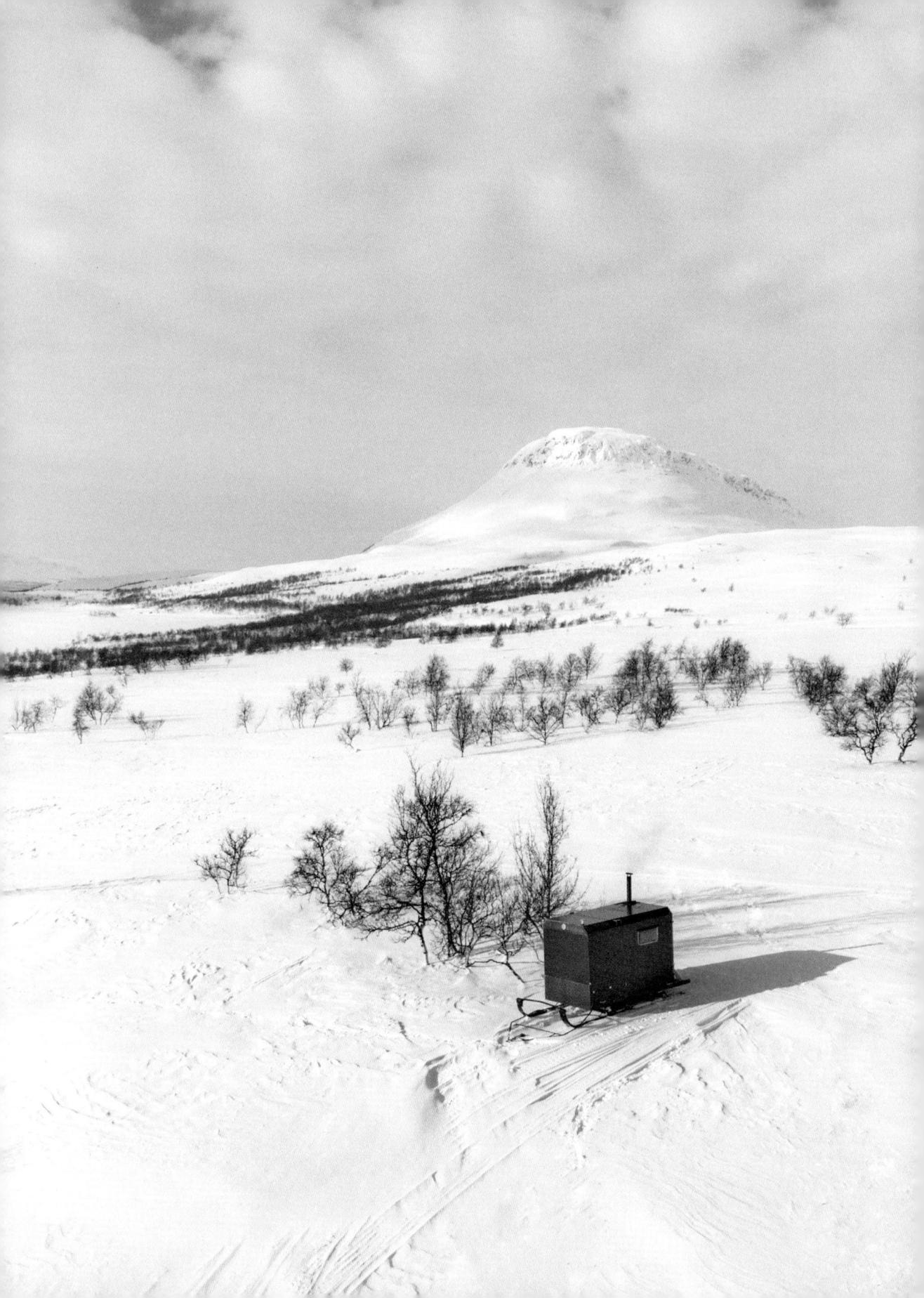

HEALTH
Good reasons to roast

"If sauna, tar, or alcohol doesn't help, you are sick to die."

Old Finnish adage

People feel good after a sauna session and have done for centuries. It's no coincidence that every culture, through every age, has enjoyed its own form of sweat bathing. From the Ottoman hammam and Mayan *temazcal* to the Japanese *mushi-buro* and *kama-buro*, from the *banyas* of Russia to the saunas of Finland, heat therapy has stood the test of time, waxing and waning in popularity, and crossing continents in various iterations. But it has not been until advances in modern medicine that we are really getting to the bottom of why exactly sweat bathing makes us feel so good.

In 2019, Finnish cardiologist Jari Laukkanen published the findings of his 26-year study by into the sauna-bathing habits of 2,000 middle-aged men in eastern Finland. Those who took regular saunas (four to seven a week) were far healthier than those who didn't. They were 50 per cent less likely to suffer from cardiovascular diseases than the non-bathers, and in regular sauna-goers, incidences of strokes, pneumonia, Alzheimer's disease and dementia were halved.

But who goes to the sauna four to seven times a week, critics argued, apart from the Finns? And could it be that those who do are not healthier because of the sauna, but rather they go to the sauna *because* they are healthier? But so surprising are Laukkanen's findings, so dramatic the disparities between the two groups, that they have fuelled further medical studies and alerted a whole new tribe of potential sweat bathers, from Japan to Norway to the USA, to the physical and mental health benefits of sauna.

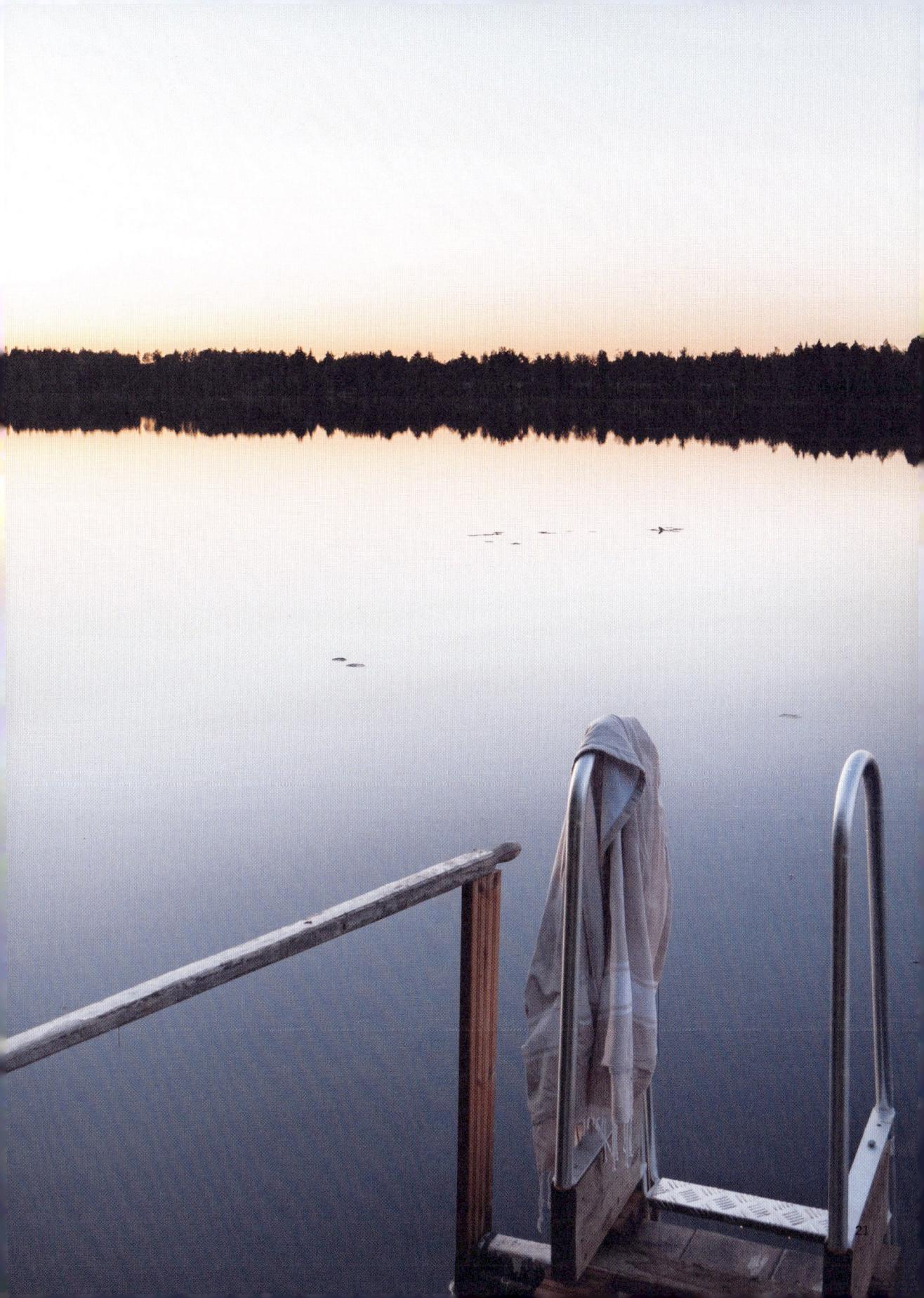

Good sweat

"Sauna makes us sweat which is a good gym work out for the organs and the blood vessels," says Hans Hägglund MD, PhD, a medical doctor and professor at Uppsala University in Sweden who frequently lectures all over the world on the medical health effects of sauna bathing. In 2020, he published (in Swedish) *The Sauna Book – Hot Facts on Sauna and Health*, which summarizes the effect of sweat bathing on our cardiovascular, hormonal and immune systems.

"Heat makes the body regulate its own temperature as we have to be at 37.5°C, so all the cells and organs work really hard to keep this stable," says Hägglund. Heart rate can increase up to 100 beats per minute during a moderately hot sauna session (70°C), and up to 150 beats per minute during a hotter one (90°C); and when we get out it slows down again. And all this cardio-flexing is a good thing. Around 80 million people a year die of cardiovascular diseases – they are the number one killer in the western world – and two recent studies have shown that a 30 to 50-minute sauna improves cardiorespiratory fitness in the same way that 30-50 minutes of moderate exercise (a brisk walk, say) does.

A 2021 study found that exercise and sauna both increase blood flow, heart rate and core temperature to similar levels. This is good news, because, according to the World Health Organization, globally about 25 per cent of adults don't meet the minimum recommended physical activity levels of 150 minutes of moderate intensity activity or 75 minutes of vigorous activity per week. In the UK, the percentage is higher, and a 2019 medical study links such sedentary behaviour to about 11.6 per cent of all deaths annually.

But if it sounds too good to be true, that's because it is. A sauna is *not* the same as a proper workout. For a start, it does nothing to promote fat loss or muscle mass. A sauna *after* training is the best combination; it feeds tired muscles with fresh blood and can help improve strength and recovery.

Sauna detox

We produce about 0.5kg of sweat in a 30-minute sauna, and while around 97 per cent of this is water, studies have shown that some toxins and heavy metals are excreted too, and sweat does this more effectively than urine. No matter how healthy we are, we live in a polluted world, absorbing arsenic from agricultural products, cadmium from cigarette smoke, lead from mercury, car exhaust fumes – you name it. So any detox helps. And in countries like Finland, Sweden and Russia where bathing and sauna are historically linked, washing, whisking, scrubbing and rinsing are all part of the process, so the skin gets a good clean too.

Maybe more importantly, sauna is a tech-free zone. Where else are we free from the ping of the iPhone, or spared the pressure of the selfie? No-one looks good naked and sweaty, and in the sauna there's no need to share; as some groups sit and chat, others stare in silence at the stove. It can be a moment to focus wholly on ourselves. Many young people say this is why they love the sauna. In Japan, *saunners* (as sauna-goers are called) refer to the sauna as the "third space" – not work, not home, but somewhere between the two where they can reset. The Japanese even invented a word for that special post-sauna feeling – *totonotta* – which loosely translates as "well balanced", or "put back in order". There's no word like it in English or Finnish – at least not yet.

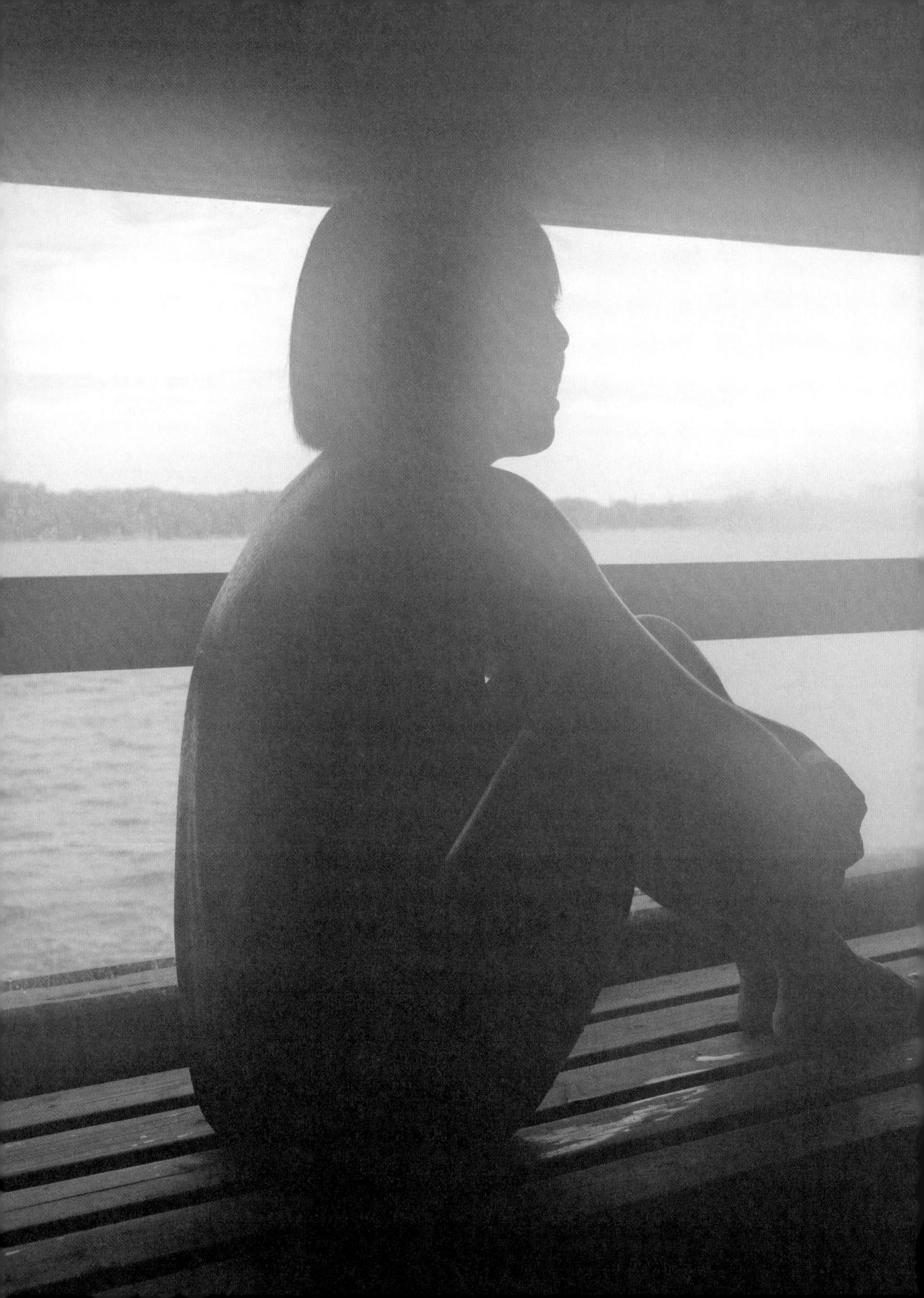

Good stress

Hormetic stress is "good stress". Things like jumping in a cold pond, or competing in a marathon, or making a really complicated cake are examples of good stress. It's the opposite of bad stress, which is induced by negative life events such as a death in the family, divorce, a tyrannical boss. Hot and cold exposures - in the form of a hot sauna followed by a dip in an ice barrel, say - provide a quick blast of good stress and an intense vascular workout.

Historically, studies have focused on the positive effects of cold stress. The forefather of hydrotherapy, Sebastian Kneipp (1821-97) - whose methods are still cited in modern spas today - pioneered the use of cold-water treatments for their healing powers, even curing himself of tuberculosis. Whereas warm water played an ancillary role. But since the Water Doctor's day, heat therapy too has been proven to have many positive effects.

Temperatures of around 38°C to 40°C stimulate the immune system, and in the same way that we can programme ourselves to tolerate the cold by exposing ourselves to decreasing water temperatures, so too can we dial up the heat, by throwing water on the rocks and embracing the heavy whoosh of steam that follows in its wake. Steady breathing is both parties' friend. Hot and cold improve our circulation so that our core body temperature drops, and the cooler our core, the less damage there is to our genetic material and the longer we live. Studies show that it takes around seven regular sauna sessions for our bodies to adapt to thermal stress in positive ways.

Left: Cult community Sompasauna was built by anarchists in Helsinki; it is free to use and open every day.

Inflammation

"There's an anti-inflammatory effect on the inner part of our blood vessels when we are in the sauna," says Hägglund, "but we don't understand the mechanism yet." There is a substantial school of thought that suggests inflammation is the cause of many physical and psychological problems, from irritable bowel syndrome (IBS) to chronic fatigue syndrome, fibromyalgia to depression.

Charles Raison MD, professor of psychiatry at the University of Wisconsin-Madison (USA), is an active proponent of this theory. "Since the 1980s, we have known that depressed people are hotter and find it harder to sweat," he says. "The pathways that control our ability to cool off overlap with pathways that regulate our mood. Body temperature and mood are directly linked."

In 2016, Raison exposed 16 clinically depressed patients to whole body hyperthermia (whole-body heating or WBH), placing them in specialist heat chambers and raising their body temperatures to 38.5°C for two hours. All reported fewer depressive symptoms for six weeks after the treatment. While it may seem counter-intuitive to heat up people who are already too hot, it actually rebalances the thermo-regulatory system. "WBH is not a sauna-like experience," Raison emphasises. "You get very hot and you're not able to go in and out. But heat has the same effect as anti-depressants; the chemicals all tie together but we don't yet know how. So, if you're depressed, you need to warm up."

Pain relief

A 2019 study in Seoul, South Korea, placed 37 patients suffering lower back pain in the sauna for 15 minutes twice per day for five consecutive days; three-quarters of the cohort declared that their pain was massively reduced afterwards. Why? Because blood vessels relax and dilate in a sauna and blood flow increases to muscles and joints which can in turn alleviate pain and stiffness. What's more, sauna causes levels of beta-endorphins – important pain relievers – to rise. For those living with pain for which there is no cure, such as rheumatoid arthritis, regular sauna sessions can provide immense relief. And for those with illnesses like lupus, chronic fatigue syndrome and fibromyalgia, where constant pain forces work-outs off the agenda, the sauna seems like an obvious "gateway therapy", offering a vascular gym session without the actual gym.

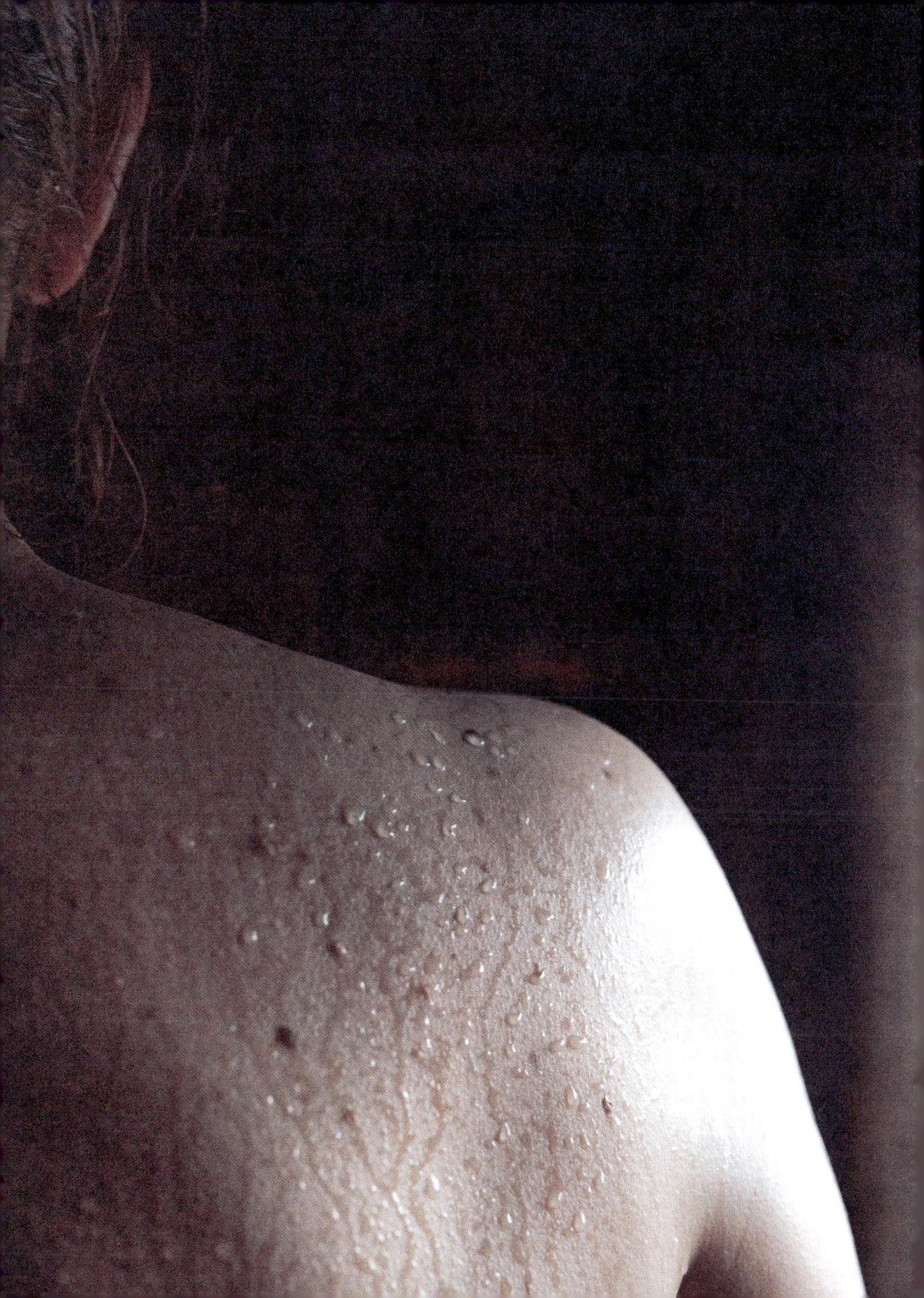

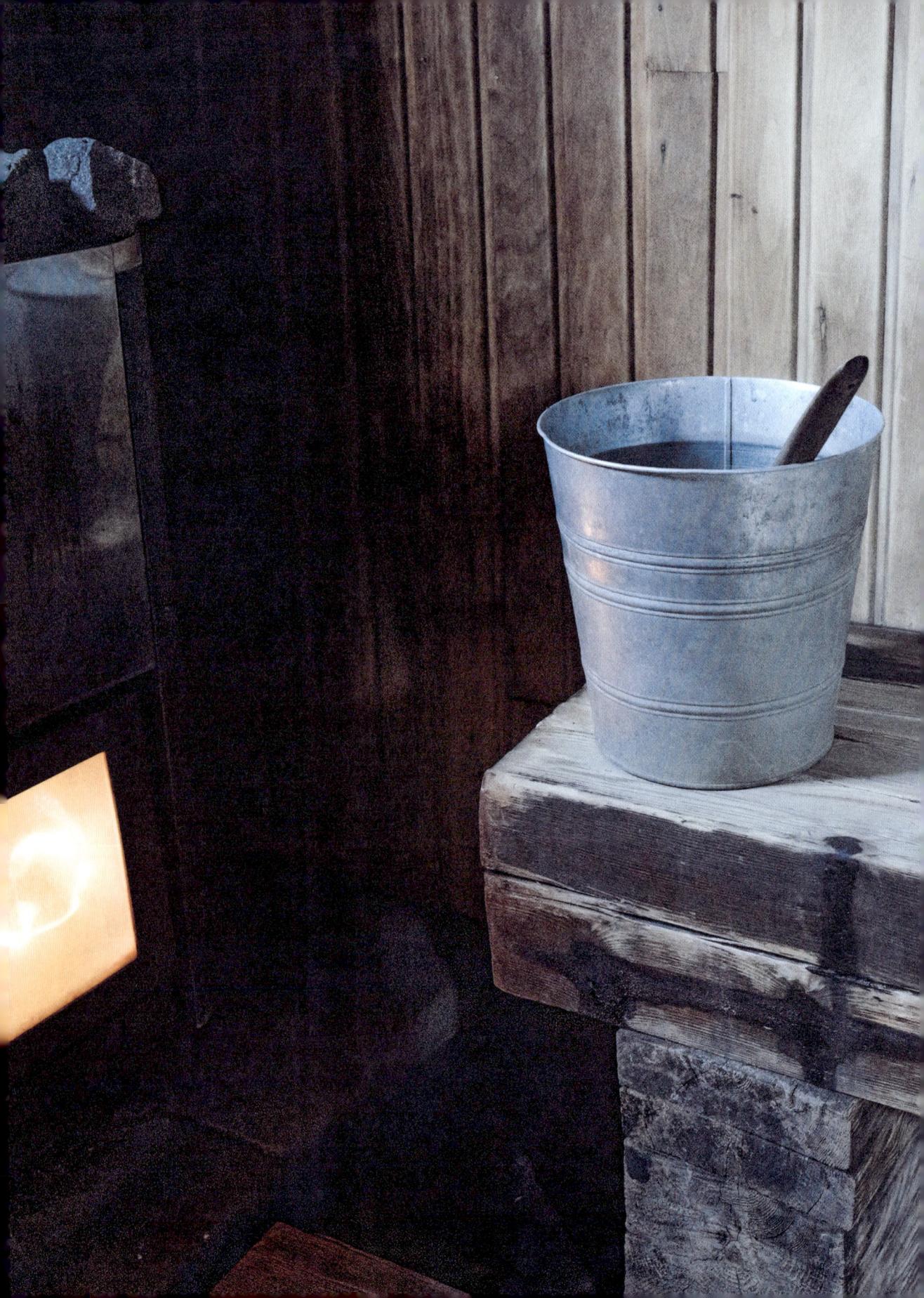

Immunity

We have moved a long way from the days when folk healers recommended inhaling pig dung fumes or placing pork with onions in a dirty sock to fend off flu-like symptoms. Since the 1970s, studies have found that sauna significantly stimulates the immune system. What's a fever, after all, other than the body's way of fighting off an infection? Sauna simply brings on a feverish temperature without any actual fever and our defence systems kick into action; germ-busting white blood cells increase in number, move more quickly and the mucous membranes of the nose, throat, saliva glands and tear ducts become more fluid. These membranes capture and expel infectious pathogens such as coughs, colds and viruses, so the hotter it is the better they work.

The heat of the sauna can also reduce viral infections. If viruses such as flu and SARS are exposed to temperatures of around 55–65°C for 15 to 30 minutes, they are deactivated. "There's a huge line of evolutionary and historical evidence that points to the therapeutic application of heat having a positive effect in dealing with respiratory viruses," says Australian doctor and founder of the Extreme Wellness Institute Dr Marc Cohen, who studied this topic in 2020. In Scandinavia, a number of bathers said they head straight to the sauna at the first sign of sniffle. Whether it's the heat that fights off the flu, or the feel-good fix that the sauna provides, that works, who knows? The point is, sauna is believed to be effective at combatting flu.

Opposite: SALT sauna complex in Oslo, Norway.

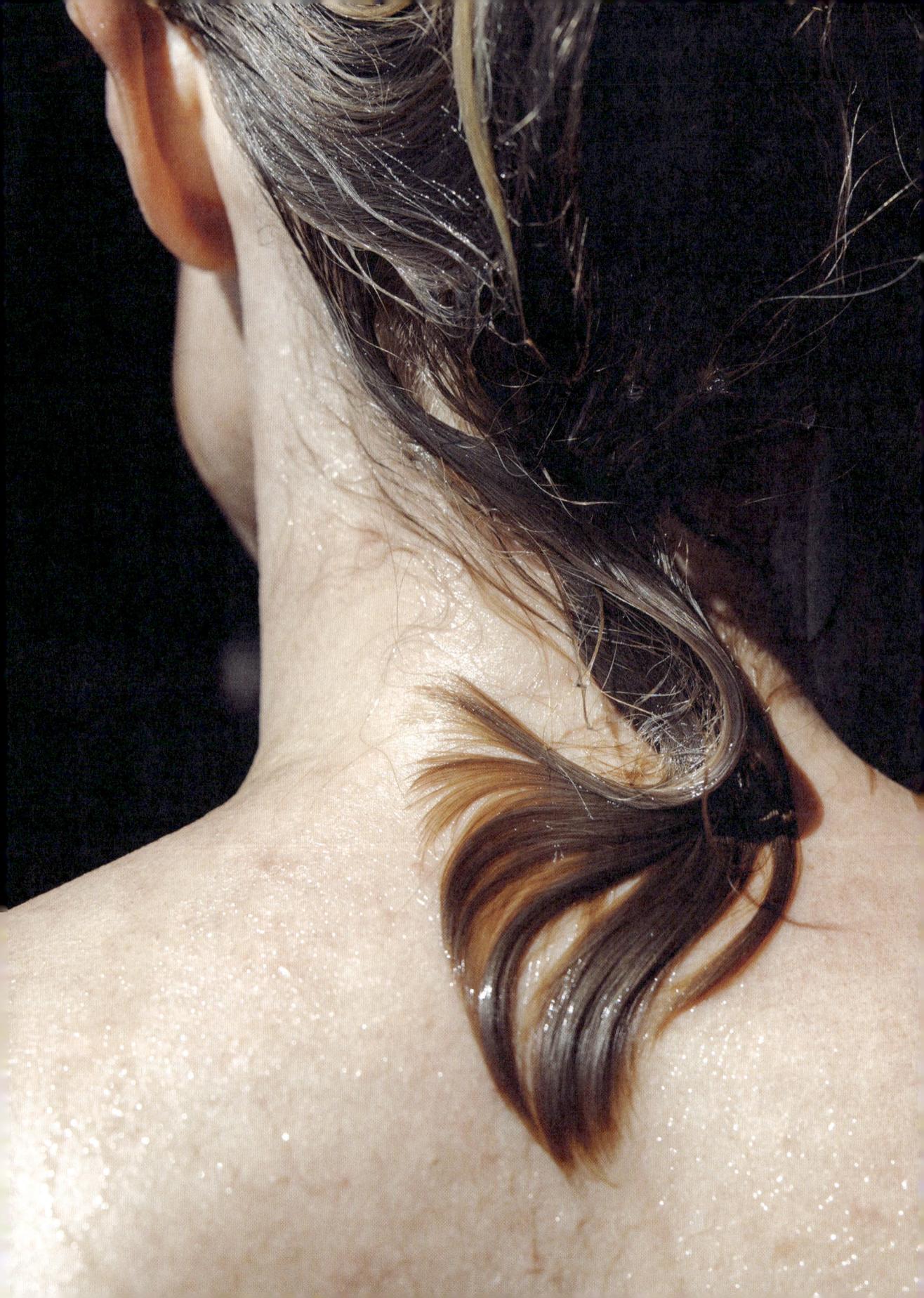

Blood pressure

The effect of the sauna on blood pressure has been one of the most well-documented areas of medical research, and the general consensus is that, over time, sauna bathing decreases our blood pressure. (Those with low blood pressure, take note: if you're new to sauna, it can cause nausea, dizziness – even fainting.) High blood pressure is a major cause of stroke, heart attack and kidney failure, so this research is good news, particularly in the UK where at least one in three people have high blood pressure.

Laukkanen's seminal study found that those who took sauna baths four to seven times a week cut their risk of high blood pressure by almost half compared to once-a-week sauna bathers. Why? Well, the most common theory is that the increase in body temperature during sauna causes blood vessels to dilate, which can increase blood flow and improve the function of the endothelium – the tissue that lines the inside of blood vessels.

Infrared sauna

The Sauna World Championship marks a dark moment in sauna history, but it made "Sauna Timo" a legend. The five-time world champion was famous for his ability to endure eyeball-melting temperatures, but in the 2010 final things took a turn for the worse. After six minutes in 110°C heat and an endless stream of *löyly*, Timo Kaukonen passed out and was dragged out with life-changing burns and trauma. His Russian rival died. Timo spent six weeks in a coma undergoing operations and skin grafts, and enduring a slow and painful recovery. Infrared sauna, with its dry heat, was part of the treatment.

It may lack the romance of the steamy sauna – there's no camaraderie, no *löyly*, no going in and out and no temperature changes (the thermometer is fixed at 60°C) – but infrared sauna triggers many of the same heat-stress reactions as a traditional sauna. It improves cell health, muscle recovery and reduces inflammation; it heats the body not the air, so it's not hot on the skin. You don't need to remove jewellery, and it doesn't wreak havoc on your hair. Strenuous it is not, making it ideal for people with intractable diseases, heart problems or mobility issues. Grand Resort Bad Ragaz in Switzerland is typical of many high-end hotels where infrared is the sauna of choice for wealthy guests.

As for Sauna Timo, he has put endurance tests to rest and now hosts therapeutic rituals in the sauna instead. Although he admits that infrared helped him recover, it will never compare to the traditional wood fired sauna: "Never," he says. "It is my love and my life."

WAON THERAPY

In 1989, Japanese cardiologist Dr Chuwa Tei pioneered infrared sauna – or Waon therapy – as a treatment for patients with serious heart conditions. It takes its name from the Japanese words *wa*, meaning soothing, and *on* meaning warm. Waon therapy involves lying in an infrared sauna for 15 minutes, before being wrapped in blankets and resting on a bed for a further half an hour. With the sauna set at constant 60°C, it raises the body temperatures of its passive participants by 1°C – enough to bring on a sweat – which in turn improves mood, appetite and sleep.

In 2012, Dr Tei founded the Waon Therapy Research Institute in Tokyo. Although he has used Waon therapy to treat more than 50,000 patients, it is still a niche treatment in Japan and is not covered by its National Health Insurance. Even so, trials show it works on a variety of ailments, from heart problems to fibromyalgia to chronic fatigue syndrome (CFS). A 2015 study on ten patients with CFS found that Waon therapy once a day for five days a week over the course of a month led to improvements in symptoms such as pain, fatigue, insomnia, appetite and mood.

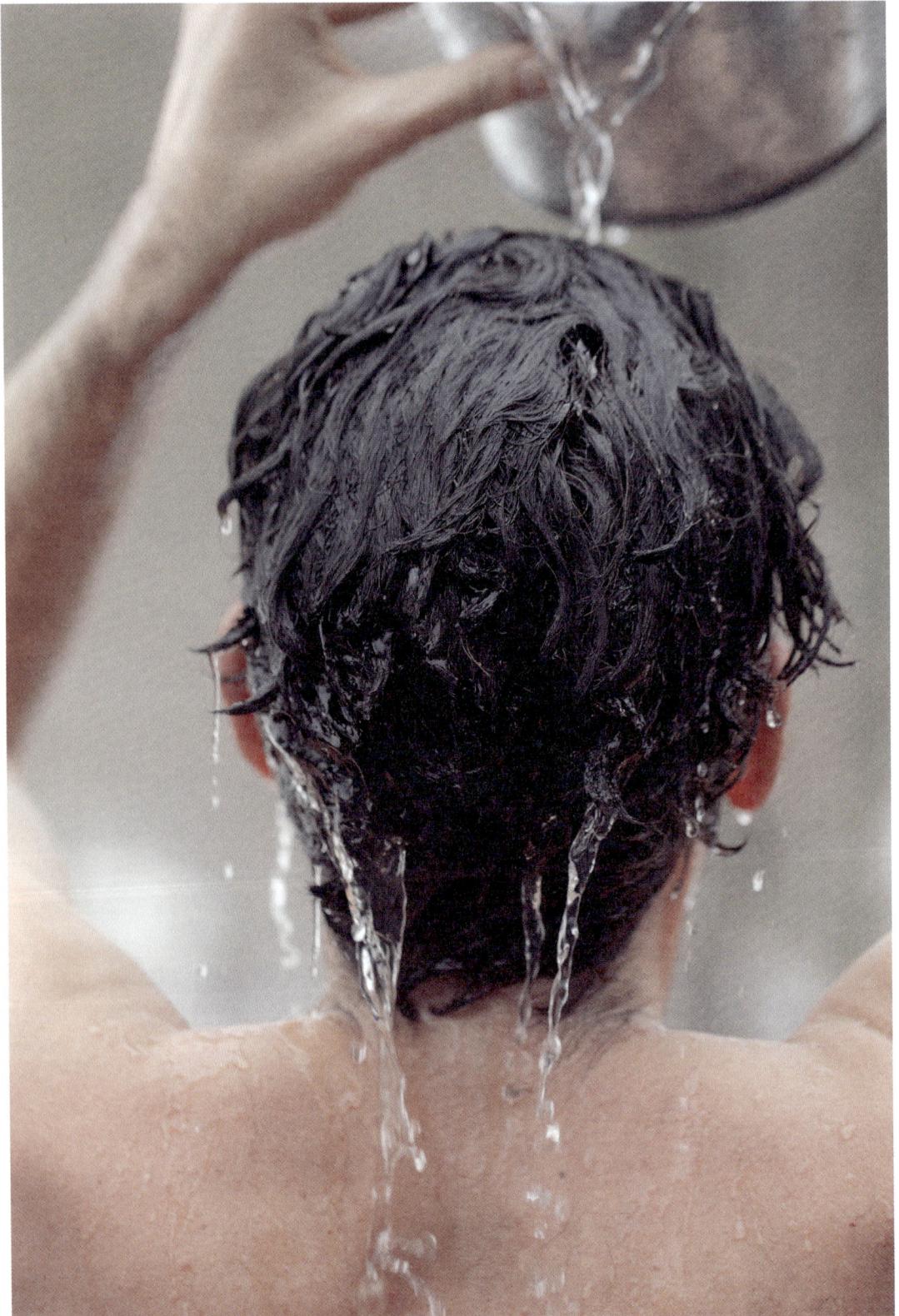

Brain cells and hormones

After 30 minutes in a medium hot sauna (45°C and upwards) heat shock proteins are activated. These are a large family of proteins that are present in all cells. In stressful conditions, and as we age, these proteins can become damaged (neuro-degenerative diseases, such as Alzheimer's, Parkinson's disease and Huntington's disease are the result of the accumulation of too many damaged cells). But exposure to heat (and, to a lesser extent, cold) causes these proteins to stabilize, repair and re-synthesize the cells.

Breakthrough drug lecanemab has been trialled on patients in the early stages of Alzheimer's and is shown to slow down the build-up of the protein amyloid in the brain, thereby slowing down the disease. More than 55 million people globally suffer from Alzheimer's, and numbers are projected to exceed 139 million by 2050. As of yet, lecanemab is not readily available. But sauna is, for those who want it.

Sauna can also make you sleep like a baby. It's no coincidence that sauna-loving nations typically often choose Saturday night as sauna night, followed by a long lie-in on Sunday. There's nothing like the soothing heat, stillness and solitude to send us into a relaxed, trance-like state. Non-scientists call this "sauna brain" – neurologists have a more scientific explanation. This game of thermo-regulatory ping-pong can often last many hours, leaving us exhilarated and purified, but exhausted too. And this is backed up by other studies that have shown that if we hit the sack with warm skin and toasty hands and feet, we fall asleep more quickly and sleep better.

But there's also a neurological dimension at play. Heat stress brings on a rush of endorphins and their counter-hormones, dynorphins. The former are feel-good chemicals that act like morphine, diminishing anxiety and preventing pain; the latter makes us feel uncomfortable and hot and bothered. One can't work without the other, and the greater the dynorphin-induced discomfort, the deeper the endorphin high afterwards. Athletes call it "runner's high". No pain, no gain.

Hormonal changes help explain the brain fog. The heat reduces levels of the stress hormone cortisol by as much as 40 per cent, causing a drop in levels of noradrenalin, which diminishes alertness.

Dr Emilia Vuorisalmi is a private General Practitioner in Finland who focuses on holistic and preventative medicine. In her book, *The Science of Love Hormones: A Nordic Approach to Balanced Health and Happiness*, she identifies serotonin, dopamine and oxytocin as a happy trio of "love hormones". In the sauna, the brain, the central nervous system and digestive system secrete all three. Vuorisalmi writes: "Dopamine keeps us active. It motivates us, rewards us and teaches us survival. Serotonin makes us search for safety with the people closest to us, encourages us to harmonize our lives and to receive appreciation from others. Oxytocin unites us, it strengthens relationships, friendships, and the attachment of parents to their children, and it helps us feel compassion towards strangers." All three hormones are needed to form lasting bonds of love, which are part of a natural and comprehensive route to improving health. In Finland, Vuorisalmi is known as the "Love Doctor".

Sauna as a gateway to healing

If we use it wisely, the sauna can be a gateway to both mental and physical healing. The moment we've finished our chores and we're chilling in the steam with friends or alone can be "a key healing one," says Vuorisalmi, "like the final part of the yoga class where you lie down. It's important to take this time and stop because this is what we are forgetting; just to be – without a phone – listening to our bodies and connecting to ourselves."

Vuorisalmi tries to suggest to her patients that their illnesses may not be chronic, and that by getting "back to balance" they could recover. "The problem is that often patients become attached to the identity of their sickness. I always remind people that our bodies are made to heal, so whatever diagnosis we have, the more steps to balance we take, the more likely we are to fix it. People have the keys for their own healing. Sometimes we need medication to push us in the right direction, and sometimes we need it alongside more holistic measures."

Neuroplasticity – the flexibility of the nervous system and the brain to think in different ways – provides us with plenty of opportunities to learn, re-learn and change our behaviour. Vuorisalmi explains how neuroplasticity and sauna combined can help with stress: "When our stress levels are high, we find it more difficult to perceive things. The sauna gives us white space where we can sit and stare at the lake or the trees. In the steam, when we feel anxious or empty, we can learn to do nothing." She advises that we use this state of "brain plasticity" to reset, to put grievances behind us, be creative, feel gratitude. "Gratitude is like a muscle; when we are busy, we forget to use it, but when we work it, it gets stronger and we see more opportunities to feel it."

Similarly, if in the sauna we can get some respite from physical pain – even momentarily – we can unblock energy needed for regeneration. "Pain relief starts with pausing, noticing and identifying that pain, and working out what it's trying to communicate," Vuorisalmi says. "Pausing gives the brain an opportunity to activate and find another path. It may be easier to freeze the situation if there is an alternative method at hand. We have to make informed changes in these situations. We need to be unhurried and active all at once. We need to be aware and create new habits." And if a problem has a beginning, it also has an end. "When we practise things regularly, they start to feel easier and, at some point, they begin to happen automatically. The connections and neural pathways that we maintain and exercise get stronger." Small paths become clearly marked A-roads down which retrained brains can travel. Vuorisalmi declares, "People have the keys for their own healing."

Opposite: Bathing in the Finnish style sauna at Hackney's Community Sauna Baths.

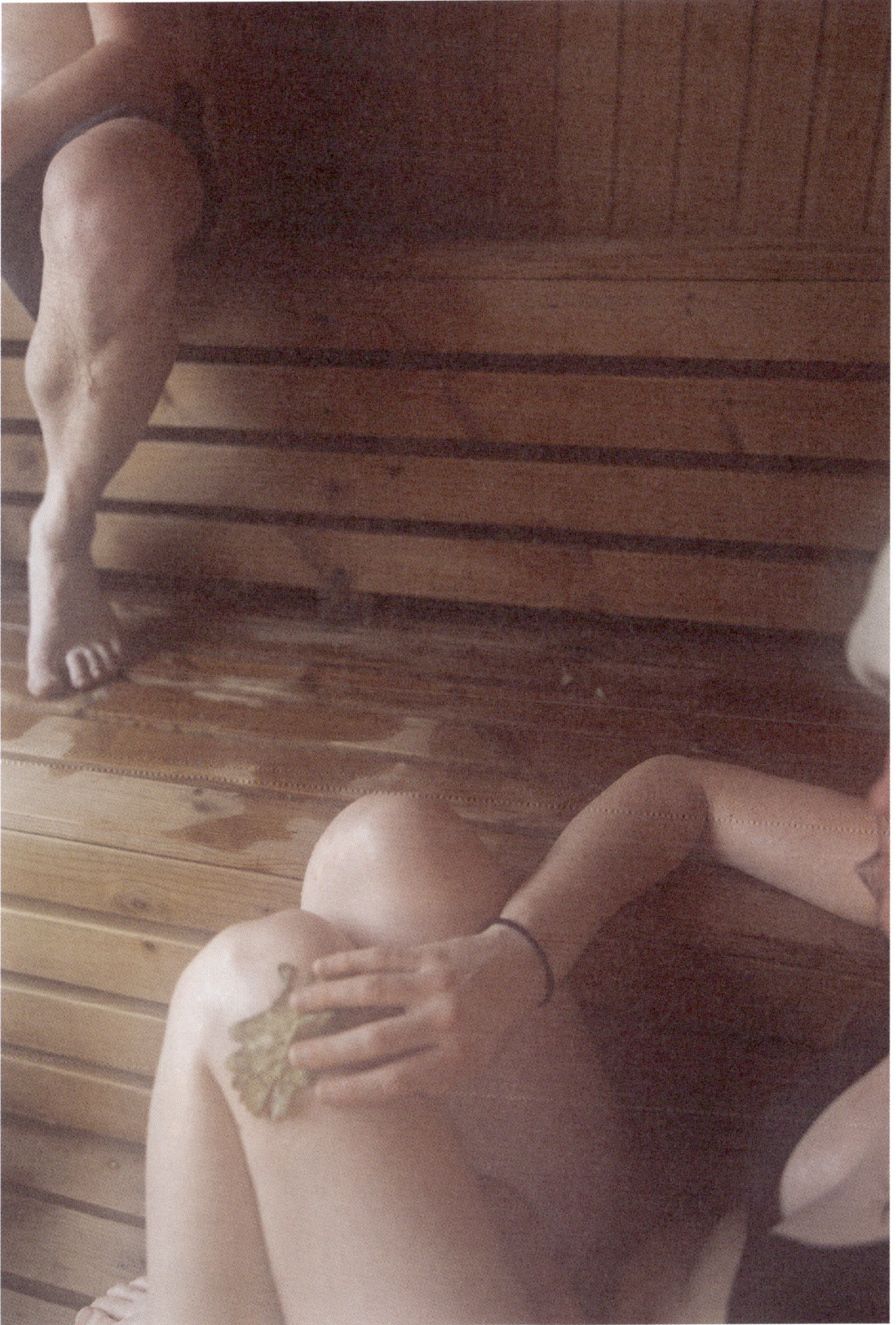

Self-motivation

But why are we ungrateful in the first place? Is it our couch-potato, overly convenient, touch-of-a-button lifestyle? Wim Hof and Raison are among those who think so: "We have everything; copious amounts of food, online sex, friends and antibiotics," says Raison, "but we feel a malaise because we have short-circuited the pathways that lead to our need for hedonic reward, our pleasure, which comes from putting in effort." In his book, *The Wim Hof Method*, Hof writes: "Our comfort-zone behaviourism has made us weak … Our immune systems have become compromised … Our biochemistry is out of balance and we can no longer function as we were meant to. On top of that, much of this illness is pyschosomatic. We are worrying ourselves sick."

So do we need some degree of hormetic stress for sustained well-being? "If we continue our technological advances and cyborgian behaviour, we will reduce the pathways towards well-being," warns Raison. "If you hike to the top of a mountain, you get more of a buzz than if you drive up it." Toasting in a sauna or jumping in an ice-cold lake gives us the hormetic stress that we need as a species. "We need to expose ourselves to those ancient stressors."

But it's hard to give up take-outs in front of the TV, or go to the gym when the sofa is beckoning. How do we wean ourselves off the easy option? One route could be to take the sauna out of the gym (where it is often too dry and badly ventilated, anyway), and see it as a social space that happens to be good for you. Adam Rang, a half-British, half-Estonian sauna expert living in Tallinn believes this is the best way to get more people into the sauna.

"The popularity of saunas has been heavily influenced by wellness trends specifically focused on weight loss and fitness. While it is certainly good to incorporate the sauna into a healthy lifestyle, this focus has stripped away the culture and traditions around it. A sauna is not just a hot room to Estonians, it's like the pub for Brits, the BBQ for Australians or the *braai* for South Africans," Adam says, at a Saturday-night sauna session in his garden in Tallinn. "Of course, it has important health benefits, some of which are more scientifically proven than others, but loneliness is one of our biggest health problems globally, so the social benefits of the sauna outweigh a lot of the wellness arguments."

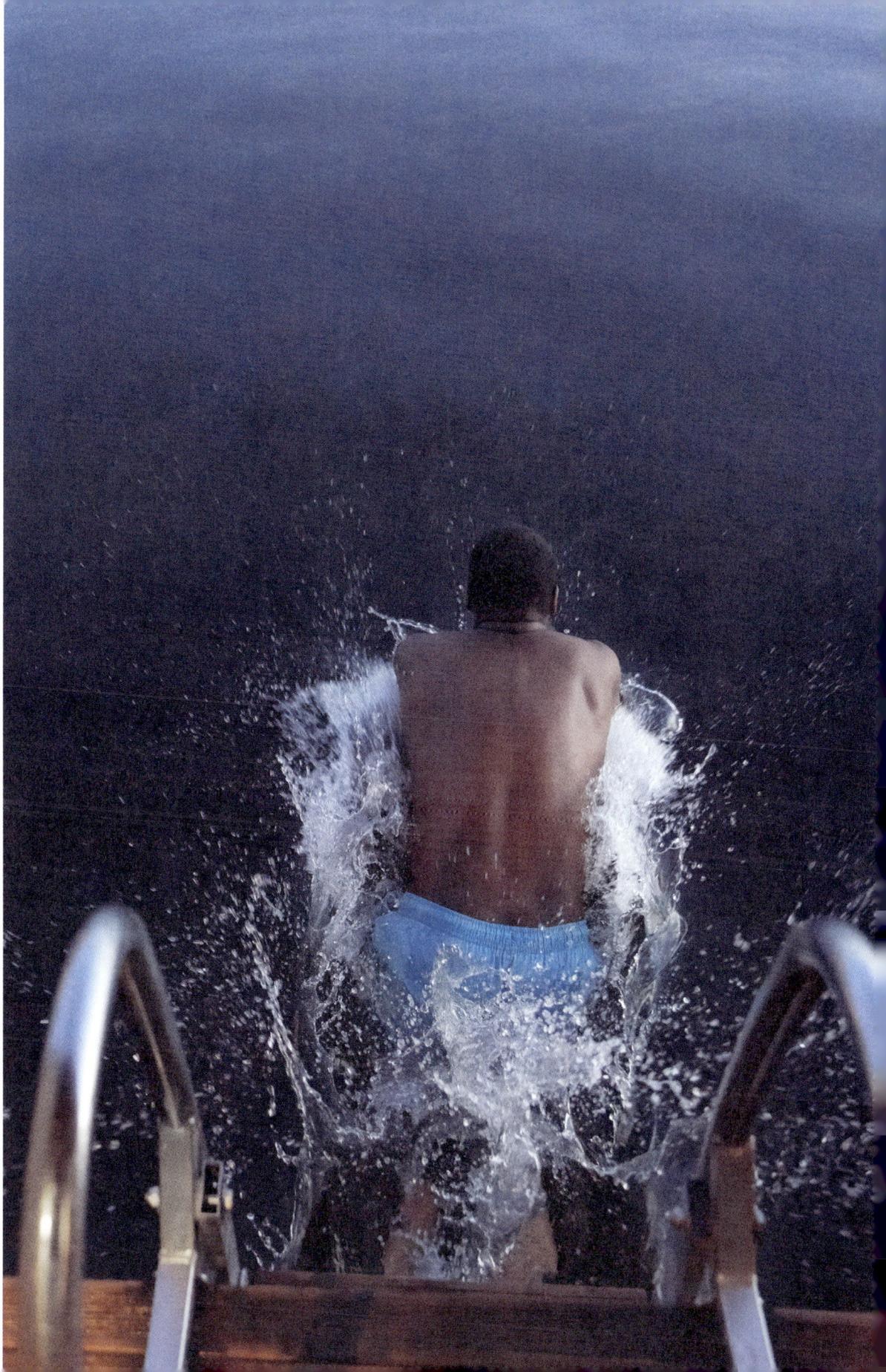

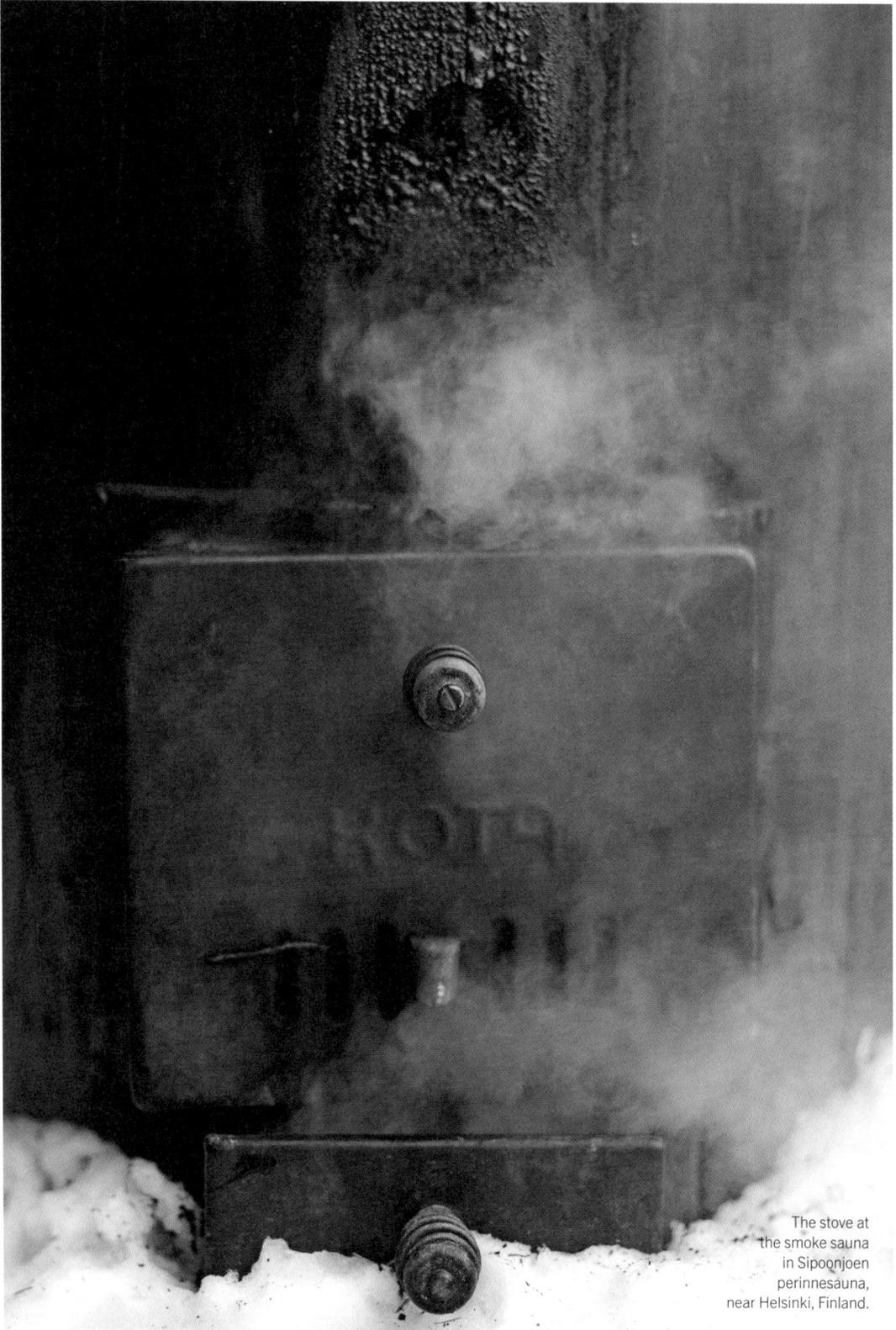

The stove at
the smoke sauna
in Sipoonjoen
perinnesauna,
near Helsinki, Finland.

The liminal space

Sauna still holds many mysteries in its steam. We can *feel* that it's good for us, even if we don't still quite know why. How, in the twenty-first century, can its alchemic powers evade the best medical minds? In our quest for data, most of the studies to date have focused on the physiological rather than the psychological impact of the sauna. But in the post-pandemic, hyper-connected, super-fast twenty-first century, where we have facts and figures at our fingertips, don't we crave something deeper, something more spiritual?

The digital generation certainly does. For Finnish duo Matti and Juha of Saunakonkeli, just outside Tampere, the sauna is "a liminal space where the constant flow and circulation of elemental energies purify, heal and renew". "Liminal" comes from the Latin word *limen* which means *threshold*, and like many young Finns, the duo was keen to explore sauna's deep roots and esoteric powers. In 2018, they went on a "sauna pilgrimage" around Finland by bicycle, visiting shamans, blood cuppers, and sauna builders who have visions. "It was an awakening for us," says Juha, who has a sauna every day and whose mother was born in one. "People think of sauna as a wellness thing, but it's more than that. It's a healing place where alchemy takes place and something beautiful comes out."

From their base in an 1890s summer house, Matti and Juha host a podcast and lead rituals and ceremonies incorporating meditation, sauna spirits, whisking, chanting and relaxation. "The sauna is like a blacksmith's forge," says Matti, "and we are the metal, burning with heat and then, in the cold water, as all that heat dissipates, we are transformed from one state to another."

On a similar journey of discovery is Miska Käppi, who runs Sipoonjoen perinnesauna, a smoke sauna in Sipoo outside Helsinki: "As a nation, we Finns know how good a sauna makes us feel, but the culture of putting this into words feels distant; it's as if it lays dormant and needs to be rekindled."

Käppi spent years studying sauna mythology, and incorporates his knowledge into transformative rituals which attract "newly-weds, new parents, fresh graduates, burned-out executives and anyone who wants to move from one stage of life to another." But what's his ideal sauna? "One in which people lose their finite form and get in touch with their transcendental selves. In the old spells, this process is called falling into a crack in the earth, and sauna is the place where you open this crack. It lies somewhere between the stones of the stove and it's where you send your pain and worry; the tired self dies and disappears down the crack, the whisking transforms your body and mind, and you are reborn."

This may sound alternative – but don't we need alternatives? In the UK, one in four adults lives in chronic pain, and in the USA, 2.6 million people, (1 per cent of the adult population) are regularly prescribed opioids and sedatives for a range of maladies. "One in ten people in Sweden is on anti-depressants," says Hägglund, "and the most common cause of sick leave is depression and anxiety." Europe, with its aging populations, spends 90 per cent of its health care budget on treatment of illnesses, and only 3 per cent on preventative measures – surely it's time to think again? And a space like the sauna, with its ability to heal visible ailments and soothe invisible ones, is a good place to start. "The basic formula is simple," says Käppi. We just need to embrace it.

MOOSKA MAGIC

At Mooska sauna complex in southern Estonia (see Chapters 6 & 7), Eda Veeroja is trying to preserve, document and reintroduce ancient healing rituals. "We only started to look at our ancient customs openly in the 1990s [after Independence], and saw that there was almost nothing left," she says. "Before that we were too afraid to speak about them. They were seen as pagan; improper and old-fashioned, something to be stamped out." The courses, workshops and smoke sauna rituals at Mooska keep this ancient knowledge alive.

Eda grew up in Võru, a region of 75,000 inhabitants with their own dialect and traditions. She learned all her sauna wisdom from her late mother and grandparents, and begins every ritual by greeting the souls of ancestors and honouring the fire. The stove plays a central role in sauna mythology; it is the symbolic centre of the household and the flame within it is seen as sacred. Treat it with respect or black magic will occur and your smoke sauna might burn down. Most sauna cultures have a mythical keeper of the flame; in Lithuania, female sauna fairies, *laumes*, look after the space and bathers leave them a whisk when they depart. In Finland, it's *sauna tonttu*, an elf who lives behind the stove and is personified in many a kitsch souvenir. It's common for bathers to offer *sauna tonttu* a log when they depart.

Historically, there were strict rules in the sauna too. No swearing, no gossip, and neighbours who were fighting had to stay away until they had reconciled. Anyone behaving badly was banished until they had apologised to the community and atoned for their failings with a ritual washing. And everyone had to bring their own whisk. It was a sign of utter destitution not to own one.

In Estonia, the first sweat is known as the "sweat of suffering", and, as they were in her ancestors' day, Eda's rituals are guided by the rhythms of the moon. "The new moon marks the moment to start over, change job, try for a baby, put past grievances and habits behind you," says Eda. "You can't cleanse when there's a full moon, or begin new things when the moon is waning. And when there is no moon at all, it's time to ask what to do next."

The ancients believed that psychiatric disorders were "nerve sickness"; anyone behaving unconventionally or strangely had been "spooked" and their spirit had left their body. It was the job of the healers to reconcile the two, and cold-water immersions were central to the treatment of conditions from epilepsy to schizophrenia. "Many people who come to Mooska are sick," says Eda. "And nowadays, most sickness is mental. Our minds are so overcrowded with chat, and we need to make silence. In the heat, it's easier to switch off the chat, and breathing can also take us into places. As a traditional healer, I try to find out why sickness has appeared; I take away blocks in the body and try to change energy ... clearing the mind takes practice, like playing tennis or the piano."

Mobile phones, drugs and alcohol are not allowed at Mooska. Transformation requires concentration. Eda declares, "It's deep stuff. I don't add anything. We have to make our own lives. If someone is not capable, or not ready, I can't change that. Healing is something people do themselves. I simply help them."

mooska.eu

Opposite: Mooska, one of Estonia's most famous sauna complexes.

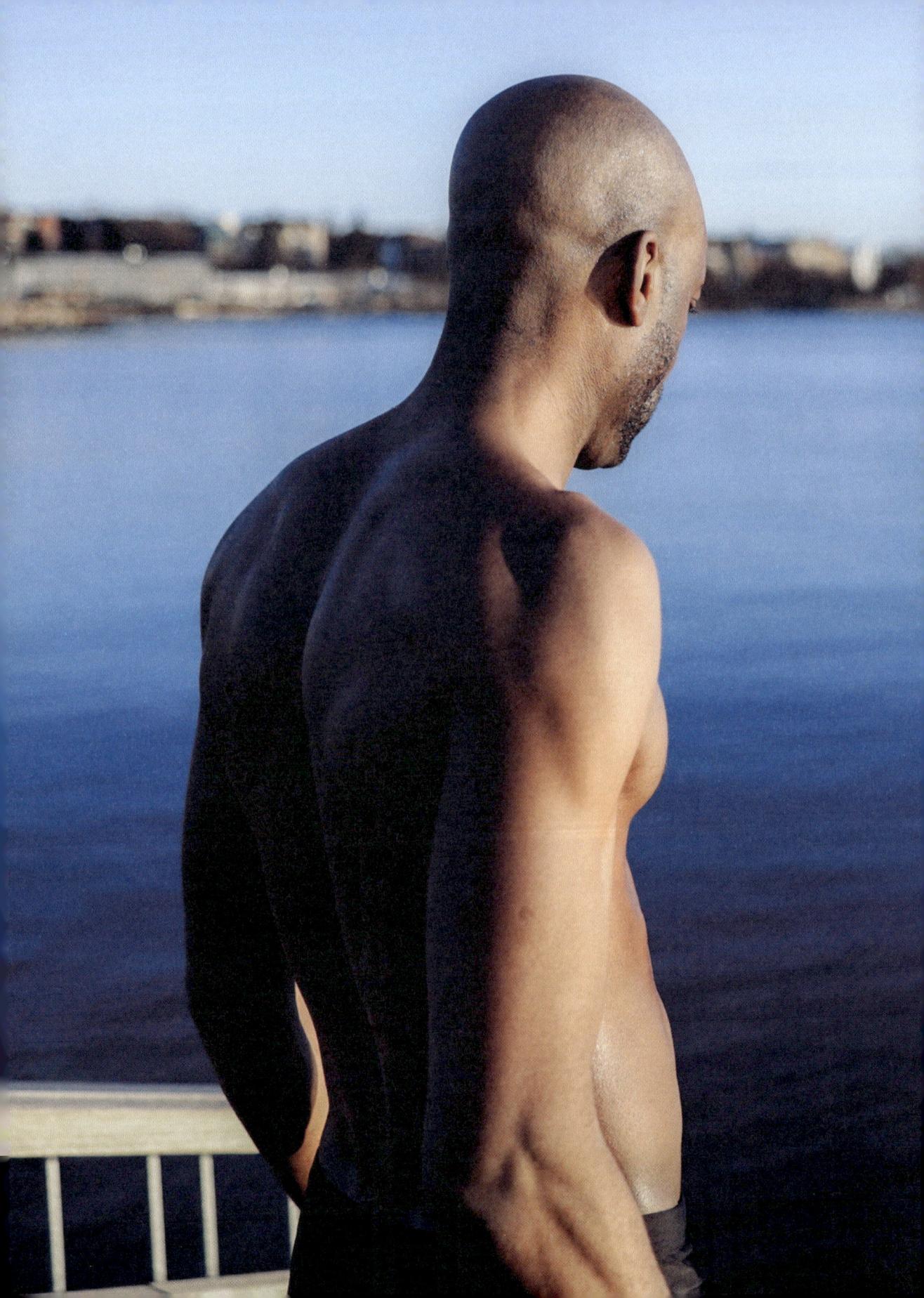

FIRE & ICE

Sauna and cold-water swimming

"Heat and cold are our great teachers."
Dutch "Iceman" Wim Hof

A t Heathrow airport last summer, a billboard of a middle-aged woman in neoprene gloves and boots standing waist deep in a briny-looking sea greeted travellers in arrivals. "Welcome to Britain," she proclaimed, presumably before throwing herself into the next breaking wave. It was a refreshing departure from HSBC ads, Beefeaters and astronaut Tim Peake, and shows just how far Brits are embracing water once again. Not since the Victorian era has sea bathing been so celebrated. While most relics of this glorious pastime have been dismantled or turned into car parks, the passion for swimming through the seasons has brought windswept beaches back to life and injected down-at-heel coastal towns with new vigour. Brighton is on course to get a new seafront lido, and tidal pools everywhere are being rediscovered – and not just in the UK. From Southsea to Seattle, bobble-hatted bathers bounce in the surf even when there's frost on the sand dunes, and groups of friends, lobster-red and shrieking, emerge from effervescent waves.

There's no downside to taking a cold plunge, but, in the UK at least, warming up afterwards can be challenging. Swimmers star jump in oversized towelling robes and make do with mugs of tea. But for some, there is a warmer alternative: over the past two years, almost 100 mobile saunas have popped up on British beaches. Created by budding entrepreneurs, or ex-pats from sweat-bathing cultures, they come in all shapes and sizes, from horseboxes and train carriages to army trucks and old vans (see Chapter 5). Mika Meskanen, co-founder of the British Sauna Society says: "I've kept a close eye on and been involved in the growth of the UK sauna movement for the last decade and I'm very excited to suggest that it's fast becoming one of the most dynamic, creative and inclusive sauna movements in the world, and putting Britain back on the map of bathing cultures."

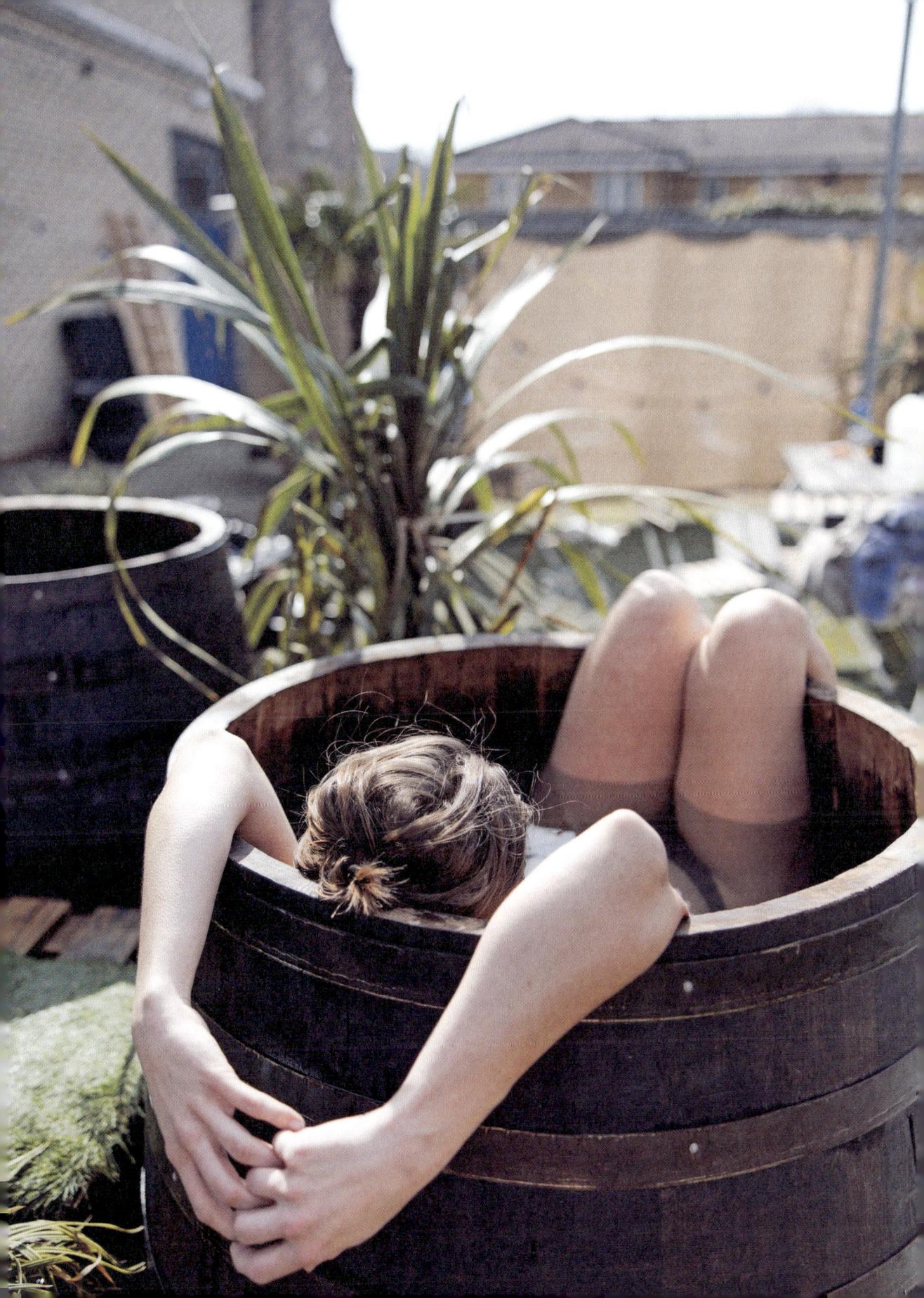

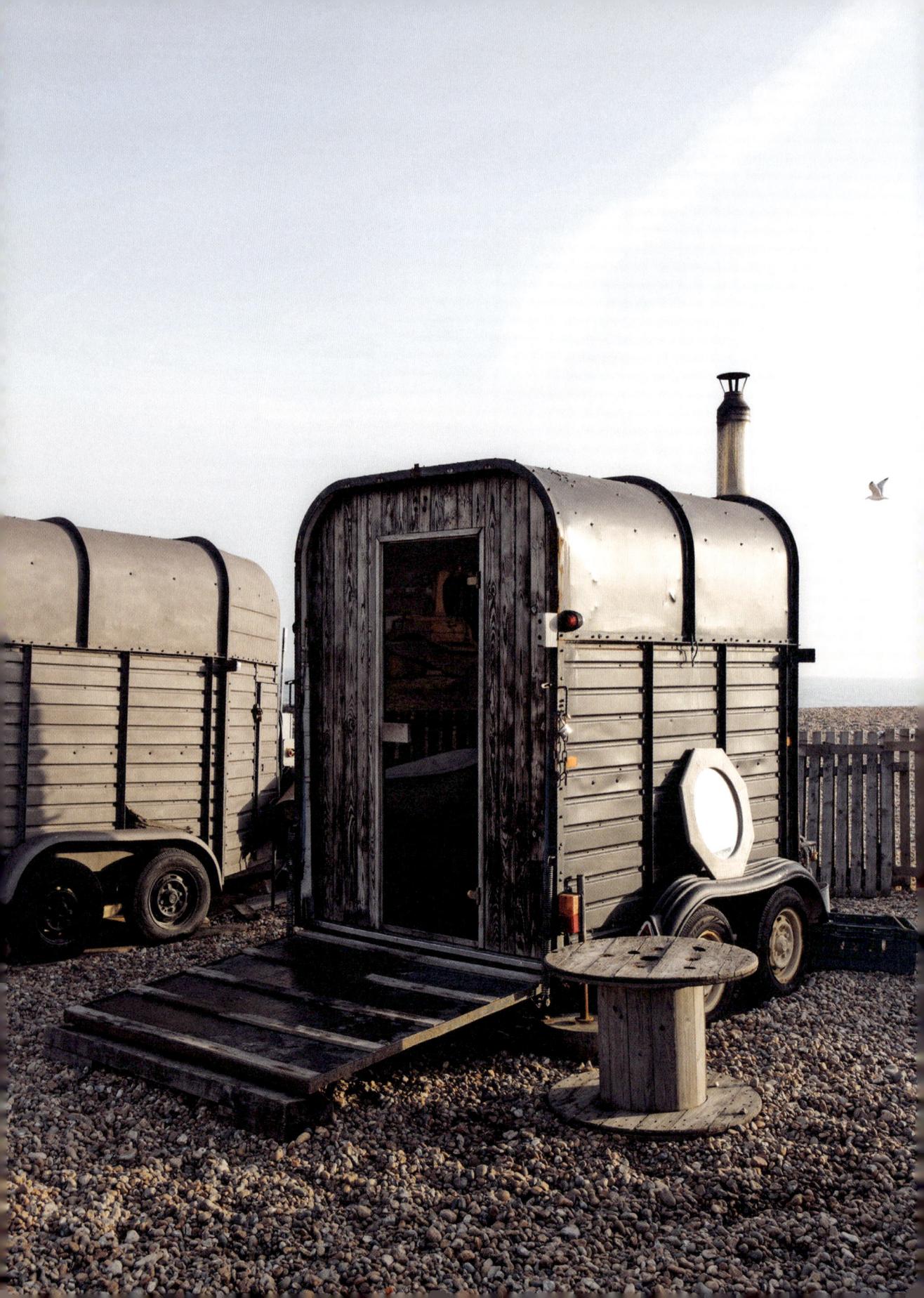

Sauna masters

In the UK, this new sauna movement started at Brighton's Beach Box Spa. Founded in 2018 by Liz Watson and Katie Bracher as a pop-up, it has since put down permanent roots and grown into a sell-out spa complex with three horsebox saunas, ice-barrel plunge pools, a bath tub and, of course, the English Channel. Liz and Katie are both qualified "sauna masters", which means different things in different countries; in Germany and Austria a *sauna meister* needs to understand *aufguss*, the art of manipulating steam around the space with a towel to conjure a "heat peak"; in the Baltics and Russia, whisking is the skill. Whisks, bunched twigs with leaves and typically birch, oak or juniper, "work like giant hands to give a phyto-thermo massage," says Katie, who is a trained *aufguss* master and whisker.

In all cultures, a sauna master is attentive to the needs and responses of their group, creating a safe, secure space. "It's not as simple as making the sauna really hot," says Katie. "It's contained and warm and can feel like a womb, and people can have emotional responses to that." Katie and Liz also know exactly how to pour water on the rocks to create a perfect steam. And they know to call this steam *löyly*, because it's not just steam, it's a magical, mystifying, transformative, healing, soothing life force – just ask any sauna pro.

Opposite: Horsebox sauna at Beach Box Spa, Brighton, UK.

The perfect sauna

What are perfect sauna conditions? It's a big question, and one that congresses, conventions, sauna summits and sauna enthusiasts spend many hours debating. Ideally, a sauna requires a temperature of 70–100°C, regular whooshes of steam and a body of cold water, or a pile of snow, in which to plunge, because cooling off is as important as warming up.

While some prefer the zing of the ice plunge, others favour the sauna's steamy grip, but there's nothing more soothing than stepping into the heat when you've lost all feeling in your hands and feet and your chattering teeth are unable to form words. And when the flames from the sauna stove are licking the back of your throat and even your earlobes are sweating, what could be more cleansing than rinsing away all that came before in cold water? Before you know it, you're addicted.

Environmental conditions aside, the perfect sauna is also about the company, about sweating it out with friends and partners, children and strangers. Being part of a community makes us feel safe and secure, and the beauty of sauna chat is that it can flip with ease from superficial to confessional, from serious to silly. And there's no pressure to fill awkward silences, because silence in the steam is never, ever, awkward.

Opposite: Sauna aficionados take much care over the placement of the rocks on the stove.

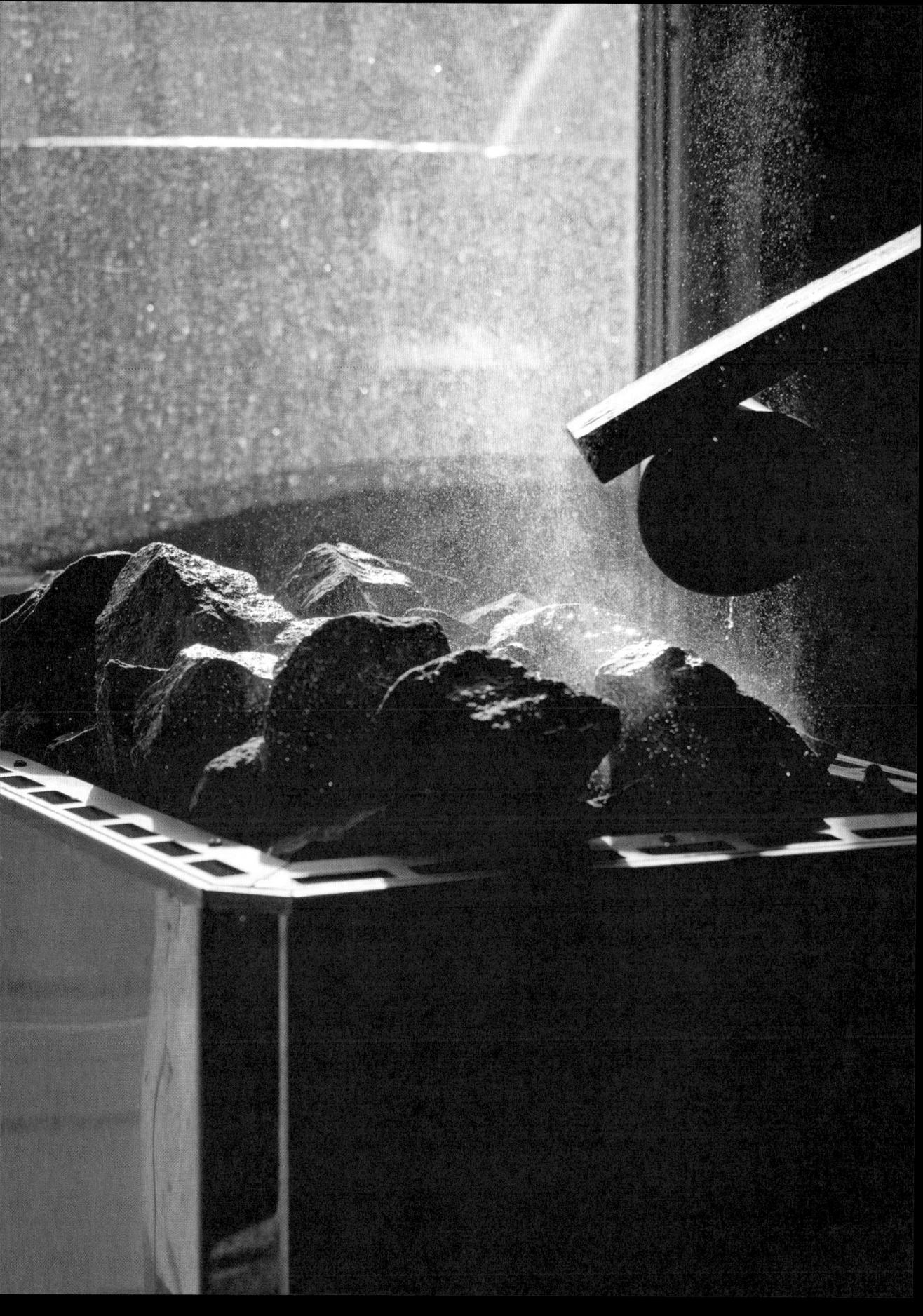

Cold exposure

In his bestselling book *The Wim Hof Method,* Dutch "Iceman" Hof writes: "The human body is well-equipped to endure gradual exposure to ice water. The water offers us ways to handle stress … It can be painful at first, but you learn to adjust to it and then you actually start to love it." By drawing on his "three pillars"– conscious breathing, cold exposure and the power of the mind – Hof has run a half marathon above the Arctic Circle barefoot, swum 66 metres under ice, and completed other record-breaking feats in sub-zero temperatures. In countries like the UK, where close-up encounters with the extreme cold is a learning curve for most, Hof is something of a guru. His disciples run sell-out training courses, and it's never hard to spot Hof trainees at the water's edge, inhaling and exhaling with frenzied concentration before they take the plunge.

Although Hof has broken world records and confounded medical minds with his super-human challenges, cold exposure and conscious breathing have been practised for thousands of years; Buddhist monks in Tibet have drawn on the tantric art of Tummo for centuries, draping wet sheets on their bodies in sub-zero temperatures for hours on end to reach a higher state of consciousness and a deep inner heat.

Recent studies on trained ice swimmers revealed that, while their core and skin temperatures plummet in cold water, they rise more quickly too, and that over time cold and hot immersions improve circulation. It's something of a paradox, but the more you cold shower or plunge in the ice, the warmer you will feel. Why? Because a cold dip encourages the body's thermo-regulation system to be more efficient. What's more, core temperatures of cold swimmers can actually rise when they enter the water; this "anticipatory thermo-genesis" is a normal physiological reaction in the well-practised.

In the non-acclimatised, however, a cold dip sends the sympathetic nervous system into fight or flight mode; novices scream and gasp as freezing water swirls round their torsos, while those who are "toughened" slide in without so much as a shiver and glide around like graceful swans. Countless studies have shown that cold-water swimmers suffer fewer coughs, colds and respiratory illnesses than non-swimmers. One theory is that this is because they produce higher levels of interleukin, the protein that regulates cell growth and stimulates immune responses.

Opposite: Breaking the ice and taking a dip from an old boat shed in eastern Finland.

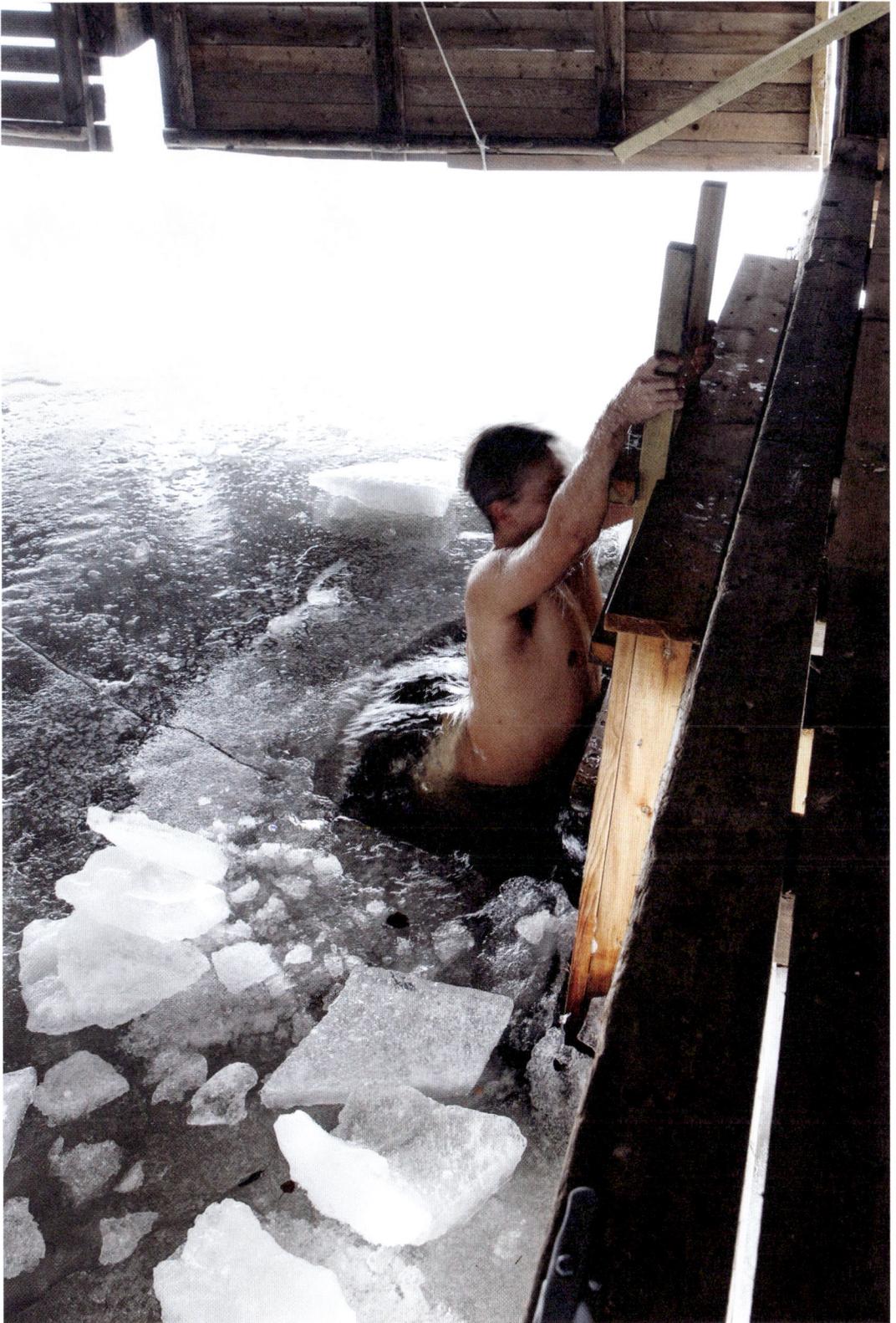

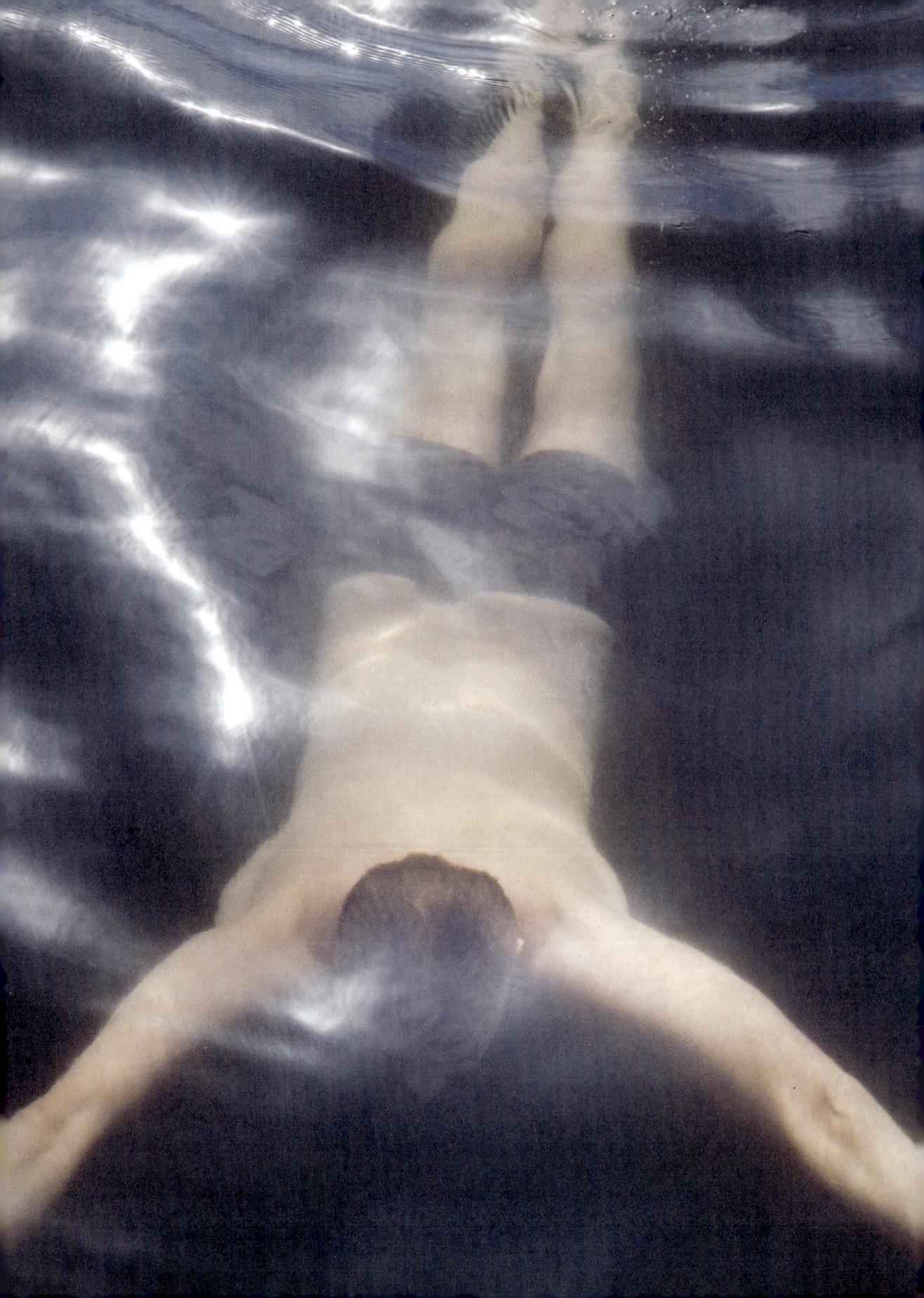

Best of both

Many doctors agree that a combination of hot and cold stimuli is the best for building resilience. Both raise our hormetic stress or "good stress" levels, and alternating immersions make it easy to hit the sweet spot. (Too little stress can leave our bodies unchallenged, too much can lead to health problems.) And exposure to both stressors makes us more able to cope with life's genuinely "bad" stress. If you can jump in an ice bath for five minutes, you can certainly deal with a tricky colleague.

Athletic types and bio-hackers seeking optimum control over their biology time their sessions in the cold and sit on the top bench of the sauna until they feel light-headed. They want to "toughen to the limit". But no matter who you are, connecting with "hard nature" through hot and cold requires mental stamina too – the Finns call it *sisu*.

Sauna and *sisu*

"Sauna and *sisu* are the great Finnish superpowers," explains Maija. "I mean, how else can we survive the –25-degree winters and months of darkness?" *Sisu* comes from *sisus*, which means "guts" in Finnish, and refers to toughness, practicality and resilience in the face of difficult challenges. It was embraced in 1917 by the new powers that be as a particularly Finnish quality after the country gained independence from Russia, and is still seen as the "social glue" that holds Finnish society together. A bit of British stiff upper lip, if you will.

Katja Pantzar is an author who lives in Helsinki and has written two books on *sisu*. She found hers when she moved to Finland and started swimming in the sea in the winter. In her first book, *Finding Sisu*, she writes: "this unique culture of resilience helps me transition from being a weaker, more passive person, scared of trying new things, into someone who feels better and stronger both physically and mentally."

For Katja, with the cold swimming came a love of sauna. "As a teen in North America, I found sauna unthinkable on so many levels; the heat, the nudity. It was not for me. Then I started winter swimming and I grew to love, appreciate and understand it. You dip, get cold and do something extreme, then you go into the sauna and relax in the soothing steam. It's heaven; like sitting round the camp fire; we chat, there's no agenda, people talk about everything. It's the best way to de-stress." But if you're new to sauna might you need some *sisu* to get you through? "Whenever you try something that is foreign, or new that might make you feel uncomfortable, you need *sisu*," says Katja. "And if you're uncomfortable being naked, or getting hot and steamy with strangers in a public sauna, you have to tap into it."

Outdoor offerings

Like many Helsinki residents, Katja is a member of a winter swimming club called *Katajanokka's Icebreakers* – thus named as it's near the fleet of icebreakers that carve channels through the harbour in the winter (one of these is called *Sisu*). It's one of Helsinki's 13 winter swimming clubs, and has an indoor changing room, a café, a sauna and its own private jetty off which members swim. In winter they cut an ice hole into the sea. Winter swimming clubs feature in most Nordic cities. "In Copenhagen, there is a waiting list of more than 10,000 people keen to join its bathing clubs, and that's before you count the people who want it do it occasionally," says Kasper Eich-Romme, co-founder of eco-picnic boat rental company GoBoat. Around 15 years ago, Copenhagen city invested more than 1 billion kroner cleaning up the harbour, and since then bathing spots have sprung up, with zoned swimming areas, changing rooms and saunas. And that's before you count the public beaches.

ULTIMATE *SISU*

Katja and a group of her female friends call themselves The Cold Sisters. One of the "sisters" is Päivi Pälvimäki, Finland's most famous wild swimmer. In her new book, *Swim Trekking in Finland*, Päivi documents her swim treks across some of Finland's most beautiful lakes, towing her belongings on a float behind her. She has *sisu* in spades. "I no longer need to call on *sisu* to swim," she proclaims, "and I only check the weather for long swims. I just get on with it because I know that a swim will never let me down. If there's a snowstorm and I'm getting into sub-zero waters, I don't listen to voices in my head." Proper *sisu*. And her humility about not even recognising she has *sisu* is also *sisu*. "The Finns are very non-market-y and low key. It's not good to boast or brag," explains Katja.

Sometimes Päivi will dig her own ice hole (more *sisu*) carving her way through 50 or 60cm of frozen surface water with her ice saw. "I believe *sisu* is a big part of why Finland has been nominated happiest country for the fifth year in a row," she says (along with a functional welfare state, unspoilt nature and confidence in society). "We don't think about the perfect. We just appreciate what we have."

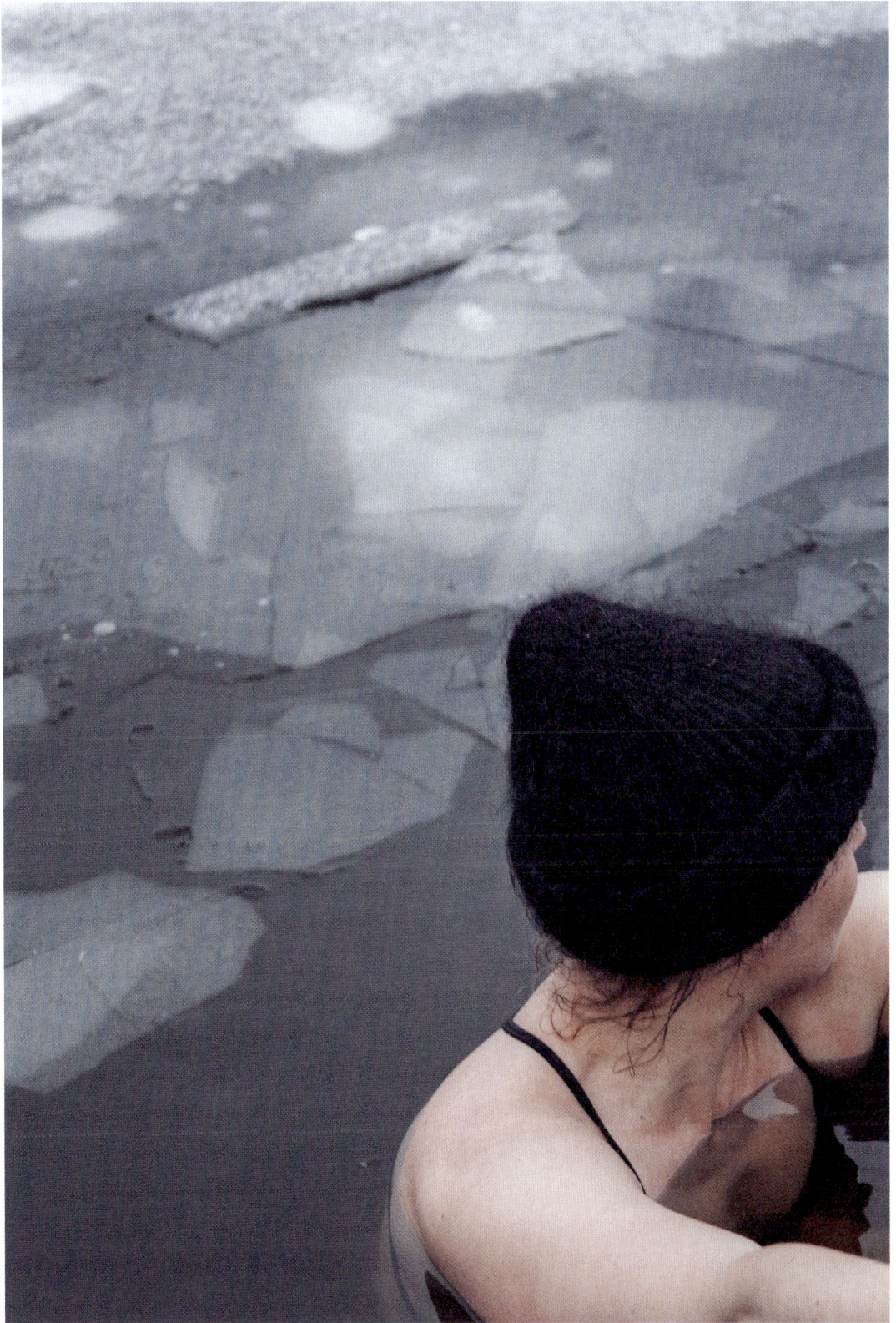

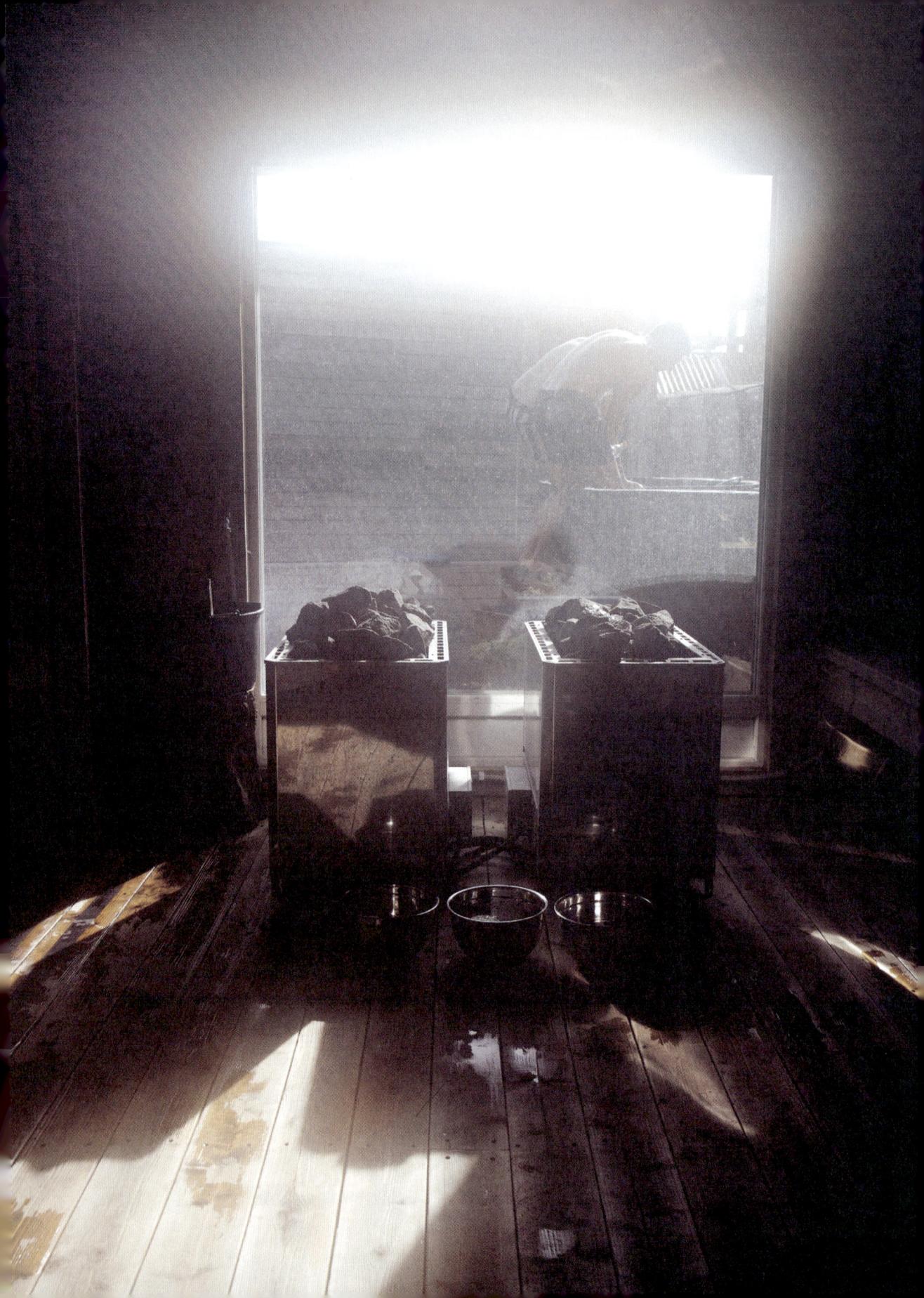

Oslo and Helsinki have followed Copenhagen's lead. In 2016, the 9,000-square-metre Allas Sea Pool opened on an old parking lot in central Helsinki. It now has more than 2,000 members, a waiting list and hosts around 800,000 visitors a year. On a bright June morning a woman in her 60s in huge black shades is swimming breast-stroke gently up and down one of its shimmering swimming pools. Nearby, steaming bathers emerge from a floating sauna and jump into the pool next to her. Tourists on the ferry to Suomenlinna chug by, looking on enviously. Wouldn't most people want to start the working week with a dip at Allas?

Allas founder and CEO Raoul Grünstein thinks so, which is why he plans to build a network of "waterside wellness" complexes in many cities. There are plans afoot for a four-pool Allas complex in the Finnish city of Oulu; and Kaarna, their floating complex in Turku, will

have six saunas. Both have conference rooms, yoga studios, restaurants and terraces. Then it's Stockholm in 2024, and after that Cardiff, and maybe Bristol. "There has been a mental shift towards wellbeing since Covid," he says, "and, increasingly, people are looking for experiences."

SALT in Oslo's fjord is a "thermal theme park" offering sauna experiences to a young crowd, new to the game and eager to experiment. Events include a mix and match of rituals – Lithuanian whisking, German *aufguss*, Latvian chanting and, in a vast event sauna, DJs, performances and readings take place in front of an audience of up to 120 people who steam in a gentle 55°C. With its bars, food stalls, barrel saunas, ice plunges and more, SALT has a low-key festival vibe that hasn't lost touch with its roots as a pop-up that arrived in 2016 and never left.

Opposite: After an *aufguss* ritual, bathers exit in haste and head for an ice barrel in SALT sauna complex, Oslo, Norway.

Cold dip or sauna?

Which should come first? It's the first question new bathers always ask, but there's no right or wrong; just do what you feel like doing. And how many rounds? At least three, but how long have you got? Russian *banya* sessions can last an entire day.

Regardless of whether you start with hot immersions or cold ones, cycling back and forth between sweating and shivering can be taxing, and there are still some no-nos and unknowns. For example, it's *not* good for certain viruses like shingles; and it's not known to what extreme you should go to if you have a weak heart. As of yet, there have not been enough studies into the optimal approach to cold and hot immersions, and it varies from person to person. But one thing *is* certain – cold exposure does not cause colds and heat does not "soften" you, as many nineteenth-century physicians liked to believe.

Hot and cold go together like yin and yang, black and white, Bonnie and Clyde. They are opposites in perfect harmony. But balancing them takes practice. If there's a sauna on hand, it's common for those new to cold-water swimming to overstretch, and stay in too long, in the hope that the sauna can provide an instant hot fix if they get too cold. It can, but not as quickly as hypothermia can set in. Don't set targets. When you start to feel numb and elated, get out of the water, and if the sauna is making you dizzy or lightheaded, step out and cool off. "To stay healthy, a person needs to move, sweat and use the water in its mildest form," said the late "Water Doctor" Sebastian Kneipp. And who can argue with that?

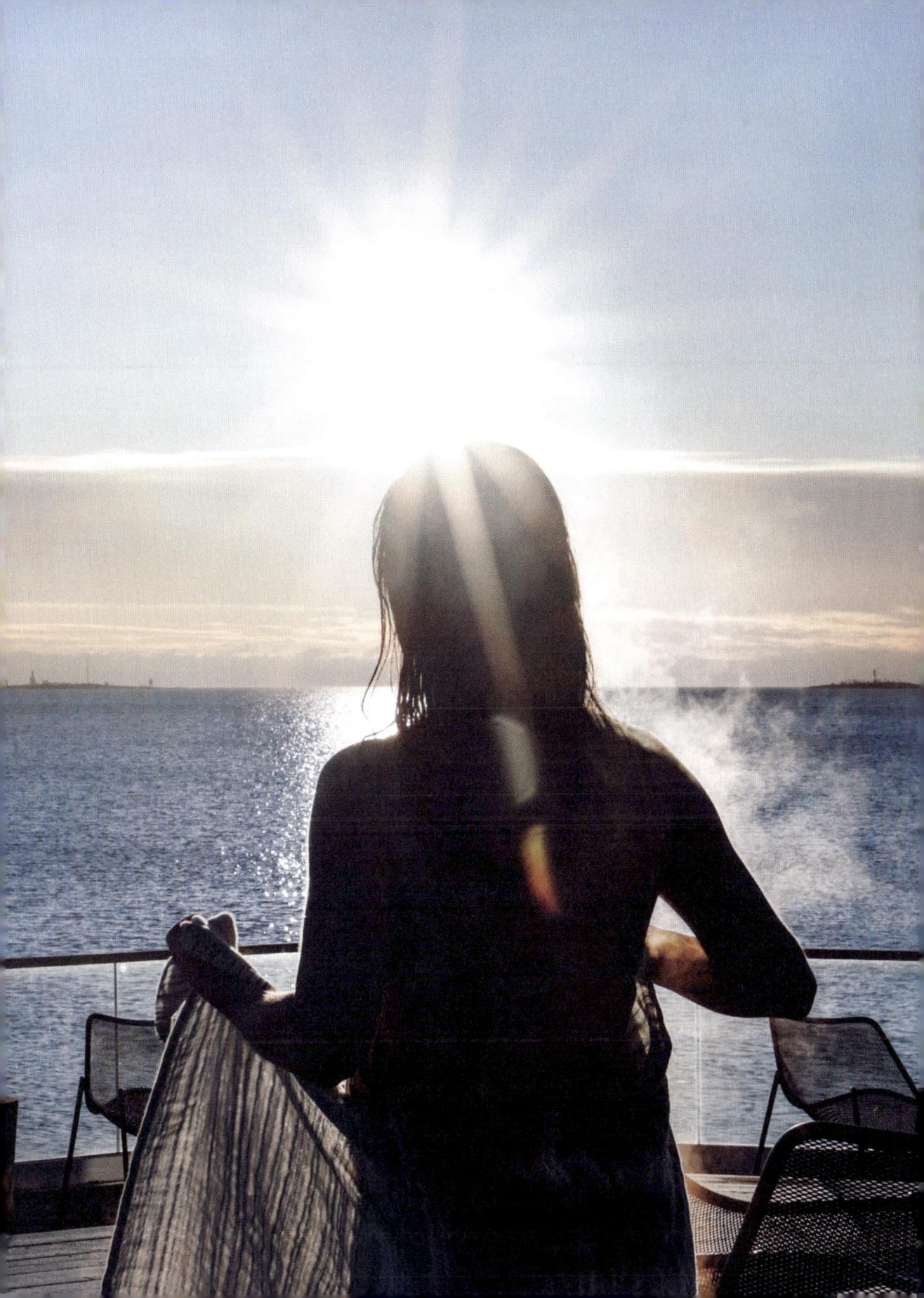

SAUNA ETIQUETTE

To strip or not to strip?

"I always start with etiquette," says Mr Viljar Lubi, the Estonian Ambassador to the UK. "When I invite British guests to my sauna at the embassy, the first thing I always tell them is that they don't have to be naked. Then they relax," he chuckles.

Nudity is such a big issue in certain cultures that the word is sometimes avoided altogether, hence the "textile-free" sauna. Most public saunas in the Nordics offer separate sessions for men and women, and it's not compulsory to be naked. But be aware that in Germany, Austria and eastern Europe clothing is considered unhygienic; in northern Italy, disposable paper swim wear became a trend – until it didn't.

How long should I stay in?

Australian doctor and founder of the Extreme Wellness Institute, Marc Cohen recommends staying in to the point where you're "comfortably uncomfortable". "Go to the edge of your comfort zone, as this builds your resilience," he says. Such "forced mindfulness" is empowering and enables us to be active participants in our own treatments. Chilling and relaxing are as important as pushing yourself. Your body needs to know how to cool down and rest. Sweating in this state can help reset the parasympathetic nervous system, the rest and digest mechanism that keeps us calm.

How often should I sauna?

Try to have a sauna at least once a week, as its benefits need refreshing every eight to ten days. But studies have shown that, for most, there's no such thing as too much sauna.

What about steam?

Learn the customs about steam. For example, in Finland, Russia, Estonia and Japan, a sauna is not a proper sauna without lashings of *löyly*; but in Sweden, the UK and Germany where electric stoves are the norm, pouring water on the rocks is discouraged, usually on safety grounds. And it's always polite to ask your fellow bathers' permission to pour.

Are there any age limits?

Sauna bathing starts early. On average, 70 per cent of Finnish children have had a sauna before their first birthday. And no one is too old to sauna. Pregnant women will sweat bathe right up to the birth date.

What about whisks?

In most countries where whisking is popular, bathers have their own whisks which they use for cleaning and exfoliation. In countries like the UK, where whisks are shared, it's polite to rinse them in a bucket of warm water between each use, and never put them in the fire.

When not to sauna

Don't have a sauna if you have an infection or a fever. When you have a fever your body can't regulate temperature effectively. And being hungover in the sauna is a very bad idea – it makes a dehydration headache so much worse. Health problems are unlikely to cause a sauna injury, but too much alcohol can.

Sauna respect

If you come across a sauna in the wilds, treat it like you would your own bathroom; replace any wood, wash the benches with some buckets of warm water and clean up your trash. And don't forget to leave an offering for the "guardians of the steam". In Norway, the trolls appreciate an extra log, as do the Finnish elves.

Sauna hygiene

Sauna is deeply connected to cleanliness, and it's very common (sometimes compulsory) to wash properly before you enter the steam; and you should always have a proper wash after the first sweat (although in the UK and Norway this is not always observed). Washing is as important as unwinding; it's customary to rinse and scrub between each round. It's also a good idea to take your own towel or mat to sit on (ideally one that's big enough to put your feet on so you can protect the bench beneath you).

A MALE PERSPECTIVE

Being the wrong gender, I had not yet witnessed a certain sauna machismo that I knew existed. A how-long-can-you-suffer, tough talk kind of session, with hard *löyly* and lots of beers. A trip to Tallinn with my husband Mark in May provided us with the opportunity to go our separate ways in the steam, and see how long we would survive. This is Mark's account of his trip to the men-only, eyebrow-singeing section of Kalma Saun.

Kalma Saun in Tallinn has a five-star, must-see rating – well, it did, until 24 February 2022, Estonia's Independence Day and the day Russia invaded Ukraine. Since then, the once-glowing reviews of Kalma had turned a little sour: "Watch out for aggressive locals," warned John H of Manchester. "Avoid." A Swedish sauna fan had told us during his visit he prodded his statue-still neighbour to check he was still alive, so intense was the heat. The outbreak of war and a near-death rumour was not enough to stop us though. Emma and I paid our entrance fees and she turned left, and I went right.

Kalma is Tallinn's oldest public sauna, founded in a building designed in 1928 by Aleksander Vladovski in Kalamaja, a former Soviet border zone between the waterfront and Tallinn Old Town. Brutalist architecture rubs up with colourful wooden houses, and Kalma fits into the former category, with a décor as cold as its façade, but not quite as cold as the babushka on reception. Borderline sanatorium, with white tiles, wipe-down banquettes, plastic buckets for washing, no towels and basic lockers (about which there is a strict hierarchy).

"Number 18, back room!" boomed a giant skinhead guarding the men-only area, his massive finger indicating the second of two rooms. I had read that the first room was for VIPs (of the tattooed, dangerous variety), and a group of them were drinking beers in a circle. I scurried past and got undressed.

Clothing is forbidden in Kalma, so before long I was naked and feeling vulnerable. Enormous men with loud voices were wearing flip-flops and comedy felt hats and speaking Russian. I had neither, and I got the feeling they were talking about me. Was I being paranoid? They certainly weren't friendly. But they weren't unfriendly either, and they paid me no attention as they beat themselves with bushels of wet birch (*veniks*), whacking their backs, cracks, sacks, the soles of their feet, and everything in between while perching, standing and squatting on every bench. It was a mesmerizing, tantric display; a sea of red flesh and a sight that can never be unseen. I later learned that mafia meetings were often held in Kalma *because* everything can and will be seen – there are no weapons or wires here.

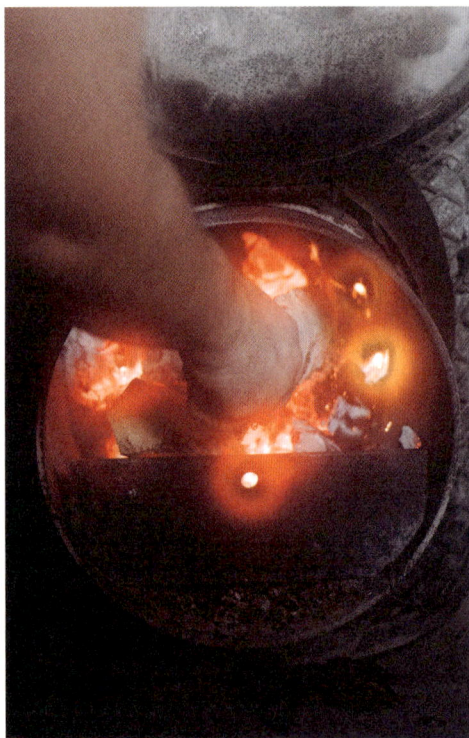

Someone ladled water on to hot rocks the size of coconuts that glowed on a huge wood-fired stove, and waves of scalding steam – *leil* – hit me like a force field. The whisking started over, more frenzied this time, and men dipped their *veniks* into buckets of cold water and particles sprayed around like disoriented raindrops. I didn't have my own whisk, having failed to notice they were on sale in the lobby for 3 euros, but a man, perched above me on the hottest bench, began to whack me on the back with his. I took this as a sign of friendship and attempted conversation; (Take that John H from Manchester). "How often do you come here? Which other *banyas* do you like?" The man's teenage son did the talking, in almost perfect English. They came together every Saturday and had done for years, like their grandparents had before them. As I grew bolder, curiosity, naiveté and a touch of Dutch courage took hold, "What do you think about the war in Ukraine?"

This could have been fuel to the (already scalding) fire. Most men in Kalma are in their 60s, born in the Soviet era in a city where the Russian population is generally under-privileged. Independent Estonia is young, smart and dynamic; it has more tech start-ups per capita than anywhere else in the world (think Skype, Bolt and Wise). For the older, Russian-speaking generation who remember life before 1991, Kalma is one of the last vestiges of post-Soviet Kalamaja. If it hadn't been 110 degrees, I might have noticed a chill in the air. After too-long a pause, my new friend said, "Will be ok," and put down the whisk.

I decided it was time to take a dip in the ice bath which was just beyond the door. A couple of hairy giants nodded their approval. They clearly wanted me out, with my idiotic questions. Even so, my friend and his son followed me and, after a cold plunge, we sat together naked on a leatherette sofa. It was awkward – and sweaty, the poor choice of material sticking to my buttocks like Velcro.

I needed to get up before I started sliding into them, as despite five minutes in the cold water I was still sweating all over. Sauna pros call this stage the "after sweat". Your core is still warm, even though your extremities aren't. To the novice, it's a strange but pleasant feeling, and it's worth taking time between hot and cold immersions to appreciate it in full.

The teenager told me there have been saunas in Tallinn from at least the Middle Ages. After independence in 1991, community saunas made it on to the stag party circuit and many became too sleazy and depraved to stay open. Kalma is one of the few places locals can still call their own.

Two fully dressed men come into the changing rooms carrying bags of fresh whisks in preparation for the evening session. Was it that late already? Time becomes elastic in the steam. As I got dressed, I could hear Emma in the lobby trying to buy a drink from the tight-lipped babushka. I felt clean and invigorated and ready for the next stop - a trip to the suburbs to sauna in a former Soviet truck. An old Russian proverb came to mind: "The day you spend in the *banya* is the day you do not age."

Kalma Saun
Vana-Kalamaja 9A,
10414 Tallinn, Estonia.
www.kalmasaun.ee

Open daily 11am–10pm.
Telephone +372 6271811

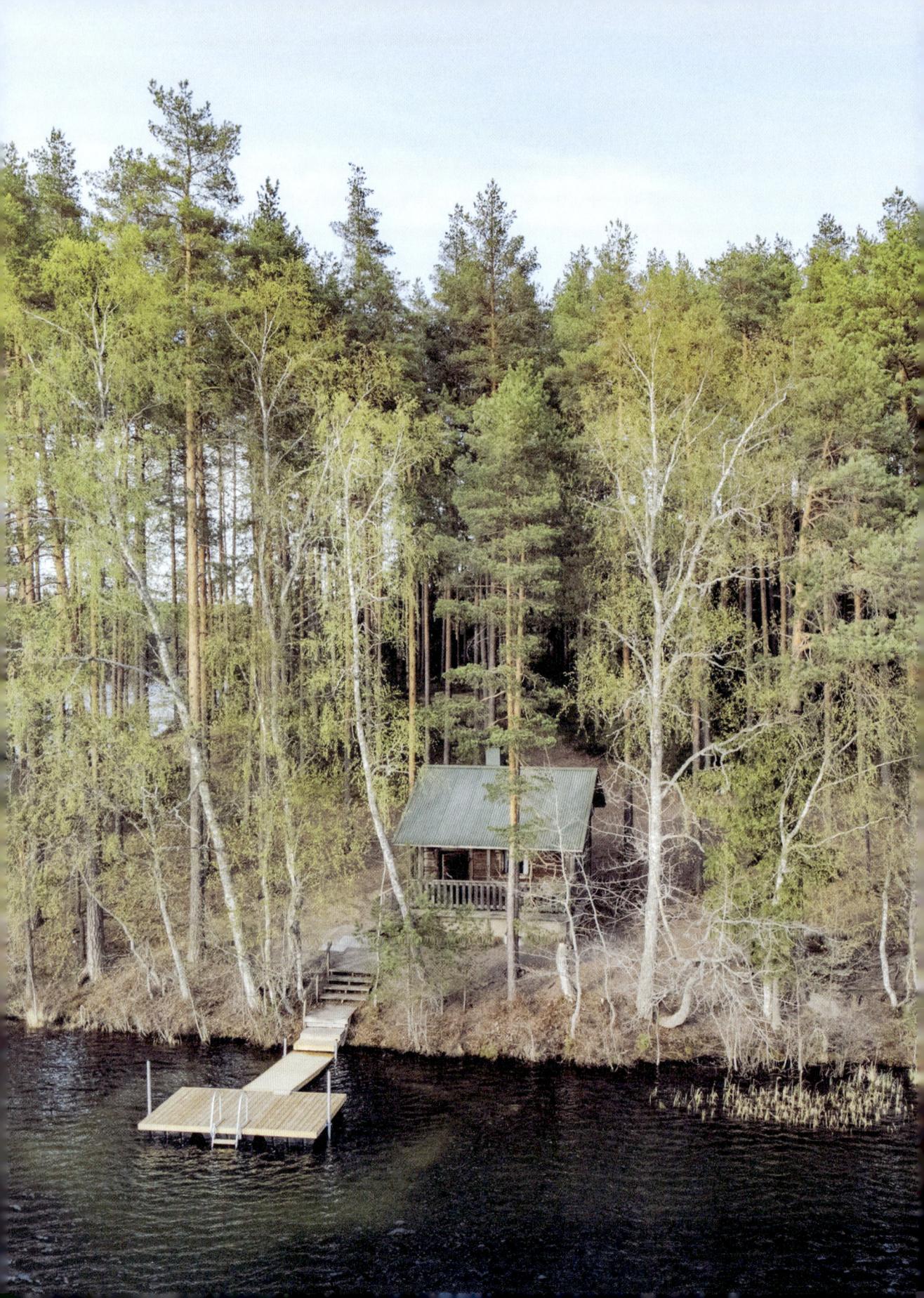

NATURAL CONNECTION
Bathing in the wilds

*"Nature teaches more than
she preaches. There are no sermons
in stones. It is easier to get a spark
out of a stone than a moral."*

John Burroughs,
The Writings of John Burroughs, 1913

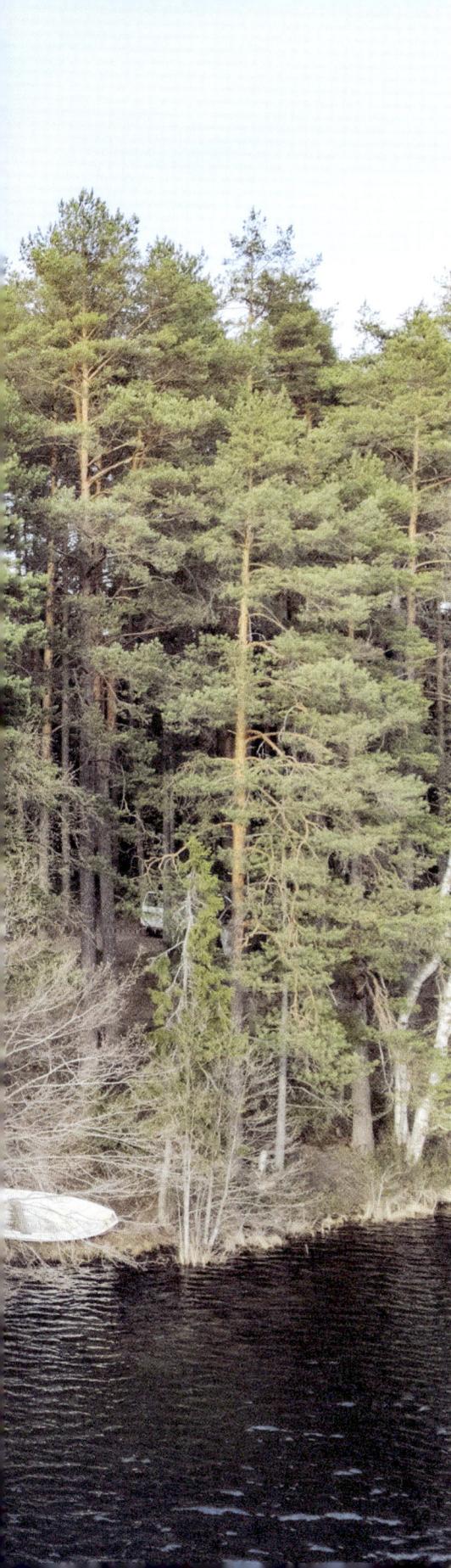

Previous: Iso-Valkee
sauna in Somero, Finland.
Opposite: View out to the
mountains of Valdres, from
the private Lappe Bu sauna
in Vang, Norway.

Environmental stimuli play a huge role in the development and function of the human brain. Even walking down a noisy, congested street is enough to trigger the fight-or-flight response and cause cortisol levels to rise. Conversely, the sound of a water fountain, the smell of a rose in a front garden, the sensation of having a sauna in the forest can activate the parasympathetic nervous system, the rest-and-digest mode, which creates feelings of calm and relaxation.

"In the light of research, nature promotes recovery," says Finnish doctor Hanna Haveri, who in 2022 wrote her first "planetary prescriptions", advising patients to access more nature (more of which later). "Even short visits to nature restore stress levels, lower cortisol and improve immune regulation. Nature in its versatility promotes immune regulation, which may reduce asthma, allergies, and Type 1 diabetes among children. This is something that surprisingly many people do not think about."

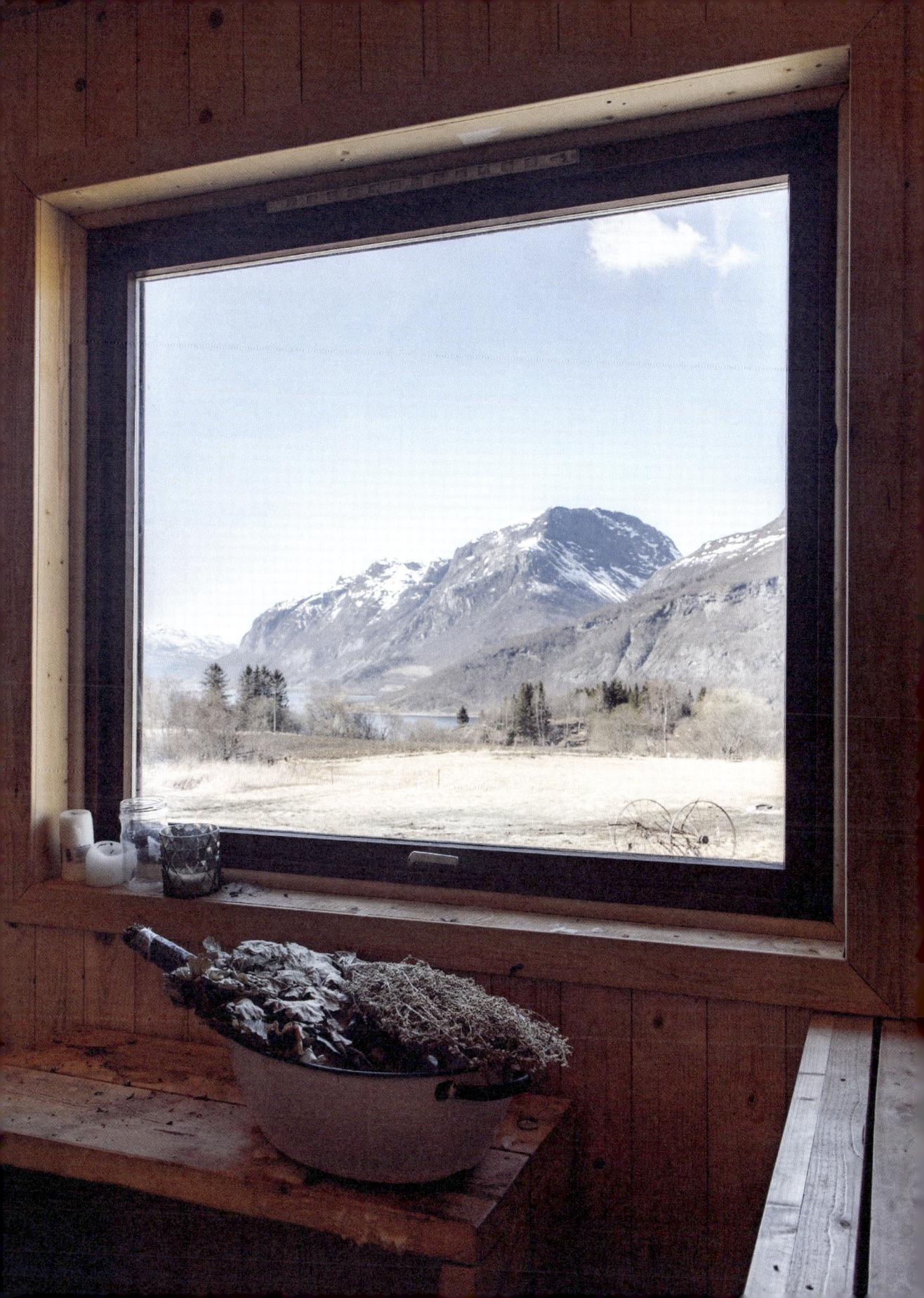

Biophilic design

According to the US Environmental Protection Agency, the average American spends 90 per cent of their time indoors where concentrations of pollutants are often higher than they are in outdoor settings. Illnesses such as Multiple Chemical Sensitivity (MCS, intolerance to chemicals, from cleaning products to car exhaust fumes) and Sick Building Syndrome (SBS) are complex and not yet fully understood, but they arise in response to our surroundings. And by 2050, 66 per cent of the world's population is expected to be living in fast-paced, high-density, urban environments.

One way to make our cities more liveable is through biophilic design – the incorporation of nature into the urban fabric. Architects and urban planners are adding water features, seasonal gardens, biodiverse environments that harbour birds and bees, and natural light and ventilation to urban spaces. Even images of nature can help. And in 2020, an online survey of more than 500 adults in lockdown in the Chinese city of Xi'an revealed those with a view of nature suffered less depression and anxiety than those with no exposure to any greenery at all.

When it comes to urban green space, bigger is not always better; psychological and physical benefits are not proportional to land area. A desolate stretch of parkland doesn't generate a positive mood, or a sense of awe, or hold our attention long enough for us to switch off and wind down. What we long for most are spaces where we feel a sense of escape and fascination, such as a sauna in the wilds with a view onto a natural landscape. Research suggests that a savannah-like scene reminiscent of the vast plains of Africa and filled with woodland and grassland, abundant resources and trees we can climb, is the ultimate Shangri-La.

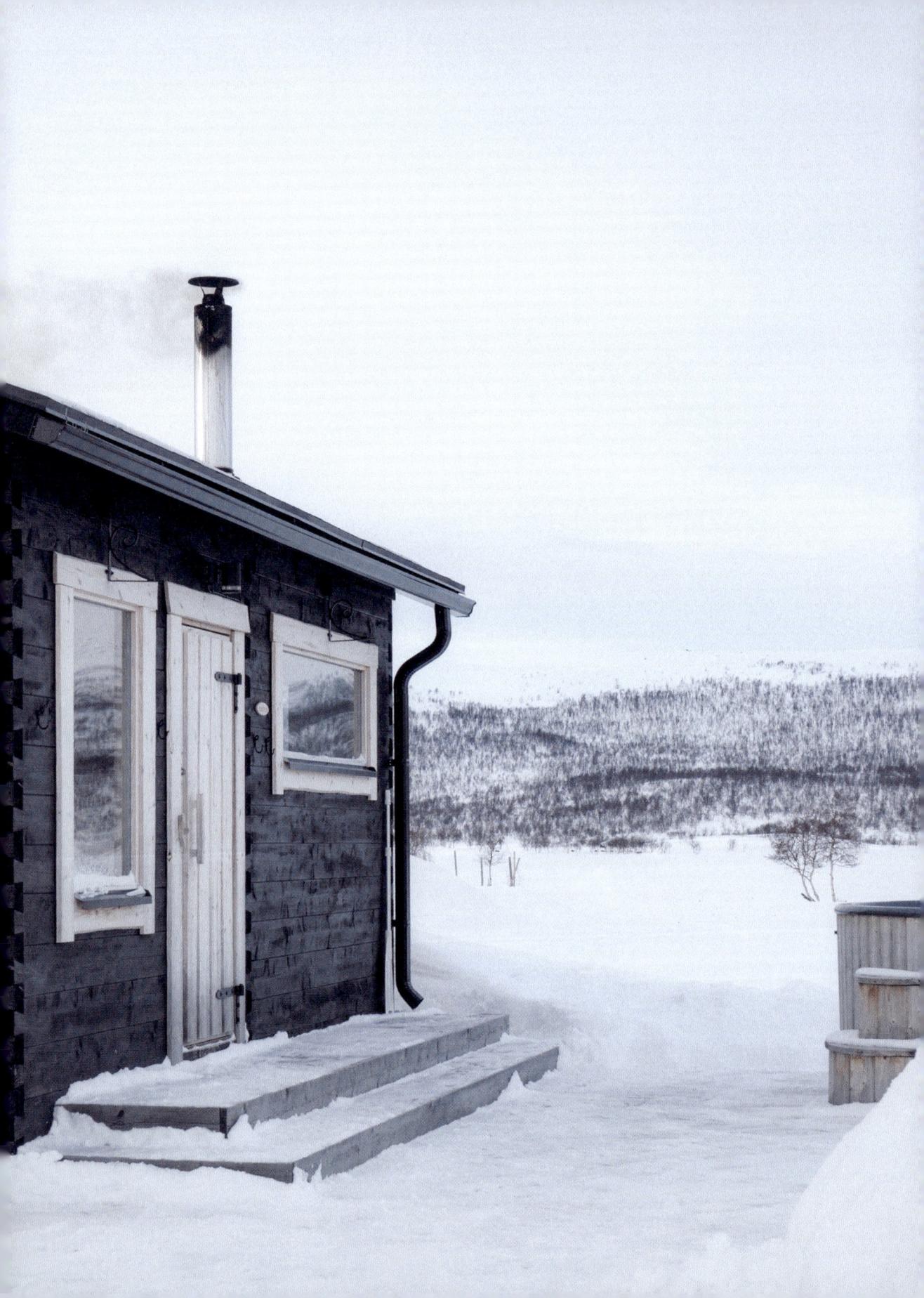

The simple sauna hut, perched on the edge of a frozen lake or tucked onto a windswept archipelago, provides "prospect and refuge" – the ability to see without being seen – which is another key element to our natural wellbeing. "Prospect" provides an unimpeded view over a long distance, essential for surveillance and planning, and "refuge" offers protection from rain, sun and predators approaching from behind.

The term *biophilia* was popularised in 1984 by biologist Edward O Wilson who declared that "human beings have an innate emotional affiliation to other living things." A 2021 study into biophilic design in architecture and its impact on health and well-being by academics at Eindhoven University of Technology identifies three design approaches needed for an evolved human/nature relationship. The first – "nature incorporation" – includes natural elements, among them water, daylight, fresh air and weather. The second – "nature inspiration" – includes patterns and geometries, textures and materials. And the third – "nature interaction"

– includes emotional reactions, among them connection to place and space, peril, refuge, order and enticement. The sauna has them all. When it's –26°C outside, stepping into the warm steam is like a reassuring hug from a loved one. We feel safe in the simple hut, sheltered but open, with a terrace from which to survey the surroundings, and nothing satisfies our primeval urge to explore, discover, order and control more than gathering firewood, chopping it with an axe and feeding it to the flames.

Biophilic design is a new term for an ancient concept. Throughout history, architects have tried to mimic the symmetries, fractals and geometries found in nature: the Fibonacci sequence that mirrors the spiral of the sunflower, Victor Horta's Art Deco vines and tendrils, the hexagons of the honey bee carved in concrete by Frank Lloyd Wright. "Biophilic design is a very good route to well-being" says Dr Haveri. "We need to plan our urban environments so that as many people as possible can have a connection to nature, whether it's a walk to the nearest green spot, or green walls and roofs."

A daily dose of green space

Dr Haveri's "planetary prescriptions" included recommendations such as barefoot forest walks, swapping meat and dairy products for a vegetarian diet, and creating wildflower meadows in backyards. Five locals, from busy young professionals to families with children and retirees, had to follow her personalized health plan for two months. Their carbon emissions and overall health were mapped before and after the trial. All participants saw a 17 per cent decrease in their carbon footprint, a 16 per cent increase in their overall wellbeing and, most strikingly of all, a 36 per cent drop in their exhaustion scores. Thirty-year-old participant Markus Kontiainen, whose plan had a special focus on mindfulness and recovery, explains: "Incorporating barefoot forest walks into my exercise routine after I have been running has been mind-blowing. I'm a performance-oriented person and this helped me slow down and pay more attention to recovery." After two months, he recorded a 58 per cent drop in his exhaustion levels.

Research shows that post-surgical patients who have images of nature to look at suffer less pain than those without, and people who work by a window that opens to the forest concentrate better than those with a view to the city.

"We don't have to make big changes," says Dr Haveri. "Small barely noticeable things become routine but they can improve the aesthetics of the working day and lower the stress load." Dr Haveri has a sauna at least once a week.

When Dr Haveri started writing her planetary prescriptions, many questioned her authority as a doctor. "They suggested that such simple ideas couldn't come from a 'real' doctor; that what I'm saying sounds like complete blah blah; that I'm telling fairy tales. But I'm a neurologist. I prescribe (and believe in) conventional medication. There are so many things we could do to prevent disease or help us to feel less depressed, and connecting with nature, in even very small ways, is one of them. … I think in five years' time we will have much more data on the benefits on nature on well-being and health." She adds, "Even if doctors are not prescribing it, we should have some kind of promotion of nature at every level of society so we can plan our living environments to bring green areas closer to people. I hope it can be a new direction in healthcare as well." She writes about these and other ideas in her book *Planetary Diet and Lifestyle* (available only in Finnish).

Opposite: Steam sauna cold plunge at Åstad Vingård in southwestern Sweden.

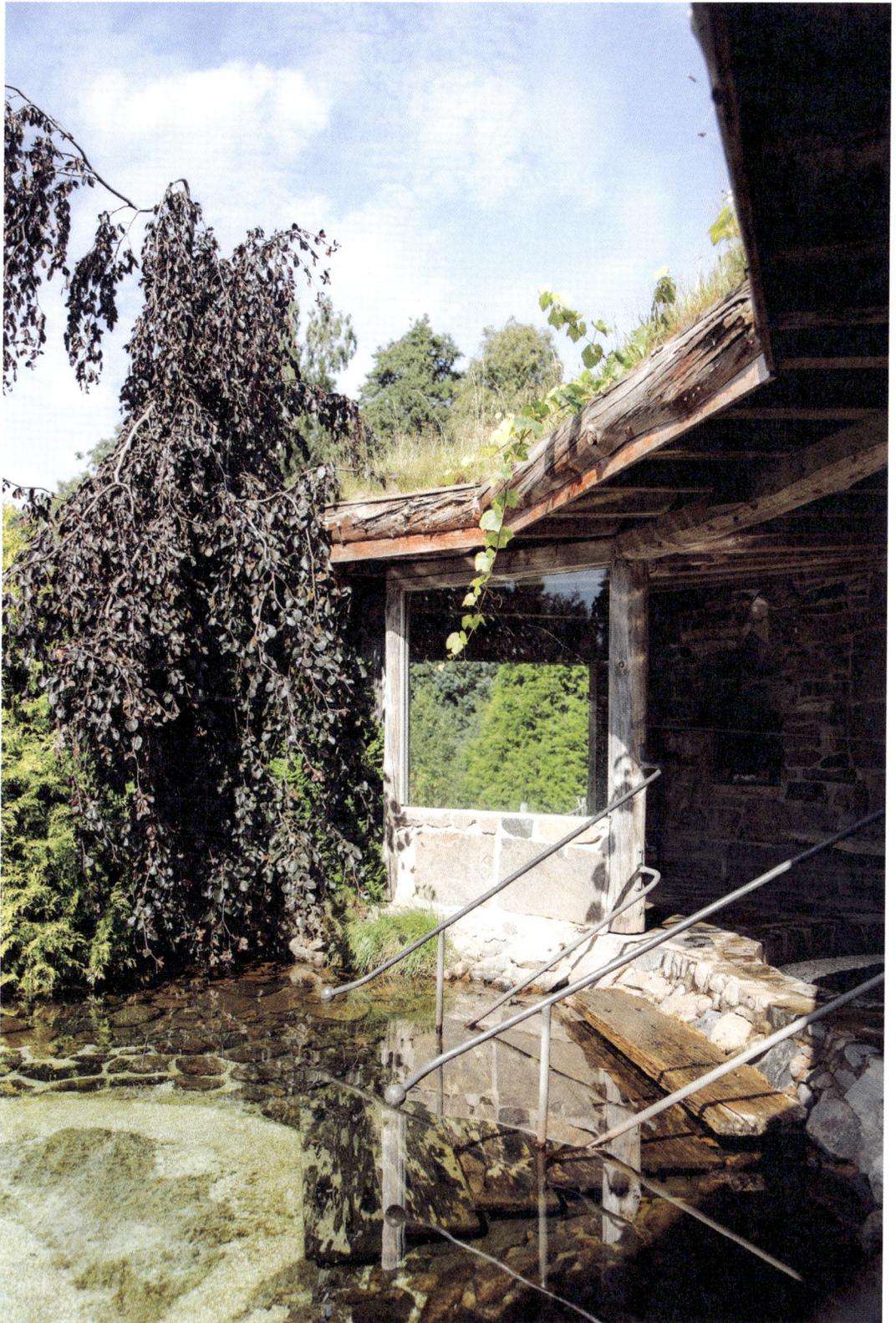

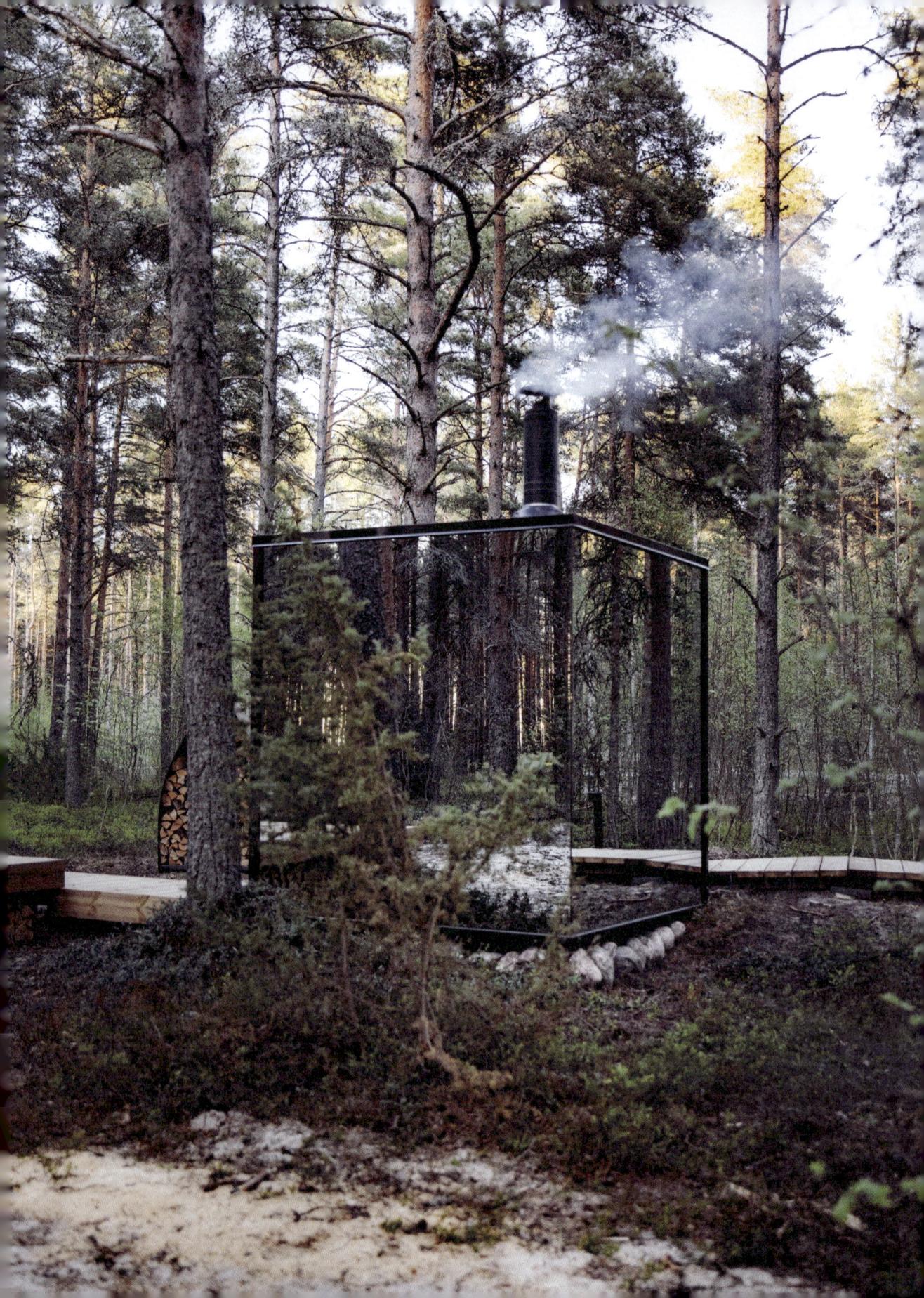

Natural interactions

The advances and technical approaches of modern medicine to healing have severed the connection between nature and well-being. "Hospitals, with their isolated wards, clean lines and lack of fresh air are one of the most divorced places from nature," says New York author, Emma Loewe. "They could be a metaphor for the medical world's relationship with it. For a long time, we have pushed nature aside in the healing process."

In her book *Return To Nature,* Emma explores how eight distinct landscapes, from grasslands and deserts, to oceans and rivers, impact our mental and physical health. "Continuing reliance on tech is not great for us. If we can, we need to extend relaxing natural elements like light and shadow into the indoor world," she says. The flickering flames of the sauna are a constant dance between light and dark, shadow and clarity, and humidity is not technology's friend. Even the most committed influencers need to switch off in the steam. One Instagram post is all a phone can manage.

Opposite: Hotelier ÖÖD specializes in mirrored rooms with saunas, like this one at Punakivi, Estonia.

Opposite: Estonian
entrepreneur Mark Zirk
built a private smoke sauna
in Võru.

Natural elements

Studies show that we also engage more with a space that changes, even incrementally, with the seasons, with time, or with the weather. Plants, fellow creatures and natural elements key to our survival (fire, water, air, daylight) are also desirable. "The cognitive benefits of getting outdoors are very interesting," Emma says. "A lot of research finds that, once we return inside from a trip outdoors, we score better on working memory tests. We tend to have less brain activity in certain regions that are responsible for things like negative self-talk or rumination."

In *Thirteen Ways to Smell a Tree,* biologist and author David George Haskell declares; "Slowing down to smell trees offers delight and a spur to curiosity. Aroma is the most ignored and supressed of the senses, yet it offers the swiftest and deepest links between the outside world and our memories and emotions, and enlivens all other senses." In Japan, *shirin yoku,* or forest bathing, is believed to aid relaxation and cause cortisol levels to drop. Bathers are "guided" through the woods and encouraged to slow down and tune all their senses into their surroundings. Similar medically approved trips to nature are also prescribed by doctors in the US, Canada and New Zealand. A "park prescription" comes with a recommended "dose". In Canada, this is two hours per week, for no less than 20-minute sessions, and can take the form of a hike, a spot of gardening or simply sitting outside in the fresh air.

Forest bathers also believe that compounds exuded by trees improve immune function. There might be something in it. A two-month study in Lahti, Finland, revealed that when the asphalt floor of a kindergarten was replaced with a real forest floor it had a dramatic effect on the microbiome (the collective genomes of the microbes that live inside and on the human body) of the children, reducing flus and bugs significantly.

"We don't yet know how natural elements affect our immunity in the long term," says Dr Haveri, "but nature in itself can motivate us to be more active. Data shows that going for a walk in the woods is more effective than running on a treadmill. We can achieve more efficient pulse and muscular levels in natural environments than in a gym. When we are outdoors, we don't just focus on the physical level of intensity of the exercise we are doing. We are thinking about other things around us and have to use coordination and balance which uses more muscles. And there are multi-sensory possibilities too. Think about all those sounds and smells in nature that we cannot recreate digitally and how positively they affect us."

In the 1980s, advances in tech and screen-focused, indoor activities led to a more sedentary lifestyle, especially among children, and the idea of Attention Restoration Theory (ART) was born. This states that time in nature allows the brain to rest, which in turn can boost focus, concentration and creativity. We process manmade and natural elements with different parts of the brain, and demand on cognitive resources in perceiving and processing specific stimuli is called "perpetual fluency". Looking at a soothing scene, particularly if it holds a "soft fascination" – the dancing flames of a sauna stove, say, or drops of water rolling down the inside of a steamy window – allows the brain to slow; there's nothing too taxing about the four wooden walls of the sauna hut decorated only with a delightful seep of resin. It may not feel like it at the time, but Sauna Brain is good for us.

Opposite: Ödevata Gårdshotell sauna in Emmaboda, Sweden.

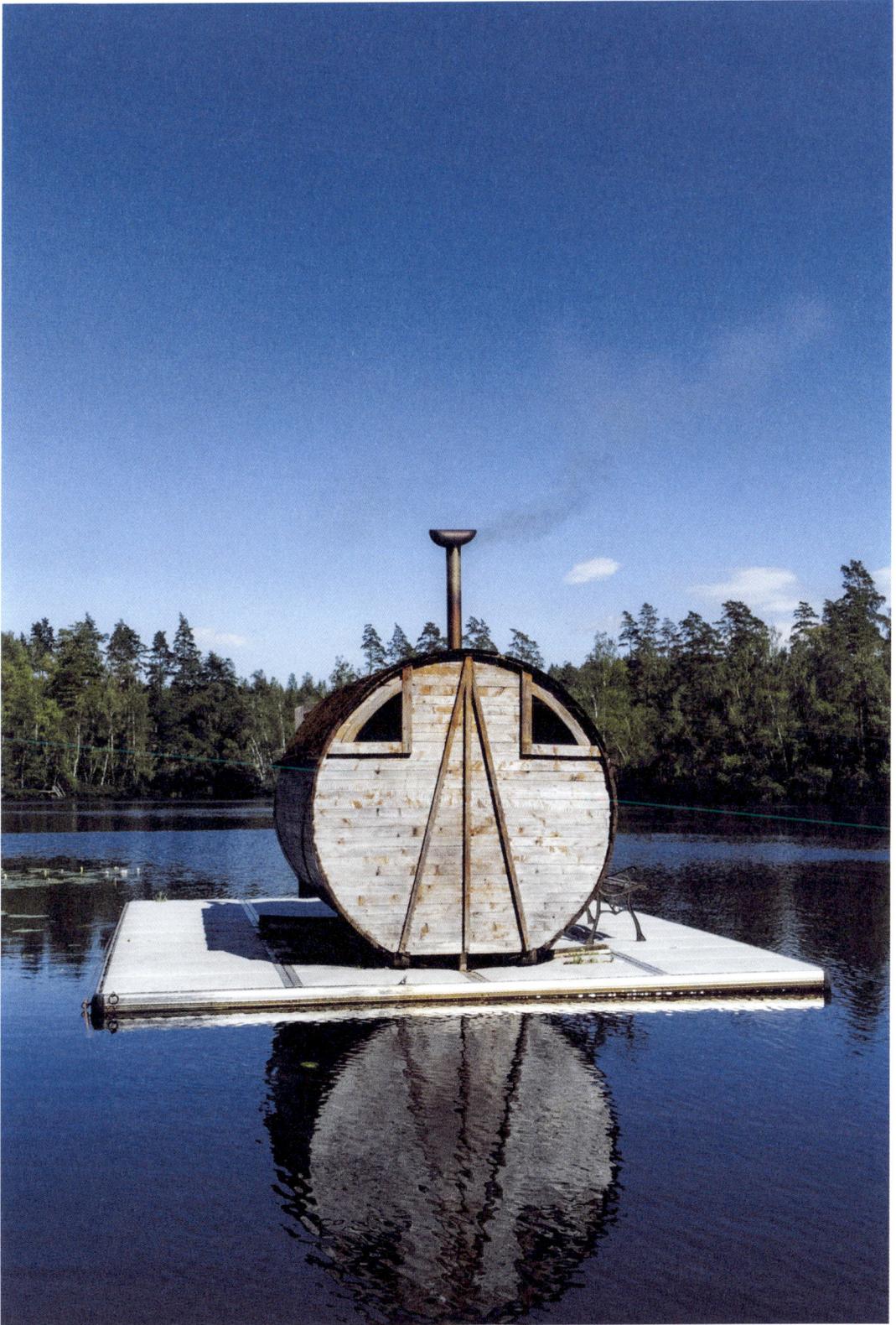

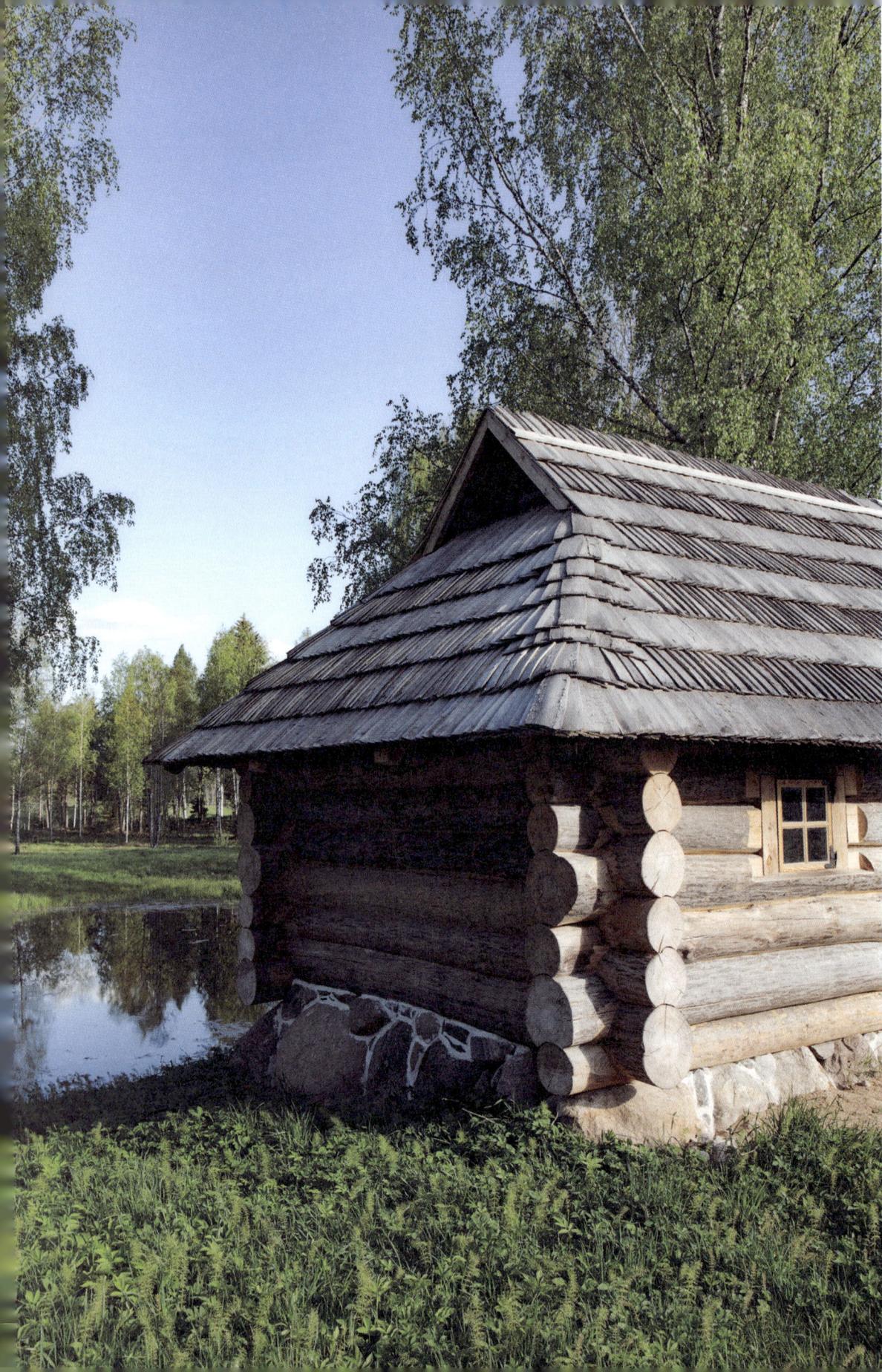

Sense of place

Having a sauna somewhere totally out there can induce hard-to-articulate feelings, and a sense of wonder and awe. "Awe is really cool," says Emma. "It's the emotion we feel when we're faced with something beyond our comprehension, like a view so beautiful and large and grand it makes us feel small. Research shows that it's one of the few emotions that makes changing our minds about something a positive experience," she adds. "It can make us feel safe enough to change our perception, and can promote creativity and social behaviour. A lot of people can relate to stepping into a new environment or an old one and seeing something new in it and feeling in awe of that place. It can be very constructive."

Such overwhelming positive feelings also help us bond with our environment. Place Attachment Theory is a major concept in environmental psychology, and argues that we tend to favour surroundings that are familiar, in locations that generate a sense of place and community, thereby realising personal identity, belonging and cohesion. Without it, we are faced with "place-lessness", which can be a major cause of depression, grief and trauma. Finnish architects Puisto create "resort-like" elderly care homes all over Finland, in which an essential feature is the outdoor sauna cabin, designed to evoke happy memories of the summer cottage.

And local materials build affection; wood that develops its own patina is more appealing to the touch than a man-made laminate, and local tiles, bricks and architectural features specific to their region all add meaning and sense of place. Some sauna-lovers with the skills, like Estonian carpenter Silver Sõrmus, are building their own saunas and living off-grid, sustainable lifestyles. Silver's sauna is a work of art: meticulous joinery, fine axe work and elegant wrought iron fixtures. It took 700 hours to make. He lives on his land between a van, a tepee and the sauna, fells his own trees and has dug his own pond. The spruce roof of his sauna features a traditional shingle technique used on barns and homes all over Estonia. This is also a feature of the Hobbit-house-like "iglu" saunas for which Estonia is becoming increasingly well known, thanks to exporter Iglucraft.

Opposite: Carpenter Silver Sõrmus built his sauna using traditional Estonian shingling on the roof.

The "church of nature"

"A sauna is often located by water in a place of natural beauty, and connecting with nature is an important part of sauna culture," says Katja Lösönen, communications and community development officer at the Kalevala Women's Association. A cultural organisation of 3,000 members, the organisation researches and revives ancient Finnish traditions, including female sauna culture. It takes its name from *Kalevala*, a collection of poems, runes and stories gathered from all over Finland in 1835 and the nation's magnum opus. "Finnish sauna culture is still guided by a variety of ancient beliefs that aim to maintain the balance between human life, nature and the universe," says Katja, "especially in women's sauna traditions."

At the beginning of the 20th century, Matthias Johann Eisen, Estonian pastor and folklorist, noted that his countrymen had three sacred places: the church, the sacred grove and the sauna. It was compulsory to go to church, but when you needed healing, you went to the sauna. After a baptism (compulsory under the church and supplemented with gifts) the newly anointed would be taken straight to the sauna to be purged of all ecclesiastical influences. Finns would often build their sauna next to a sacred tree so they could scratch the names of dead relatives into its bark. "In the past, we understood that we are deeply interconnected with each other and the surrounding nature," says Kaarina Kailo, an adjunct professor at the University of Oulu who studies Finnish folklore and sauna traditions. "The individual and collective life cycle and rituals in the sauna served to renew our bonds with the cosmos and what we now call the 'ecosystem' or 'environment'."

Sauna was, and still is, connected to the healing powers of nature. Water, air, fire and earth, long celebrated by our ancestors as "hormones" of well-being, joined forces in the healing space of the sauna. The building itself also had a deeper meaning. "The sauna was built in the image of the tree of life, as a microcosm of the three levels of the universe," says Kaarina. "The upper realm (the ceiling) the sky world, the middle realm (the benches) the earth, and the underworld (the floor) of the dead. All of its core symbolism replicated the cycles of growth, interconnection and symbiosis with the end goal of altered states, deeper consciousness and rejuvenation."

Keeping the fire burning required intuition and a deep understanding of your surroundings. You had to "feel" them, breathe them and live alongside them. For our ancestors, this was healing in itself. As Kaarina explains: "the ancients established a connection with nature and the elements and nurtured the relationship between humans and the non-human world. The consecration of sacred place and ritual preparations were as central an aspect of sauna rituals as bathing itself. They helped put the bather in the appropriate state of mind to begin to concentrate on renewal and spiritual wellness." It was a "church of nature" where miracles happened.

Opposite: Community sauna in the village of Fiskars, Finland.

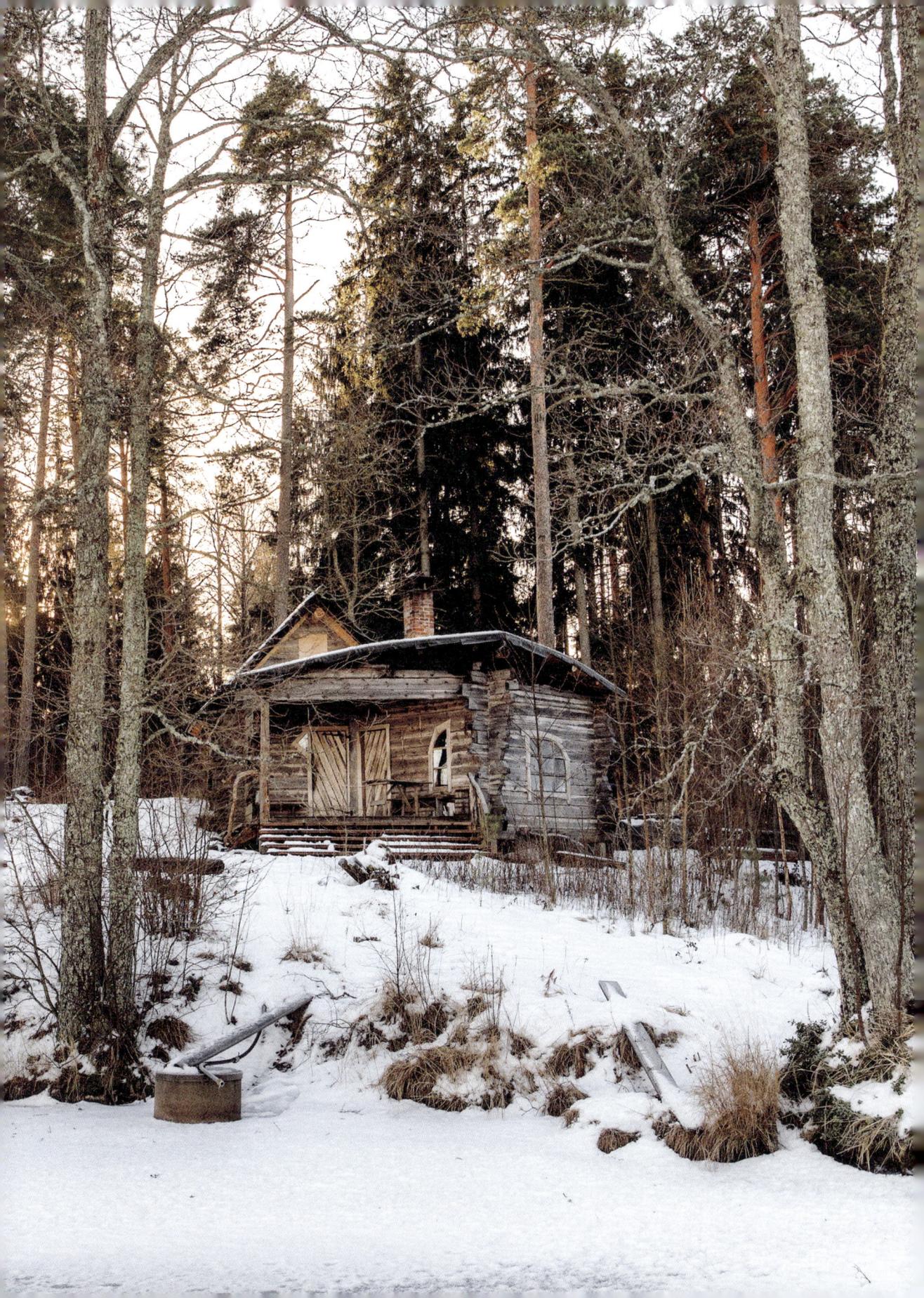

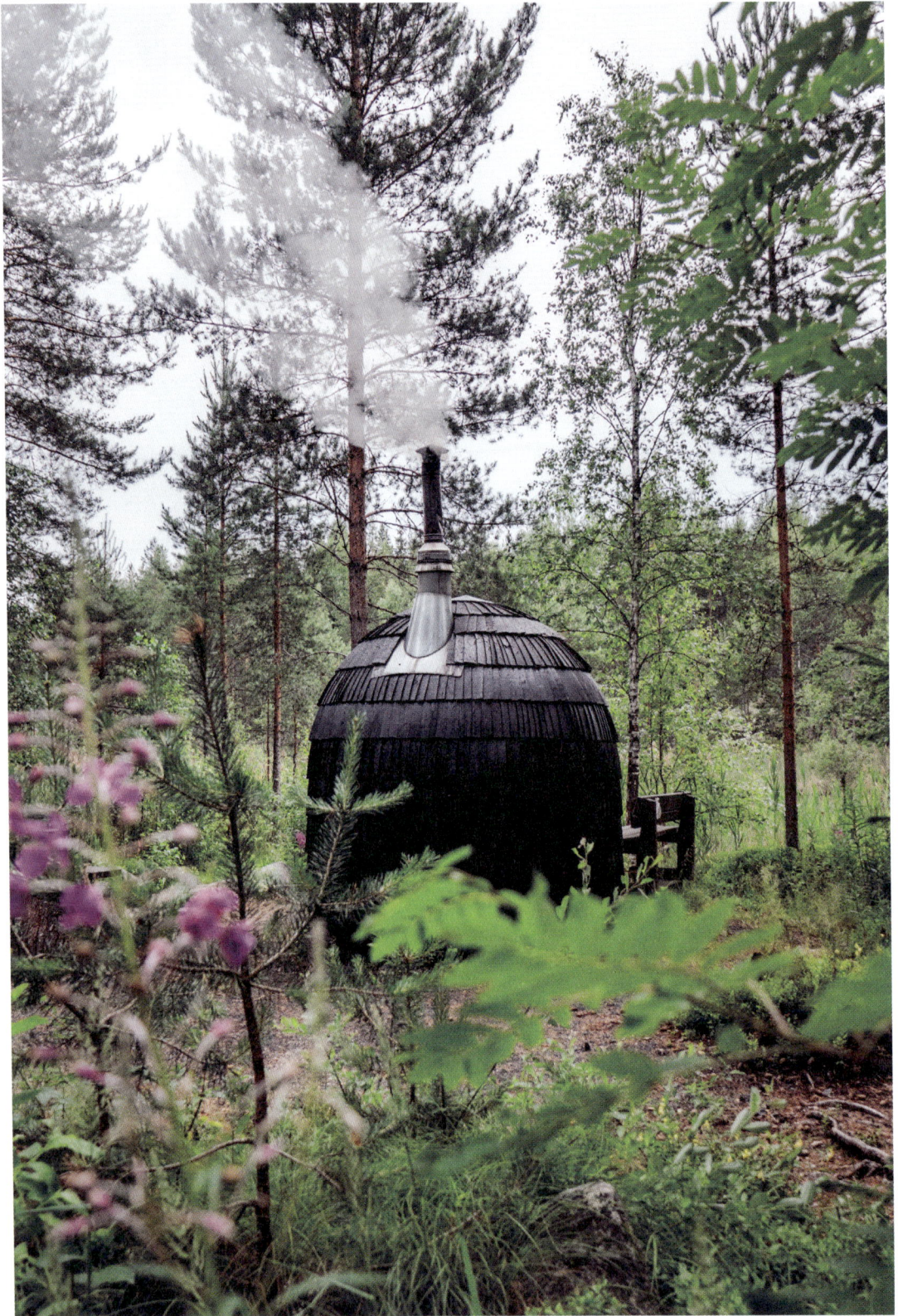

Remote retreats

Today, to be in untouched nature is a luxury; the harder a place is to reach, the more desirable it is. Nothing beats having a sauna away from the reach of Google maps. Taking a cross-country hike and stumbling on a random public sauna, when your muscles are aching and you have time on your hands, is a joy like no other. To this end, Kalsholmen Safe House is a circular huddle of four wooden shelters and a sauna on an island in the Norwegian Sea. There's no electricity or running water on Kalsholmen, and visitors taking the hour-long boat ride to cook, sleep, keep warm by the fire and adapt to whatever the winds and tides throw at them.

Finnish architect Sami Rintala designed the Safe House, and his studio Rintala Eggertsson Architects has created barely-there refuges, tucked into the craggy coastal outcrops of northern Norway, and shelters that offer respite from the sand-whipped shores of Sweden. They are physical manifestations of Rintala's belief in "freespace". "We need freespace to think freely," he says. "Every healthy, sustainable civilization has a space that allows counter-thinking, critical views, pluralism, even anarchism, in their blue-print. To be so close to nature, we are emboldened by it, is a privilege."

When it comes to sauna, Finnish-born Sami is a purist. A simple wooden box, even without a constructed floor, is enough. "It's a multi-sensory experience, not just a feast for the eyes, consumed through the safety barrier of a glass picture window." And it's about cooling off on the deck as acorns snap from hefty oaks and hit the ground like heavy raindrops; it's about mud between the toes and the cawing of crows at dusk. Sami adds: "More than ever, we need spaces that are free to visit, affordable for everyone and empty, not because they lack something, but because they remain so until they are filled with the free thinking and actions of their visitors. With the ideal sauna everything is already there. What more could you add?"

Opposite: Matkuslampi sauna in Finland sits in the middle of the forest and is free to all.

Floating saunas

One click of Instagram reveals that floating saunas are everywhere: from Tasmania to Vancouver, Czech Republic to Maine. Drifting along in the middle of a lake, or meandering along a gentle river, then jumping into the water any time you please, is the ultimate sauna-in-nature trip. And in big city harbours where space can be tight, building on the water instead of on the shore is an obvious option. That the Norwegians, a nation of boat builders and fearsome seafarers, could crack the floating sauna concept is no surprise. Why feel the heat on dry land, they reason, when you could add the soothing motion of gentle waves to the sensory mix? Why bathe in the plunge pool of a basement banya when there's a whole harbour to swim in? Gingerly stepping down a ladder into a frozen ice hole from a hatch in the sauna floor beats stepping out into the bracing cold. These ideas and more have dropped anchor all the way along Norway's coast.

Arctic Circle Spa

In the far reaches of Lapland, where space is in abundance and the freezing temperatures guarantee that anything you build will be moored in ice for months, it is even easier to experiment with land-meets-water, hot-meets-cold floating innovations; take the Arctic Circle Spa, suspended into the Lule River in Swedish Lapland or the Ödevata floating sauna in southern Sweden.

Opposite: KOK's motorised saunas in Oslo ferry bathers to the quieter waters of the fjord (*page 94*).

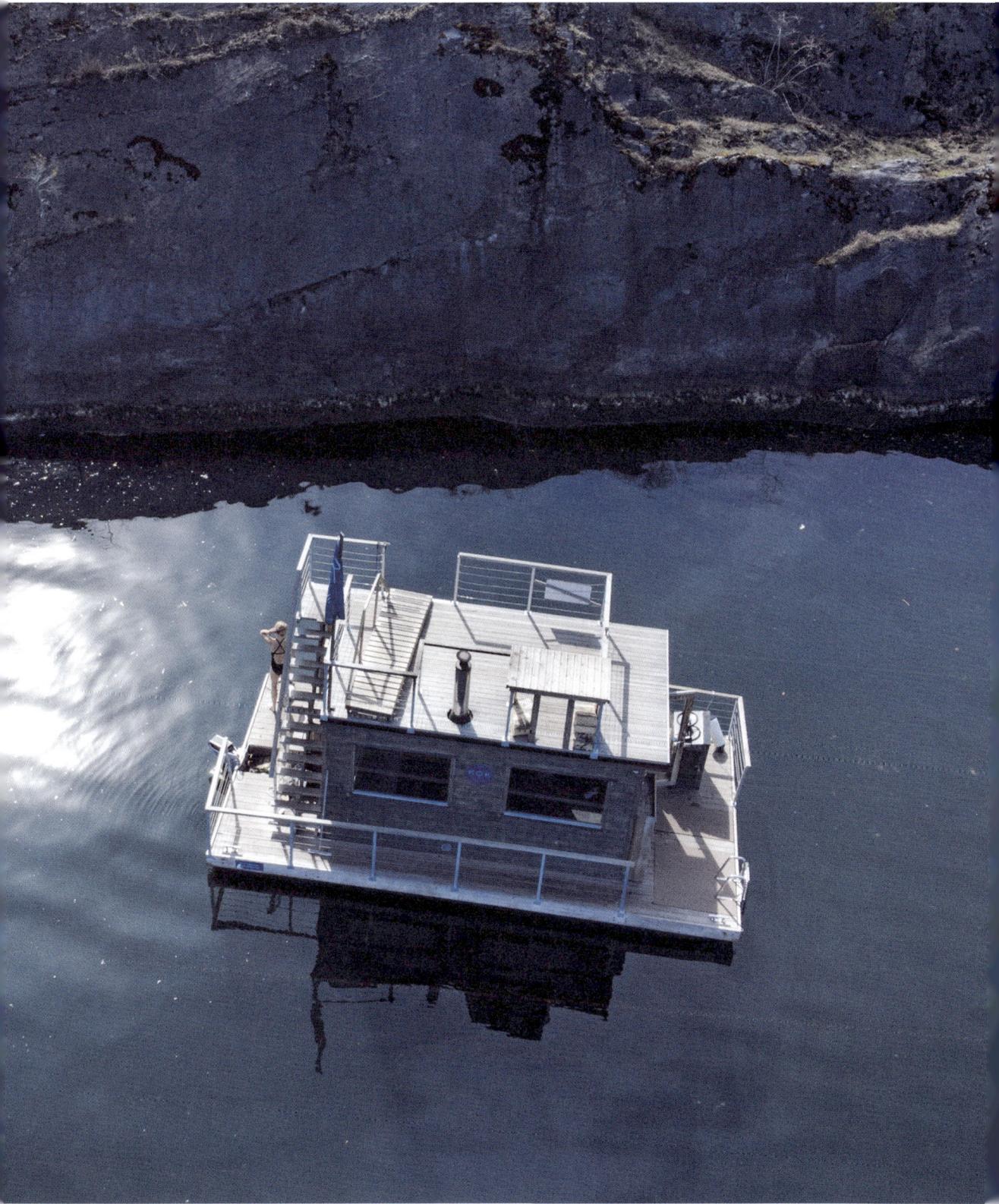

ARK, Trondheim

ARK in Trondheim is the largest floating spa village in Norway. So far. It's a global mix of bathing ideas: four Finnish saunas, a Russian *banya*, a Japanese *onsen* (hot springs), two saltwater pools, a Turkish hammam and a bar. Its sustainable design comes from Rintala Eggertsson architects who created Norway's first "spa ship" *Vulcana* in 2009. And his "ARK family" is a series of small mobile saunas and compact bathing houses for private and public bathers.

KOK, Oslo

KOK is a fleet of chic floating saunas powered by electric motors in Oslo harbour. Groups of up to 14 can hire a KOK cabin for two hours or more and chug out to the fjord, steaming in the sauna en route before jumping into the *brekwasser* where sea and fresh water meet. The water is salty – not Mediterranean salty, but softer and sweeter. KOK saunas have no lifejackets, changing rooms or toilets, but you can bring your own food and drink and head wherever you want, away from the bustle of the harbour and out to the islands, where the singsong chirps of linnets, sandpipers and goldfinches drown out the engine hum. KOK's founder Kristin Lorange relishes these trips. "Out here, you can be in nature. It's important for people to feel they belong to the fjord. If they have a sense of ownership, they will look after it." If cities around the world can all clean up their waterways, she predicts a sauna revolution, where having hot-cold immersions become like "a gym membership for your wellbeing."

Oslo Badstuforening

Hans Jørgen Hamre is a Norwegian politics teacher in one of Oslo poorer suburbs. He recalls: "In 2013, we were living in boats on the waterfront. On a whim, I decided to build a floating sauna out of driftwood that I found in Bjørvika. The fjord should be for everyone, but everywhere we went in the city, we were never welcome." Ice bathers from the Ministry of Foreign Affairs swimming club helped Hans Jørgen secure a spot for his sauna in 2015. "The diplomats and the anarchists became friends and the sauna became very popular," explains Ragna Marie Fjeld. "We had to formalize it in some way so that more people could enjoy it." Fjeld quit her job at the Ministry and helped set up Oslo Badstuforening, the non-profit sauna association that has evolved from Hans Jørgen's project. Oslo Badstuforening has 14 saunas, 37 employees and a long waiting list for their monthly passes.

Floating under the imposing, controversial Munch museum, Hans Jørgen's "Seagull" sauna occupies a prime spot in honour of its history, while the newer saunas vary in design. Oslo Badstuforening also boasts the city's first "sleepover sauna", Bispen & Munken. The simple, floating platform has a sauna, toilet and double beds, and guests can row themselves over from the dock in a small wooden boat. Sleeping bags, supplies and security are not provided, and the façade of the cabin is open to the elements. In a city where even VIPs are keen to strip off and sweat, it's no surprise that the Bishop of Oslo was the first guest.

Wrapped in a towel and sipping water on a gangway buzzing with bathers, Fjeld explains: "Our mission is to bring sauna to the people. We hope and believe it is more than a trend, that it becomes something people do as often and naturally as skiing in the forests around Oslo."

Opposite: Oslo Badstuforening's floating sauna can be rented for overnight stays.

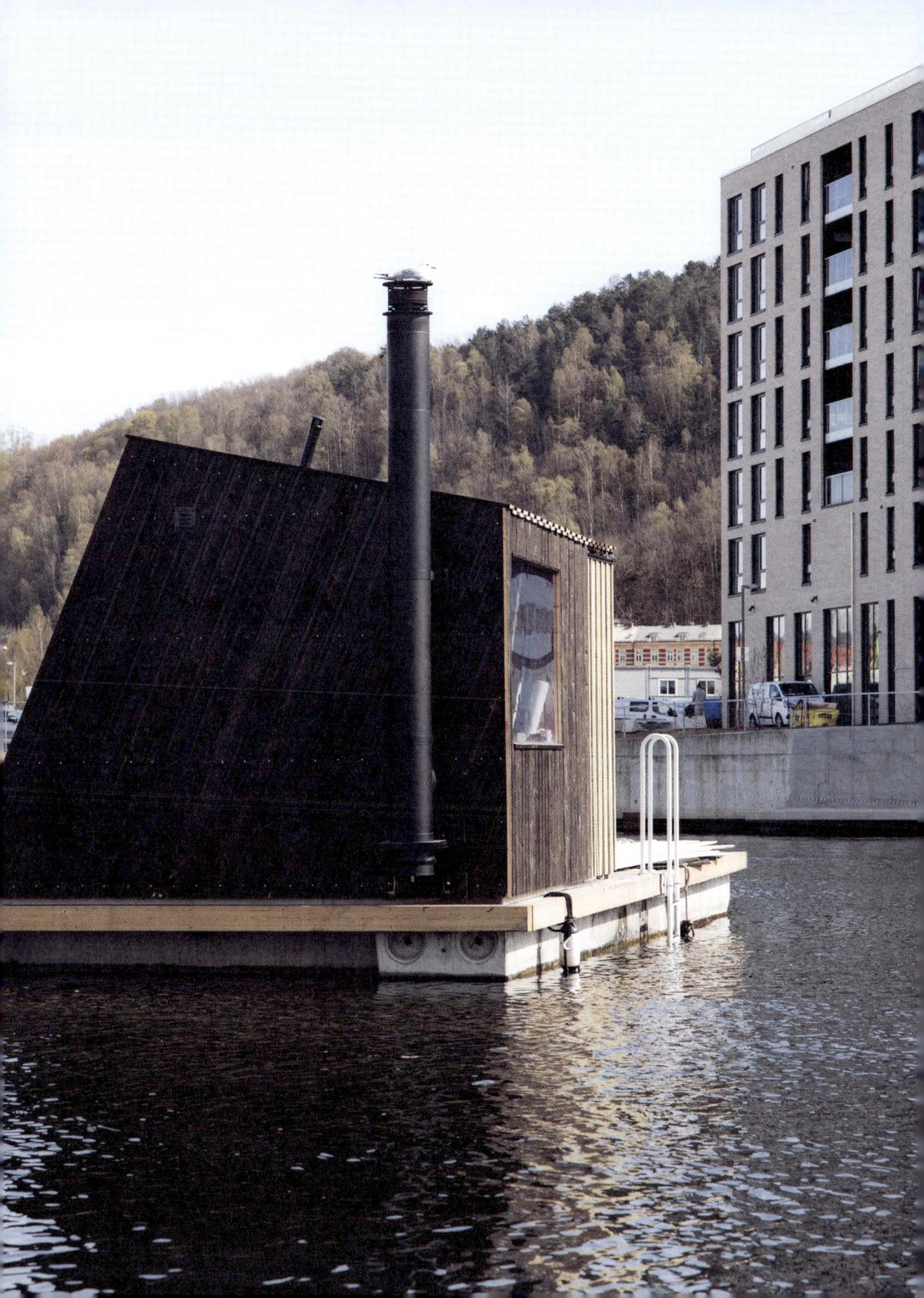

COMMUNITY
Meet and heat

"A friend may be waiting behind a stranger's face."

Maya Angelou, *Letter to My Daughter*

"In the sauna, it's not just about the things we can measure," says Helsinki-based author Katja Pantzar. "There's a beauty that arises. You can have intimate conversations with people and you don't even know their names." And you don't need to. Sometimes the company of strangers provides the most comfort of all. The steam irons out the seams, loosens the knots. Every winter, Katja swims at her local winter swimming club and has a sauna, sometimes alone, sometimes with friends. "For a great many people in Finland, the sauna is where they really open up and talk. It can be like group therapy," she explains. "We'll discuss our mental health, about being tired, or overwhelmed and we'll talk about the state of the world; how politics and the climate crisis is affecting us. And about positive, uplifting things – art exhibitions, theatre, books, the beauty of nature and its restorative effects." And being naked, or semi-naked, in the shadows, enables inhibitions to dissolve. "Someone might talk about a health problem or a topic like menstruation or menopause, which ordinarily might have some taboo around it. In the sauna, we are equal; there's no judgement. Simply put, it's the place where we try to make sense of the world and our place within it."

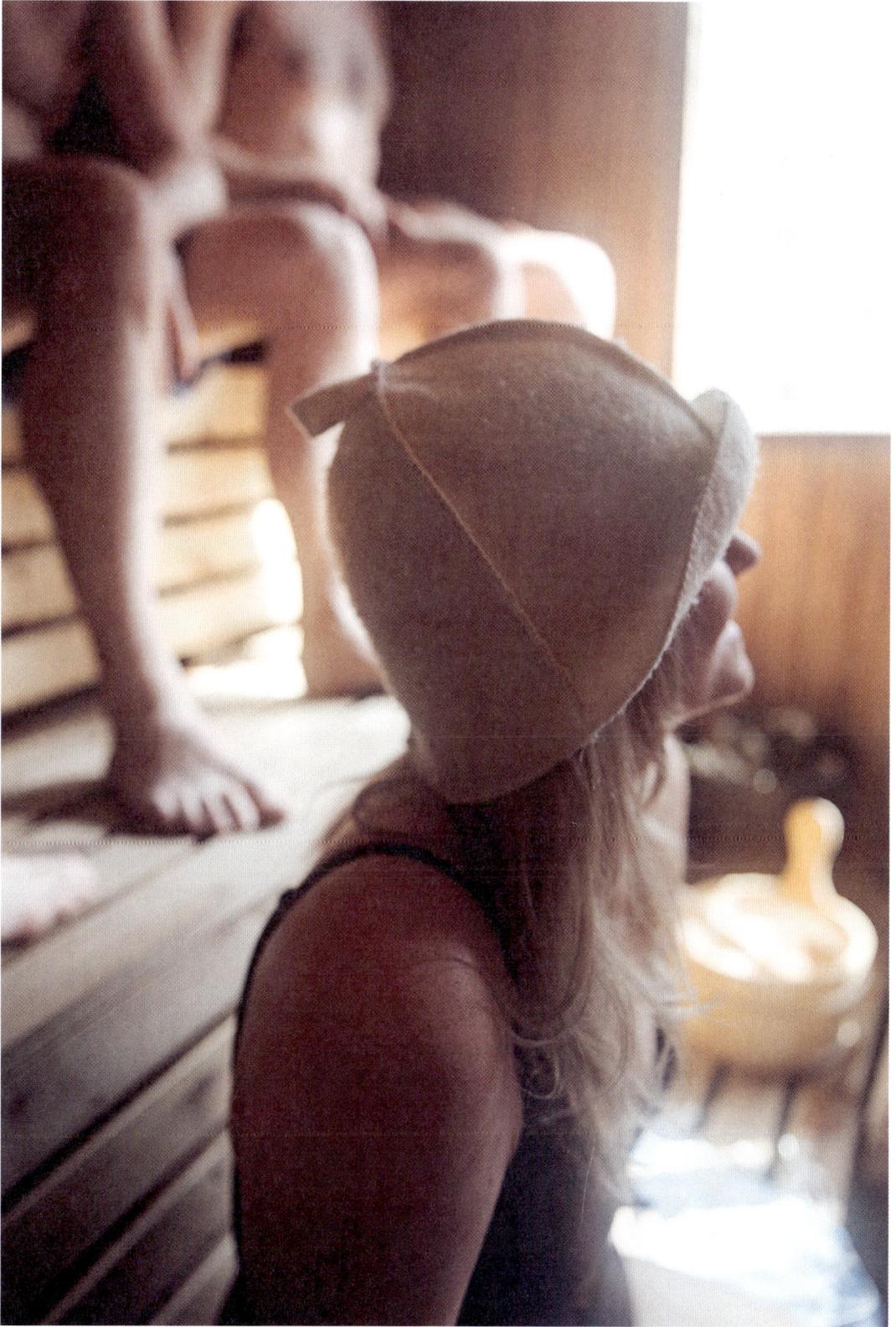

Sauna night

Sauna can provide the perfect excuse for a get together with friends or a family. Saturday night is sauna night in many cultures. It's the time to wind down after a long week, relax and catch up, then have a good sleep and a Sunday lie-in. In rural areas, people will travel many miles to sauna with friends and family. "In my experience, the best (and fastest) way to get to know a Finn is to share a good steam," says Katja. "I've also heard this numerous times from Finns and foreigners. The importance of the sauna goes beyond just physical wellbeing."

Carpenter Toomas Kalve and his artist wife Epp Margna live in Võru County in south-eastern Estonia, a region famous for its smoke saunas. These are typically wooden huts with soot-blackened walls and no chimney, and cabbage-sized rocks heated by an open fire for many hours to produce a soft, gentle heat and soothing aroma. The smoke sauna dates back millennia and is seen by many as an esoteric, transformative experience (see "Mooska Magic", Chapter 1).

In 2014, the Estonian smoke sauna was placed on UNESCO's Representative List of the Intangible Cultural Heritage of Humanity. Toomas and Epp helped organize the listing, travelling the country documenting around 300 ancient smoke saunas, some of which have been in families for generations.

In 2010, Toomas built his own smoke sauna in his garden. It's semi-underground, with a grass roof and is set next to a glassy lake blooming with late-May purple water lilies. Toomas kitted it out with hand-carved wooden headrests and elegant bathing utensils, which he also exports.

Almost every Saturday the couple invites their children and grandchildren for a smoke sauna session. Epp explains the ritual:

"In summer, we light the fire at 11am so that it will be ready by around 5pm. The children and grandchildren and friends all gather. It's a long evening. There are no rules about who goes in with who, generations, and men and women, all mix together, but if someone wants the softer side of the heat, they go later. You can't take an argument into the sauna; you learn this when you're very young. Issues are resolved before you enter. If you want to talk politics, you can do this in the front area where you change. But who wants to do that? Often, we sing old folk songs [called *regilaul*, Estonia has one of the biggest collections of these songs in the world]. There's no cleaning ritual as such, we go in and out of the sauna and the pond around five times and use whisks. That makes you feel really clean. We drink beer or vodka, but not too much, and afterwards we always have cake. There has to be a cake! We see our sauna as part of the family, and when we leave, we show our gratitude. You must always say thank you to everyone, including the sauna builder and the person who carries the water for the *leil*."

Opposite: Late-night summer sauna session at Oslo Badstuforening, where jumping off sauna roofs is part of the fun.

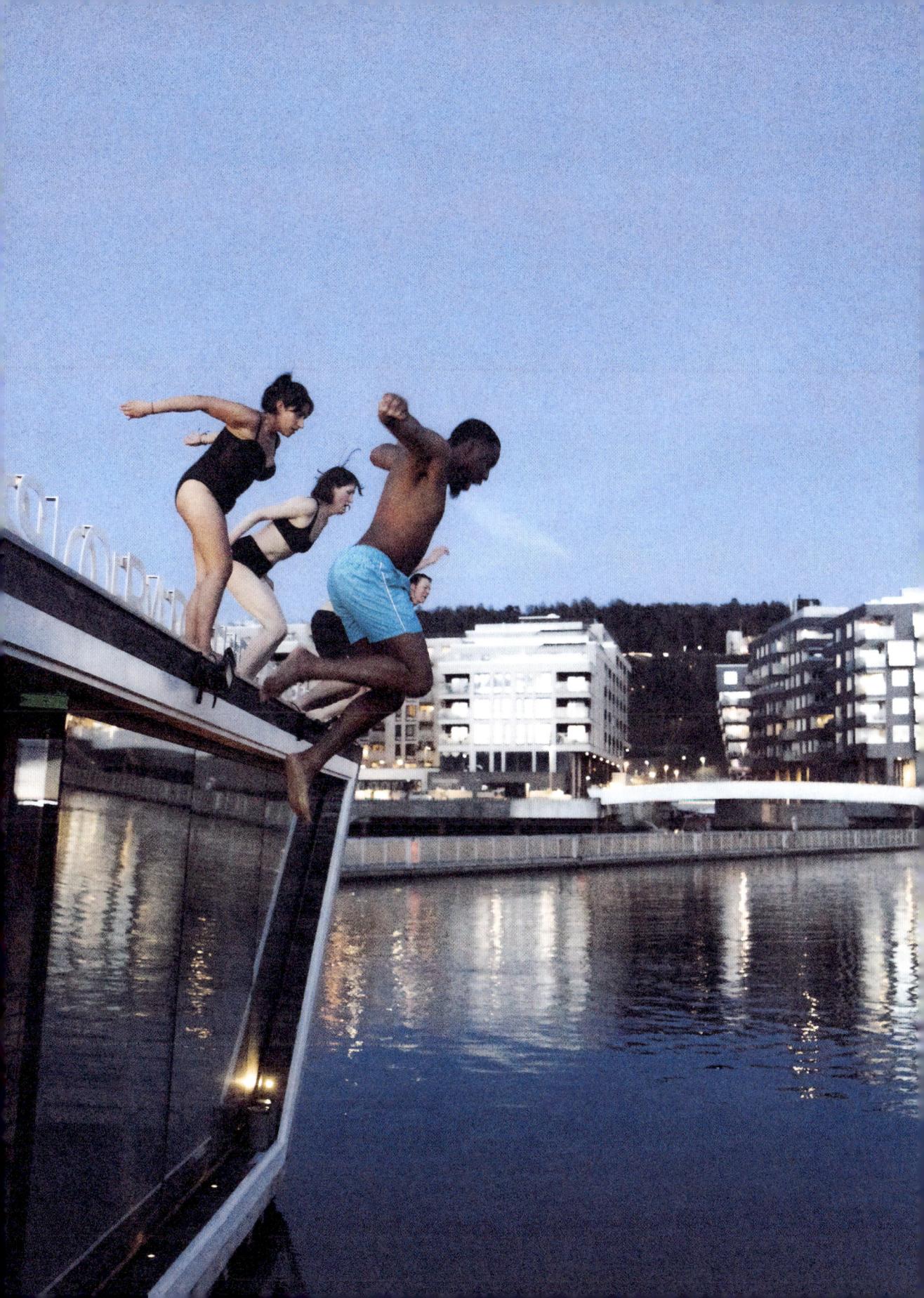

A place to gather

Adam Rang, the sauna expert from Tallinn who we met in Chapter 1, runs mobile sauna events from a converted Soviet truck. And countless deals have been sealed in his sauna truck, which he delivers to Estonia's many tech conferences so dot commers can iron out the Ts&Cs in the steam. "People approach sauna from different angles, but for me, it's a social thing. It's about bonding with family and friends," he says.

Most Sunday nights, Adam goes to Heldeke!, an underground sauna in Tallinn's hipster district, Kalamaja. It's literally underground, marked by a discreet entrance on a salubrious tree-lined street. With a sauna and a cold plunge pool, vaudeville theatre and bar, it's also a fringe arts venue that hosts performances in Russian, Estonian and English. When the owner, Australian comedian Dan Renwick, started Heldeke! four years ago, he knew nothing about sauna, but wanted to provide a venue for stand-ups like himself and young talent keen to get a break. The separate sauna nights took off too.

Opposite: Feeling the heat in Löyly, Helsinki, Finland.

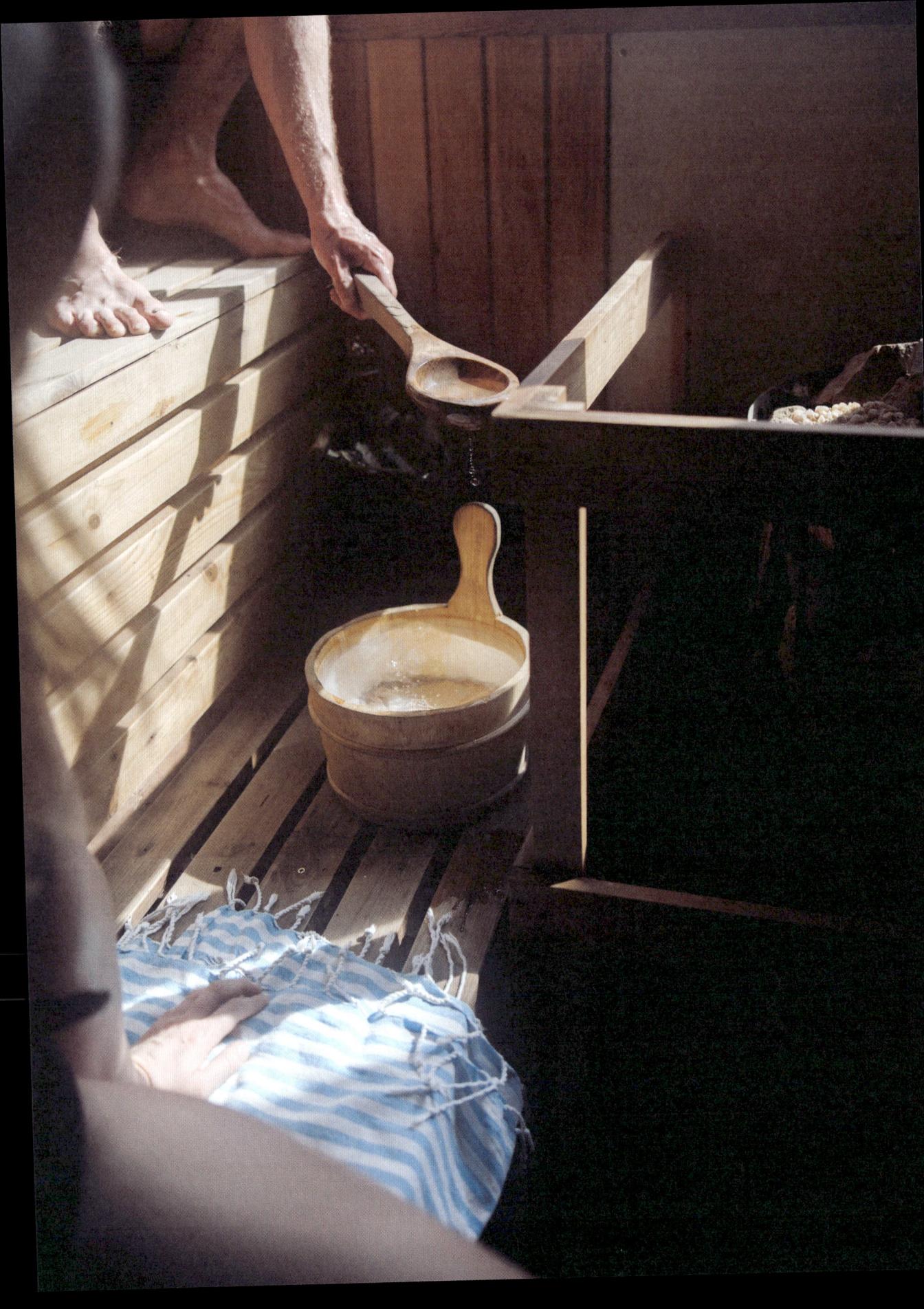

At a Sunday night session in May, the sauna is packed; around a dozen mostly naked men and women in their 30s chit-chat in the steam and drink pints in a raucous circle round the plunge pool. Two tech guys from Mumbai are visiting a friend. They've never had a sauna before, and the heat reminds them of the streets back home. A tattooed Lithuanian artist and an American marketing exec share their experiences about being expats in Tallinn, and an Estonian widower with three young kids says Heldeke! is his lifeline.

Dan is a sauna convert. "It's an easily accessible activity where you can have a chat and a giggle that doesn't involve drinking a shit load of alcohol," he says with Aussie bluntness. "No one looks at you sideways if you just want a lemonade, and there's no competition about how long you stay in, so it's good for your self-confidence. You can do what you want. No stress." And it *does* feel like the pub, minus the clothes and the smoking. Everyone talks to everyone. We all stay beyond our two-hour time slot, and are asked to down our drinks and leave by the kindly barman. Kicked out at closing time.

Opposite: Community Sauna Baths in Hackney, London.

Sauna around the world

"People who come at sauna from the fitness or gym perspective and believe that it's about suffering are overlooking the cultural and historical aspects," says Adam, who sees himself as an enthusiast who wants to connect with authentic sauna culture. (He has his own smoke sauna in his garden.) In Estonia this is easy, since sauna exists in every sector of society. But what about in countries like the UK, Ireland and South Korea, who have to go back millennia to find any home-grown, sweat-bathing rituals? For these nations, it's like looking at a recipe for a melt-in-the-mouth chocolate cake and realizing they don't have any of the ingredients. It's about starting from scratch, appropriating, reworking and tweaking the best bits from other sauna cultures.

German *aufguss*? Tick. (The Japanese call it *auf goose*.) Finnish *löyly*? Tick. The moment when bathers were allowed to pour water on the rocks and create steam marked the moment sauna first took off in Tokyo; the fail-safe recipe for *totonotta* (well-being) is sauna for seven minutes, dip in cold water, sauna for five minutes, cold water bath, another five minutes sauna, and final cold water bath. Lithuanian whisking? The Brits are leaping into it with enthusiasm.

Tent sauna parties; seaweed wraps; peat treatments, honey and salt scrubs; IKEA sauna buckets and ladles; Japanese *saunner* T-shirts; kitschy, felt sauna hats. Each culture interprets sauna in its own ways.

As we saw in Chapter 1, in Japan, the sauna is seen as an "elsewhere zone" (beyond home or work) that induces *totonotta* and a good night's sleep. Talking is unusual in Japanese steam sessions, and solo saunas – single person units with their own showers – are a new addition to the booming sauna scene. Helsinki's cult Kulttuurisauna, where silence, pickled eggs and a die-hard following are the order of the day, is rumoured to be opening an outpost in Japan.

Opposite: Sompasauna in Helsinki, Finland.

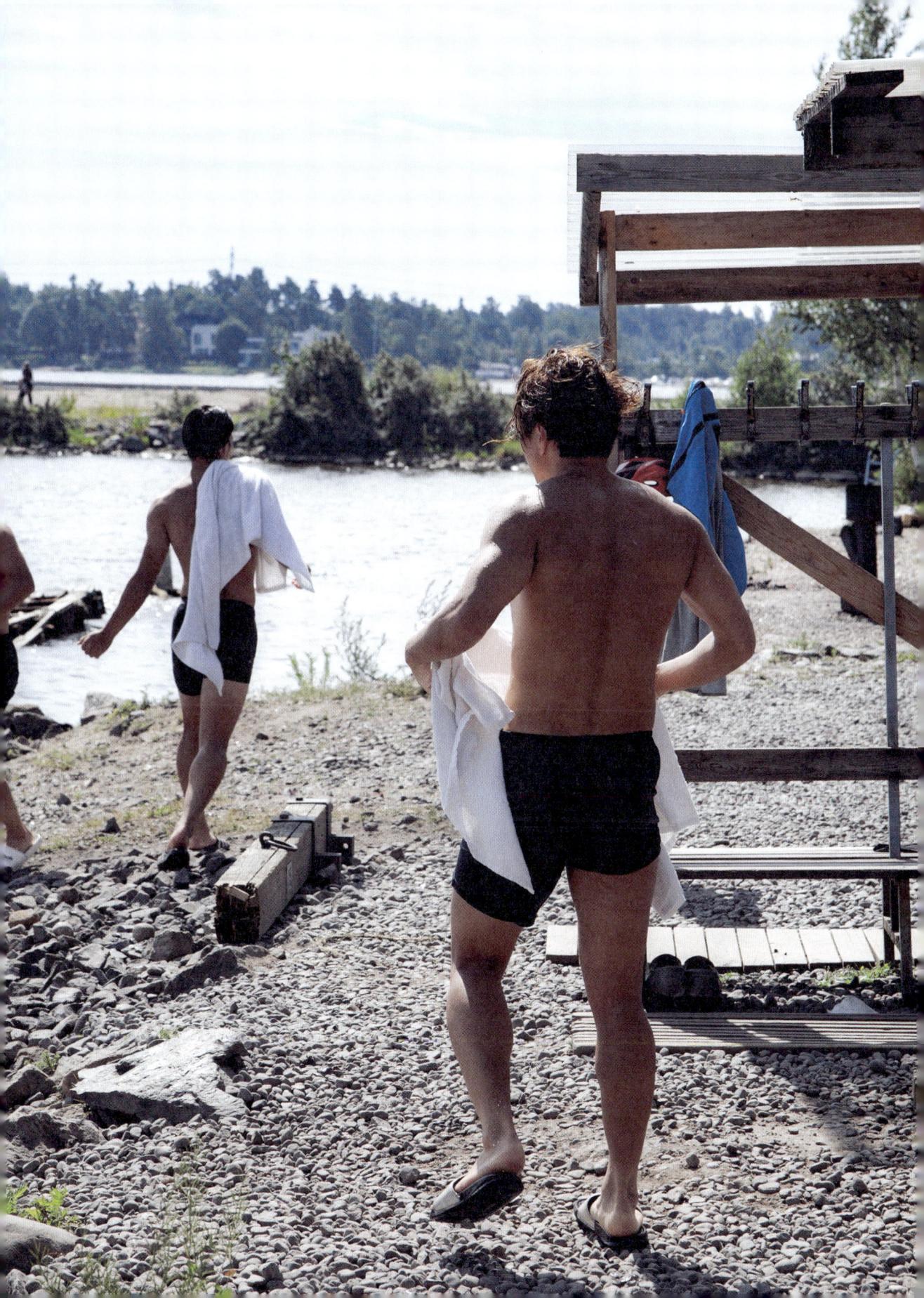

SAUNA ACCESSORIES

The first time I saw a bather in a sauna hat, I thought he had grabbed grandma's tea cosy and put it on for a laugh. Oversized, largely unflattering and sometimes the only garment present, they are more garden gnome than glamorous; but it turns out sauna hats are extremely practical. They trap air, helping the head stay cool, which means you can endure the heat for longer without overheating or feeling dizzy.

Today, the material of choice is unprocessed felt, which is antibacterial, self-cleaning and breathes well. Up until the Middle Ages, bathers wore straw hats soaked in water. Felt came later, from the East, with the nomadic peoples of Central Asia. In its absence, the next best thing is linen, which is also antibacterial and breathable, but doesn't offer quite the same "coverage".

Hats are deliberated outsized for a reason. They can be pulled right down to the nose, protecting the forehead and the ears from a fierce *löyly*, which has a nasty habit or squirreling its way right into your eardrums and straight to your brain if it can. And, for many, they offer a place to hide; a hat drawn over the eyes gives off the signal that you want to be left alone.

When he's enjoying a sauna rather than working in it, Juha Kumara of Saunakonkeli, likes to hide underneath his hat in a dark corner. In 2017, he wrote a bachelor's thesis entitled "An ethnographic exploration into the experience of wearing a sauna hat". He found that the role of a sauna keeper (providing guests with washing buckets, whisks and sauna hats) hasn't changed since the Middle Ages, and that right up until the 1930s in Finland, travelling healers would urge bathers to wear a felt hat to protect the blood vessels in the brain.

Hat designs are often colourful and kitsch; in the Nordics, Viking horns and reindeer antlers are popular, as are floral and New Age motifs. A stylish sauna hat is generally something of an oxymoron except in Japan, where plain white models are popular. Here, no-one goes to the sauna without the right gear. Towels, flip flops, water bottles, hats, essential oils, are all essentials, as Japanese sauna makers TTNE know only too well. Its line of accessories, emblazoned with the word *saunner* which it has trademarked, are a big part of the sauna bathing ritual. And the new Bastua sauna collection by IKEA and Finnish design house Marimekko offers colourful buckets, ladles, shower curtains and the like. But if you really want the perfect hat, it's best to find a felt expert to make you one. Or design your own.

Opposite: Estonian carpenter Toomas Kalve's wooden sauna headrests covered in felt (top left); many community saunas offer hats, loofahs, soaps, scrubs and towels.

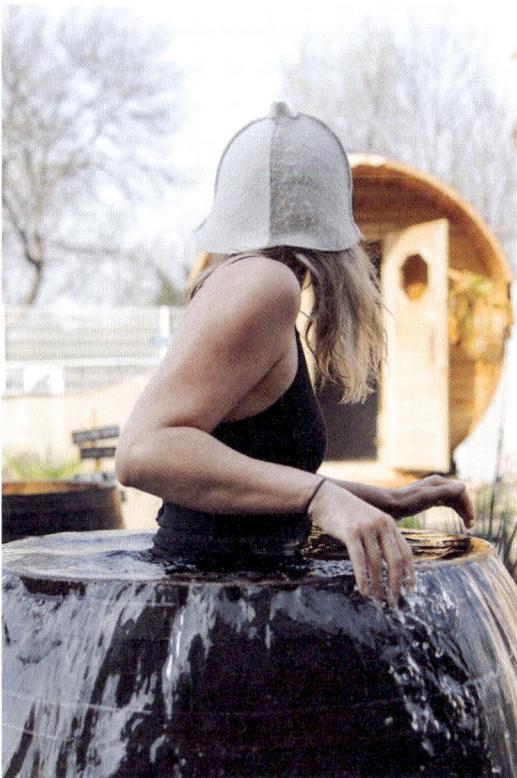
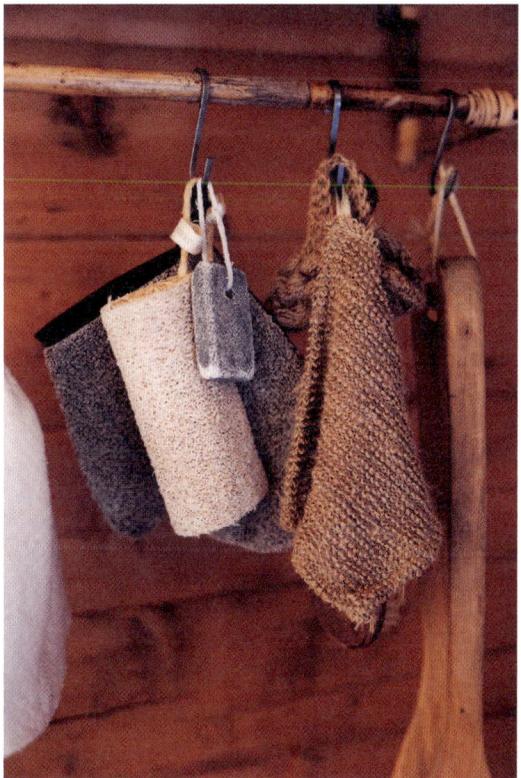

Sauna in the UK

"A big question we ask ourselves is what does sauna culture look like in the UK," says Victoria Maddox, co-founder of Community Sauna Baths. "What will we inherit, what will we adapt and what will we invent that's entirely new?"

Opened in 2022, the group has sites in Hackney and Stratford and held the first Saunaverse festival in 2023. It largely follows the Finnish tradition: wood-fired saunas at 80°C-plus, cycling the heat with a plunge in a cold-water barrel, pouring water on the stones. But in a country that has always liked to remix the best bits of other cultures (boil-in-the-bag chicken korma and tinned ravioli, anyone?), the UK's Hackney hotspot is also a sauna test centre. "People really like whisking," says a former director of the Baths, Gabrielle Reason. "They say it's a real stress release. The whisks are bald after one day from being used so much. And one of our regulars has started bringing *aufguss* (see Chapter 2) to the sauna. He learned it from watching YouTube videos and practising the towel movements in his kitchen."

Opposite: Community Sauna Baths in Hackney, London.

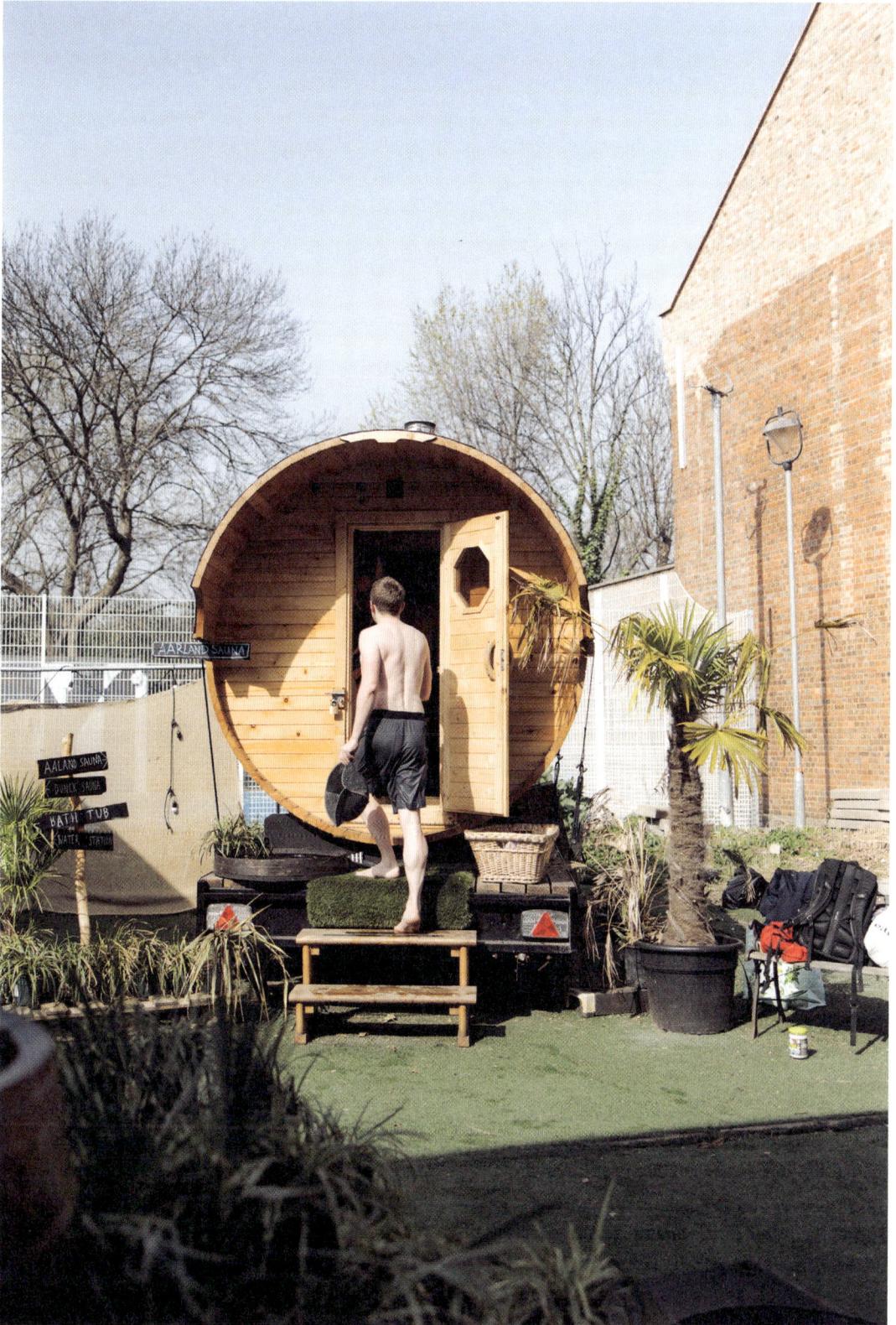

The saunas chuff merrily in the back garden of Hackney's former Eastway public baths, built in 1934 and closed down 50 years later. The bathers here reflect the area – young, curious, diverse. The Sauna Baths' ethos builds on research that suggests sauna is a powerful preventative measure for conditions like cardiovascular disease, Alzheimer's and depression; and it's a novel way to turn disused land into a space where people can meet and create a community.

In the largest wood-fired sauna (designed originally for racehorses), a newcomer asks what the birch bushels are for and a regular demonstrates whisking. It's packed, and almost everyone is talking about how the heat is making them feel. Heart palpitations, deep sweat, outer body lightheadedness. A whoosh of *löyly* sends many running for a cold plunge. "It's surprising, but we find that people love to chat, whereas in many European saunas, silence is preferred," says Gabrielle. "Maybe it's something about going through an intense experience together, or the excitement that they've found something that's rarely on offer these days." Victoria adds: "In its most simplistic form, sauna is rugged and offers a back-to-basics, fundamental need to survive that speaks to an ever-disillusioned society being pushed and herded into a new world of tech."

Opposite: Community
Sauna Baths in Hackney,
London.

Gabrielle recounts a mixed sauna session trip at the New Docklands steam baths – a no-frills bath house with a following among east London's boxing community. "A group of black Londoners was hanging out and chatting and scrubbing or "schmeissing" (whipping) each other with raffia brushes and a mix that, bizarrely and alarmingly, contained the disinfectant Dettol," she says. "A Russian guy who spoke no English came over to ask them what they were doing. They did their best to explain, but he couldn't understand. So he just stood and watched. Eventually, once he'd got the gist, he joined in. That's one of the most wonderful things about bathing; it's almost like a language … One of the most resounding and frequently heard things bathers mention is how they love the people and the sense of community they find at the sauna baths," she adds. "People come with friends, but they also come alone and meet new folks, which is so important at a time when we are living through a loneliness pandemic in the UK."

According to a 2021 report by global data analysts Nielsen, a post-Covid focus on wellness has seen a boom in consumption of non-alcoholic beverages and a decrease in alcohol intake among millennials. Covid allowed many to rethink their drinking habits away from social pressures. "Many say they feel disillusioned with social occasions always revolving around expensive meals or alcohol," says Gabrielle.

Research suggests that there are fewer pubs in England and Wales than there have been for more than two decades, and four out of five people have seen a pub close down within five miles of their home – with potentially disastrous impacts. Could the sauna provide the community and support that the local pub or church group once did? "Absolutely," says Gabrielle. "As these things have disappeared from the places we live, they've been replaced with online imitations or pricey commercial options that don't facilitate connection and are often a car drive or bus ride away. We want sauna to be a local meeting place that people can reach on foot, where they'll get to know their neighbours."

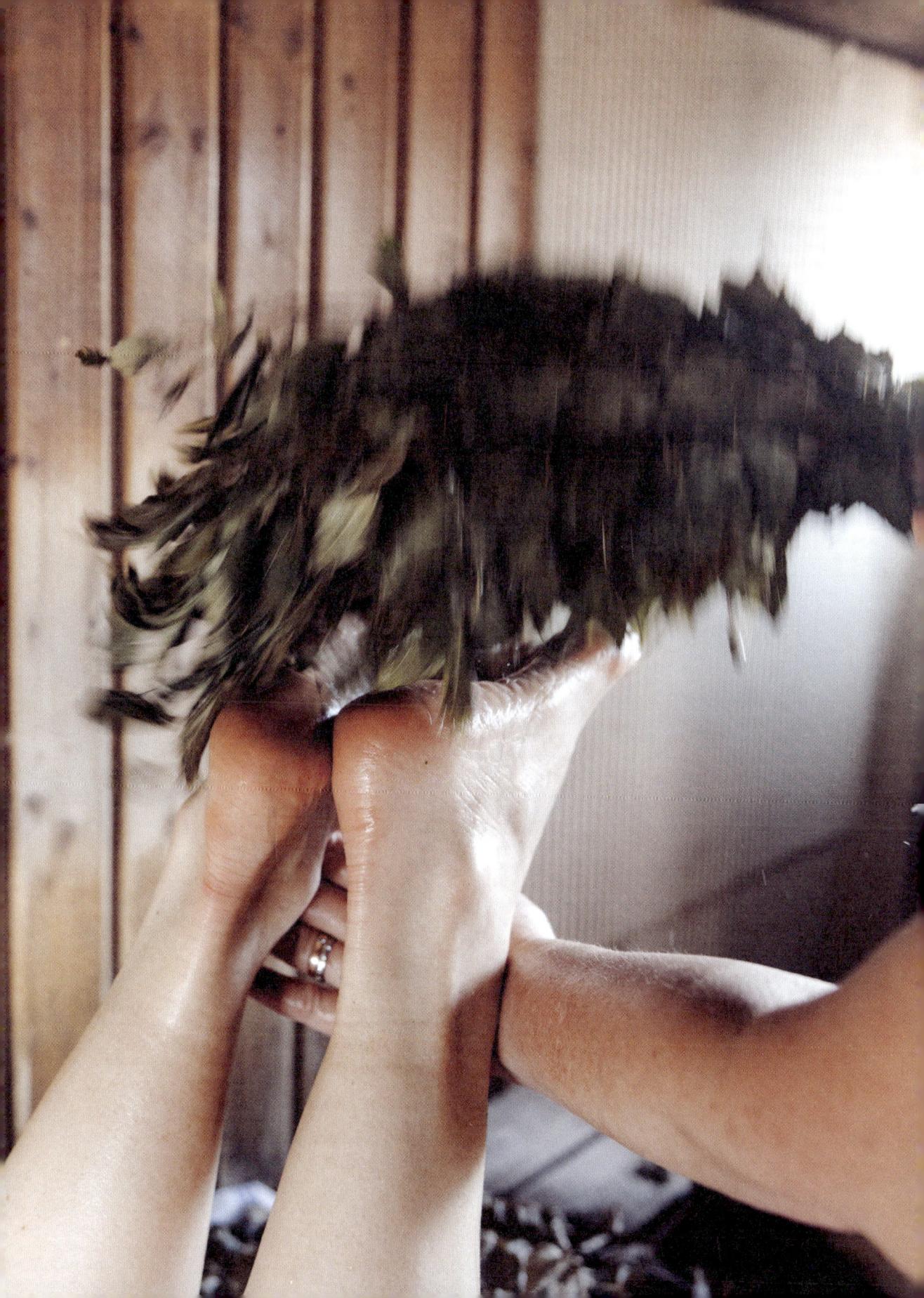

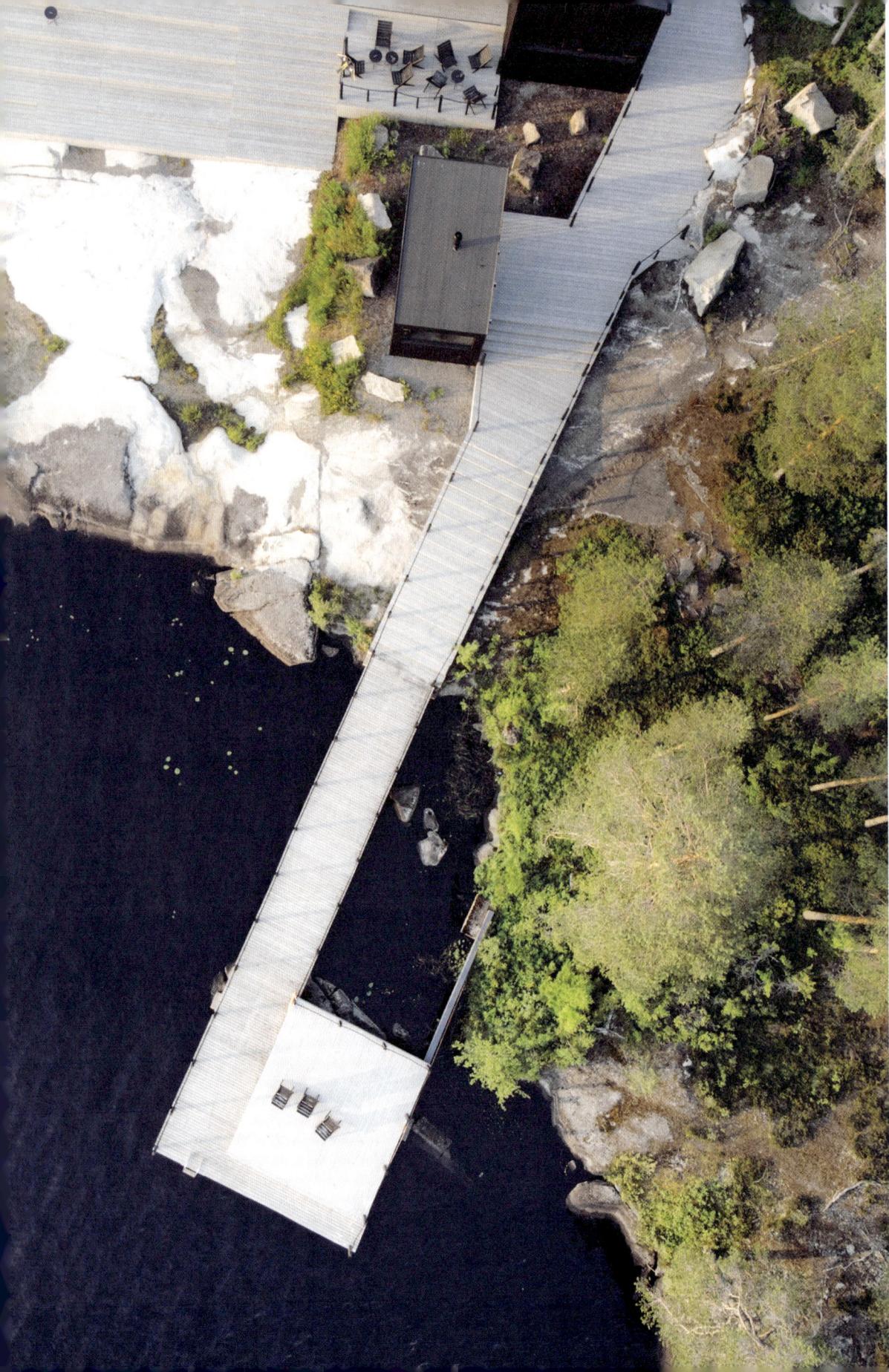

STEAM CLUBS

What is a sauna without a sausage and a beer afterwards, or, in Japan, a bottle of Pocari Sweat and some rice balls? Why should the taste buds miss out, when all the other senses are satisfied in the steam? All that sweating builds an appetite. Which is why a new generation of "steam clubs" have become destinations in themselves. They're places to eat, drink, date and meet friends, and the sauna is the heart of action, not an add-on in a corner plot.

Norwegian lifestyle company Pust runs sauna complexes in Tromsø, Bodø, Kadettangen (Oslo) and Narvik. "We develop infrastructure that facilitates people to live their best lives," says Pust "Sauna Boss" Erik Stange Ankre. The saunas are hard to miss, with their cool, curved, Norwegian spruce roofs, designed by local carpenters. Each sauna club comes with a pust.kafé – a vegetarian cafe and gastrobar where drinks with and without alcohol are served to a backdrop of carefully curated tunes. They also feature pust.huset – co-working spaces "where you will be inspired to follow your own dreams, build cool projects, make contacts, co-create and collaborate," says Erik. On the same floor, there's a separate room for positive self-development. "Our experience is that you can make a big difference to people through relatively small projects," says Erik. "Saunas have activated parts of the city that were previously either 'dead' or associated with something other than the pleasure of bathing, recreation and sweating."

Tampere in Finland is the "sauna capital of the world"; it has 50 public saunas for a population of 250,000. That's almost a different place to bathe every week. One of the best is Kuuma, a sauna complex on the river with two mixed saunas, a smoke sauna, a buzzy restaurant and a heated roof terrace for up to 200 people. "In Finland, we're rethinking the sauna as a whole experience," says Heikki Riitahuhta, founder of Puisto architects, who have created two resorts where sauna, spa, restaurant and beer combine to give off holiday vibes.

So too in Estonia, where, until recently, saunas have been largely private. Iglupark in Tallinn has ten hotel rooms, five saunas and office spaces for hire, and an Iglubar serving snacks and drinks; and there are plans to open more elsewhere in Estonia. Perched on the harbourfront overlooking the Baltic Sea, the park is made by Iglucraft, a company founded by two sauna fans who work with local carpenters using Estonian materials. The Hobbit-house style, finished with local shingling is not an indigenous, historic design, but lots of people think it is – which is good news for Iglucraft who came up with it.

So, what's next? "A nightclub and a sauna," says Heikki. Is he joking? In Finland, ferries, trains, building sites, trains and military bases have their own saunas. Even Helsinki's famous Ferris wheel has a "sauna carriage", so maybe he's not.

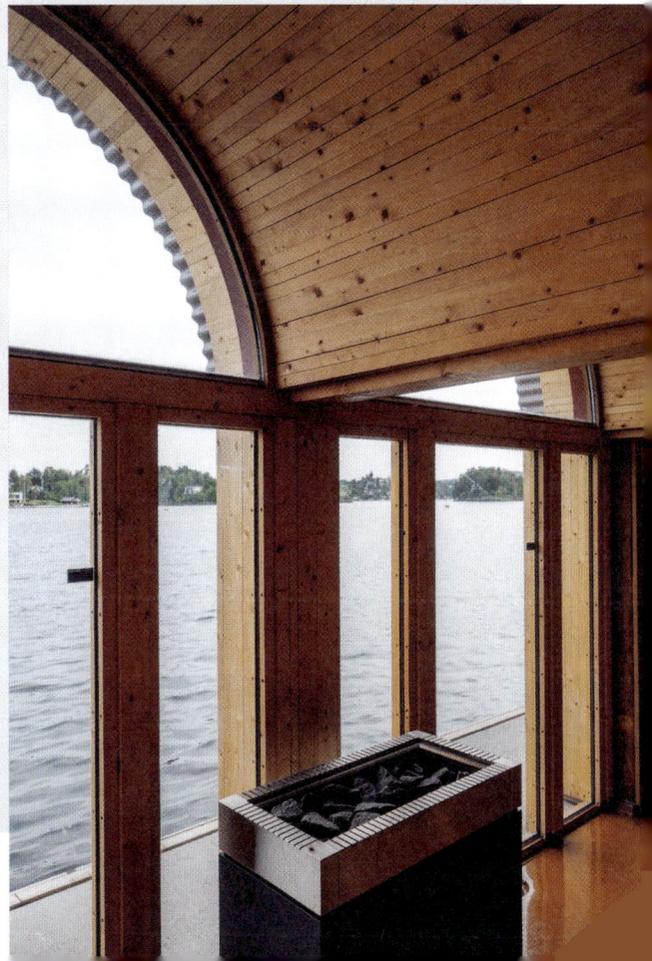

Communal success

At the 24/7, counter-culture, free-for-all that is Sompasauna in Helsinki, nudity, beers and the threat of demolition are the norm, and the sounds of Japanese, Finnish, French, English and Korean linger on a gentle Baltic breeze. Illegally constructed from found materials on a plot earmarked for development in 2011, Sompasauna is an experiment in DIY architecture and grassroots action.

At first sight, it looks like Day Five of a festival where everyone has lost their clothes. Piles of wood and debris – sauna fuel – lie around waiting to be chopped. A tall, naked man in his 60s obliges, and his manhood hangs in jeopardy as he wields an axe with hefty swings. On closer inspection though, Sompasauna is well-tended oasis; neat little flowerbeds planted with marigolds, a charming wooden jetty decorated with life rings and window boxes of geraniums, and three saunas lovingly crafted from discarded materials and decorated with cartoons, graffiti and art. The volunteers who look after Sompasauna do so with passion.

"So, what do you want to know?" says Niklas Roiha, one of Sompasuana's directors. He's in his 30s, has shoulder-length blond hair, piercing blue eyes and is naked, arms crossed, pelvis thrust forward. At the start of my sauna journey, this would have felt intimidating, but now I'm used to nudity. Even my own. Almost. I hold his gaze. "Where are you moving to next?" I ask, because ever since it was first constructed, Sompasauna has been on the run from the authorities. It has relocated six times and burnt down once. "We're not sure yet, but we will stay here in Kalasatama next to the water," he says, nodding disapprovingly towards the ugly glass towers under construction in the near distance. Next year, they will put down foundations where Sompasauna now stands.

Previous: Floating sauna Pust Kadettangen in Oslo, Norway. **Opposite**: Sompasauna in Helsinki, Finland.

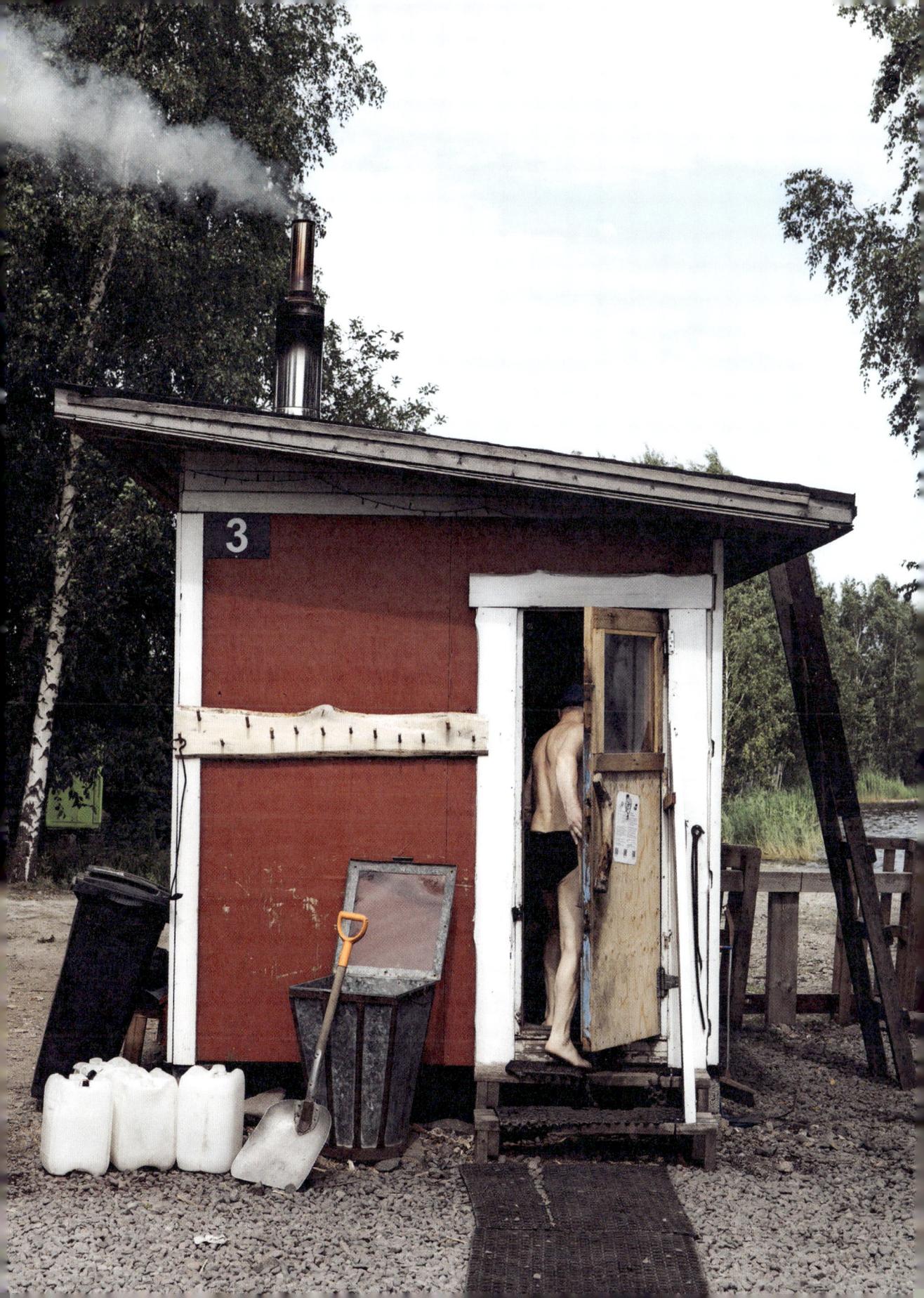

What was founded as a rebel yell by a band of anarchists is now a famous landmark, tourist attraction and symbol of Finnish pride. "In the beginning, every time we built the site, the police destroyed it," recalls Niklas." Now, visitors come straight from the airport without even going to the city centre." Politicians have paid visits too, and Sompasauna has won many awards. It's totally free; no money changes hands. People bring their own snacks, drinks and firewood, and funds are raised from memberships, donations and the return of empty cans to the local supermarket.

But there are rules. A sign reads: "This sauna area is reserved for sauna goers! Hanging around, partying and grilling should be done elsewhere on the island." And aggressive or lewd behavior is not tolerated. Someone called "The Viking", a huge man with a long beard and sauna burns on his arms, makes sure of that.

Under a makeshift stage, a free-for-all piano and guitar are seized upon intermittently by anyone who fancies it and retired vicar Aarne Laasonen is playing the saw. The haunting, melancholic sound lends itself perfectly to folk songs and lullabies, and Aarne's renditions have gained him a following at folk festivals. His finale, performed in swimming trunks and sauna hat, is a crowd-pleaser, a mournful rendition of *O Sole Mio*.

Opposite: Sompasauna (Helsinki, Finland) is often so packed that bathers position themselves in what the Finns call "Front Bottom, Back Bottom", making two rows on one bench.

On the door of the hottest sauna, a drawing of three chillies is an omen. It's legendary, this sauna. A vindaloo. Inside, it's 110 degrees already, and Niklas is sloshing dollops of water onto the rocks. After three minutes that feel like three hours, my earrings sear through my earlobes (note to self: never wear jewellery in a vindaloo), and fellow bathers are crossing their arms and shoving their hands under their armpits – the international sauna sign for "It's Insane In Here And My Fingernails Are Melting".

I, too, feel like I am turning into a waxwork dolly whose forehead is peeling off, being pricked by a thousand tiny pins. "Get me out get me out get me out," I cry silently as, next to me, a young guy from Cameroon who has been living in Finland for ten years starts shrieking and twitching and swatting himself, like a cartoon character who has just sat on a wasp's nest. Niklas opens the door and tells him to take some air. He rushes out and never reappears. I'm hot on his heels and throw myself into the sea. It's a tonic sent from heaven; I bob in the gentle waves for ages and wonder whether sauna goers are the main reason for rising ocean temperatures in this stretch of the Gulf of Finland.

There's no way I'm going to sear myself again on the chilli grill, so I head to the "entry level" sauna instead. It's a cool 60 degrees. Outside, Aarne is reciting poetry (in Finnish) to a French couple and a group of Japanese tourists who have set up an elaborate picnic on a makeshift table next to the shore. Aarne clearly likes an audience. And the audience likes him back.

Sompasauna is a utopian experiment gone right – and the mix of ancient sauna traditions, *talkoo* (community spirit) and citizen-driven activism are what UNESCO was keen to protect when it added Finnish sauna to its Representative List of the Intangible Cultural Heritage of Humanity in 2020 (as it did with Estonia's smoke sauna tradition in 2014). It has captured the imagination of bathers all over the world. The collective can-do mindset that led to its creation in the first place is known as *kaupunkiaktivismi*. It loosely translates as "communal activity", and encompasses all sorts of initiatives, from "set-up-your-own-flea-market day" to, "set-up-your-own-restaurant day". It encourages people on said days to initiate something anywhere they please without the usual red tape, expense and health and safety restrictions. It's a freedom of expression that most other countries deny its citizens. Why? When we are left to our own devices, we *do* still know how to nurture, nourish and connect with our fellow man, even though it may not always seem like it. Sompasauna proves it.

Opposite: Playing the saw is one of many distractions at Sompasauna in Helsinki, Finland.

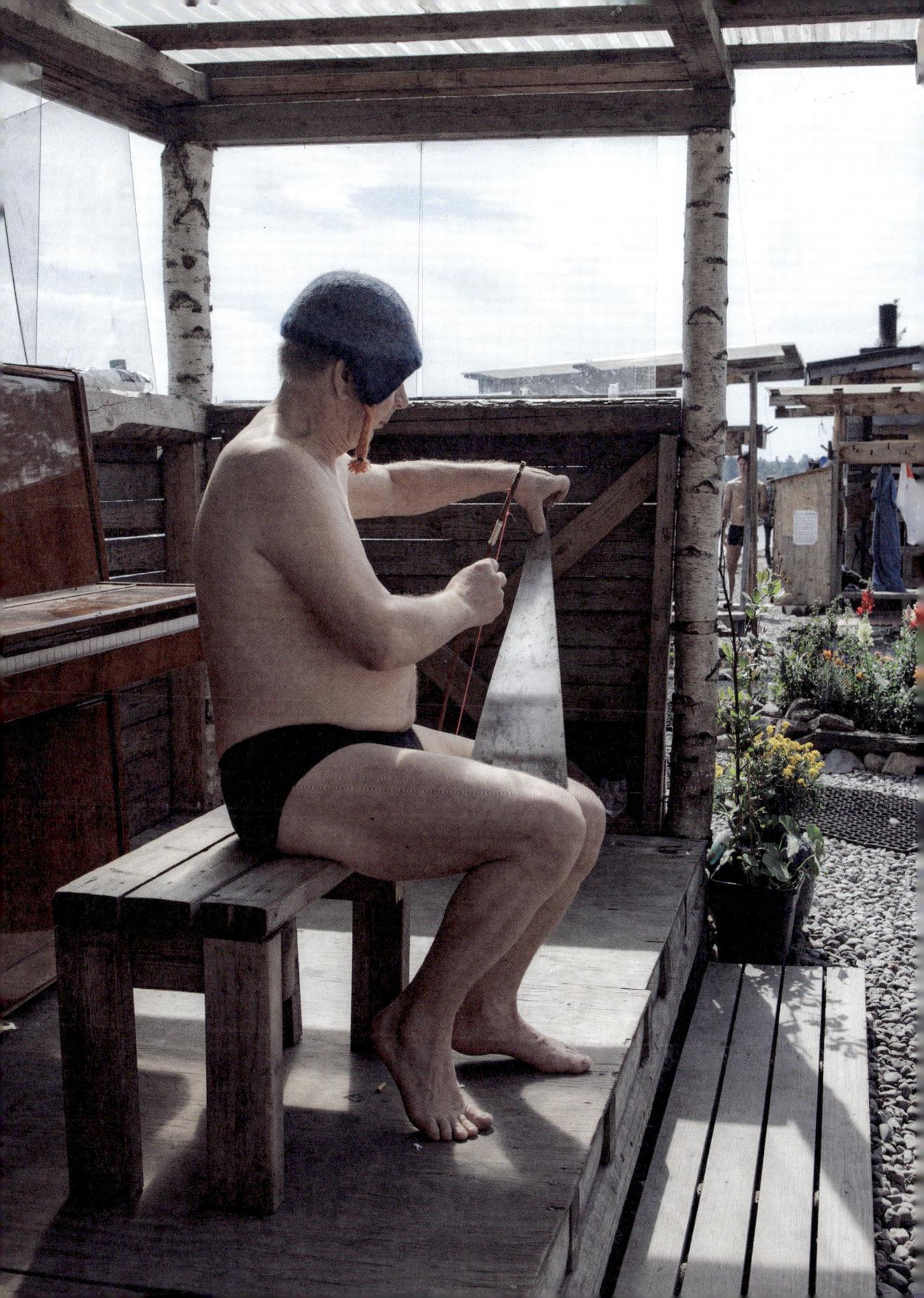

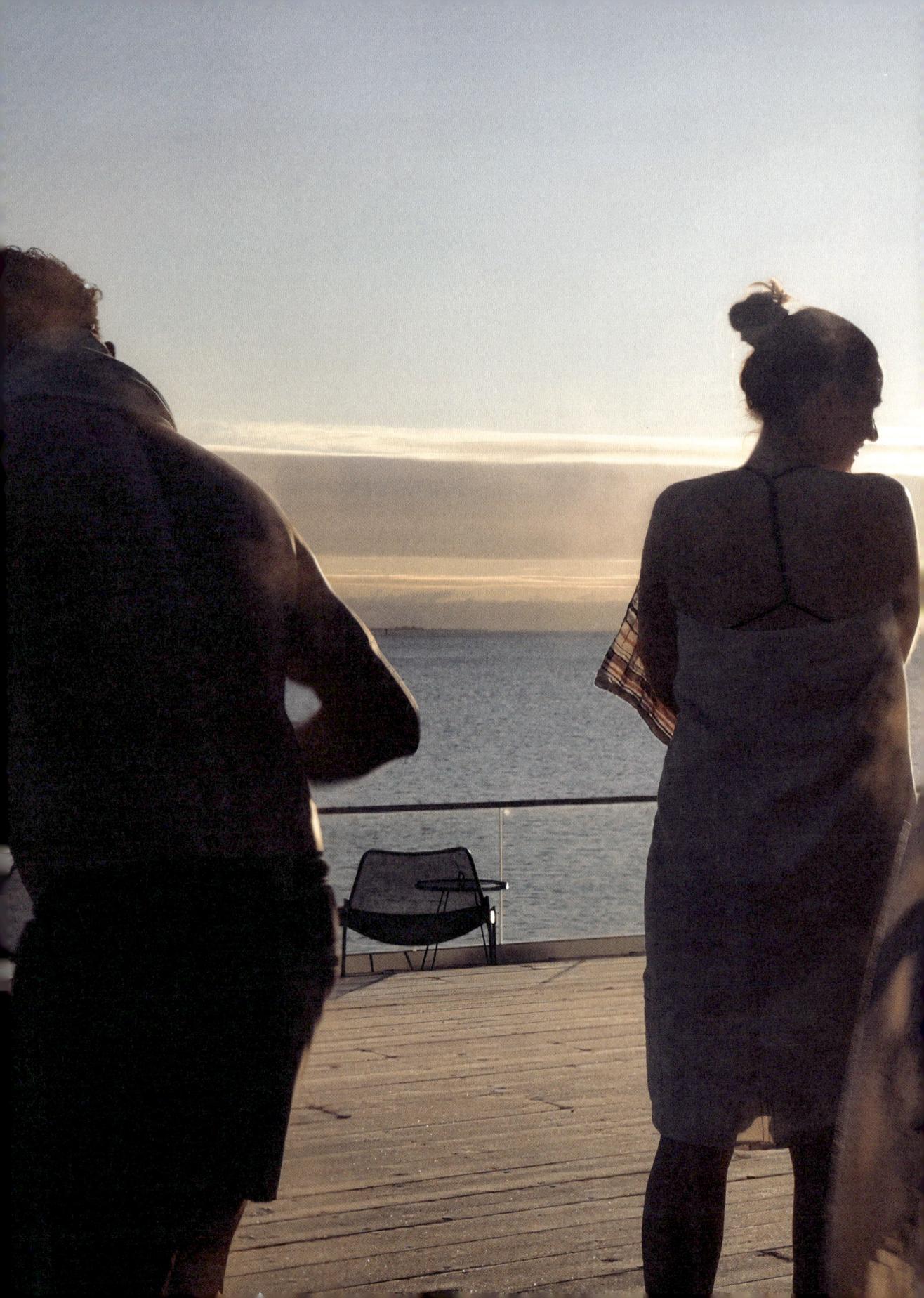

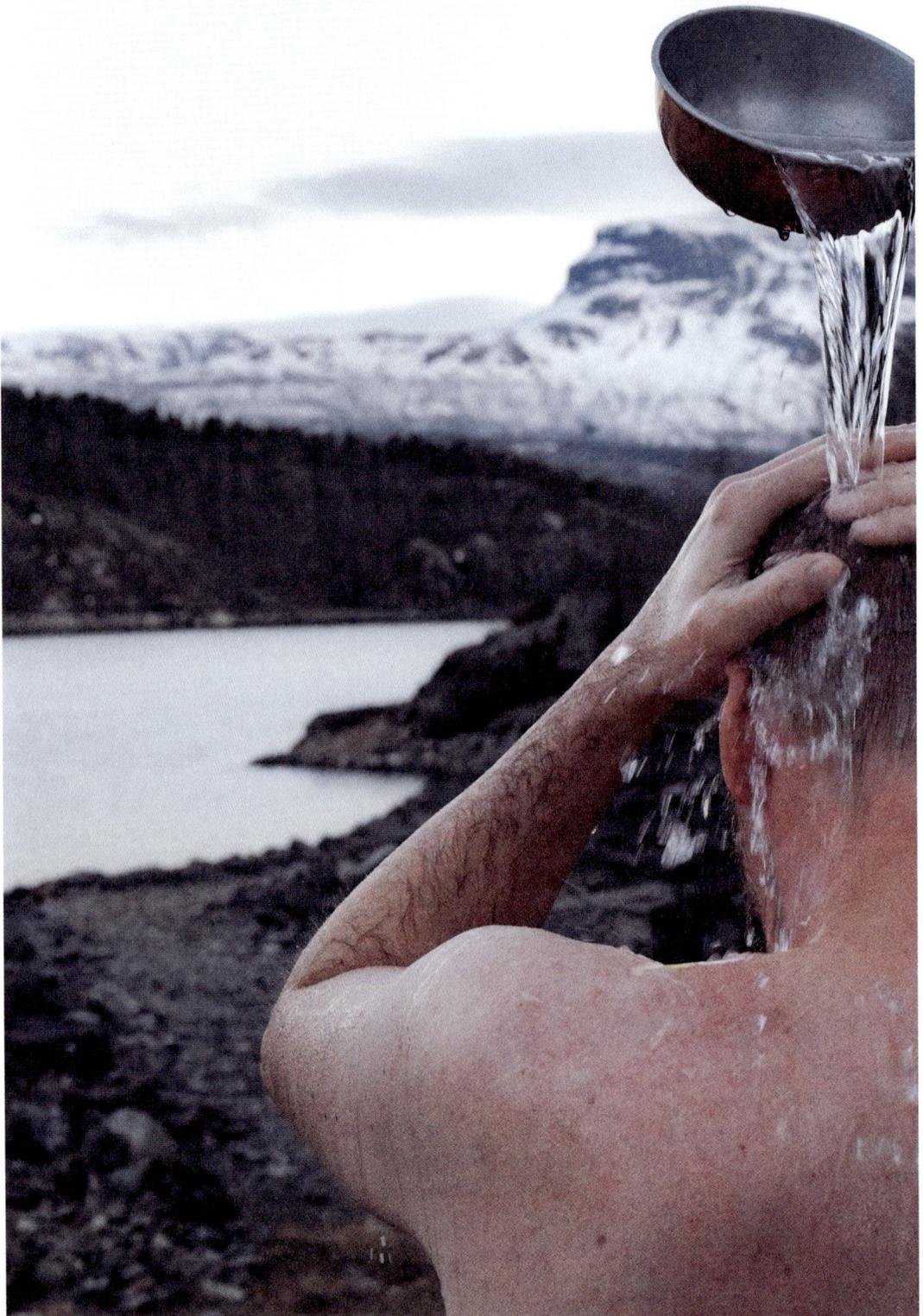

BADSTUFOLK

We had been told there was a movement in the making, that young creatives were eschewing an expensive life in Oslo's suburbs for a more back-to-nature existence. A sauna community was growing in Valdres, a remote valley in central Norway midway between Oslo and Bergen. Its pioneers, who called themselves *Badstufolk*, were Knut Lerhol and Hallgrim Rogn; childhood friends who were portraying a magical Eden in which naked, blond children frolicked with cows in green pastures while near-naked Norsepeople chilled on wooden sauna decks, steam rising off them like newborns. We had to meet them.

Our host, Farmer Knut, had given us instructions on how to find his farm in the remote region of Valdres four hours north-west of Oslo. "Take the E16 for 3.5 hours. Turn right at the bridge with yellow railings, pass a sign for the Riddarstøga museum, a big stone and a huge waterfall, then you drive down to Lerhol Farm. Good luck!"

As we left the suburbs of Oslo, glorious April sunshine was urging winter to be gone; stubborn snow still clung to the hilltops and frozen lakes were reverting to liquid form, as lone fishermen plucked at the ice. Telltale wisps of smoke curled out of shoreside saunas; although winter was shifting, the need for a steam wasn't.

We passed several wrong stones and wrong waterfalls, before pulling up at Lerhol Farm outside the village of Vang. Knut's dog Kvikk skipped over, followed by Hallgrim carrying towels and a picnic box. He was clean-shaven and dressed in hiking gear, no *Game of Thrones* jerkin or Viking beard (what had we been expecting?). First things first; we would head to the Lake Sauna for a steam, then drink beer and eat sausages around the camp fire.

Knut grew up taking a sauna every Thursday with his granddad at the local swimming hall. After returning from mine-clearing service in Afghanistan in 2009, he needed a place to relax and, with the help of an Estonian carpenter, he converted the decaying family playhouse into the Lake Sauna.

"It worked. Lots of heat, lots of fresh air, and because it was made of reused material, it was easy to clean. We tried out lots of birch whisks, scrubs and water," he says. Before long, he had found his place to relax.

Like many of the buildings in Vang – the nearest village – the Lake Sauna has a grass roof and a little wooden door. A couple of oars hang from hooks on one wall. Knut takes his kids out trout fishing on Lake Vangsmjøse, which in summer can be as warm as 16 degrees.

Knut's family has owned Lerhol Farm since 1647 – for 16 generations. It's one of the oldest in the region and, like all farms in the area, it has access to water, land and hill, which provides summer pasture for the cattle. Every July and August, he and his wife Kristin, the kids and his parents take the cows up to the sweet summer pasture and decamp to the summer cabin, where they swim in the waterfall and steam in Eldmølla, the sauna that straddles it (see Chapter 7). Before Knut made it possible to stay on the mountain, his parents – and the generations before them – would herd the cows to the pasture and back, every day – a journey of seven kilometres. (There's a reason why milk from Valdres is among the best in Norway.)

Hallgrim throws some water on the rocks in the cabin's sauna and my eyeballs film up. I guess it's really hot, although I can't read the thermometer. The sauna is small, just big enough for Knut's family, and he is very proud of the stove and the rocks. Many stories are told about sauna stones; that they must be granite boulders of three sizes – "cabbages", "beetroots" and "potatoes"; that they can come from a river only if the sauna is by a river; that they should be stacked with

"cabbages" on the bottom, then "beetroots" with "potatoes" on the top. "I'm a real rock nerd," confesses Knut. "I take them from the lake, light the fire and heat them up. When the fire has gone out, I pour water on them to see which are the strongest."

We run down to the lake to cool off. It's about 5 degrees, silky smooth and clear – a delicious bolt of cold after the heat. We do a few more "rounds" between sauna and lake, (in Norway, three is standard), then dress behind an old upturned fishing boat. Before locking the sauna, Knut throws a log on the fire, this dries the sauna out, but there's a deeper reason behind it too.

Behind Lerhol Farm is Jotunheimen, the most famous mountain area in Norway. *Jotun* means troll and *heimen* means home, and Valdres is the land of the trolls. In Norwegian folklore, trolls come in many shapes and sizes, from giants to tiny creatures with magical powers. They hide deep in the forests or up in the mountain, and the sauna *jotun* guards the sauna's spiritual soul. Ignore them at your peril.

There's no airport in Valdres, and the last train pulled up here in 1988; tourists flock to the better-connected neighbouring valleys of Gudbrandsdalen and Hallingdal. In 2015, Knut and Hallgrim galvanized the municipality into building a community sauna for Vang's 1,600 neglected locals. Students from the Norwegian University of Science and Technology came up with a design, and in the true spirit of Norwegian *dugnad*, the village chipped in with materials, time and labour. "This *dugnad* concept means we help each other with good projects," says Hallgrim. "And this is a good project." It's also a nod to the past, to the time when almost all the rural saunas were owned and built by the community who came and donated materials, money and man hours. In modern-day Vang, the municipality picked up the 35,000 krone bill.

On the last Friday of every month, Hallgrim and his co-workers go to the community sauna from 3pm to 4pm. There's no lock on the door and anyone can use it, as long as they play by the rules: clear away rubbish, and either pay for firewood for the sauna or refill what you use.

"Vang is becoming known as a sauna municipality," explains Knut, and in recent years, more young people have moved there; among them are Sindre Eikeland and Victoria Ose, who left Oslo and bought a derelict farm in 2020. "We moved to Vang for a calmer life," says Sindre, "to learn crafts, live outdoors more and work with the resources around us without indebting ourselves too deeply."

Their first project was to build a sauna. It's called Lappe Bu – the "Patched-Together Cabin". An old school door marks the entrance and the exterior has been made from the old silo in the barn. The interior is Norwegian spruce, which is cheaper than aspen and doesn't sweat sap during a session. It was built by 20 locals who celebrated with a party and a feast.

Nearby, Marta and Pål Lalim are building a sauna and a bakery. They moved from Oslo to Vang 12 years ago. "We decided we wanted a life where the snow falls more slowly and the coffee tastes better. And the people in Vang are one of a kind," says Marta, who is raising her two young sons the country way. "Our lifestyle is focused on hunting, slow living and breathing fresh air. We want to show people in their 30s, like us, that you can create and live a fulfilled life in the mountains." The couple's home is made from re-used windows, old bricks and second-hand furniture, and they bake bread and pizza and hunt moose, elk and deer. "Being in nature, coming home, going in the sauna and having a glass of wine in the bakery afterwards is a vacation for us," says Marta. "And it's all happening where we live."

Hallgrim invites us for a Swedish-style sauna on Sunday night. His wife Emma is from northern Sweden and moved to Valdres on the condition that they build a sauna – which he duly did from a cabin given to him by his

grandmother. It too has a grass roof, and is propped up on granite slabs on the bank of a river that unwinds and unfolds down the valley. And unwinding and unfolding is what it's all about; wooden cooking utensils hang along one side, and there's a barbecue and wood-fired hot tub nearby.

"The Swedish sauna (*bastu*) is much more closely linked to the ritual of bathing than the Norwegian one (*badstue*)," Hallgrim explains before outlining his Sunday night Swedish sauna ritual: "Light up the *badstue* at 6:30pm. Fill two wash basins and two buckets with hot water and cold water from the river. This gives the sauna a sweet humidity and luke-warm water for washing. After a short cross-country skiing trip in winter or a jog in the summer, and after the kids are clean and asleep, my wife Emma and I go to the *badstue*. It's around 65°C. We do a few rounds, but before we plunge in the river, we do an all-over body scrub. We wash each other's backs with Emma's special cloth. Serious amounts of dead skin loosen up which we rinse off in the sauna. Before we end the session, we wash the strategic spots (feet, private parts, under arms) while we air out the sauna and bring the heat down. Then it's on with the robes and chill until bedtime. It's SO much better than a shower. And it takes the *badstue* experience to a new level that is hard to manage without."

To my British ears, this routine sounds romantic and a little bit erotic. And there is a Finnish saying: "The beauty of a woman is at its best just after the sauna." So, what's next?

Hallgrim answers: "It's crucial that there are no expectations of sex. I can count on one hand the times our Sunday sauna has turned into something like that. But afterwards, when you are SO clean and the mind is on a nice ending … that's another story. I mean, do what you want in your own sauna, but the culture has nothing to do with sex at all.

"One goal that many in the community share is that the public sauna revolution can help normalize all kinds of bodies and de-sexualize nudity. We have a long way to go, but it's a hope!"

Before we leave for Oslo, we thank them both for being such great hosts, and Maija complements them on their *löyly*. "Very soft and punchy," she smiles, with a definitive nod. They look visibly proud. (Being Finnish, Maija is treated like a visiting dignitary by Norwegian sauna folk; they almost doff their sauna hats). Some weeks before, in a horse-box sauna in Brighton, she had explained: "There's a joke that Finns can only say whether *löyly* is 'good' or 'bad'. If you're really talkative, it's 'so-so'." The Badstu boys must have known that joke.

Page 124-5: Cooling off between rounds at Löyly in Helsinki. *Previous*: Knut Lerhol, one half of sauna duo Badstufolk, outside his Lake Sauna in Vang, Norway. *Below*: Hallgrim Rogn, the other half of sauna duo Badstufolk, converted his grandmother's summer cabin into his riverside sauna. *Next*: Knut and Hallgrim run to the lake to cool off.

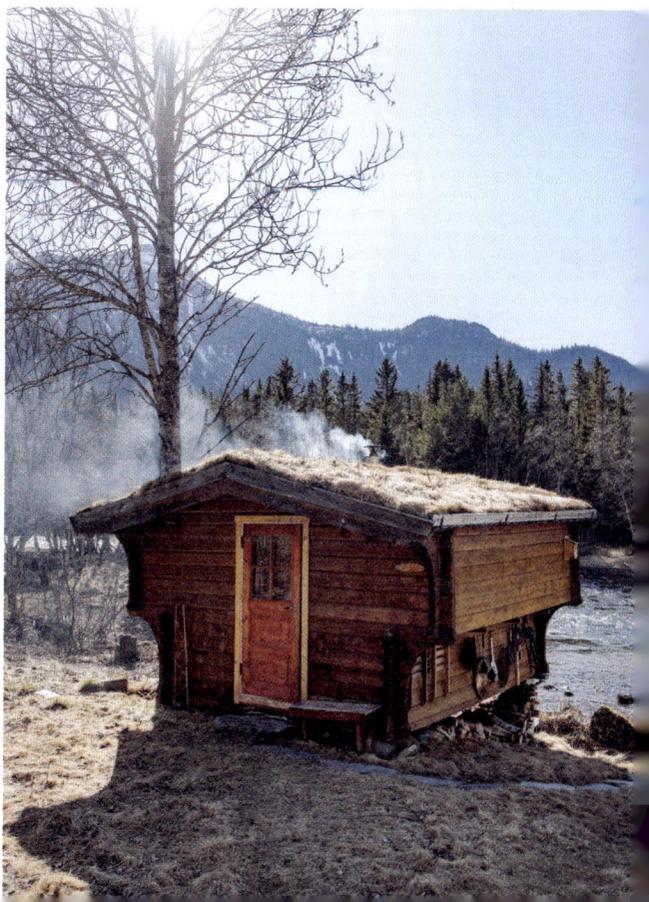

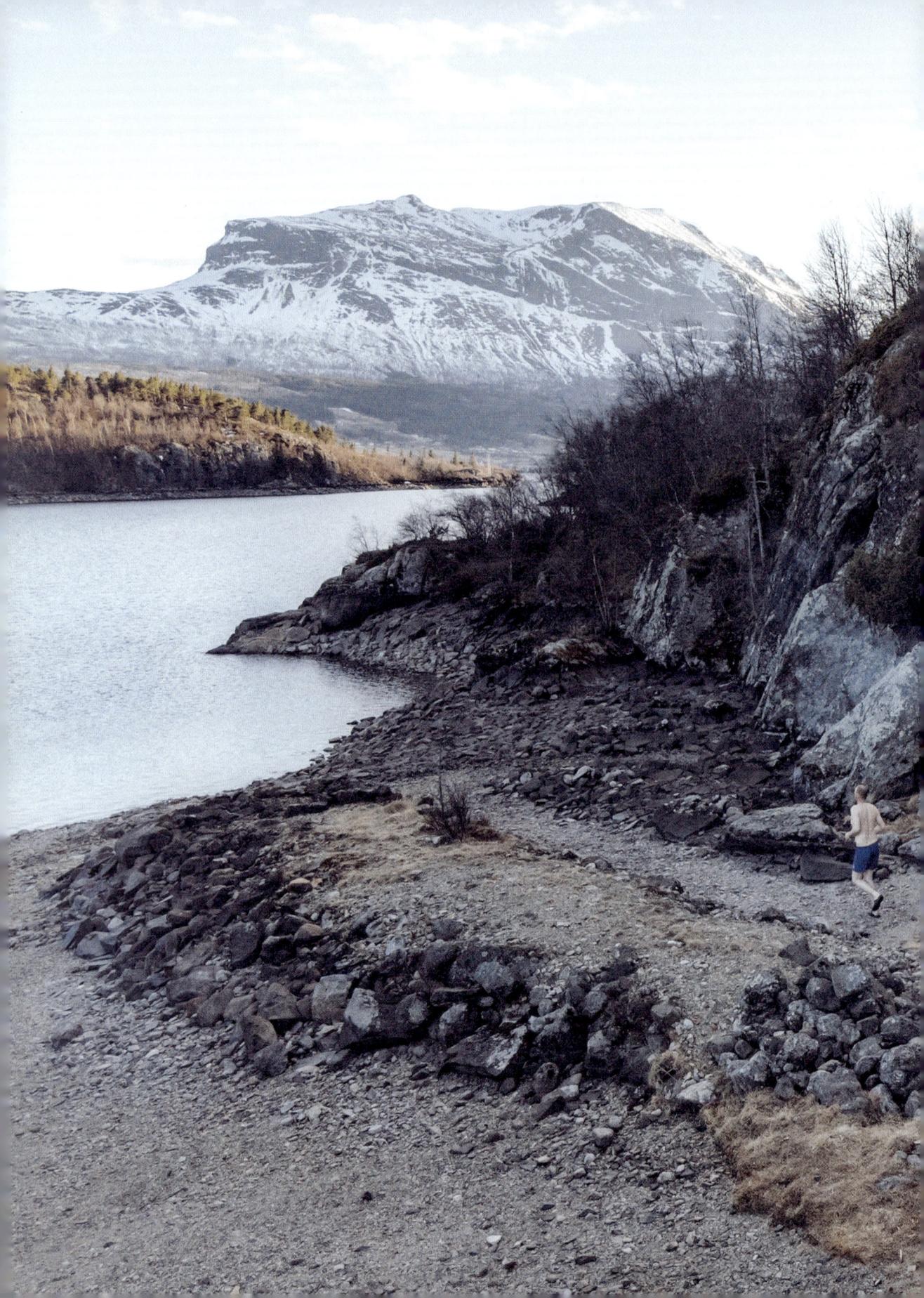

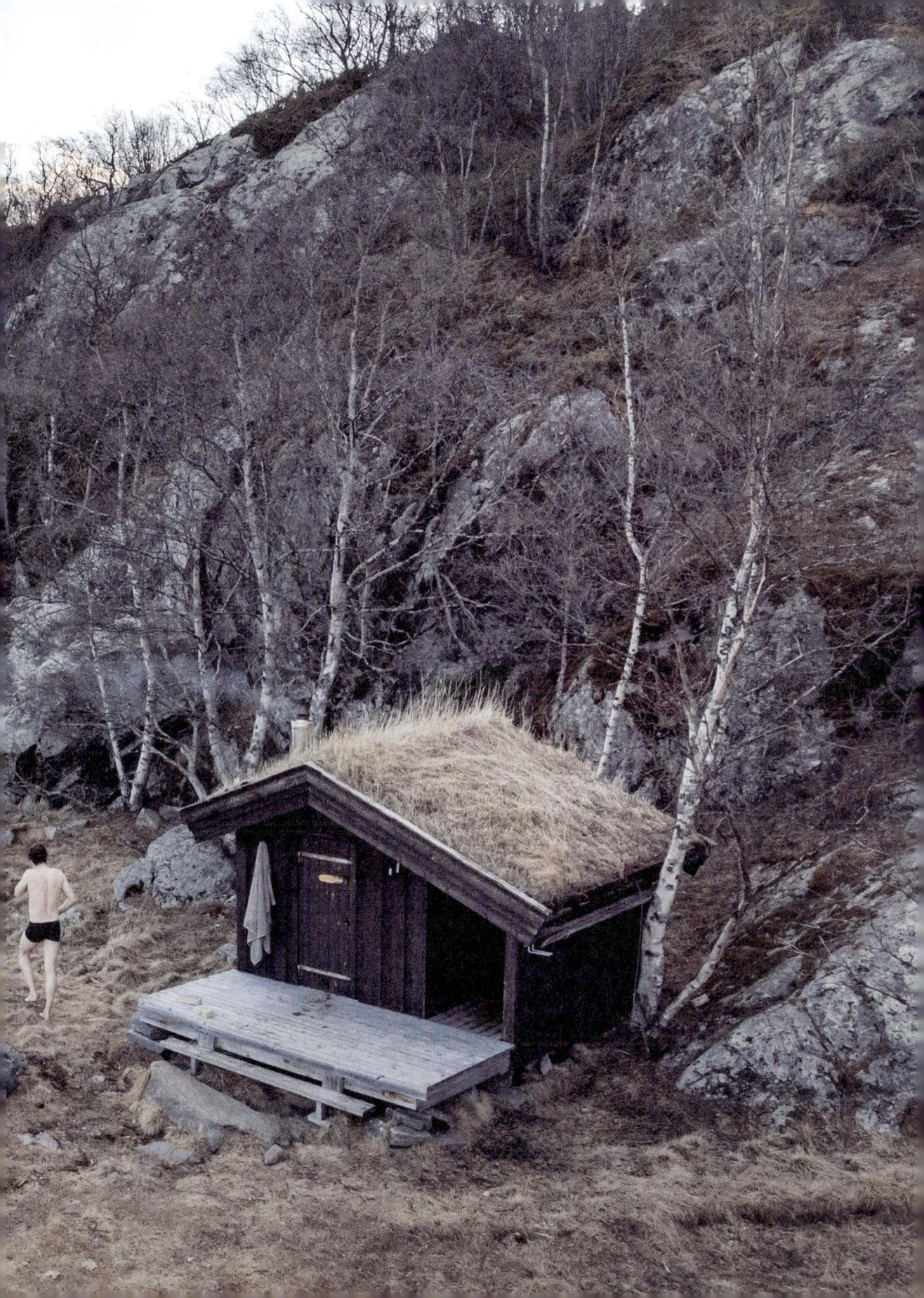

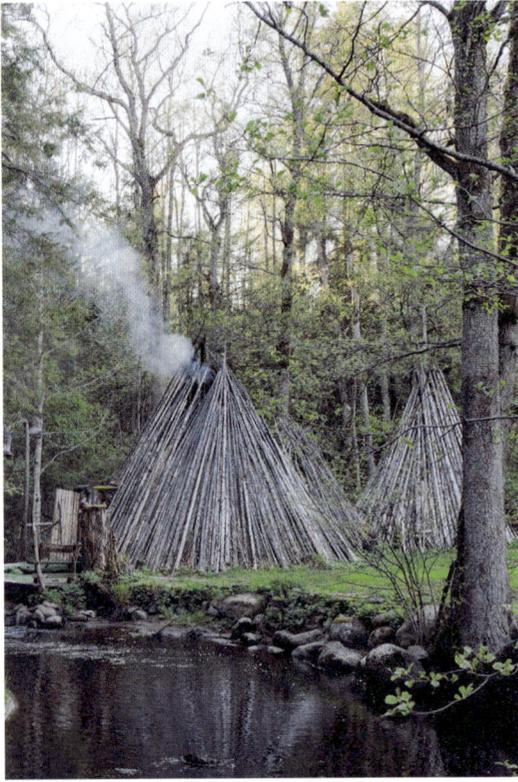

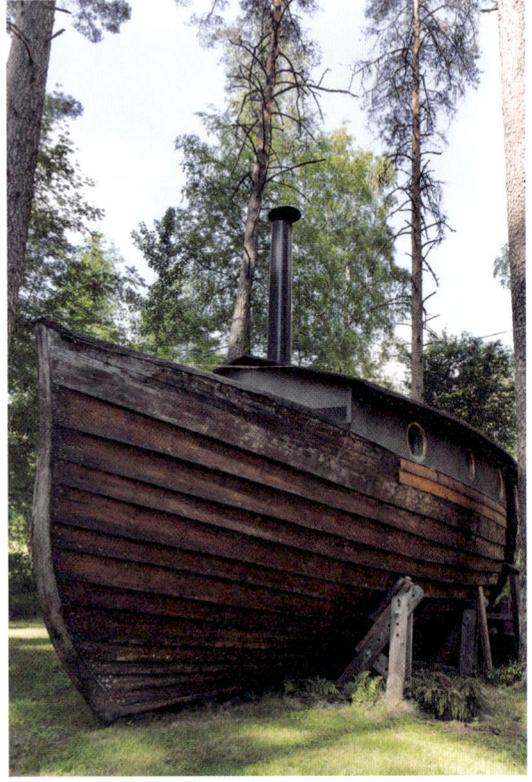

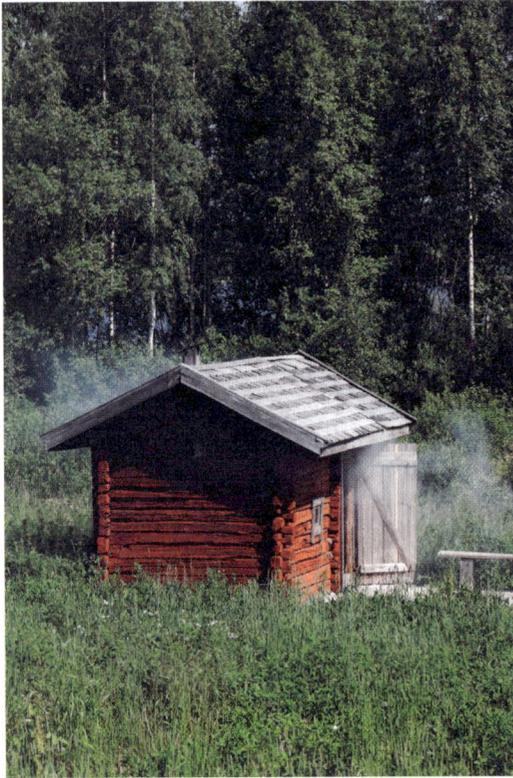

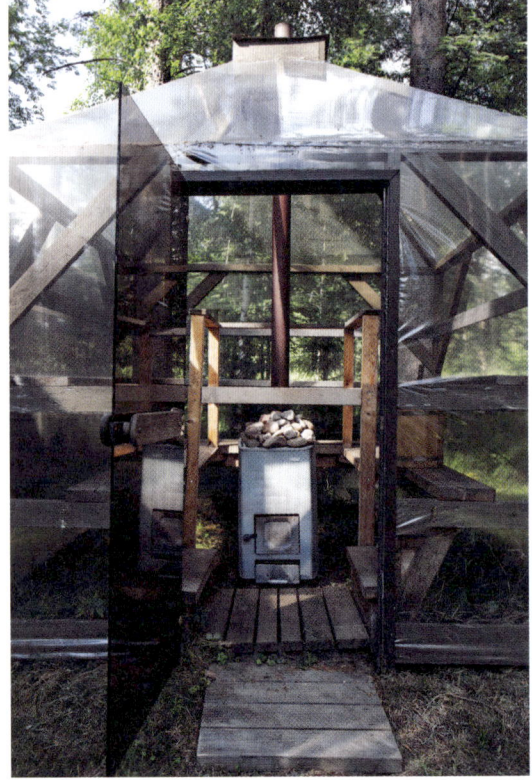

SAUNA VILLAGES

In 2020, Finnish sauna culture made it onto UNESCO's Representative List of the Intangible Cultural Heritage of Humanity. With it came renewed interest in sauna weekenders, sauna marathons and the "sauna village", a kind of sauna theme park found in Finland and Estonia. Some of these come with a whiff of historical re-enactment (Viking themes are popular), but the saunas themselves are usually the real deal.

Jämsä Sauna Village features 23 smoke saunas dating from the 1880s to the 1940s which have been salvaged from different parts of the country. Among them are war saunas rescued from Lapland, simple rural saunas, smoke saunas and pit saunas, all built with the finest woodworking skills. Saija Silen of Finnish Sauna Culture is working with a team of volunteers to restore them, and since the best way to preserve a sauna is to use it, every Saturday in summer Jämsä is open to visitors. "It's like it was in the old days," says Saija, "no electricity, no running water; the purest of sauna experiences."

In Estonia, set deep in the forest an hour from Tallinn, is Raudsilla – a village of tepee saunas, event saunas, and cold ponds ringed by a chocolate-brown river. Here, the absence of kitsch and the artful use of wood, moss and local stone make sweating in a tepee feel as authentic as it gets.

Further afield, Shingo Fujimori is a Japanese comedian and *saunner* who is planning to build a sauna village in Nagano Prefecture. It will not just be a place to take a sauna, but rather a new form of community, a *fourth* place that is neither family, friends nor work. Online, this growing community is devising the physical village, but Fujimori hopes it will be a place to "deepen friendships, find friends, cultivate a field, sing songs, be cool. And have a great sauna."

Opposite (clockwise from top left): Raudsilla sauna complex in Estonia; Viking boat sauna in Urpolan Kartano Manor, Finland; greenhouse sauna in Urpolan Kartano Manor, Finland; Jämsä sauna village traditional smoke sauna in Finland.

SAUNA THEATRICS

When Thermen Bussloo in the Netherlands opened its Theatre Sauna in 2022, 200 bathers came together in the steam to watch performances accompanied by lights, sound and live music. It was a much-anticipated blockbuster addition to the Bussloo Wellness Resort. Here, an hour from Amsterdam, guests enjoy a smorgasbord of bathing traditions from around the world; they can be whisked the Latvian way, sweat to an *aufguss* ritual, or float in the salty waters of the Mexican *cenote*. But most of all, they can have some fun.

Likewise, Grand Resort Bad Ragaz in Switzerland realizes that, in the spa world at least, the simple wooden sauna box is not enough. Getting healthy should be enjoyable, not a chore. At its Sauna World, guests can indulge in nine different sauna experiences from Latvian *pirts* rituals (a new popular addition) to the Kelo sauna (made from Scandinavian kelo wood) to infrared saunas. Bad Ragaz is also home to the largest event sauna in Switzerland, offering up to 120 bathers a full timetable of *aufguss* rituals that range from the meditative to the entertaining.

The first event sauna opened at Satama sauna park outside Berlin more than a decade ago. Since then, its founder Thorsten Planemann du Chesne has coined the term "Well-Tainment", and even if the word hasn't caught on, the concept has. When his event sauna in Berlin for 250 people opens, it will be the biggest one in the world.

In a forest outside Oslo, The Well is a spa complex with a similarly international feel. Norwegian billionaire Stein Erik Hagen has bought local Finnish, Japanese and Turkish traditions to bathers, and next up is an event sauna for 90 people. "This will enhance the social aspects of The Well," says Stein Erik. "It's important to allow large groups of people – friends, families, and companies – to have a collective experience."

Such a variety of saunas is now expected in high-end spas across Europe. High-octane guests with short attention spans and stressed-out CEOs need that X-Factor to get them to switch off. And what better way to be taken out of yourself than by watching a performance, a poetry reading or a DJ set in a large event sauna with a crowd? Bussloo's Fabien Dolman sums it up: "Sometimes, sitting in the sauna on your own can be a little bit boring."

Opposite: The stove "altar" at SALT in Oslo caters to up to 120 bathers.

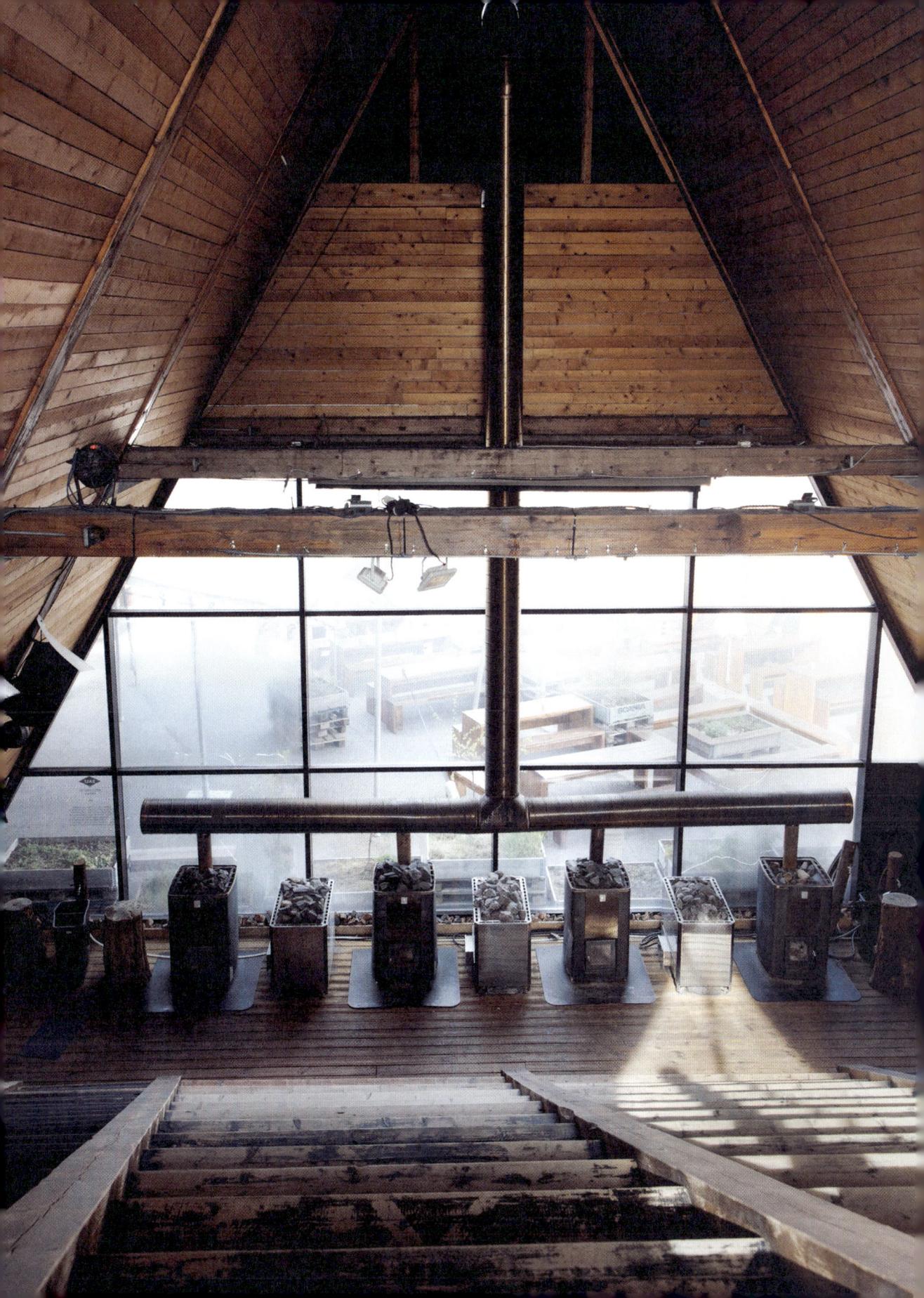

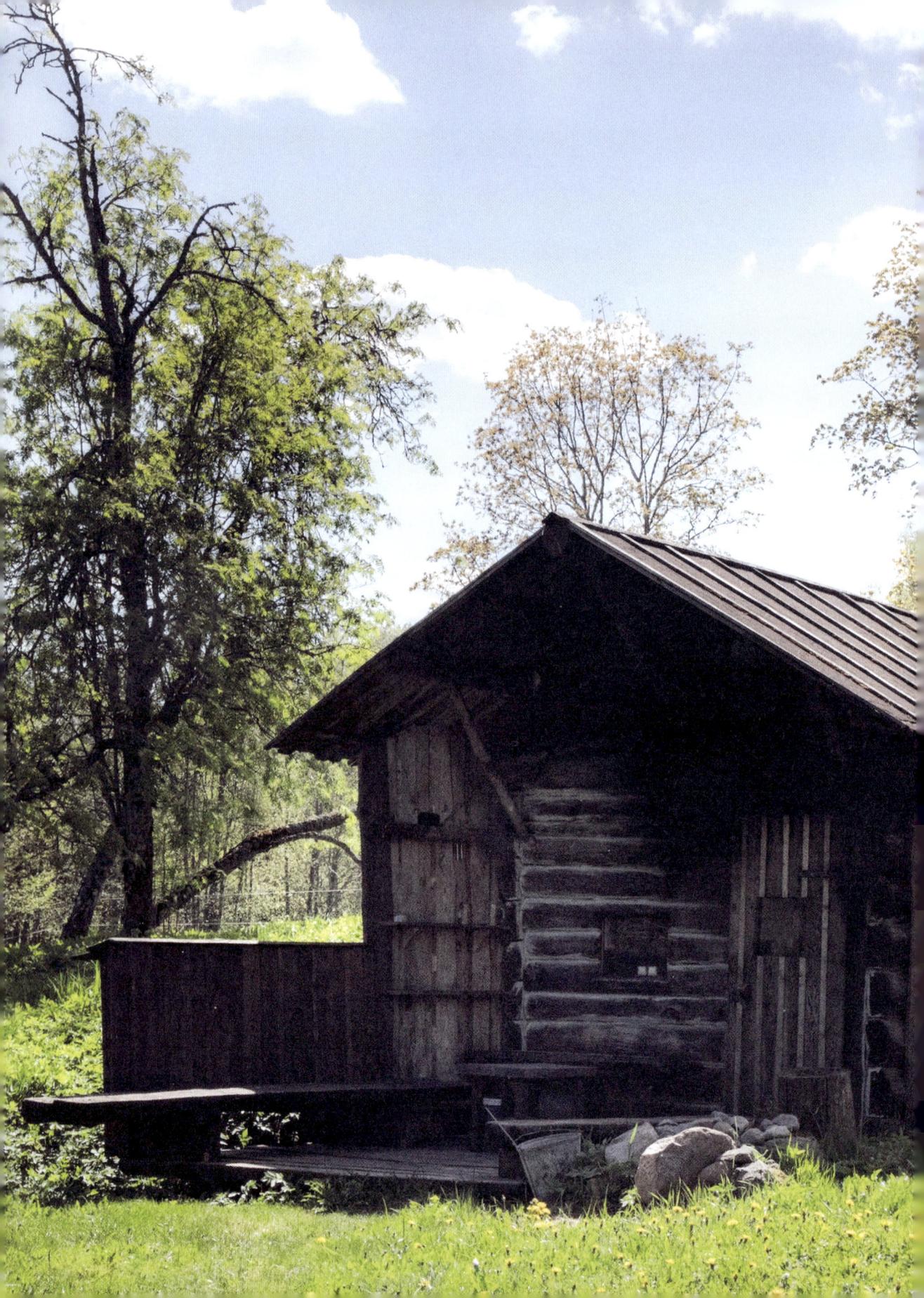

HISTORY
Humble beginnings

'Exploring the world around him, primitive man evidently tried all things and held fast to that which was good."

Aldous Huxley, *Moksha*

From the Islamic hammam, the Native American sweat lodge to the Russian *banya*, many cultures have their own sweat-bathing traditions. In colder climates, early "sweat houses" were dugouts covered in hides or furs, little more than a pile of hot stones heated by a fire (it's thought that the word *sauna* comes from the Sámi word *soudnje* which means "pit in the ground"). In Japan, natural caves were used as sweat baths, and these evolved into bathhouses at temples and next to monasteries. In Ireland and Scotland, stone huts with tiny entrances and no windows have been used, on and off, since the Bronze Age.

Previous: Toomas Kalve built his underground sauna on his farm in Estonia.
Opposite: Hevossilta underground smoke sauna in Forssa, Finland.

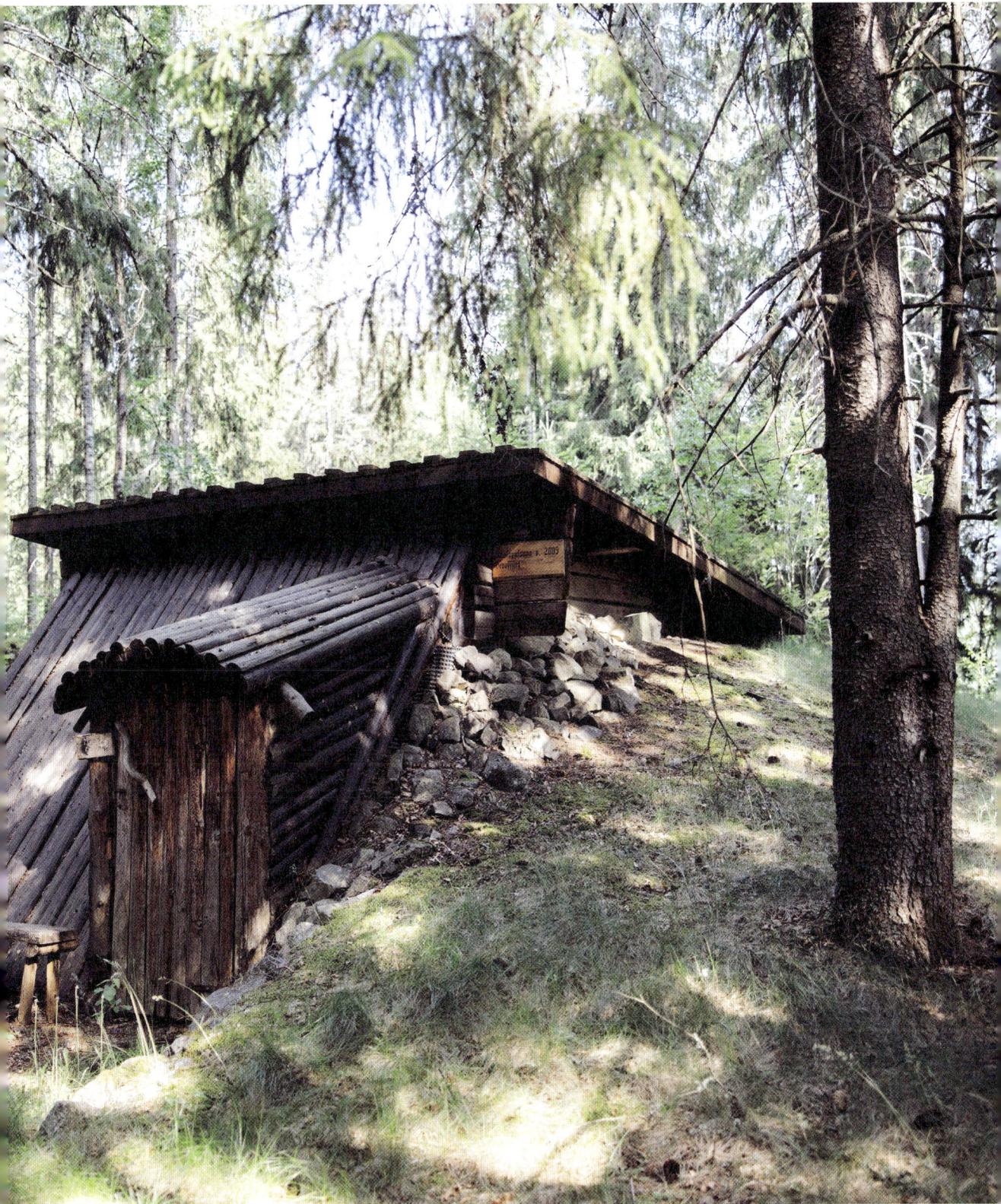

Northern Europe

In Northern Europe, sweat houses evolved from caves to pit saunas – one-third above ground and the rest below, supported with poles. They were multi-purpose spaces where whole families would sleep, eat, dry and ferment food and wash. Pit saunas had very good *löyly*, and are still enjoyed today by enthusiasts at historical "sauna villages" (see Chapter 4). Turf saunas, with their roofs made from old pastureland, also have a *löyly* that is soft, mellow and never aggressively hot. But such details are for the pros. To most, "old" saunas refer to simple wooden huts with or without chimneys dating back a hundred odd years or so.

Often, these wooden saunas were the first thing to be built on a smallholding. Grandparents, parents and up to 15 children would live in an 8-square-metre space until a separate dwelling had been built. Then the farm hands and serfs would move in. This clan of peripatetic labourers were referred to as "sauna people".

Life in villages revolved around the sauna. It was the pharmacy, the bathhouse, meeting room and hospital. Most were frequented by a folk healer who would travel from village to village performing "miracles" and healing the sick in the steam. Female elders took care of birth and death rituals and children would gather to learn. (The Finnish board of Education issued drawings from which school saunas were constructed.) The dead were laid out on "corpse boards" and prepared for the afterlife, and in rural areas, people were born in the sauna. German artist Alexander Lembke, founder of The Sauna Project, has photographed many Finns who were born in the steam. The most recent was in 2012.

In the steamy shadows, highs were celebrated, lows were soothed, problems were solved, forgotten or put into perspective and ideas were born; from seismic moments to petty minutiae, life in all in its variations was dissected, celebrated and lived to the full.

Opposite: A simple structure in the wilderness of Muotkatunturi in Finland allows anyone to sauna by simply throwing a tarpaulin, kindly left nearby, over it and lighting a fire in the central stone stove.

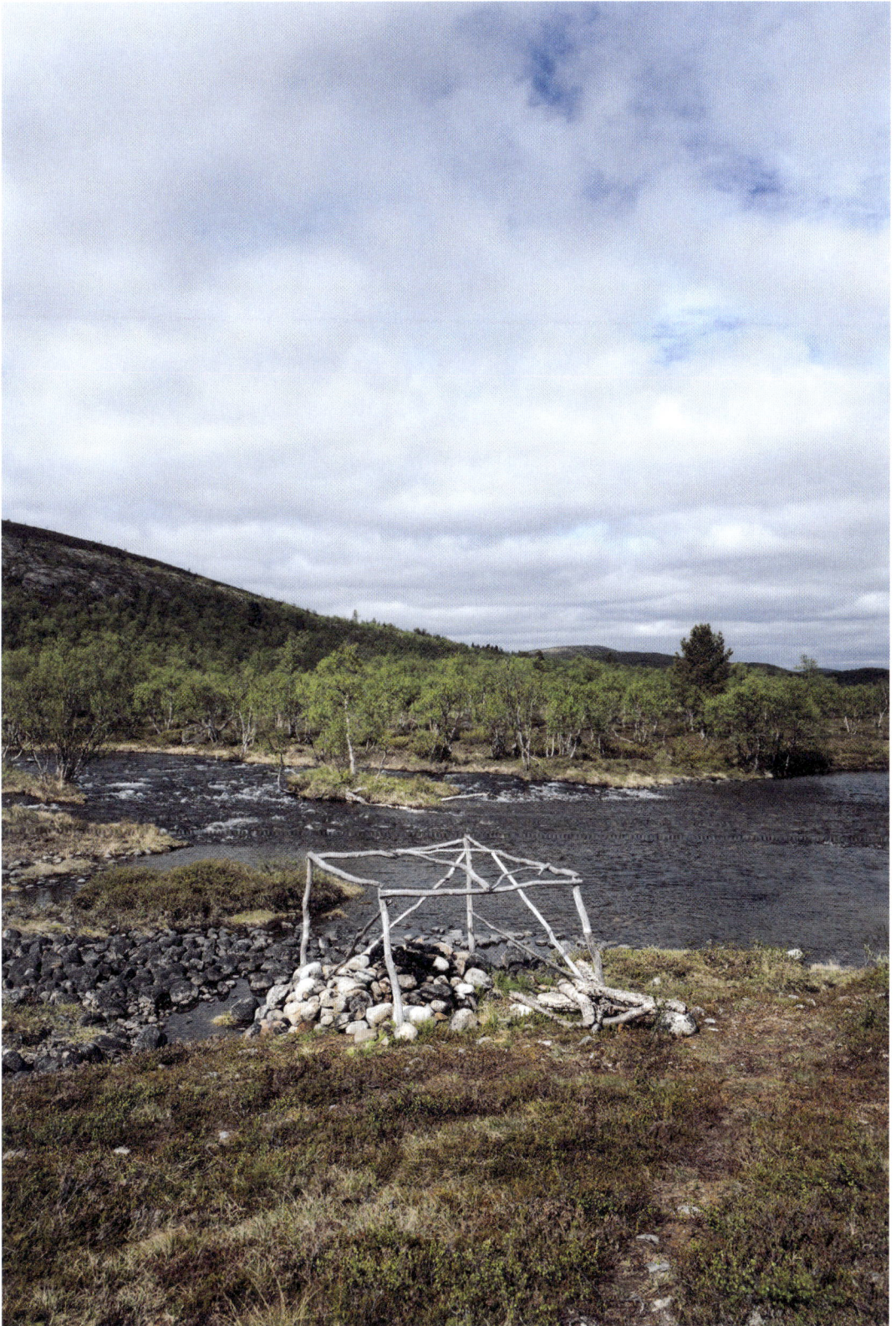

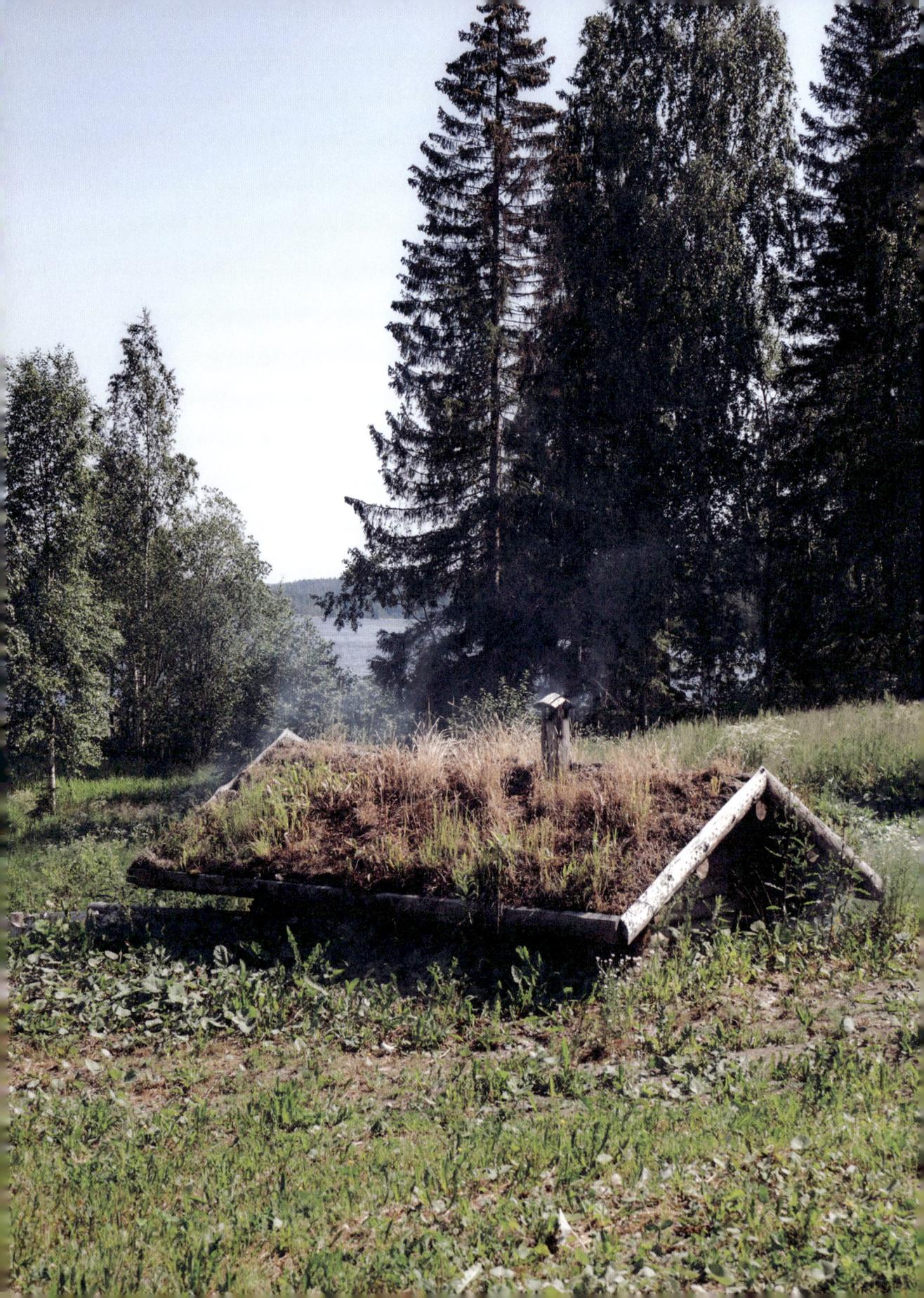

British architect Sarah Wigglesworth, whose eco straw-bale house in London has won several awards, recalls a visit to Seurasaari Open-Air Museum in Finland to look at medieval buildings: "The museum recreates village life in Finland from the Middle Ages. The prevalence of the sauna in every setting demonstrates how it was the communal pivot of social life."

"To talk about sauna is to tell the story of Estonia," says British-Estonian Adam Rang. "For generations, our culture has been under threat, but sauna has survived despite the odds," – and much to the fury of Christian crusaders and Soviet colonizers who did their best to stamp it out.

Saunas varied from village to village. Often, the community came together to donate time and materials to create it. They still do; Sompasauna in Helsinki and Vang in Norway are thriving, modern-day "sauna communities". Building a bathhouse from whatever is lying around, then sweating with friends and celebrating with beers is a national past time in the Nordics, and there are many DIY sauna books, conferences and online forums dedicated to the cause.
(See Chapter 4.)

Irish sweat houses

Early sweat houses dating back to the Bronze Age are being unearthed all over the UK and Ireland. Often built into hillsides and almost always located near open water or a well, these stone igloo-like constructions were covered in earth, had no windows and a tiny entrance, in order to retain the heat for longer. More than a hundred of these structures dating from the 1600s to the early 1900s have been found in County Leitrim. What exactly these beehive-shaped mounds of uncut rocks were used for is a mystery, but Irish archaeologist Aidan Harte, former co-ordinator of the Leitrim Sweathouse Project, is determined to find out.

"We can't be sure, but we think they were used for healing and cleansing," says Aidan. "They were a functional, private space, too small for communal, ritualistic activities," he says. They were still in use in the 1950s, but the oldest reference is from 1790s in Donegal. "The working poor were living in very damp conditions; pleurisy and arthritis were rife. Homes were small and smoky, fuelled by a peat fire. The smoke killed ticks and lice and protected the thatched roof from damage, but it wreaked havoc on the skin, leaving a waxy, unhealthy-looking complexion. And harvesting kelp for its iodine left farmers smelly and dirty. Sweating it out in a small hot cave meant a deep clean and relief from any pain.

Who introduced these sweat houses to Ireland? "Most are concentrated in the north-west of the country, Leitrim and Sligo, so common thinking is that they arrived with the Scandinavians; but this is unfounded, and there are very few around the Viking cities of Cork and Limerick, Wexford and Waterford," says Aidan. "They are different to Native American sweat lodges, which discounts seafarers from across the Atlantic. What's more, versions dating to the Bronze Age have also been found."

The Sweathouse Project is using radiocarbon dating to try and determine the age of his findings in Leitrim. "Perhaps they were indigenous," he says. "The Irish were very well travelled in the sixteenth and seventeenth centuries, fighting in wars in Europe and Scandinavia. It wouldn't have taken a eureka moment in the hills of Sligo to do something similar."

The project's findings have led him to conclude that the old stone huts were certainly used for some form of cleansing and healing. After heating up the walls and floor, a fire in the middle was extinguished and a "patient" would sit on a layer of rushes, a cabbage leaf on his head to keep it cool, and sweat himself back to health. A reference from the 1890s on Rathlin Island in Northern Ireland reveals that eligible young women went to the sweat house before the annual fair so they could be fresh-faced for any suitors.

So far, no evidence of ritualistic activity has been found, "but there was a fear of sweating alone in the dark, and someone would be on hand to supervise," – whether he or she played a shamanistic role, Aidan doesn't know, but they were on hand to manage anyone in need.

Opposite: Nineteenth-century sweat house in County Cavan, Ireland.

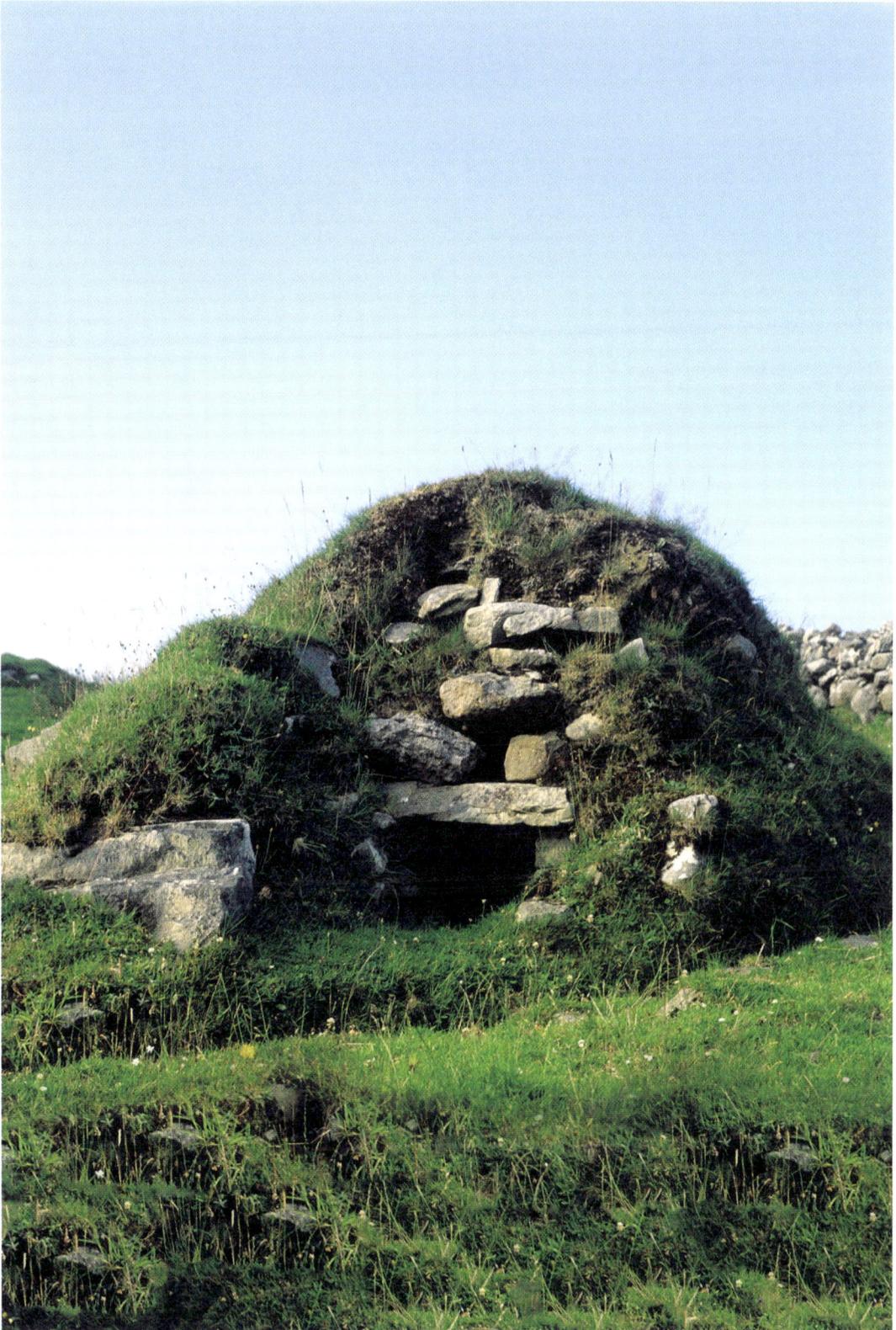

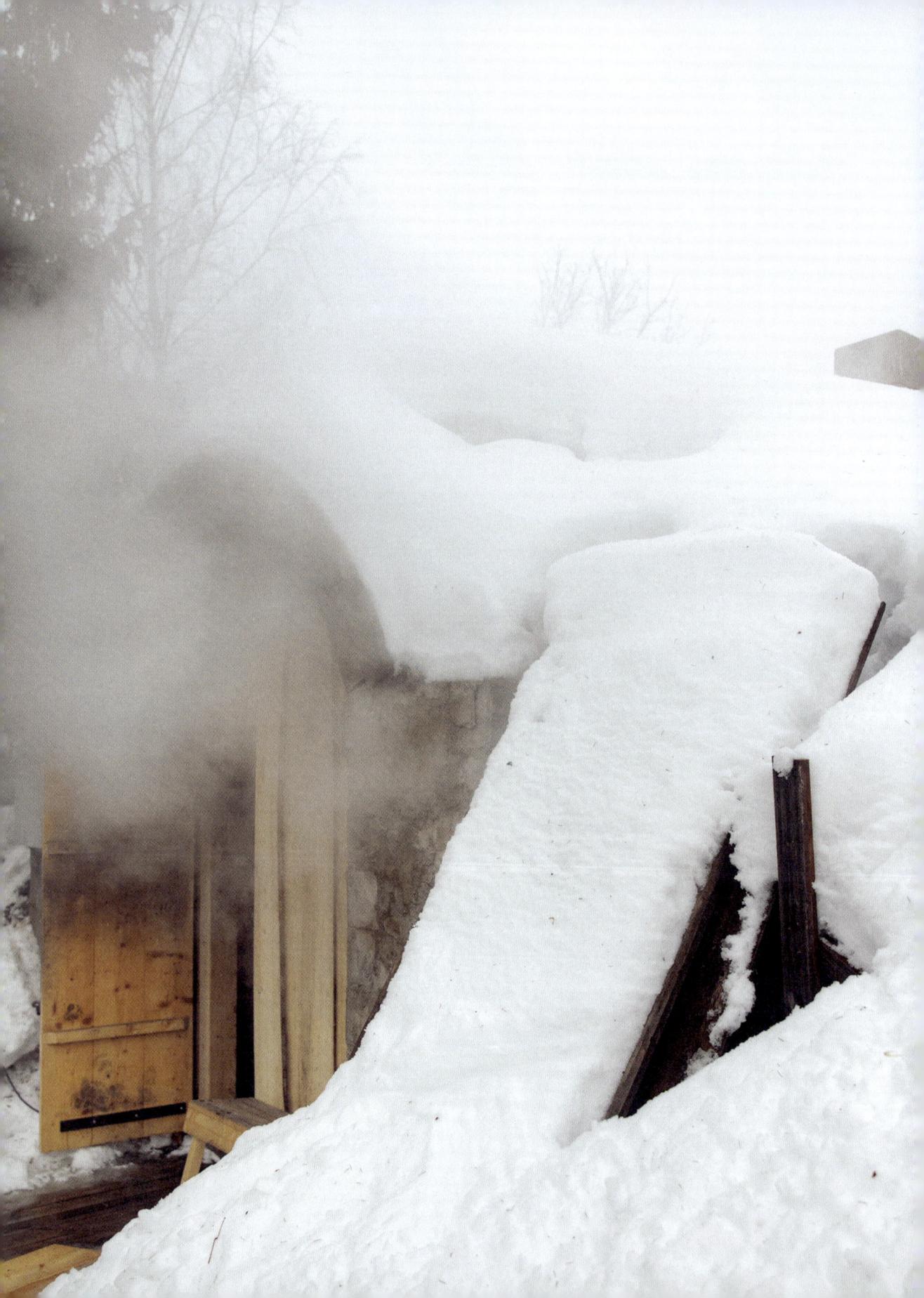

Smoke sauna

For many, the smoke sauna is the mother of all saunas. The bathhouse of our forefathers, it was often the first building erected on a homestead where a family would sleep, eat, cook and wash. A fire in the ground would heat large rocks for many hours, and it had no chimney, no windows and small vents to let the smoke out. The dark, womb-like space was essential to life in the cold, damp climates of northern Europe where the ancients believed fire was sacred. The sauna, as the keeper of the flame, also had magical, transformative powers.

By the 1900s, smoke saunas had largely died out in urban areas, replaced by more practical wood-fired and, later, electric saunas. Where the smoke sauna did still exist, on smallholdings and at summer cottages, it was the preserve of private owners who fired it up for special occasions. It takes around five hours to warm up, and requires skilful handling so that it doesn't go up in flames; in the hands of the inexperienced, many do. There are only a few sauna masters up to the task.

To the sauna novice, having a smoke sauna is like diving off the deep end before you've learned to swim (See pages 151–56). You sweat immediately; your skin feels different, so does your hair. Sometimes you have the taste of smoke in the back of your throat and your eyes can be bloodshot afterwards. So, is it worth it? YES! By the time you enter, the fire has died out, the smoke has been let out, the benches are perfectly blackened and the whole space is infused with a deliciously sooty aroma. There's no metal in the sauna, just fire, earth, water and air – so many believe it's full of negative ions that create a healthy electromagnetic field and give off better energy than positive ions. The rocks radiate a gentle heat of around 60 degrees and glow well into the night. And the *löyly*? It's like comparing fast food with fine dining; the heat of the rocks produces a steam that wraps its arms round you like a lover and it's hard to tear yourself away.

Opposite: Sipoonjoen perinnesauna smoke sauna near Helsinki, Finland.

As mentioned in Chapter 4, in 2014, UNESCO added the smoke sauna tradition of the Võru community of Estonia to its Representative List of the Intangible Cultural Heritage of Humanity, declaring that it "comprises a rich set of traditions including the actual bathing customs, the skills of making bath whisks, building and repairing saunas, and smoking meat in the sauna." It was a timely intervention given that in Tallinn there's only one public smoke sauna, and that's in a museum.

Since then, city spots from Löyly, Sipoonjoen and Kuusijärvi in the Helsinki region, to Kuuma in Tampere have built their own smoke saunas. They're not as authentic as a 200-year-old smoke sauna in the depths of the forest, but how could they be? For the best smoke sauna, you need to head out to the wilds to Lapland, say, where fire and ice form seemingly impossible combinations.

The challenge of lighting a smoke sauna and keeping it lit through changing winds and air pressures is a ritual in itself. It's a therapeutic step away from modern life, a break from a screen. And there's no app (yet) to tell you how to do it.

Opposite: Inside a smoke sauna in Jämsä Sauna Village, Finland. *Next*: Doodlings on the windows of Mark Zirk's smoke sauna, Estonia.

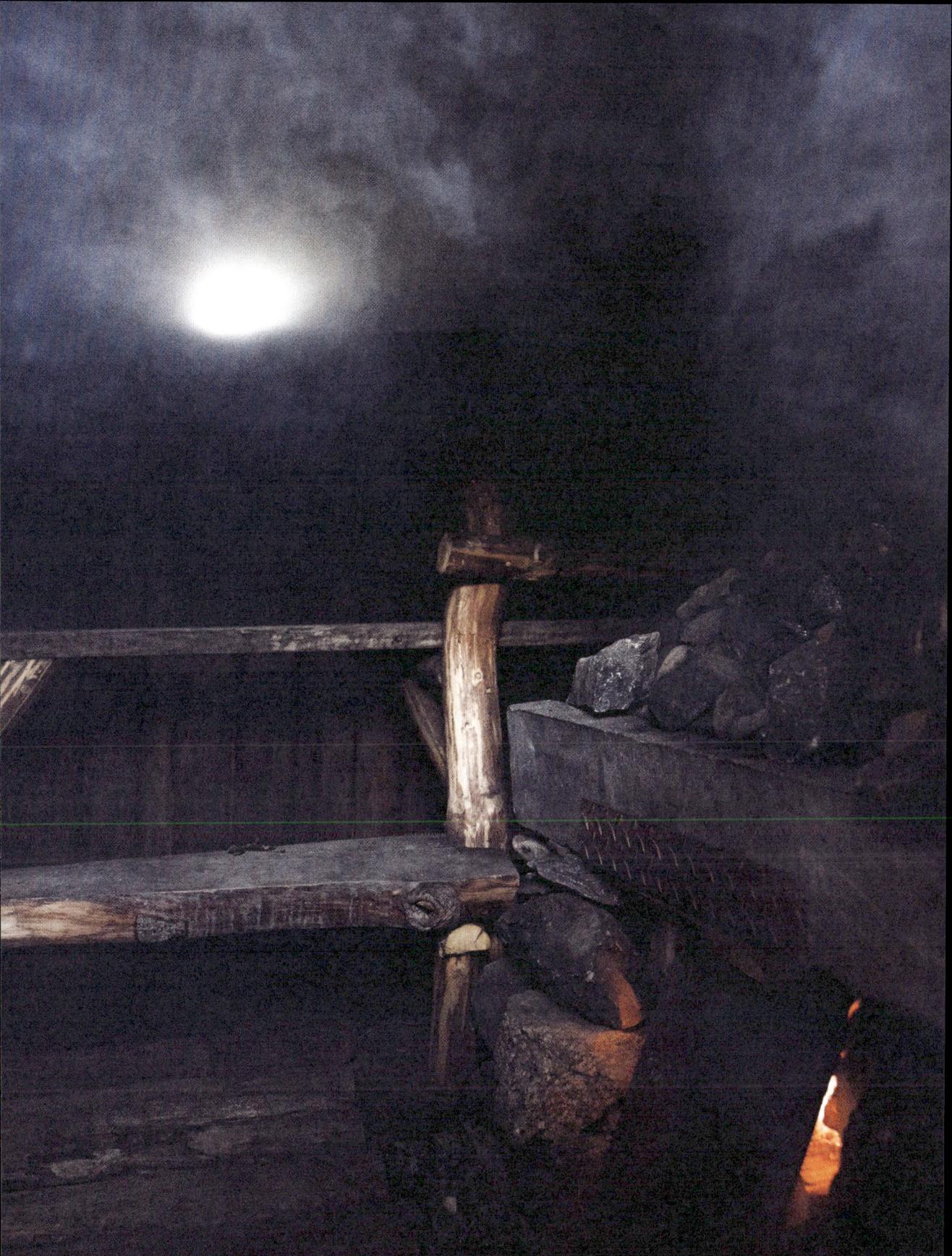

OUR SMOKE SAUNA EXPERIENCE

As we stepped into the unknown, Maija had a few words of solidarity. "No vipers, no nudity and no hallucinogenics," she said firmly, as we turned off the main road. "These are my boundaries." "OK!" I nodded, unloading the stash of beers into the fridge in the back of the van. Fast-forward 12 hours, and we were both naked, swimming in a moonlit pond and feeling an incredible (natural) high like no other.

We'd come to visit a traditional smoke sauna in Võru County in south-eastern Estonia, on the invitation of the artist Peeter Laurits. When he had suggested it, at his private view in Tallinn, we had jumped at the chance. We knew it was a great honour, and that the smoke sauna is sacrosanct, especially in Võru. Families and friends will travel miles for the experience. Many compare it to the Native American sweat lodge, in that it's dark, hot and transformative, a place where the ancients would perform rituals honouring birth and death, ecstasy and pain.

Our journey from Tallinn to Võru had taken four hours along the Soviet road that connects Estonia from north to south. The neon green of spring had delivered carpet upon carpet of yellow dandelions interrupted only by telegraph poles, where the resident cranes had crafted their huge nests. There are very few hills in Estonia, but the flat landscape hides its secrets well. Throughout history, the people of Võru have been masters of deception, hiding their traditions and beliefs from the Soviets and all the colonizers who came before them. And many of these ancient traditions, such as using *löyly* and fire to connect with their ancestors, are still practised in the smoke sauna. We had heard that bathers drank viper's poison as a cure for inflammation, and glugged down ether – not so much for its long associations as an anaesthetic, but to induce hallucinations and euphoria. Bathing for relaxation was just one part of the story.

Peeter was waiting for us in the Kütiorg valley, Estonia's most hilly region and, in the spirit of subterfuge, one of its most treasured. Peeter moved to Võru a decade ago, and now creates hyper-real images of forests, marshes, fungi and flowers inspired by the region's mythological relationship with nature. He is a convert to its many pagan traditions, and had told us we would meet poets, artists and shamans. Maija had picked up a crate of Finland's finest beer on the ferry from Helsinki to Tallinn and we were both excited. It sounded like a kind of Baltic Burning Man without the sand and the LA hipsters. But we were also apprehensive; would this be like Midsommar, the movie in which naïve foreigners get drawn into a pagan-like cult with disastrous consequences? The words of American writer Hunter S. Thompson came to mind: "There is nothing in the world more helpless and irresponsible and depraved than a man in the depths of an ether binge." And what about those psychological territories – repression, neglect, denial – that would be difficult to face? What exactly did our host have in mind?

In an attempt to lighten the mood, I read out an email that a fellow British journalist had sent me about his experience of a smoke sauna in rural Finland.

I guess my story illustrates a cultural difference between the English and the Finns. A few years ago, I went to northern Finland to interview a printmaker. Before my trip she told me of her fin-de-siècle wood sauna. I must join her and her brother for a sauna. Now I am not comfortable with public nudity – barely even nudity in private – so I replied that I'd love to, it would be an honour, and, crucially, that I had already packed my bathing shorts. Mention of my trunks became a leitmotif to our emails. Anyway, in the event, I managed to retain my decency, and lasted fifteen minutes in a blackened-by-soot Victorian cubicle the size of a magician's box, sprayed by the sweat of the

*artist's brother, before I exclaimed how
I must take a dip into the lake. I've never felt so
happy to be in freezing water surrounded by
suspicious-looking pond scum. On the drive
back to Helsinki, I felt like a smoked kipper, and
felt nauseous from the combination of pent-
up anxiety and the hot-cold equation.*

Maija didn't laugh at this particular strain of
British humour. But to me, it struck all the
right chords, especially the bit about "pent-up
anxiety".

We met Peeter, an exuberant character in his
60s, and drove together to a small farm where
Mark, a tech entrepreneur from Tallinn, had a
smoke sauna. A gentle curl of smoke was the
only speck of darkness on a crystal-blue sky.
We said hi, handed over the beers and we all
cracked one open. What was the plan?

"In Võru, preparing for the sauna requires
communication with nature and the cosmos
around us," explained Peeter, with a straight
face. We would go to the sacred grove of
Tammetsõõr, a thousand-year-old ring of
ancient oaks and pay respect.

On the way, we met neighbours and dogs
and stopped at an old smoke sauna next to a
pond. It belonged to a biologist friend of the
group who was at a conference. "This sauna
gives you blessing to enter the oak circle,"
said Peeter. We duly went in and got blessed.
Tammetsõõr is a protected site, and ribbons
and trinkets were wrapped round gnarly tree
trunks, coins had been left on woody stumps –
offerings from the many visitors. As we sat and
imagined the power theses mighty oaks had
held for centuries, Peeter picked a stem of Lily
of the Valley, considered in Pagan folklore to
be full of magic, and placed it in the middle
of the trees. An offering from us all. And a lot
easier to pull off than a human sacrifice.

Back at Mark's place, it was time to sweat.
The men stripped off and cracked open
more beers while Maija peeked inside.
She came out exuberant. "The smoke is soooo

good. I can't wear a swimming costume in
there." "Really?" I cried, my heart sinking.
So, it had to be ACTUAL NUDITY for me too?
This was overwhelming. No man apart from
my husband has seen me naked for 20 years.
I grew up with brothers, a household full of
men, and went to a single-sex Catholic school;
awkwardness and embarrassment were
etched into my every limb. Until then, the gulf
between my Nordic friends and I had been a
series of small, charming dividing lines. Now, it
was a vast, gaping chasm. What to do?

I didn't want to be the prudish outlier, and not
being naked would be more uncomfortable
still. There was nothing for it. I stripped off
behind the van and grabbed my sarong,
vowing it would never leave my side. I entered
the dark hot space clutching it like a toddler
with a security blanket and sat in what I
thenceforth referred to as the "Self-Conscious
Sauna Pose" – knees up and together, covering
my breasts.

The others were quiet, already waging their
own private battle with the heat; conversation
required too much effort; instead, we stared
at the chink of light through the window and
watched it work its way through a smoky mist
and land on the earthen floor. Breathing was
easy, the benches were below the smoke-line
near the ceiling and Mark had removed the
smoke and ash before we had entered, This
act, called *karmulõuna* in Estonian, is part of
the ceremony. It was late and still light. I was
exhausted, but not tired – the disorienting
Scandinavian summer hours playing havoc
with my circadian rhythms. But who cared
about time? Hours, eras even, slip away when
you're naked and sweating in the dark with
strangers. We could almost be speaking in
tongues – if we were speaking at all.

The sweat came straight away and the soot
was soothing. I automatically massaged it into
my skin, and later learned that soot is alkaline
and is often used as a "first wash" to get rid
of toxins. Mark stood up and poured some

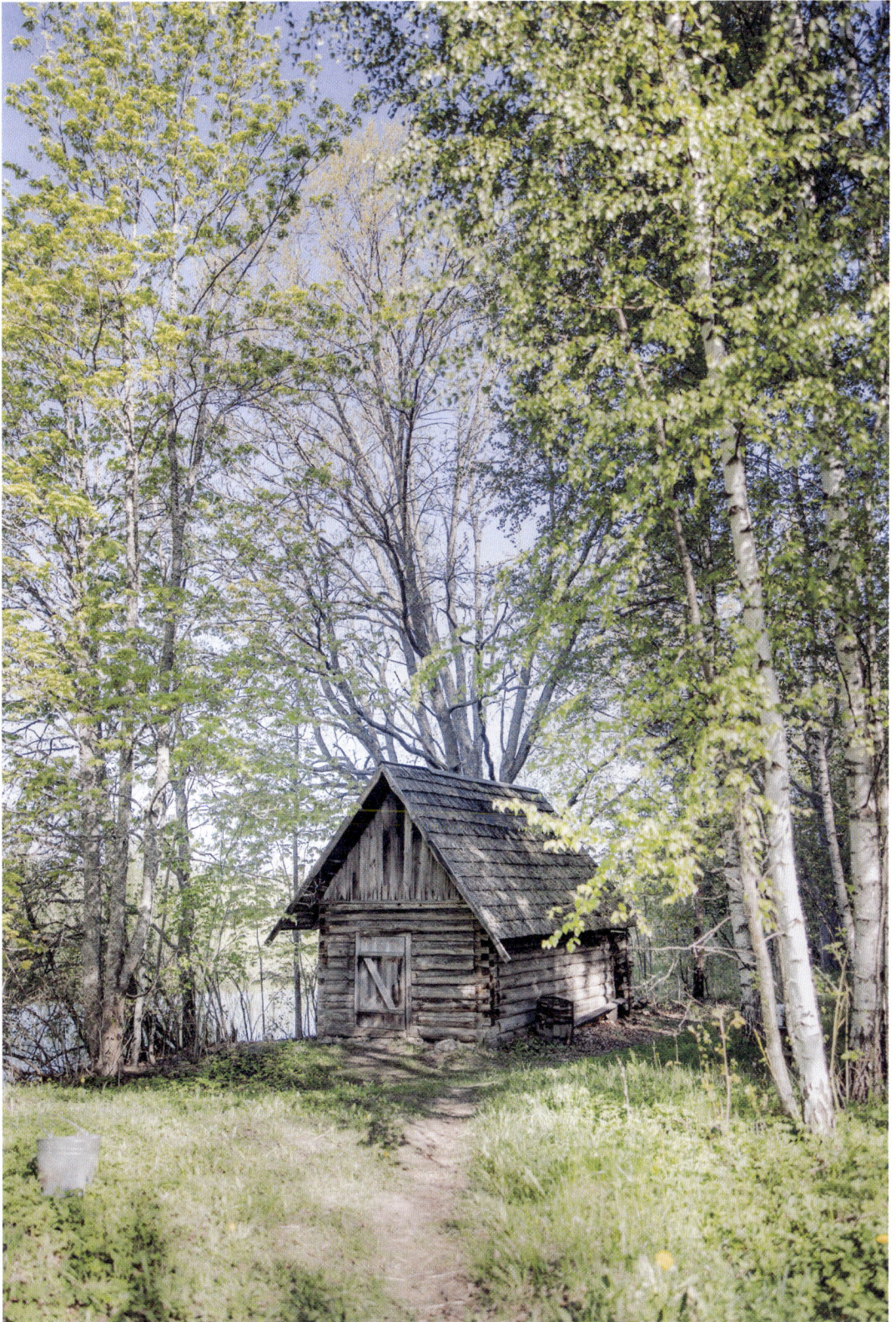

water on the rocks. It was scalding – eyeball-fogging, nostril-burning heat. The words of Miska Käppi, a young sauna master in Helsinki, came to mind: "In old Finno-Ugric spells, the smoke sauna is where we lose our finite form and connect with our transcendental self. The process is called 'falling into a crack in the earth'." I started feeling dizzy, so went outside, steam rising off me like a newborn calf, and took a dip in the pond. When I returned, a neighbour who Peeter had invited to join us while we were at Tammetsõõr was lying outside on the floor, her feet in the air, as she struggled with a drop in blood pressure. Minutes later, I was next to her, in the same pose. "It can be intense, so just say if you're not feeling good," she said, wiping sweat out of her eyes.

The men had crossed the pond to Mark's second, wood-fired sauna. Maija, the neighbour and I decided to join them and we punted over, naked, on Mark's homemade wooden raft. The water was warm and had a soft, brown peaty texture. The wet-brake squeal of cranes filled the air. The sauna was a mish-mash of mosaic floor, and wattle and daub walls decorated with old bottles and pink elephants. Mark poured some beer on the stove and the earthy smell of hops sizzled into my nostrils.

"You may have bloodshot eyes for a day or two," said the female neighbour (whose health and safety tips I was largely grateful for). "It often happens in the smoke sauna." I wailed inwardly and closed my eyes. I didn't much want to look like a lab rabbit for the rest of the trip. Already I felt like the troll in the woods, with witchy, smoke-infused hair. But why did I care so much? Wasn't that the point? To be naked, vulnerable and let go of such vanities? I wondered if I had packed my anti-frizz serum and cringed when I noticed my sarong had slipped off. If I hadn't been so red in the face already, I would have blushed. But no-one noticed. Or cared. I guess my ego and I had some way to go before we parted ways.

Darkness was finally falling and our cosmic drama was heading to a crescendo – now back in the smoke sauna, someone was playing a didgeridoo. Its rhythmic pulsing fused completely with the tantric mood. That anyone could muster the circular breathing needed to play so well was impressive in the extreme heat.

Mark was preparing the whisks. Whisking is an art. Getting the heat to spiral in the right way takes years of practice. My turn first. Lying face down on the top bench, Mark gently whipped the soles of my feet, my arms and my head, building up the steam. In the past, whisking was believed to penetrate body and mind and provide answers, often when people needed them most – before a wedding, or a work deal, or at the loss of a loved one.

The smell of the birch and the smoke was swirling around my brain, and Mark's whisking grew more and more frenzied. He suggested I turn over. It was a step too far. I was not ready for a full-frontal whisking by a man I had barely met. Instead, I hopped up, grabbed my sarong and headed out for a final dip in the moonlight. Maija followed, having also declined the frontal offer. Hurrah! A shred of boundary remained! Was this some kind of fiery foreplay, my British (almost) Catholic mind enquired. Everyone was always saying that sex and food both taste better after a sauna. But Maija gave an adamant no; Estonians whisk each other naked all the time.

Back in the house, we gathered, fully clothed, round the kitchen table and ate soup and bread. "So, how did you find your first smoke sauna?" Peeter asked. "Incredible," I answered (gosh, the food really was delicious!). It was a paltry response for such a huge experience, I knew, but my thoughts were scrambled and I was exhausted. And I was very proud of myself for having stripped off in front of strangers and for holding my own in the heat. When, a few weeks later, I fully processed that evening, I filed it into my Top Ten Life Experiences So Far.

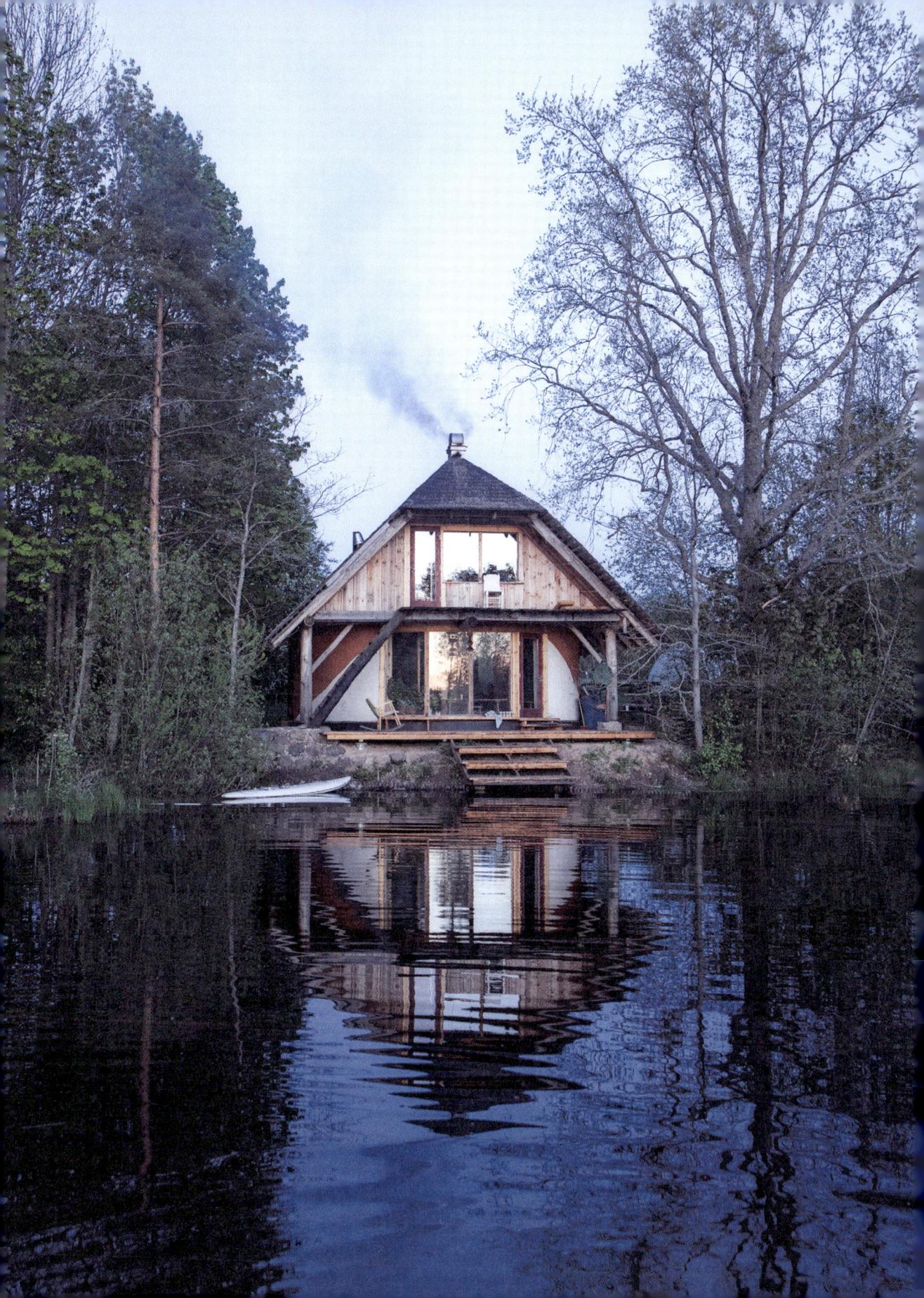

I had been initiated into a sacred Nordic ceremony, and I felt privileged.

The next morning, after a fitful night of vivid dreams, I rose before anyone else. As I took my hormone meds, my anti-anxiety meds, my god-knows-what-else meds, I thought: "Am I'm the classic middle-aged product of a sauna-less society?" I looked in the mirror. Thankfully, no lab rabbit eyes.

I wandered across the garden in my sarong and plunged naked into the pond. I went back into the sauna. It was still warm, leaves from the whisking were scattered all over the floor, and a metal pail of water was sitting was on the stove. It had an ethereal silence punctured only by the persistent cockerel crowing in Mark's barn. I poured a few ladles of warm water over me, scrubbed myself down and stepped out into the spring-saturated sunshine.

How lucky was I? The sauna had unleashed dormant stores of vitality. I felt exhilarated. I wanted to hug the trees, sing songs and run around barefoot forever. And I couldn't wait to recount our adventures, and show off about my going naked, when I got back to London. The ancients always said you must only leave the smoke sauna when your heart is filled with gratitude. And mine was. I knew I would want to be back for more.

Page 153: Mark Zirk's smoke sauna, Estonia. *Previous*: Mark Zirk built a wooden and clay sauna near his smoke sauna. *Opposite*: The moment when the steam hits you in Mark's smoke sauna. *Next*: One of Mark's neighbours joins the smoke sauna and cools off in his lake.

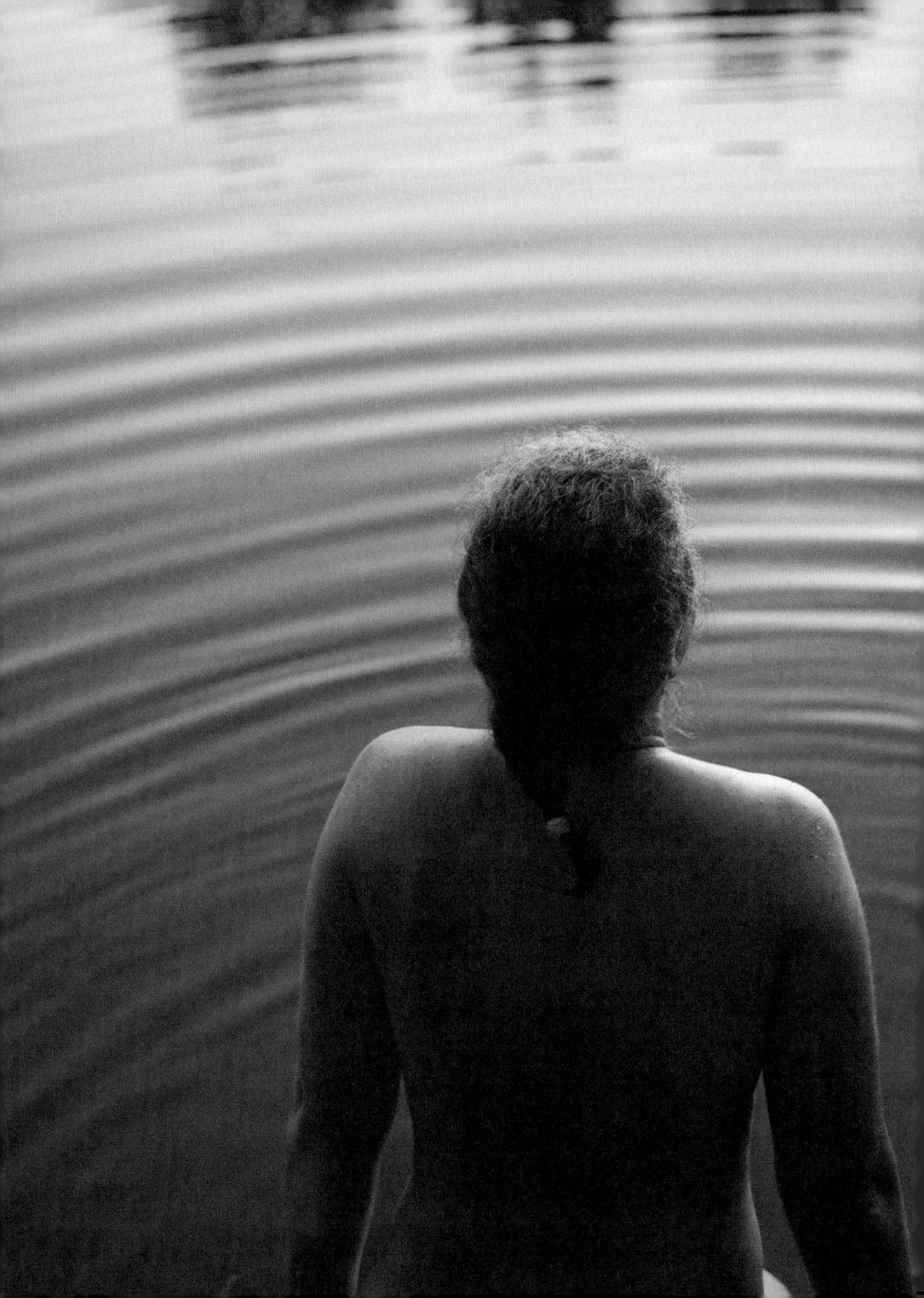

Nudity

As society evolved, sauna fell in and out of fashion. People would bathe naked, and they still do, though most community saunas offer separate sessions for men and women. In the past, female bath masters would wear linen garments, and they still do, but they encourage "patients" to be naked. For most, the sauna is synonymous with getting clean, and sweating in swimwear defeats the point. This is a challenge for those cultures not used to public nudity – like the Brits. But the more you do it, the easier it gets. What starts out as an excruciating exercise in trying *not* to appear naked while being naked, turns, over time, into something freeing and non-judgemental. Seeing naked bodies of all shapes and sizes sharing the bench becomes normal. Not a big deal. No-one cares and no-one is looking. And the perfect body? Well, there's no such thing, despite what social media tries to tell us.

Max and Jake Newport own Finnmark Sauna and supply authentic Finnish saunas and know-how to private clients in the UK. The brothers developed a love of sauna after visiting Finland in 2015, and return regularly to see their suppliers. Max explains: "I often had to be naked in meetings in the sauna. I was so shy about stripping off at first, even in all-male saunas, but after a while I dropped the averted glances and hurried awkward movements. There are no seedy, sordid undertones and it has been really healthy for me to see that we come in all shapes and sizes. It helps us get over body issues." Nudity is not a topic he ever raises with his clients, or ever will. "No way. It would take something monumental and an awful a lot of time for Brits to be comfortable being naked together in the sauna."

Christian crackdown

The Christians held the view that the sauna was a suspect place, a den of iniquity and vice (but titillating nonetheless, as early illustrations of naked bathers by European travellers to Scandinavia often show). Swedish academic Charlotta Forss has researched the morality of Swedish sauna from 1600 to 1800 and explains: "Community saunas were bawdy, raucous places and sexual assault and prostitution were commonplace. They had no changing areas, were often not very clean, and it was easy to steal purses and jackets." It led to a crackdown. Plague epidemics reinforced preachers in their sermons against such establishments of "debauchery".

In Lithuania, fire departments forbade smoke saunas, and doctors everywhere railed against them – the body could not support such an immersion without feeling discomfort, or even death, they decreed, and water entering through the pores brought with it "bad air". In 1765, Swedish physician Anton R. Martin visited the poor border areas of Vyborg (now Russia) and concluded that the sauna smoke caused in-grown hairs round the eyes and made people look older and fatter than their years. And, he declared, excessive sauna bathing was the reason why children in Finland were regularly constipated. Church and State had exerted their will, and by the end of the Middle Ages, few saunas existed in central European cities. Stockholm's last public sauna closed in 1725.

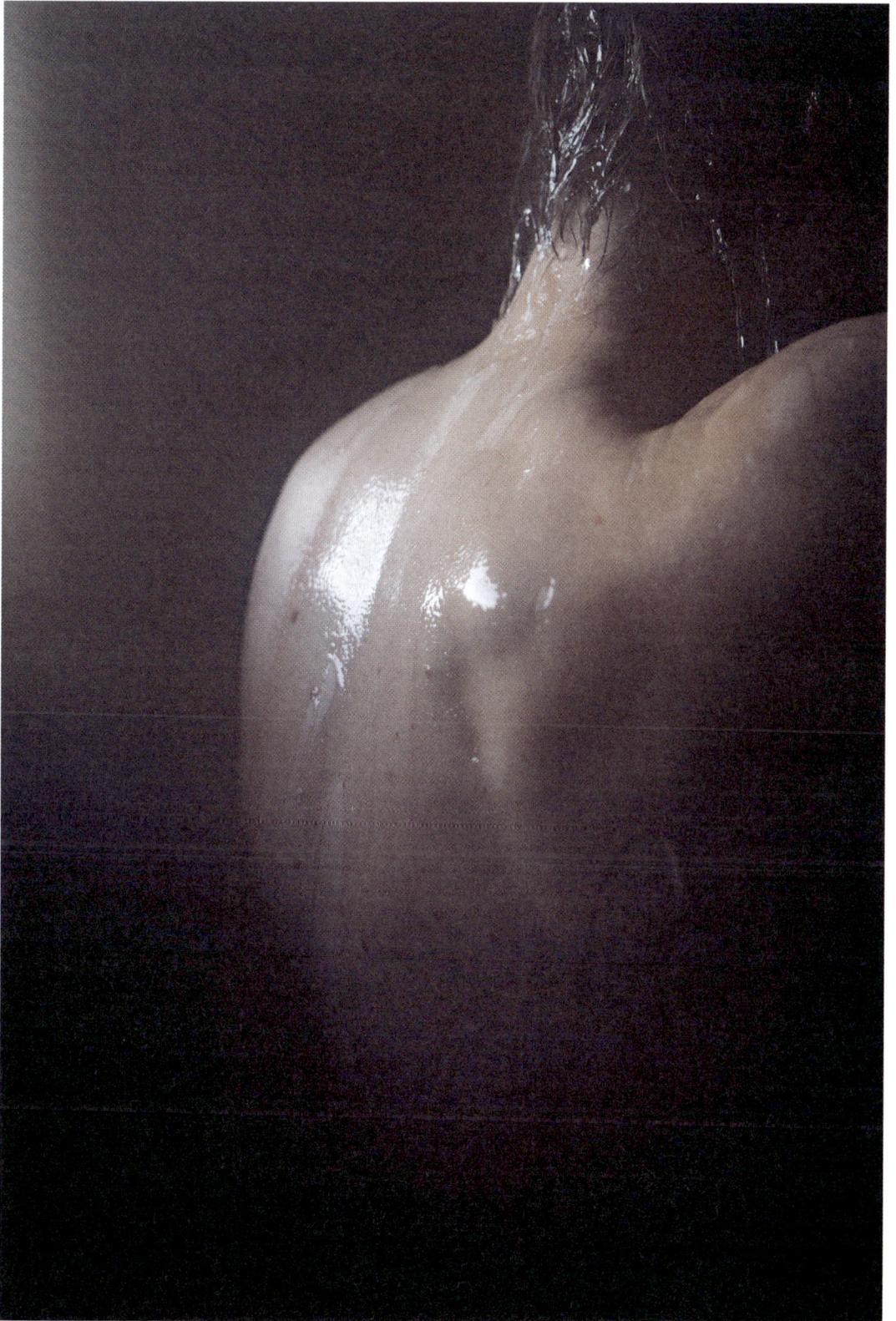

Cleanliness before godliness

When bacteria were discovered 100 years later, disinfection became the route to stopping the spread of disease and public saunas were once again seen as a route to good health. They were easy to build, could hold a crowd and required only small amounts of water, heated in modest-sized tubs. This led to a building boom and governmental campaigns to promote personal cleanliness.

"Hygiene was used as a way to arrange, regulate and rule society, to avoid class conflicts and improve the wealth and health of everyone," says Karolina Wiell, Doctor of Economic History at Sweden's Karlstad University. "Until this point, the theory as to how to make people healthier, live longer and be more productive had not been invented." Wiell has documented the last of the saunas in rural Sweden from this period and says: "It's speculation, but in communities where the social side of the sauna was always more important, it survived. Purely functional saunas where washing was the main role have disappeared."

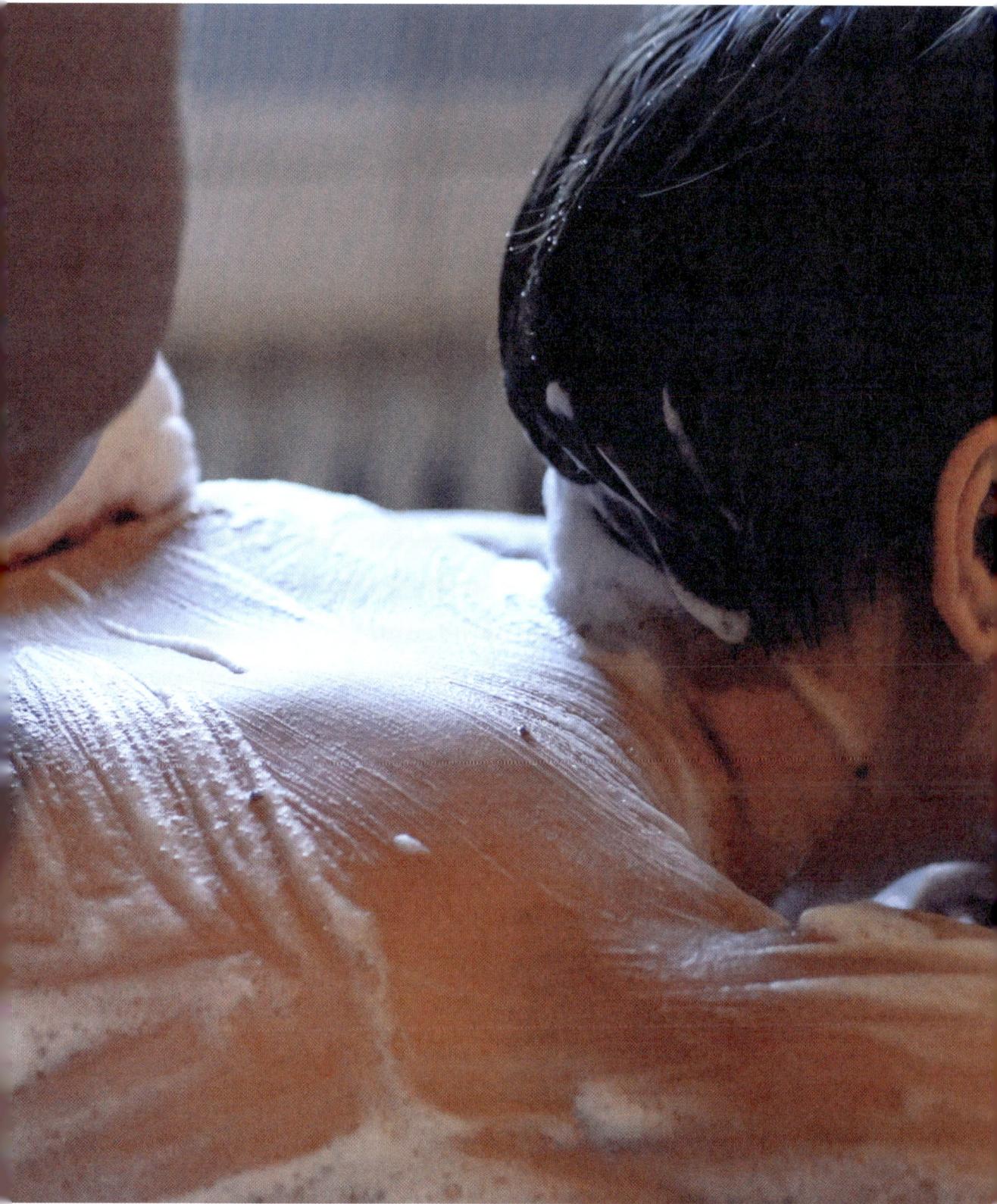

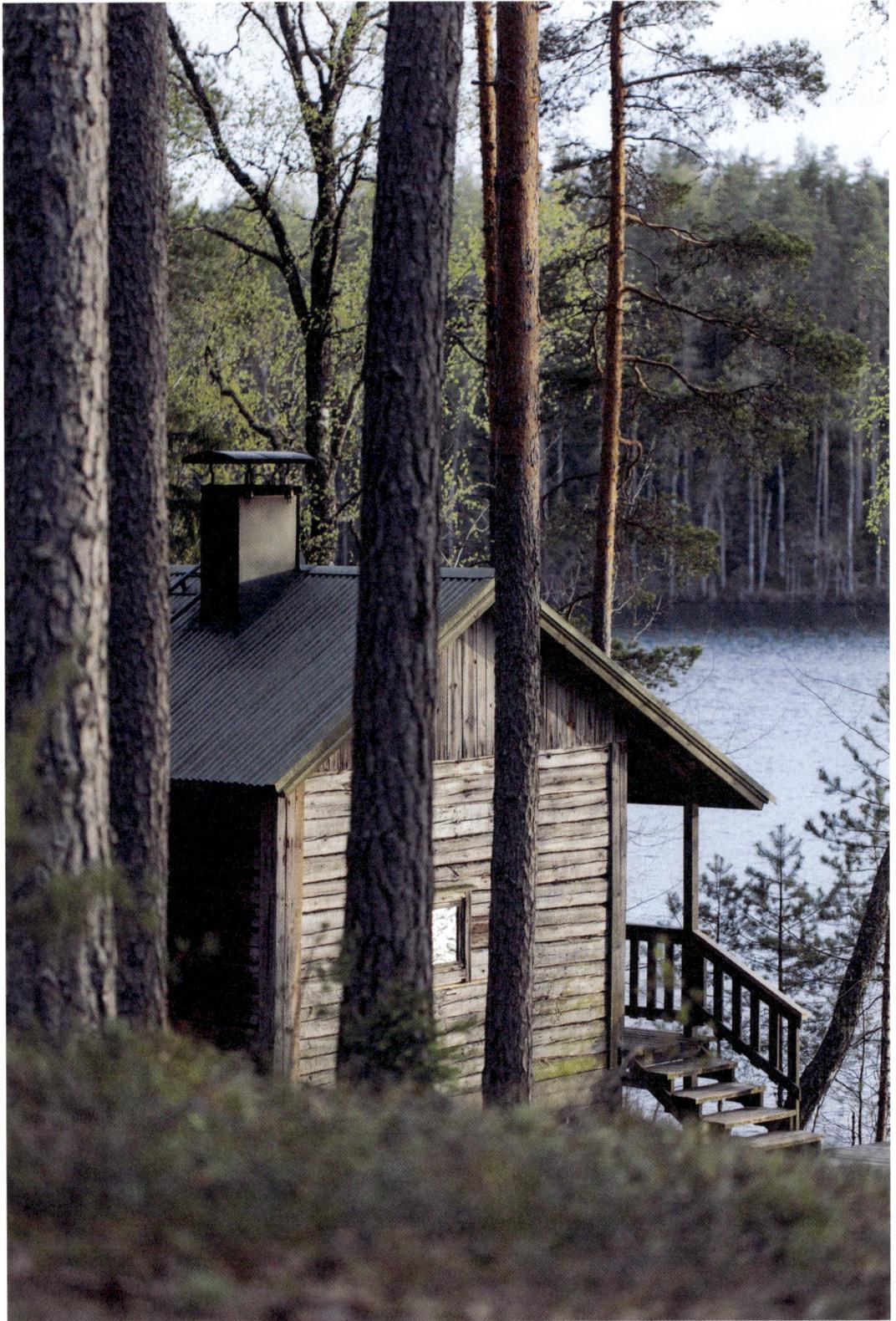

Decline and rise

From the 1930s onwards, "bathroom-ization" was a feature of the cities. Those who had the means were installing bathtubs in their homes and no longer needed to wash in communal baths. Meanwhile, in less-developed rural areas, there was a national drive to create more community saunas. Between 1920 and 1950, 10,000 public saunas were built in Sweden, in Norway it was 300. Remote Finland, in the meantime, had a record 500,000 saunas – now it's more than three million; not bad for a country of five million people – as every Finn will proudly tell you.

In the cities, community saunas dwindled, catering only to a small minority who couldn't afford to bathe at home and to gangsters who preferred to conduct business meeting in the nude. In Japan, it's still forbidden to bathe in public if you have a tattoo, thanks to the tattooed yakuza types who colonized the sauna for so long. The demise of the community sauna was reinforced by the arrival of the electric sauna stove in the 1930s. Quick, cheap, clean and easy to heat, it rapidly became an integral feature of an apartment block or hotel. By the 1950s, having a sauna evolved from a necessity in a harsh climate into a leisure activity to be shared with family and friends.

The decades rolled on. With Scandinavia's new found prosperity, it became a status symbol to install a private sauna at home. With globalization, families and friends started to travel and disperse. Soon those bathers with basement saunas found themselves sweating alone. Private and safe, but a little bit lonely. And who wants to be alone, now we're more alone than we have ever been? Bit by bit, private sauna owners started to crave the camaraderie of the past.

Opposite: Iso-Valkee sauna in Somero, Finland is available to rent and sits on a crystal-clear lake.

SAUNA AID

There's no war in the sauna – history has always decreed that discord and dispute must be left on the doorstep (see Chapter 4). When you're naked, exposed and vulnerable in the steam, its easier to resolve conflicts than escalate them, and deep heat does not discern between warlords, rogues and refugees. The sauna is even mythologized as the secret weapon in tiny Finland's victory against the Red Army in the Winter War of 1939–40.

With this in mind, when a natural or man-made disaster occurs, Sauna Aid – a multi-country initiative sponsored by the International Sauna Association (ISA) – springs into action, donating time, money and services to their charity arm. Sauna Aid provide movable sauna facilities an dsupportive services to people facing natural and manmade disasters. It uses the healing power of sauna for those on the frontline of disaster situations.

In 2011, after the Fukushima tsunami and nuclear plant accident, the ISA and the Japanese Sauna Society operated a tent sauna where more than a thousand locals were able to wash and be "decontaminated".

In 2022, Mikkel Aaland, the sauna world's elder statesman and author of this book's Foreword, documented the transport and delivery of a portable Pixxla container sauna to the Ukrainian front line, and is planning further expeditions.

Wood-fired and agile, these saunas don't depend on electricity and can be moved easily from zone to zone. In cooperation with the Lithuanian Bath Academy, Sauna Aid is also offering free sauna sessions to Ukrainian refugees suffering trauma and free online training to the bath attendants servicing them.

And in Estonia, a new charity – Saunas For Ukraine – is building mobile saunas and driving them to the Ukrainian frontline. Each one comes with laundry and washing facilities, water tanks and power generators. They are being used by 400 to 600 Ukrainian soldiers each week.

sauna-aid.com
@Saunas4Ukraine.com
saun.slava.ee

Opposite: Portakabins make innovative portable saunas, like this Hiedanrannan public sauna, which sits on a derelict factory plot in Tampere, Finland.

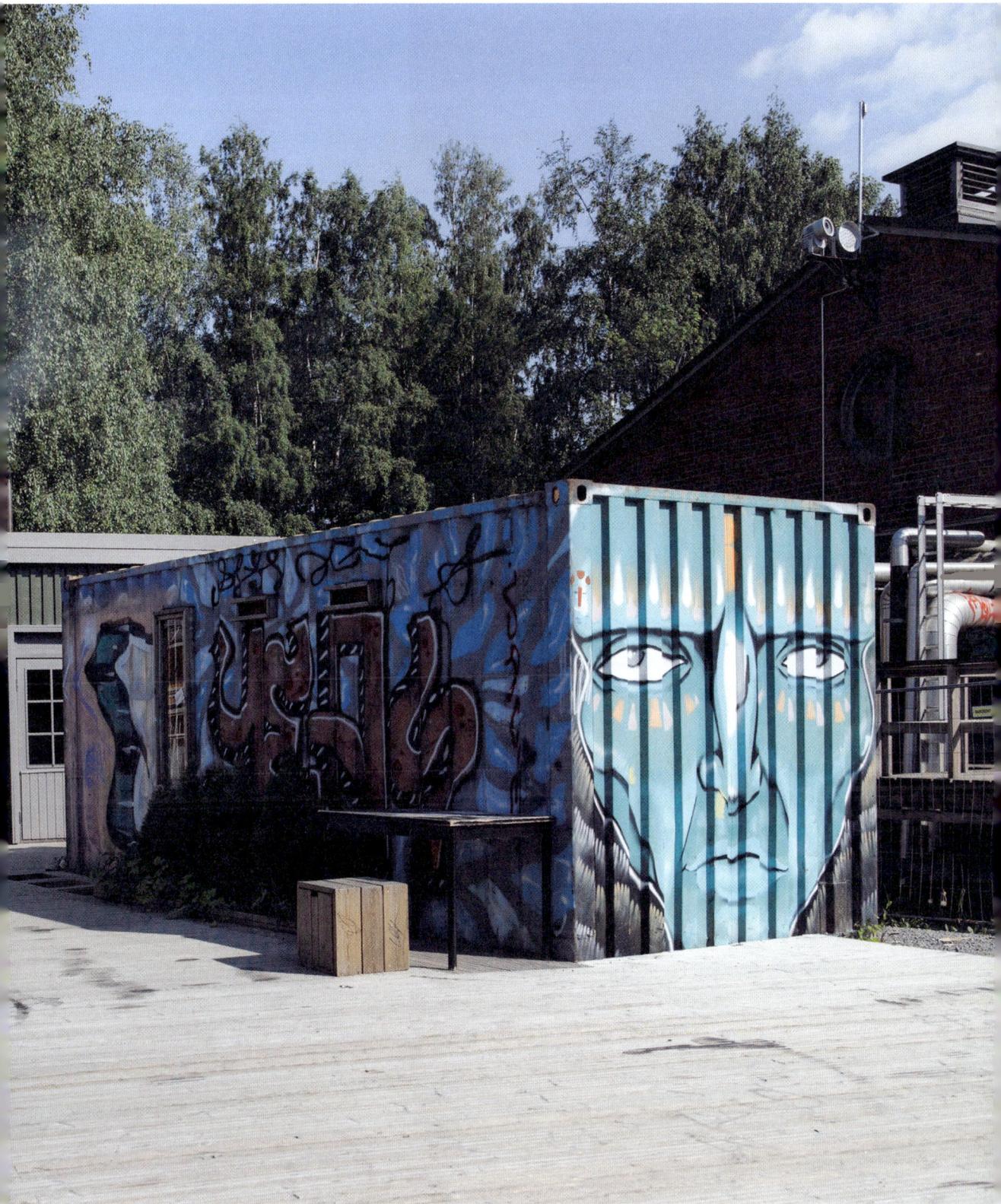

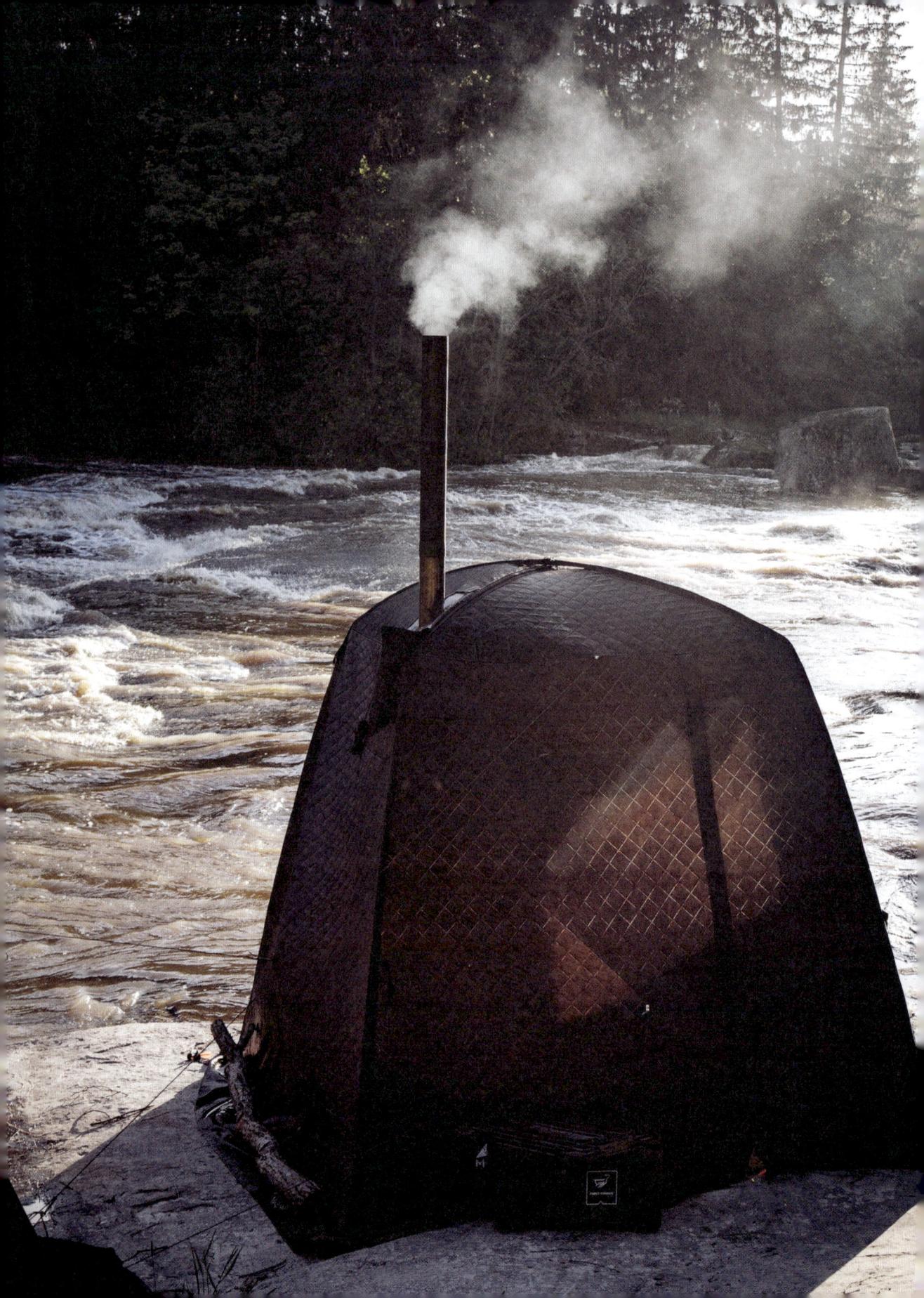

Sauna on the move

In 2020 and 2021, the global pandemic emphasized the perils of social isolation, the need to look after our health, and the joy of being outdoors. In Japan, Covid-19 meant public saunas were closed, which, combined with people being given coupons to get them out into the countryside, led to the rise of the tent sauna – now an essential extra in Japanese glamping resorts. A tent sauna typically costs around 1000 euros, holds a maximum of five people and reaches 100°C in 15 minutes. Thanks to vents in the sides, it has good *löyly*, and the stove doesn't need rocks, so it's not *too* heavy to haul on a hike – or, you can just pitch and perspire in the comfort of your yard.

Popping up in beauty spots is Pixxla – a mobile, self-service container sauna from Slovakia with a wood-fired stove. It can be booked on the move, up to three hours in advance and comes clean, fresh and ready to go. Never before have saunas been so portable and adaptable, and existed in so many shapes and forms.

Opposite: Maija's tent sauna in action in southern Finland.

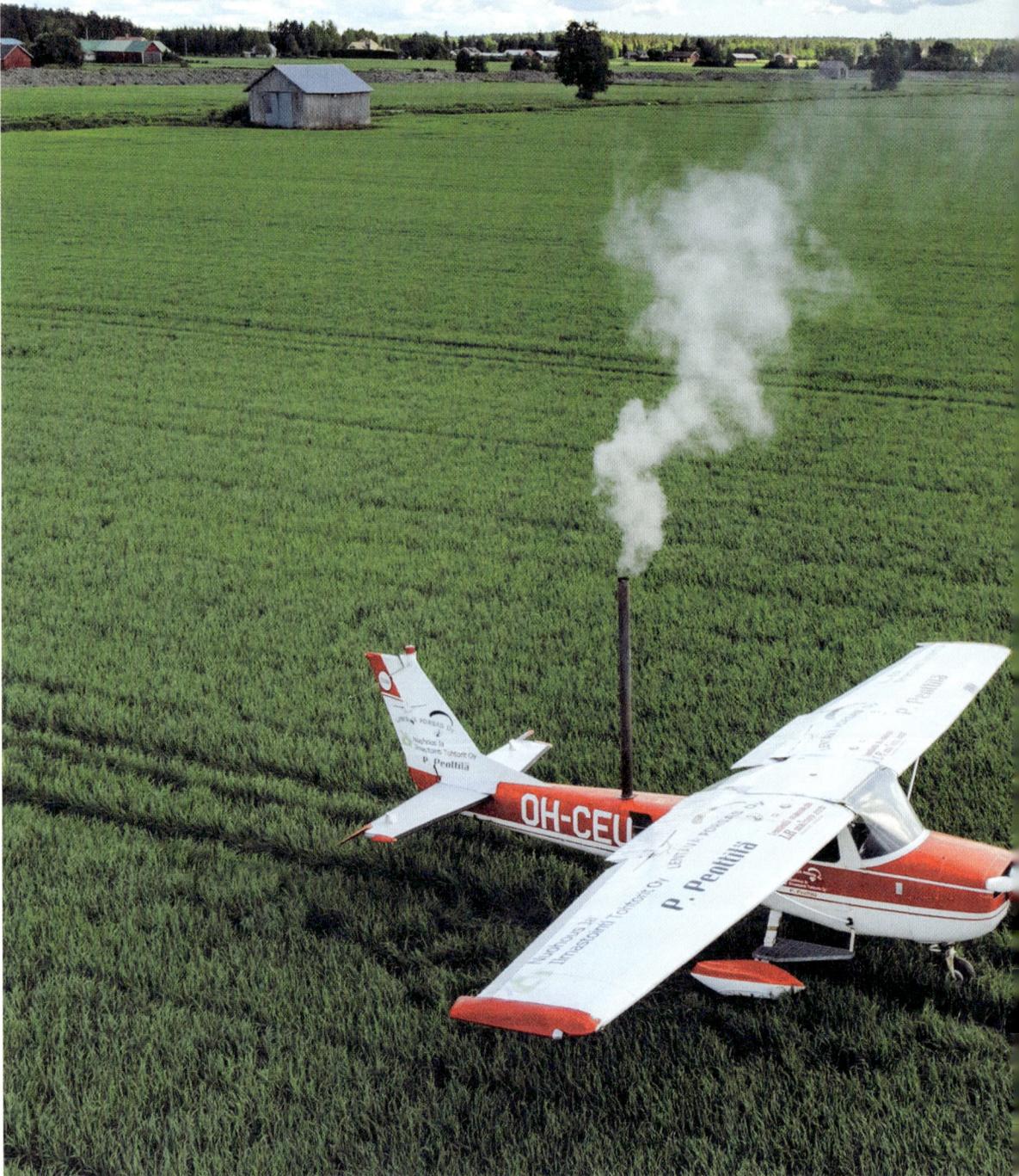

A group of Finnish friends converted a vintage Cessna into a sauna.

SAUNAS ON PARADE

Cars, trucks, planes, trains and telephone boxes – basically, anything with a roof and some sort of wall – all have sauna potential. The Mobile Sauna Festival in Teuva in Finland is an annual parade of ingenious inventions. Here, to the sound of frenzied hooting and clapping, helicopters, combine harvesters, military trucks and even a Cessna plane, take to the streets. Plastic sheeting, wool, straw, grass, peat – any material that is insulating – is reworked into sauna stuffing. The Cessna sauna belongs to a group of Finnish farmers, self-confessed "crazy sauna maniacs" who were inspired by the Teuva parade 11 years ago. They bought the vintage plane at auction, built their own stove, and set about converting the cockpit into a hotbox. Water is stored in the wings, and whooshes of steam are administered via a button marked Cabin Heat. The friends take their Cessna sauna on tour and pilots from all over Finland join them in the steam.

DIY sauna

Never before has building your own sauna been such a popular pastime. During the pandemic, sales of back-garden saunas soared, and DIY enthusiasts with time on their hands took to creating their own. In the winter wilderness of Lapland, it's not unusual to stumble upon a homemade ice sauna solidified to the surface of a frozen lake. Those with the know-how wield chainsaws, tractors and diggers to create sauna huts from 20-cm-thick planks of ice. Sometimes these ice saunas melt after a day. But that's not the point. It's about getting together with friends and battling the elements, completing a challenge. And what better way to pass the time during those long dark winters than by sweating it out?

Meanwhile, on urban waterfronts, community saunas and cold-water swimming clubs have made a comeback; only this time with lockers, showers and supervision. In rural regions, old smoke saunas are being fired up after decades of neglect so that we can reconnect with nature and ourselves. In cities, sauna theme parks, event saunas and *aufguss* rituals are turning sweating into an entertaining art form. And, once again sauna is booming.

Opposite: The ice sauna in Sahanlahti resort in Puumala, Finland melts every spring and is rebuilt every winter.

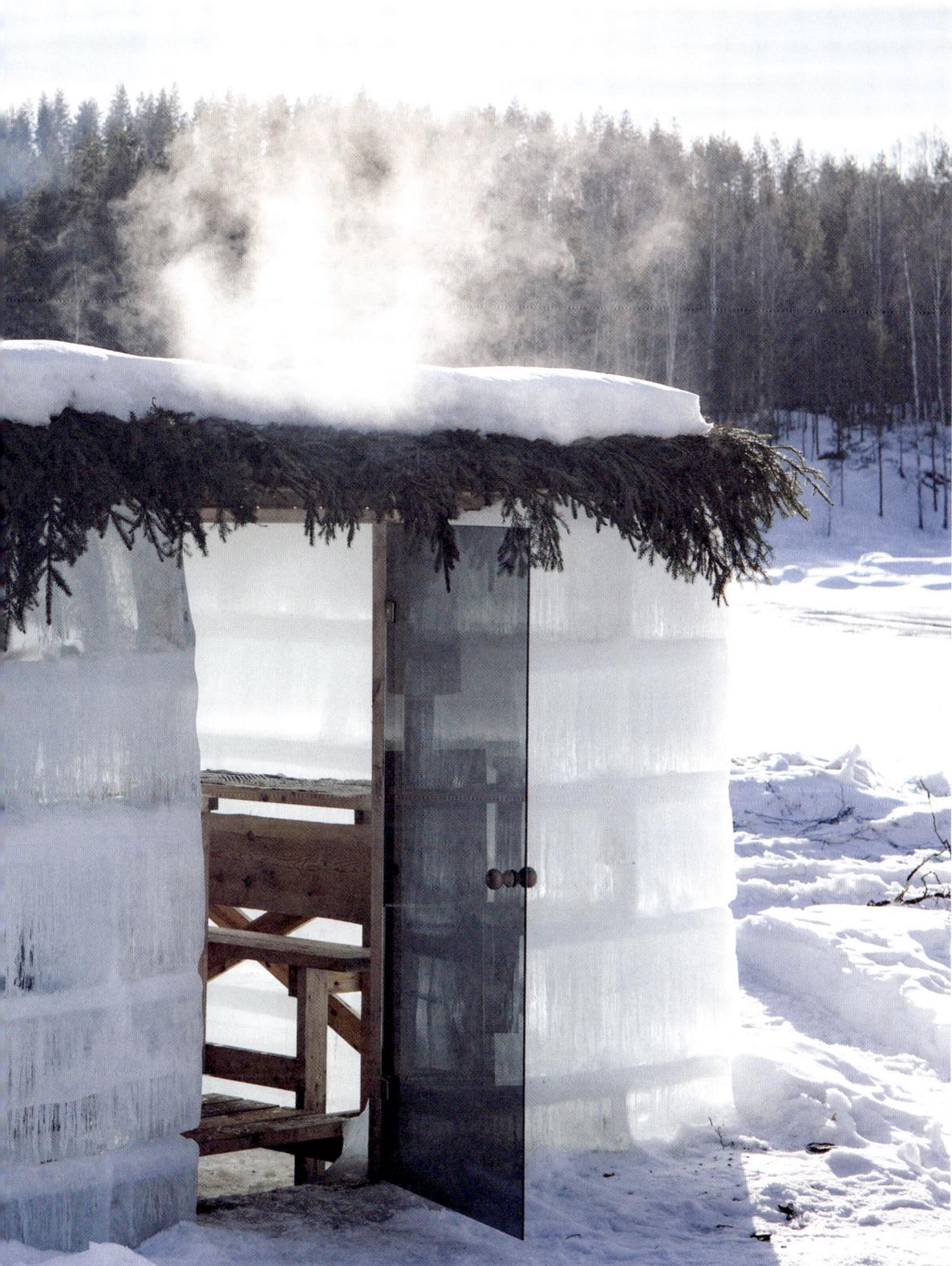

SAUNAS AS WORKS OF ART

Sazae

"For several years, the words 'experience-based' have been used to define things that are premised on appreciation," explains Taichi Kuma of feted Japanese architects Kengo Kuma & Associates. Naoshima is one of these things. With its art museums, design hotels and installations by world famous artists, this celebrated "art island" draws around a million visitors a year. "Naoshima has many interactive works, but most of them remain as extraordinary experiences," adds Taichi. "Sauna, by its very nature, gives us time to face ourselves." What he means is that while Sazae sauna may appear to be a look-but-don't-touch artwork, it's actually a fully functioning sauna, servicing guests at the island's Sana Mane glamping resort. Shaped like a conch shell, it features curved benches which hold up to 20 bathers, walls that gently curl towards the sky and a hole at the top which lets in natural light. "The sauna allows you to go inside yourself and experience the nature of Naoshima on a deeper level," says Taichi.

Sazae is also another example of Japan's prowess at building world-class saunas with boundary-pushing design. This is in part down to the country's largest sauna builder, TTNE. Founded in 2017 by Dai Matsuo and Daisuke Akiyama, TTNE is largely credited with bringing sauna culture to Japan. It christened a new generation of bathers *saunners,* and creates coveted sportswear emblazoned with the Saunner logo. It has championed sauna as entertainment and hosts sauna-related events. Daisuke Akiyama admits that Sazae was a challenge, and it breaks all the rules of conventional sauna design. But isn't that what art is for?

Art Sauna

At the esteemed Serlachius Museum Gösta in Finland, the Art Sauna is an extension of the gallery walls. Works by international artists appear in the changing areas, sauna towels and accessories are designed by well-known textile artists, and an outdoor tiled shower is an artwork in itself. The sauna's complex, labyrinthine design by Barcelona-based architects Héctor Mendoza, Mara Partida and Boris Bežan also breaks the rules. A large circular sauna with hand-crafted aspen benches seats 20 people and offers views across a glistening lake; a private lounge and dining area pays homage to Finnish design maestros, among them Alvar Aalto and Eero Aarnio.

People travel a long way to visit the Serlachius Museum Gösta. Its collection of Finnish masters is legendary, and the contemporary wing (by the same Barcelona-based architects) hosts international-level artists. There's a fine-dining restaurant, a sculpture park, nature trails, a shop, a café and the majestic lake where you can swim or hire a boat. The sauna is an extra draw, the next stop on the museum's "journey into architecture, art and nature". Visitors arriving by boat, canoe or raft can dock at its private jetty, and the outdoor hot tub and ample terrace are the perfect place to unwind. The Art Sauna, say the museum directors, relates to "a new sauna culture where, instead of traditional relaxation and washing, people seek experiences and a sense of social togetherness."

Opposite: Sauna bathing is a new addition to Finland's famous Serlachius Museum. *Next*: Mänttä art sauna at the Serlachius Museum, Finland.

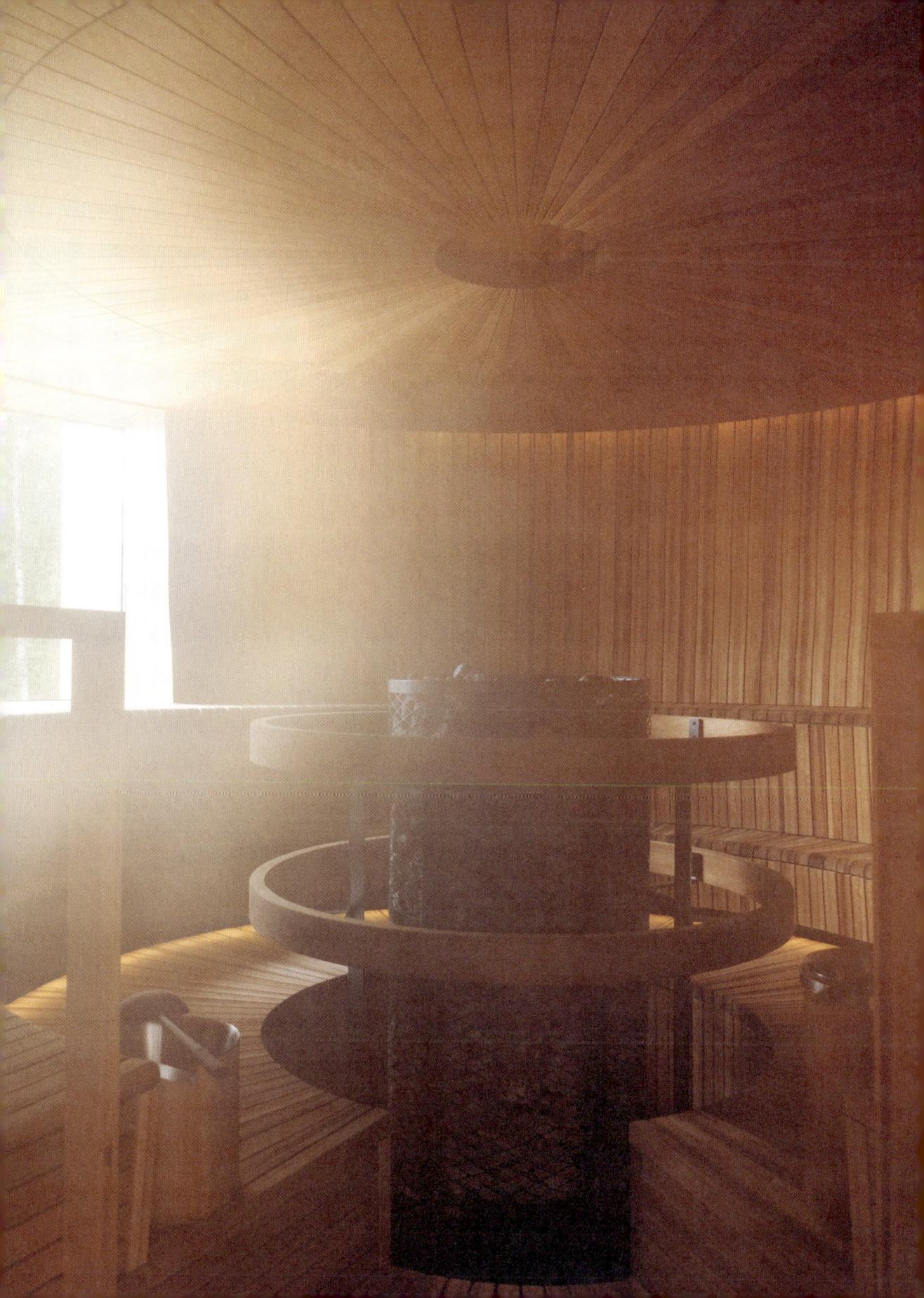

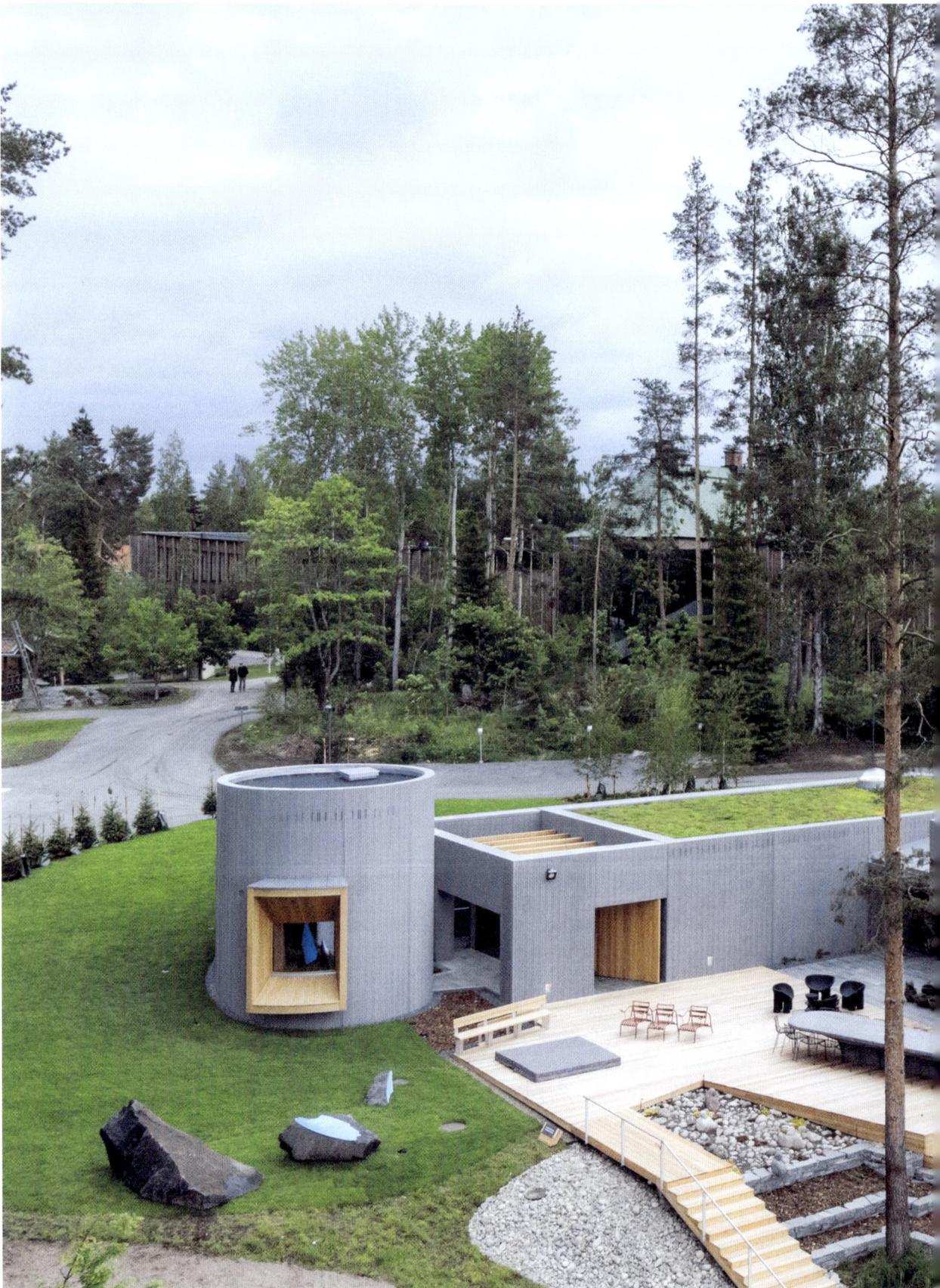

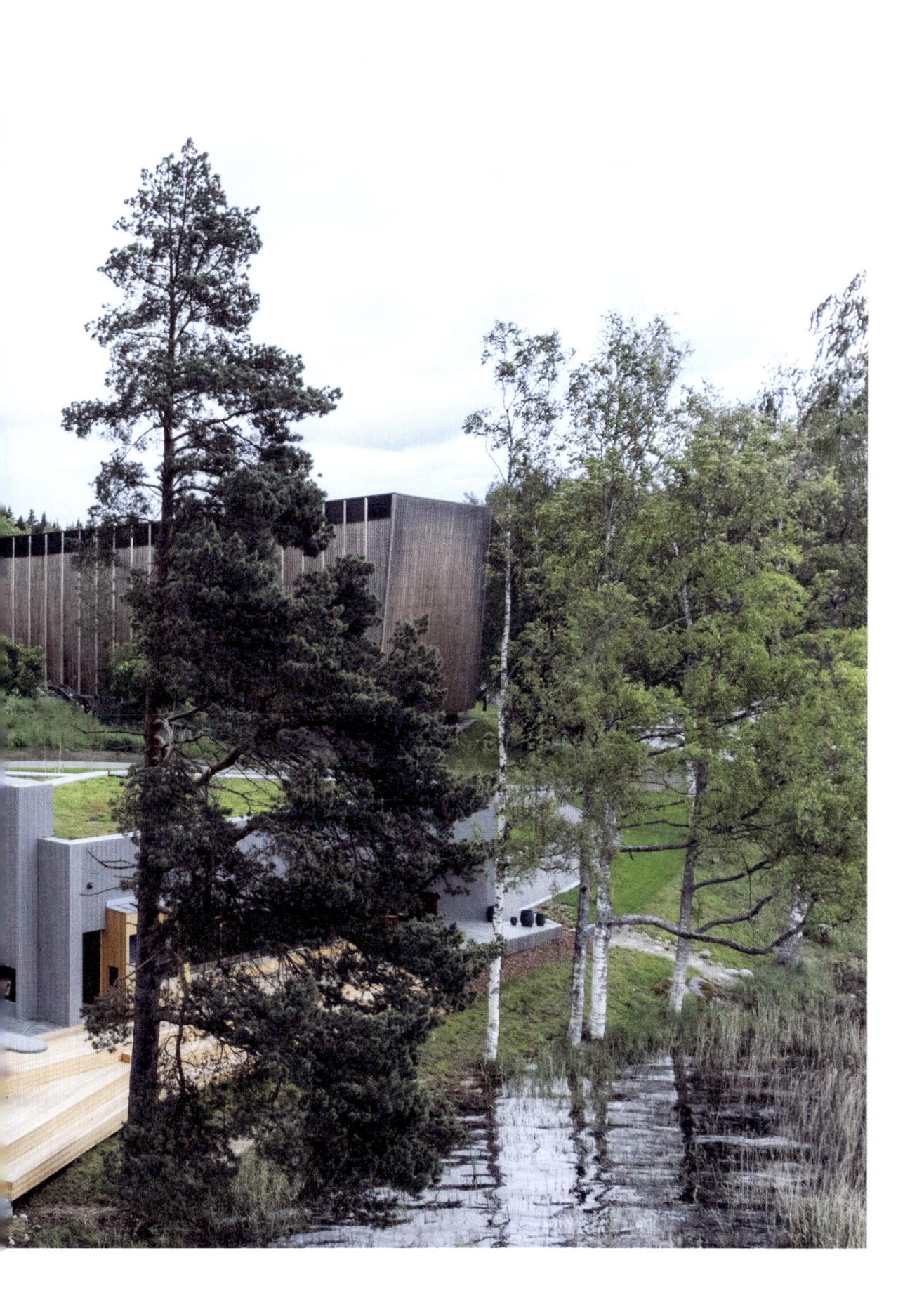

SAUNA DIPLOMACY

It was one hot ticket – an invitation from the Finnish Embassy in London to join them for a Diplomatic Sauna Evening in their new sauna. It wasn't as bizarre as it sounded. Almost all 98 Finnish diplomatic and consular missions have their own saunas (Tokyo has two), and some have many members – like the Diplomatic Sauna Society of the Finnish Embassy in Washington D.C., whose members make Capitol Hill spin.

Buoyed by the success of Washington's club, in 2022 the Finnish Embassy in London opened its own Diplomatic Sauna Society. As Heli Suominen, Press Counsellor at the embassy and our sauna host, explained: "Our important stakeholders receive numerous lunch invitations and so on, but an invitation to a sauna evening is something completely unique." Yes indeed.

Countries on the edge of a menacing superpower, Finland and the Baltics have always had to be masters of diplomacy. And the sauna has often been their secret weapon in negotiations. When the Iron Curtain went up in 1940, Estonians, in a canny move, added large eesruums, or relaxation areas, to their saunas. Here, basking in the afterglow, they would embark on drink-fuelled negotiations over allocation of resources with Soviet officials. Many a deal was done after a deep sweat.

Finland puts much of its post-war prosperity down to the foreign policy of neutrality towards the Soviets that Urho Kekkonen, President of Finland from 1956 to 1982, famously adopted. At his presidential sauna society, Kekkonen would assemble his inner sanctum every Saturday from 11pm until the early hours to discuss the country's affairs. The story goes that when Soviet leader Nikita Khrushchev dropped by in 1960, the pair stayed in Kekkonen's seaside sauna until five in the morning. Soon after the visit, the Soviet hardball was prepared to support Finland's desire to integrate and cooperate with the West. Eventually, a free-trade area comprising Finland and seven EFTA (European Free Trade Association) countries was created in 1971, and Kekkonen's sauna in the Presidential residence Tamminiemi is now a tourist attraction.

Despite Kekkonen's efforts (or perhaps because of them), the Finnish Embassy in London does have an air of Soviet Brutalism about it: grey metal safes, bags of rubbish marked "Confidential Waste" and a metal detector line the route down to the basement sauna. Emptying pockets and opening bags to pass through it, the idea of stripping off feels more like a punishment than a pleasure. But in the new sauna area, candles, snacks, wine, robes and slippers – all from Finland's finest producers – make for a jolly ambience. By the time we hit the steam, myself and four female news journalists had discussed Brexit, fossil fuels, the financial markets, interest rates. And sauna. All off the record.

Finnish officials love to emphasize the role sauna has played in their military victories. In 1944, troops built more than 200 saunas on the Russian front and fought off their enemy. And climate never stopped them; when they landed in the Sinai Desert in the 1950s, Finnish troops built 35 saunas from whatever was at hand – wooden telephone poles left by the Israelis and an Egyptian military transport platform became a sauna on wheels, and everyone was invited.

In 2008, former Finnish President Martti Ahtisaari was awarded the Nobel Peace Prize for his efforts at resolving international conflicts. When asked how to look for compromise when parties are poles apart, President Ahtisaari replied: "The most important thing is to just meet and talk, meet and talk. Especially in the early stages." And where better to do this than the sauna? In the high heat, decisions and negotiations take less time; excitement dies down and political differences melt away.

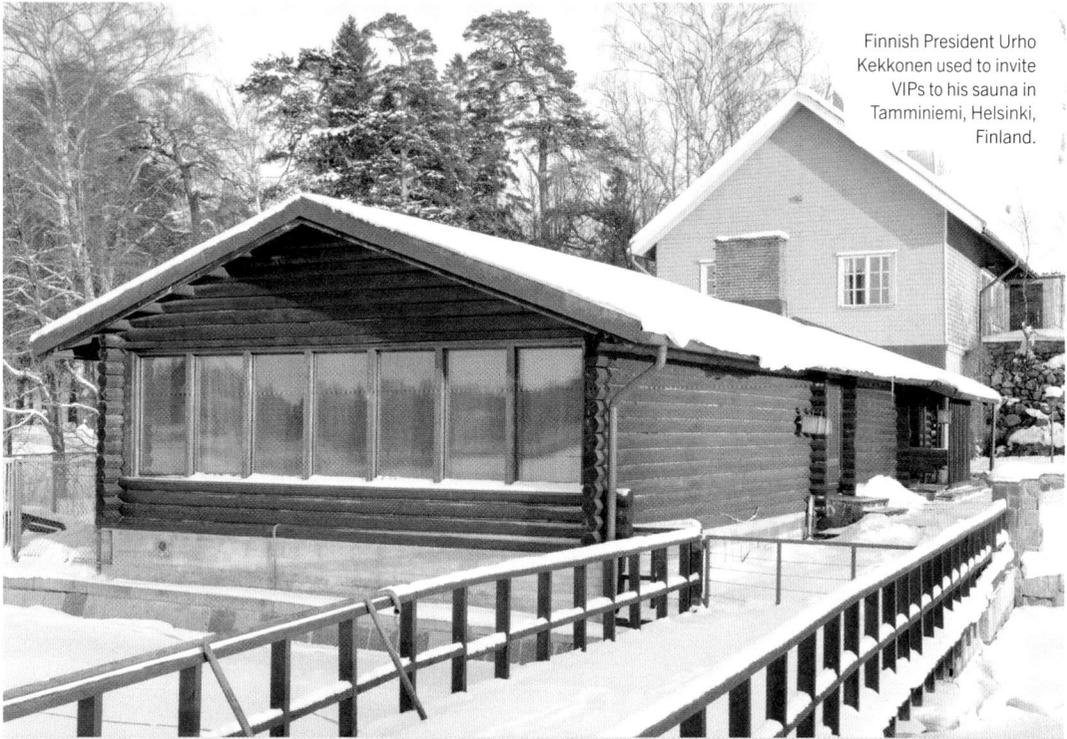

Finnish President Urho Kekkonen used to invite VIPs to his sauna in Tamminiemi, Helsinki, Finland.

Back in London, "Sauna is a way to get to know our country in a broader sense – the nature, the society and the culture," says Heli. "Here, we want to spread the word of sauna to journalists and help them experience proper Finnish sauna." It worked. After an hour and half of convivial steaming, we all wanted to move to Finland, with its generous welfare packages, solid education, progressive childcare laws and thriving sauna scene.

Viljar Lubi, the Estonian ambassador to the UK, is also trying spread the sauna message among London's diplomatic circles. Under a chestnut tree, in his bijou Kensington garden is a dinky Iglu sauna by Estonian makers Iglucraft (David Beckham, Guy Ritchie and Matthew McConaughey are also clients). Mr Lubi explains: "I invite guests into the sauna and we get to know each other and discuss all sorts of matters. It's a psychological gesture that shows you have nothing to hide. It builds trust." Over the years, he has seen many gridlocked discussions shift in the steam. And if you're with

Estonians, or any other culture that uses two forms of "you", the sauna is where you shift from formal "you" to its informal alternative.

In the UK, Mr Lubi has learned to exercise such sauna diplomacy with, well, diplomacy. "I never invite Brits in the first time I meet them, especially if they are female (if they accept, they go with a female colleague). "And I'm never surprised if they are too embarrassed to go in, even in swimwear. It's a huge psychological step. They don't say no exactly, and they are usually more willing to go with me than with their colleagues. In the UK, inviting someone to the sauna can mean very dodgy things."

But in the diplomatic sauna (indeeed, in all saunas), everyone is equal; there are no superpowers or mini-powers, no superiors or servants. If you agree on something when you are all naked, it's more difficult not to keep your word. "If you go to sauna with someone, it's a bond," says Mr Lubi. "It means you have become more familiar, and next time you meet, you can move things on."

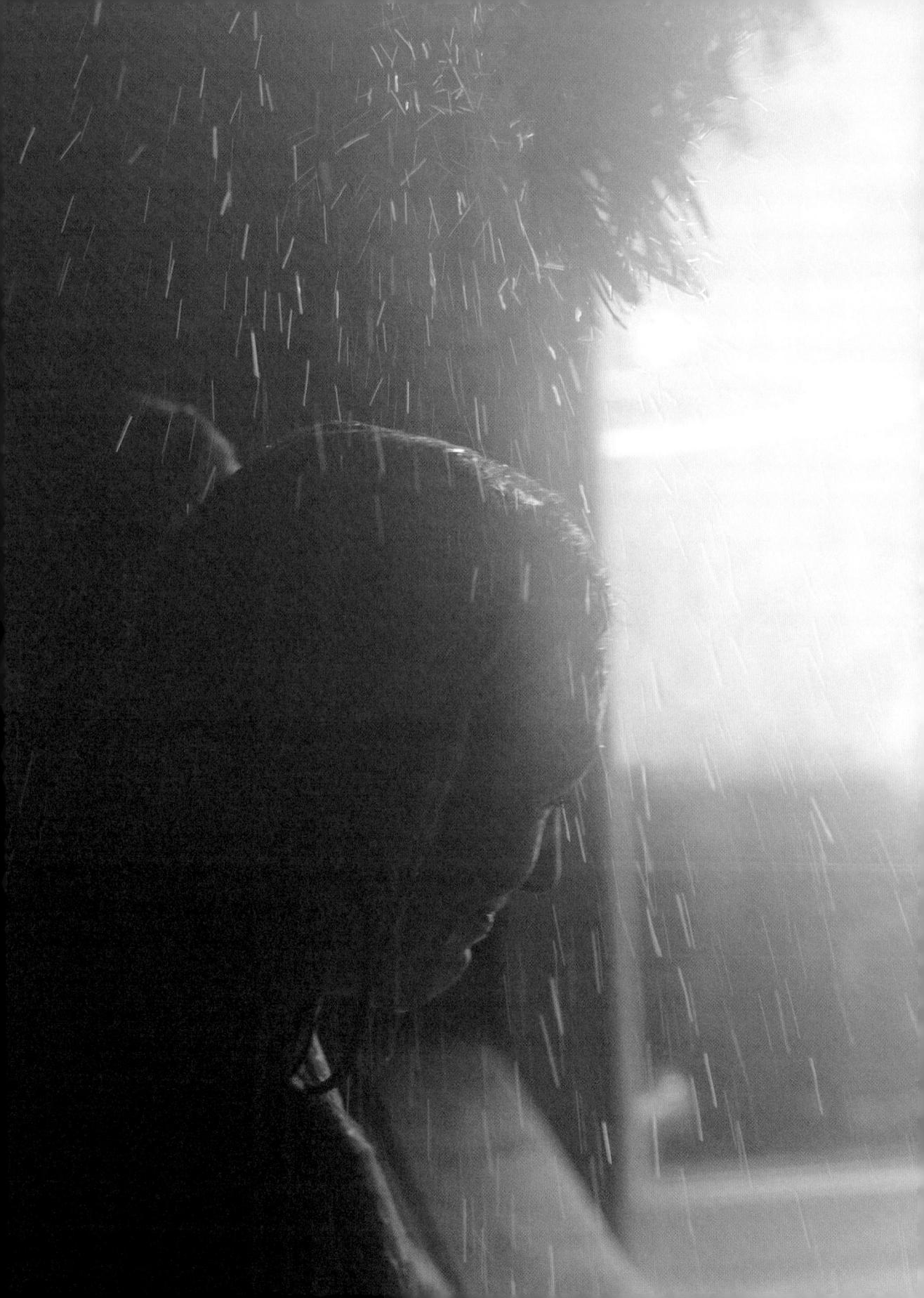

RITUALS
What lies within

"There are two different types of people in the world; those who want to know, and those who want to believe."

Friedrich Nietzsche

The sauna was part of life from the cradle to the grave; it provided a clean, safe space in which to give birth. New mothers would rest in its warm embrace and grandmothers would introduce newborns to the power of the steam. When the cycle of life had run its course, in the sauna the dead were cleaned, blessed and prepared for burial. Family members who were sick would be moved into the separate sauna hut to be healed in isolation. The sauna was a place to heal, help each other, hand down wisdom and simply hang out. And with it came spells, songs and incantations.

Every community relied on a folk healer who would travel from village to village, their pockets full of snake skins, bears' teeth, special stones; their heads full of magic and secret knowledge. In the clean, private space of the sauna, they would practise herbalism, bone-setting, cupping, massage, energy healing. Rituals connected the body with the soul, the living with the dead, men with women, man with nature. They were passed word of mouth from generation to generation, and were performed to cure jealousies and desires, to absolve the sinful and celebrate the fortunate, to reunite body and mind. Sages would read the patterns left by birch leaves after whisking, and interpret the sauna flame, the spit of the stove, the shape of the rocks. Every element had a deeper, often supernatural meaning. If you had a good soul, you got good *löyly*. And if your sauna burned down, it was a sign of retribution.

Previous: Cooling off with a birch whisk.
Opposite: Inside Fiskars Village sauna in Finland.

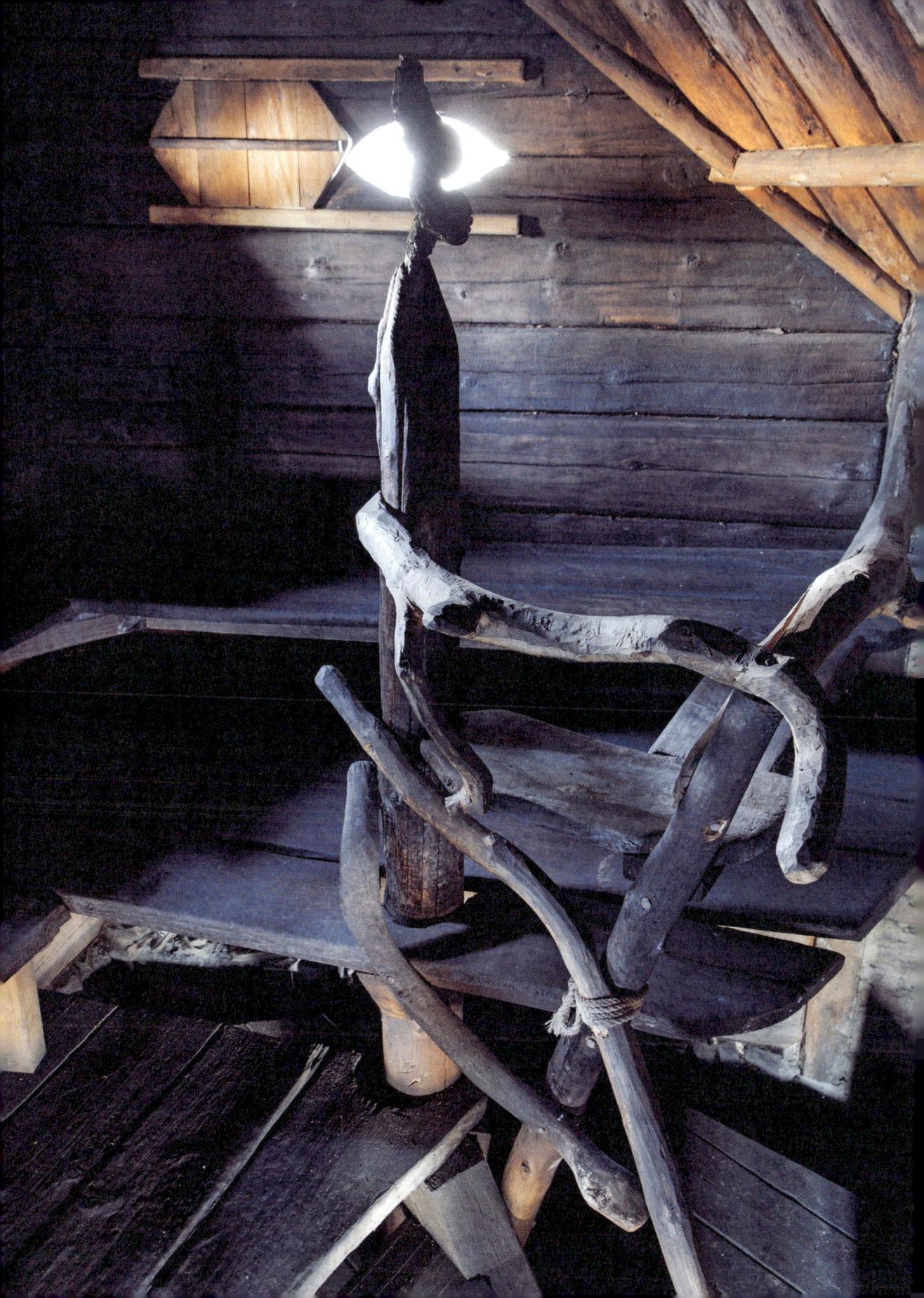

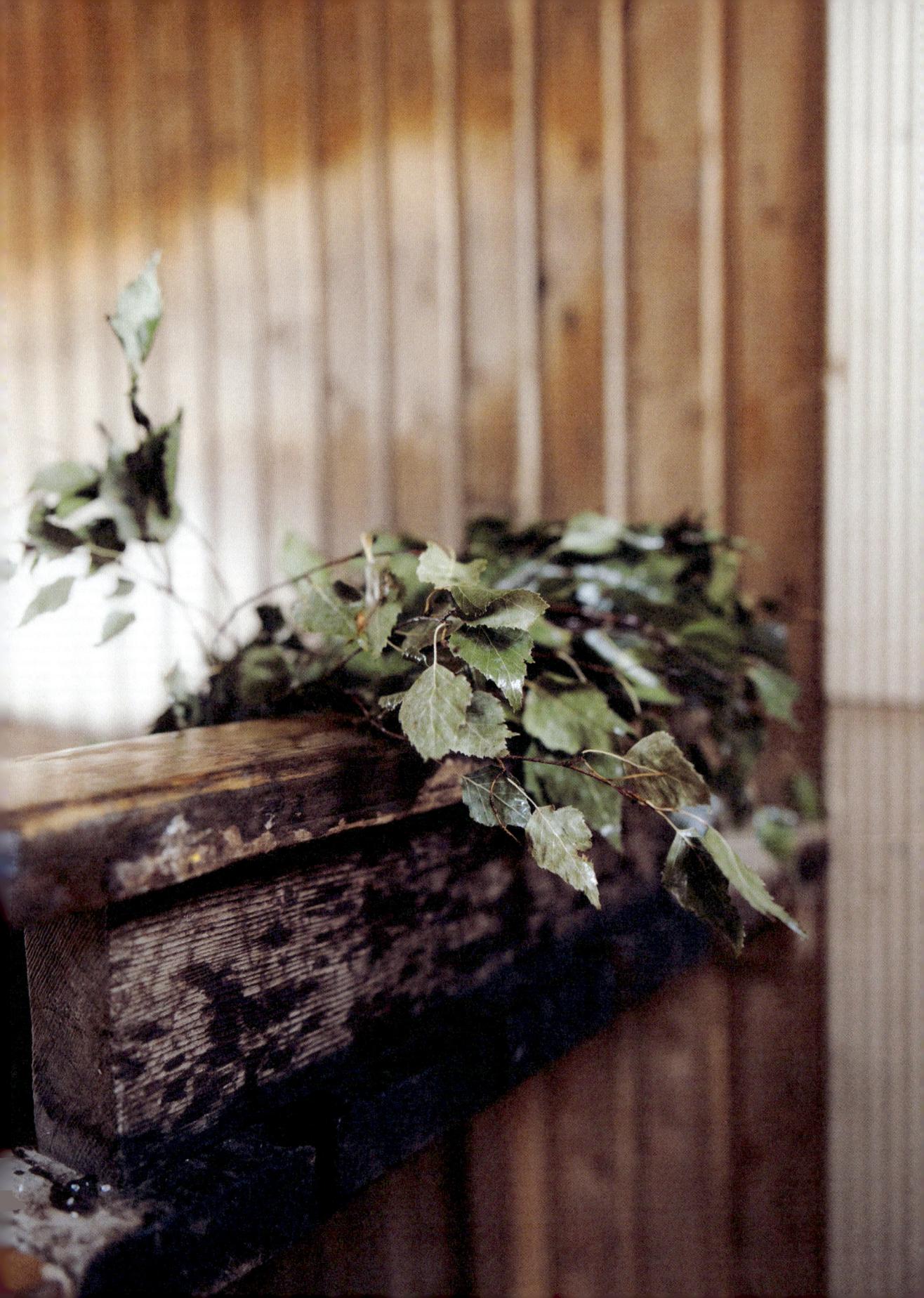

Rites of passage

Most of the ancient spells have vanished in the ether, but many feel that there should be space for these myths and rituals in the modern sauna. Dalva Lamminmäki is a doctoral researcher at the University of Eastern Finland, Joensuu, and studies Finnish folklore and sauna culture. "Finnish sauna and folk healing have strong historical, communal and mythological connotations and they belong together," she says. Much of this sauna mythology appears in the *Kalevala* (Finland's work of epic poetry) and Finnish runic songs; Dalva explains: "Elias Lönnrot, the *Kalevala*'s compiler, was an expert in folk medicine. He presented sauna as a diverse space for healing." The poem has created a lasting foundation for the sauna as a key symbol of Finnish identity, and it's not uncommon to see the gods and goddesses of the *Kalevala* carved into sauna doors and windows.

Opposite: Fresh birch leaves picked in the summer make the best whisks.

Spells and incantations

Midsummer, Christmas and other special occasions were celebrated with incantations, poems, special herbs and whisks. Fertility and "love raising" rituals boosted male stamina and virility and enhanced female sensuality. (After a woman had given birth, a rite was performed to "close" her vagina; unmarried women, keen to find a spouse, would gather their sweat and slip it into a potential suitors' drink to lure him.)

"Seers", "verbalists" and "ecstatics" would cast spells to bring good fortune, ward off evil spirits and change behaviours; the envious or admiring glances of strangers and neighbours could be averted by the mystic's supernatural powers. In 1890 in Finland, folk healing was declared illegal, and speaking of spiritual or supernatural sauna practices became taboo. Wisdom was passed on in secret, through word of mouth by elderly female bathers, guardians of the healing sauna. In the 1800s, Russian poet Alexander Pushkin called the *banya* "a second mother". No one since has come up with a better description.

Opposite: Ashes at Mooska, Estonia; these contain alkaline properties, which are good for cleansing the skin.

Going back to its roots

In the same way that grandma's old culinary skills – fermentation, pickling, distilling, and the like – are being dusted down and taken off the shelf, so too are old sauna spells and rituals. The Lithuanian Bath Academy is training the Japanese, Brits and Finns in the art of whisking, and at a conference on tradition, it hosted speakers from the UK, Finland, the US and Japan who came together "to discuss the place of tradition in today's world, to take stock of the diversity of sauna traditions and to discuss ways in which we can continue and nurture these traditions."

Institutions such as Mooska (see Chapter 7) and the Kalevala Women's Association (see Chapter 3) are rediscovering and reinterpreting old sauna rituals and healing recipes and for new audiences. One of its members, Kaarina Kailo, declares: "Finns have lost the rich ritual practices surrounding wedding preparations, the raising of erotic powers and the uses of various types of plants and flowers for whisks. We want to provide bathers with magico-mythical knowledge about the old ways as part of a solution to the world's dissociative trends. We have lost the healing properties of the sauna as a ritual of centring the self and being alive well."

The contemporary sauna scene often focuses on the well-being, relaxation and detox benefits of the steam; but what about the psychological transformations, those small incremental shifts or major epiphanies that can happen?

Opposite: Birch whisks ready for action at Beach Box Spa in Brighton, UK.

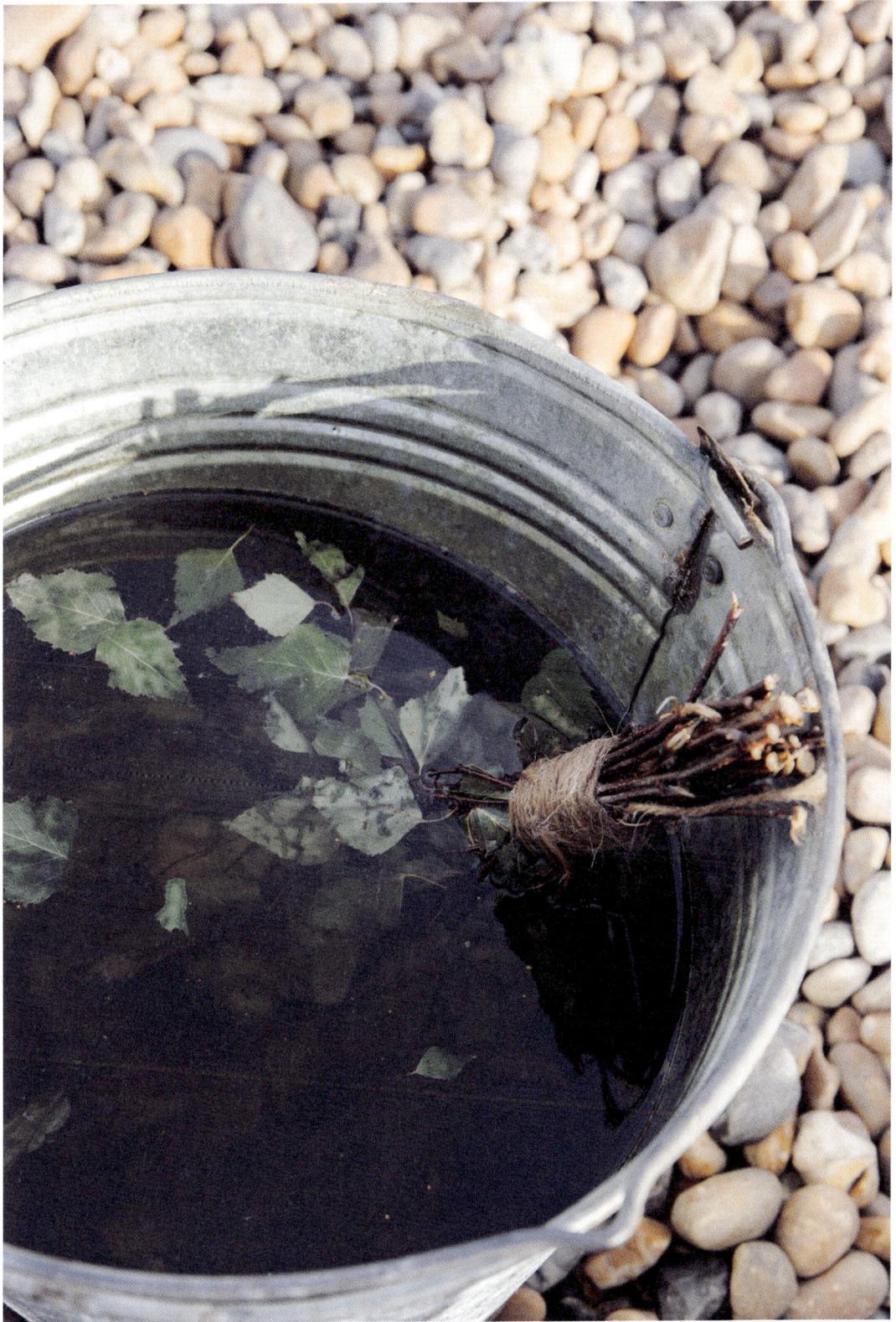

Altered states

Sauna shamans or sages believed the sauna was the portal to another world, a gateway to ancestors and a liminal space in which to connect with the spirit world. "The sauna was a temple of wellness and everyday spirituality," says Kaarina.

After suffering corporate burnout in Canada, Kaarina turned her attention to Native American sweat-bathing rituals, and discovered many connections with her native Finnish folklore. "The point of the ritual was not only to increase knowledge about physiological processes, but also to regenerate the world and be regenerated by it in return."

Kailo has spent many years studying Native American sweat lodges and Finnish sauna throughout the ages, and finds many similarities. "The sweat lodge rituals were based on wholeness, healing and spirituality. Sweating for the common good, reaching a trance-like state, and connecting with ancestors.

Traditionally, the ancient Finns, like Native Americans, worshipped the four elements – air, water, fire, earth – in the sauna. It was a microcosm of the three levels of the universe: the upper realm, the sky world; the middle realm, the earth; and the underworld of the dead. All of its core symbolism replicated the cycles of growth, interconnection and symbiosis, with the end goal of altered states, raised consciousness and rejuvenation."

Opposite: Leaving your mark; handprint on the sauna door at Mooska.

Today, sauna shamans Matti and Juha (see Chapter 1) travel to Japan, Norway and all over Finland hosting ceremonies with titles such as "Symbolic Death and Rebirth" and "Sauna Meditation". Whisking, chanting, summoning sauna spirits and celebrating nature are the norm. In the same vein, sauna master Miska Käppi (see Chapter 1) travelled the world exploring other religions, until he realised that all what he was looking for was under his nose. He hosts rituals in Sipoonjoen Perinnesauna near Helsinki that tap into old Finnish beliefs and guide people back to their roots. "I feel like a dumb baby," he says. "We have lost so much wisdom from our ancestors. Many Finns have enjoyed a sauna a thousand times, but the culture of putting the spiritual experience into words has died. We talk about design, heart rate, nervous system, all of which are fascinating, but easy to look at. What about the other things? We pretend they're not there."

Describing these "other things" is like trying to describe colour to someone who has never been able to see. It's impossible until you have lived it. And in a world where everything is measured, quantified, analyzed and assessed, enjoyment of the ephemeral and appreciation of the unknown is stronger than ever. The sauna is inexplicably connected to the universe, but we don't know how. "There are many things that don't make sense," says Miska, "and many things that make up human needs. If we deny ourselves spiritual space, we deny part of ourselves." Our ancestors sweated it out in hope of finding the answers they were looking for. A new generation is doing the same.

Opposite: Cinnamon soaked in water gives off a sweet-smelling steam.

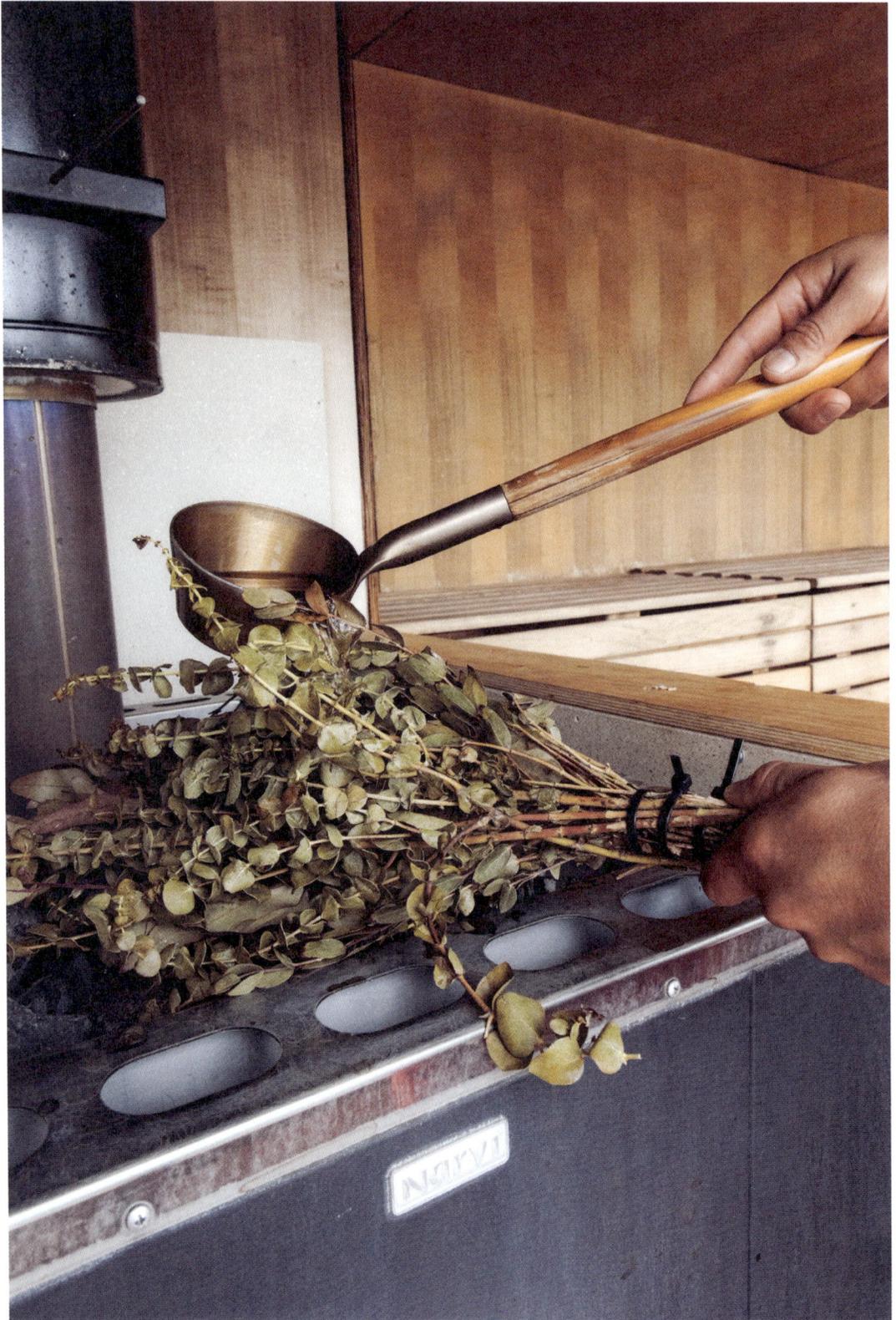

Purification the Lithuanian way

Birutė Masiliauskienė is a Lithuanian bath master who frames her rituals around ancient female traditions, the seasons and the elements. We meet at Wild Spa Wowo in Sussex to experience one of her two-hour introductory rituals. She's in the UK to run a course in whisking with Katie Bracher, founding member of the British Sauna Society and a trained sauna master – one of the few in the UK so far.

"The bath master is a farmer, the body is the land," says Birutė, tying one of her freshly made birch whisks with a supple sliver of twig. For more than 20 years, she has healed the humps and hillocks and soothed the furrowed brows of bathers all over the world. Everything she uses in her rituals she makes herself, from the whisks and ointments to the infusions and scrubs; and, like all bath masters, she works in loose cotton and linen garments, and prefers participants to be naked, though this is not compulsory.

For an audience unaccustomed to sauna, Birutė starts by showing us whisks, usually made of birch in midsummer, when the leaves are at their softest and full of saponin, a soapy like sap rich in minerals and antioxidants. As the first tree to grow back after the Ice Age, birch is rich in symbolism in the Nordic regions, and represents rebirth and new life. But whisks can be made from any tree – maple, linden, hazel, fir, cherry or mountain ash (the ancient tree of fertility). Juniper, with its ghostly form, marked the space between the living and the dead, and was used after a plague, disease or a deep loss to whisk the evil eye away.

"Sometimes, those new to sauna think the whisks look dangerous, that they are going to be punished with them," she says. It's why, in 2013, she and her colleagues at the International Bath Academy in Lithuania came up with the term "leaf whisking"; until then, "lambasting" had been used, which all agreed gave off the wrong message. "Rather than being tools of torture, whisks are there to help. With their different smells and textures, they're a modern-day sauna aromatherapy," she says.

Opposite: Wetting the whisks in preparation for a ritual at Oslo Badstuforening.

Seasonal flow

Birutė begins her ritual in "winter" when bathers are cold. Time is spent warming up, getting used to the space and acclimatising. "It's like going into the kitchen and smelling what is cooking," she explains. It's the "first sweat". In every sauna culture there's always a first sweat to open the pores and release toxins, microbes, chemicals and perfumes, followed by a wash (see Sauna Etiquette, Chapter 2). Even saunas next to open water have a proper place to wash. What is the sauna if not the chance for a deep clean?

Birutė has no rules about how long you stay in – or out. "It's like playing on a swing; you have to feel pleasure inside and outside, and every turn is a little bit deeper," she says, "you go a bit further." Lithuanians tend to turn to the number four: four elements, four seasons, four rounds; and lots of different whisks. Depending on the time of year, Birutė brings 20 or 30 different plants to the sauna.

Next comes "spring", which involves "snowmelt, water, touch, waking the body up," says Birutė. She whisks me all over with hypnotic pats to the head, back, buttocks, feet. The swishes and sweeps of the whisks in action are a distraction; they echo the rhythmic beat of the snare drum, and have long been used to encourage a trance-like state. "The smell and texture of the whisks and the sound they make speed up transformation to a more meditative state," says Birutė. "And this helps me as I'm often trying to solve problems."

After rinsing off any fallen leaves, she applies salt scrub to promote sweating. It's made from dry salt and she always adds little extras – essential oils, birch extract and/or horse chestnut powder to help thin the blood – and she tosses the mixture back and forth between two bowls like a master juggler. Fine particles fly and it's good to inhale them; salt has been used as a treatment for respiratory problems for centuries. Salt saunas have long been a common feature of mining communities.

Opposite: An Ecuadorian sauna master at Oslo Badstuforening prepares for a sauna ritual.

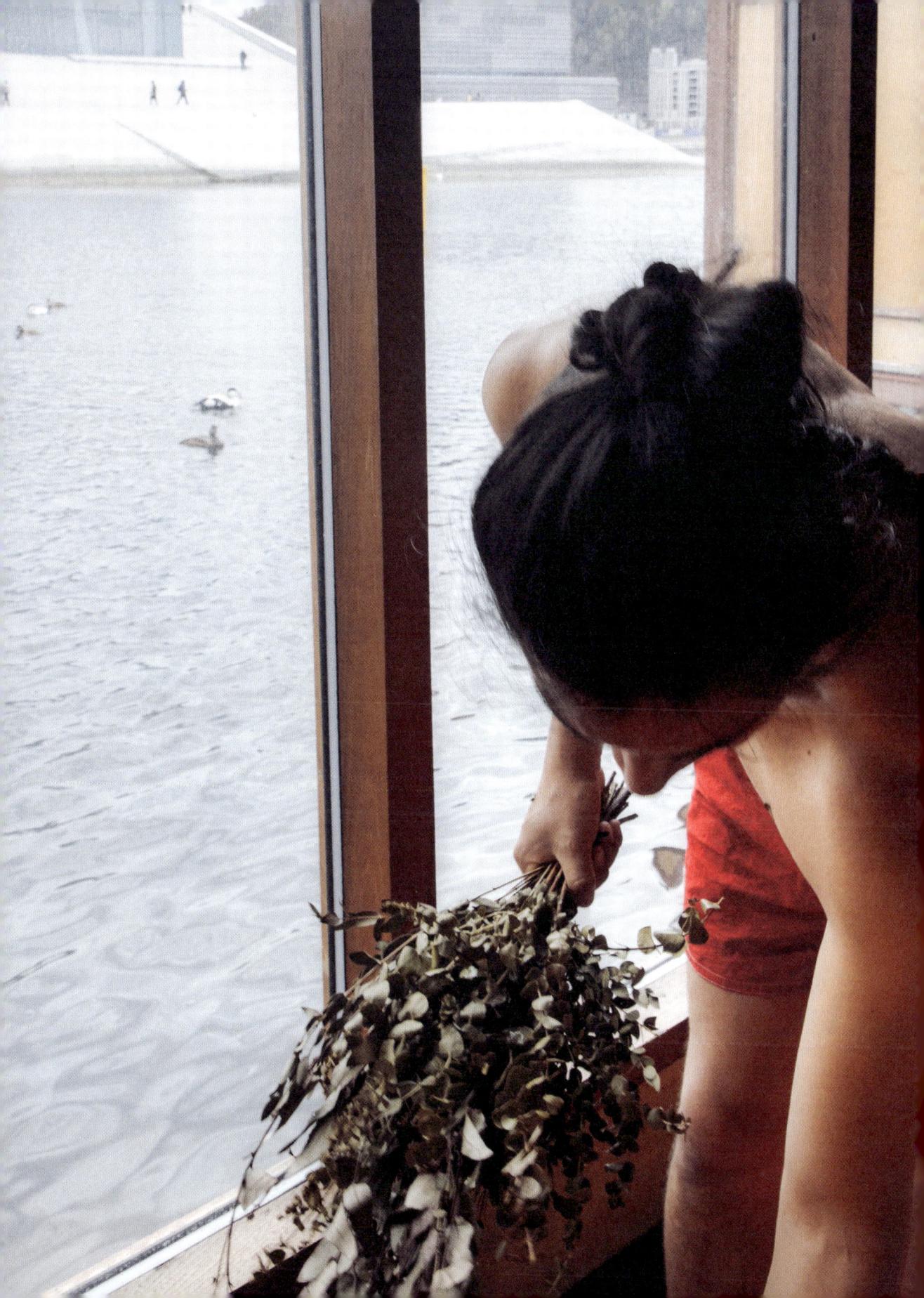

If "winter" is barren flatlands and "spring" is rolling foothills, "summer" is rugged mountains with glaciers on top. Peak season. Summer is the most intense part of the ritual, when emotions can boil over. The whisking is frenzied. Slap, slap, slap, on heads, breasts and thighs, and whoosh upon whoosh of *löyly*. Every sweat-bathing culture has its own word for *löyly* but its meaning is always the same: breath, soul, life force. As the temperature rises, Birutė moans and sighs and cries out, encouraging me to join her. I'm self-conscious and can only manage a few stress-relieving sighs. Incantations, poems and songs were an essential part of a ritual, and shouting out the names of former lovers, or naming wrongs out loud was a way of exorcising them.

Then comes the moment of relief – and there always is a moment of relief, ranging from shoulder-dropping sighs to a huge cathartic shift – and Birutė has seen them all. Tears, laughter, panic attacks, orgasms, shivers. The heat and the whisking bring about a heightened energetic state and a shift in consciousness where rational thoughts can dissolve. "Both are necessary if someone is to be healed. People who meditate and receive therapy train their minds to believe in a new reality, but often the body hasn't caught up," says Birutė. "It's the final stop." When we undress and are almost naked, body memories – those layers of life that are hidden in our tissues and buried in our bones – can come out. "In the sauna, the body never lies."

Whisking at Beach Box
Spa in Brighton, UK

After the summer "climax" – emotional, sexual or both, or when the energy blocks have been released – comes "autumn", the final season. After all the sloughing and scrubbing, it's time to rest and be replenished and come back down to Earth like a gently falling leaf. Birutė pours a sauna bucket of warm water over my head, washes and applies a honey wrap – sweet smelling, surprisingly un-sticky and packed with antibacterial goodness that heals wounds and moisturises. It feels soft and fresh and symbolizes happy new beginnings, and its aroma blends with the caramel, smoky notes of the sauna and the unmistakable hint of birch. I leave feeling cleansed, elated and curious. Do I have any trapped "body memories"? I want to return to delve deeper and find out.

"Most people don't come with the intention of receiving a therapy-based treatment," says Birutė, "but they are always looking for some sort of relief." She treats people suffering PTSD and trauma, and has been running sauna sessions with Ukrainian refugees in Lithuania (see Sauna Aid, Chapter 5). For this kind of work, years of experience are crucial, regular sessions are recommended, and high temperatures are often advised. One of her techniques is to take the patient to a point "where they have no more thoughts, apart from 'IT'S SO F*****NG HOT'. This stage is an absolute must because it leads to a few seconds of pure meditation. It's so hot, the brain just collapses."

And if it sounds familiar, it has echoes of the heat immersion therapy that American doctor Charles Raison is trialling as a treatment for a depression in the US (see Chapter 1). But extreme heat is just one of Birutė's tools, "Sometimes we need the opposite; a gentle touch, warm water, a light stroke, hugging with warm whisks, breathing, sound. It depends on the state of the client."

Opposite: At Arctic Land Adventure sauna, frozen birch leaves are added to water in winter months to make an aromatic and deep-cleansing bath.

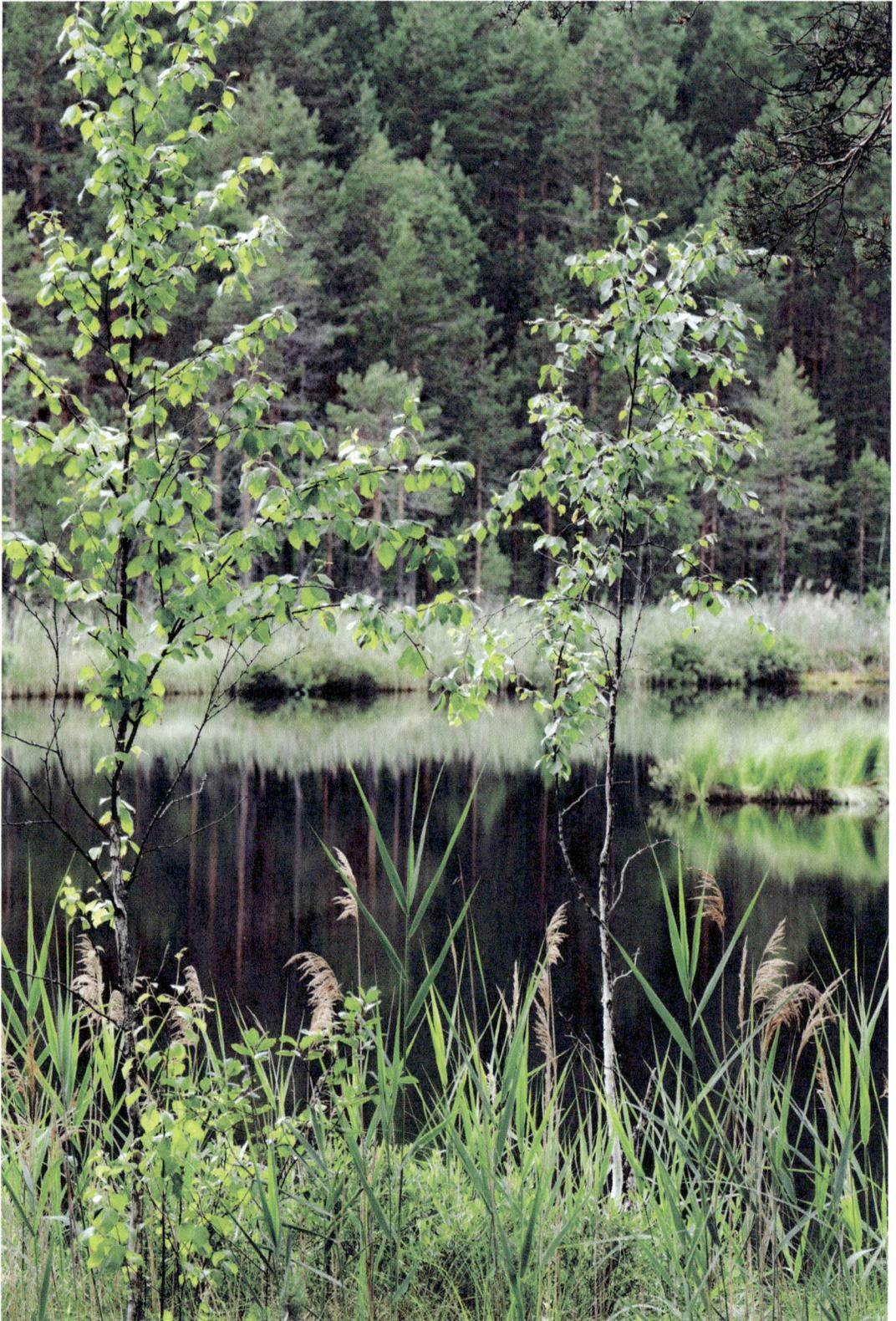

Nature bathing

"Nature bathing" rituals like Birutė's are commonplace in Latvia and Lithuania, but they can be found elsewhere too. At five-star spa resort Bad Ragaz in Switzerland, Latvian *pirts* is the latest ritual to appear in its new Sauna World complex. It's aimed at guests – whether in groups, couples or solo bathers – who want to go back to basics, to the methods of our forefathers, and its celebrated protagonist Māra Zute is from a family of Latvian bath masters.

Similarly, The Bath House in London regularly hosts *banshiks* (the Russian word for sauna master) to offer its guests an authentic sauna experience. For 30 years, Lithuanian bath master Vladas Jokubauskas has been treating royals, sportsmen and celebrities all over the world. His ritual is rooted in Russian whisking (*parenie*), hot and cold immersions, aromatherapy, peels and massage. In the private *banya* at The Bath House this experience with a *banshik* like Vladas costs upwards of £200 per person. His secret? "I listen to each client, understand their physiology, help them find ways to stay strong and healthy. The ritual reboots the whole body, the endocrine, lymphatic and nervous systems, the organs; every part of it brings well-being."

Opposite: Views from Matkuslampi sauna in Finland.

THE LATVIAN *PIRTS*

Māra Zute grew up with the *pirts* (the Latvian sauna); her family runs Pirts Skola, the leading bathing academy in Latvia; and she works in Switzerland, bringing traditional rituals from her country to new audiences.

How important is the pirts to Latvians?

It's a lifestyle, like going for a run or going to church. It's a holy, sacred place, silent and warm, a place to connect with my inner "I". There's always an urge to balance yourself in the *pirts*. There are so many rituals, but popular today are the *Pirtīža* ("separation") between a newborn and its parents that happens seven or eight days after the birth; and the modern bachelorette party, where the mother of the bride washes her daughter's back to get rid of the past and prepare her for a new life.

What is involved in your rituals?

In my "Touch of Nature" ritual, the *pirts* is around 60°C with 40 per cent humidity, so it's softer than the Russian *banya* or the European *aufguss* (which is performed with a towel, and is showy and expressive). We work with contrasts and nature, and use hot and cold water, herbs, and birch, oak, linden and maple whisks from Latvia – people are always amazed by how fragrant these are. We play traditional Latvian folk songs and touch bathers with the whisks. People say it's calming, meditative and quite personal.

But rituals operate on different levels. At Pirts Skola, the Level 1 diploma involves around 500 hours of study, exams, tests and a practical. The next level is *pirts* master, where you study energy fields and go deeper. But learning the *pirts* is a never-ending process.

People in Latvia spend years doing it. I'm on the way to being a master, but I'm not there yet; in Switzerland, I'm training others to offer the Latvian experience.

Are pagan beliefs still alive in Latvia?

Very much so. We are very esoteric people, connected with energy and nature. We are not a spa culture – the forest is our spa, and half of Latvia is still forest. We have Christianity, but it's very "Latvianized". People go to church but they follow pagan beliefs too, which follow the winter and summer solstices, spring and autumn equinoxes, and the cycles of nature. Wisdom is passed on by word of mouth – you have to live it to learn it. There's a charm to that, but the younger generation, including me, is writing it down.

What are the differences between Lithuanian and Latvian pirts?

They are very similar; both involve the cycles of nature and the seasons. We are brothers and we exchange a lot of ideas. And we both have the black smoke *pirts* without a chimney, which is similar to the Finnish smoke sauna.

What's next?

My mission is to explore Latvian traditions and spread the love of rituals and nature, and become a *pirts* master. With *pirts*, I help myself and others to find balance and I connect on a deeper level with people. I want to create wellness that has respect for tradition. It's so pure and honest, and people need that.

Opposite: Badstufolk's first creation, the Lake Sauna at Knut Lerhol's farm.

Bridal sauna

The bridal sauna has never gone entirely out of fashion, but it's growing in popularity today, thanks, in part, to The Kalevala Women's Association and its focus on reviving female Finnish traditions.

Modern interpretations of the bridal sauna can be found all over Finland, but they take inspiration from ancient themes. The bride-to-be gathers in the sauna with her closest female friends who decorate it with plants and flowers, and with nettles, thorns and thistles – reminders that marriage can be a rocky road. In the past, the maid-of-honour would wash the bride in egg to boost her fertility, and make her cry, for if she didn't shed a tear in her bridal sauna, she would be crying all her wedded life. Now, there are no eggs, but a salt scrub is still applied to wash off lovers past, and former beaus are vaporized in the steam if the bride-to-be shouts out their names. The ceremony finishes with a honey wrap, to bring joy and sweetness to the future union.

With her Finnish wellness brand Terhen, Terhi Ruutu is interpreting ancient rituals and giving them a modern twist. Her female-friendly healing approach is popular with bathers in spas all over Finland. At a Terhen bridal sauna, Terhi makes a scrub with herbal offerings donated by guests, which they then keep as a souvenir. And she who catches the bride-to-be's flowers, amassed by her friends, will be the next to wed.

"For women, the sauna has always been a safe space, somewhere they would meet and share their joys and sorrows," says Katja Lösönen of the Kalevala Women's Association. Techniques may have changed in this symbolic "threshold" ritual, but the ideas of sisterly solidarity, breaking with the past and preparing for a new life are as strong as they ever were.

HONEY RITUAL

Honey has always played a key role in folk healing; so revered was this sweet elixir that the ancient Egyptians depicted beekeepers on the walls of the pyramids; the Greeks, Hippocrates among them, mixed honey and beeswax with vinegar, blood, herbs and spices to create healing tinctures, balms and ointments. In many shamanic traditions, the bee symbolizes fertility, community, prosperity and hard work; and its antimicrobial, anti-inflammatory properties make honey a useful alternative in keeping bacteria, viruses and fungi at bay while soothing burns and chronic wounds.

The honey wrap is still a popular sauna treatment, and traditional healer Dalva Lamminmäki uses it regularly, sometimes mixing it with salt or coffee grains to exfoliate the skin. "It's really effective as a natural disinfectant, and the heat of the sauna improves this effect. Because it's sticky, it pulls impurities out of the pores and leaves the skin soft." In the heat of the sauna, when it mixes with sweat, this stickiness seems to melt away, making it easy to wash off. And such is its time-worn associations with good health, happiness, hope, strength and new beginnings, the honey wrap is often the final stage of a longer ritual.

Opposite: Beach Box Spa in Brighton (UK) creates its own essential oils and mixes them with salt scrubs.

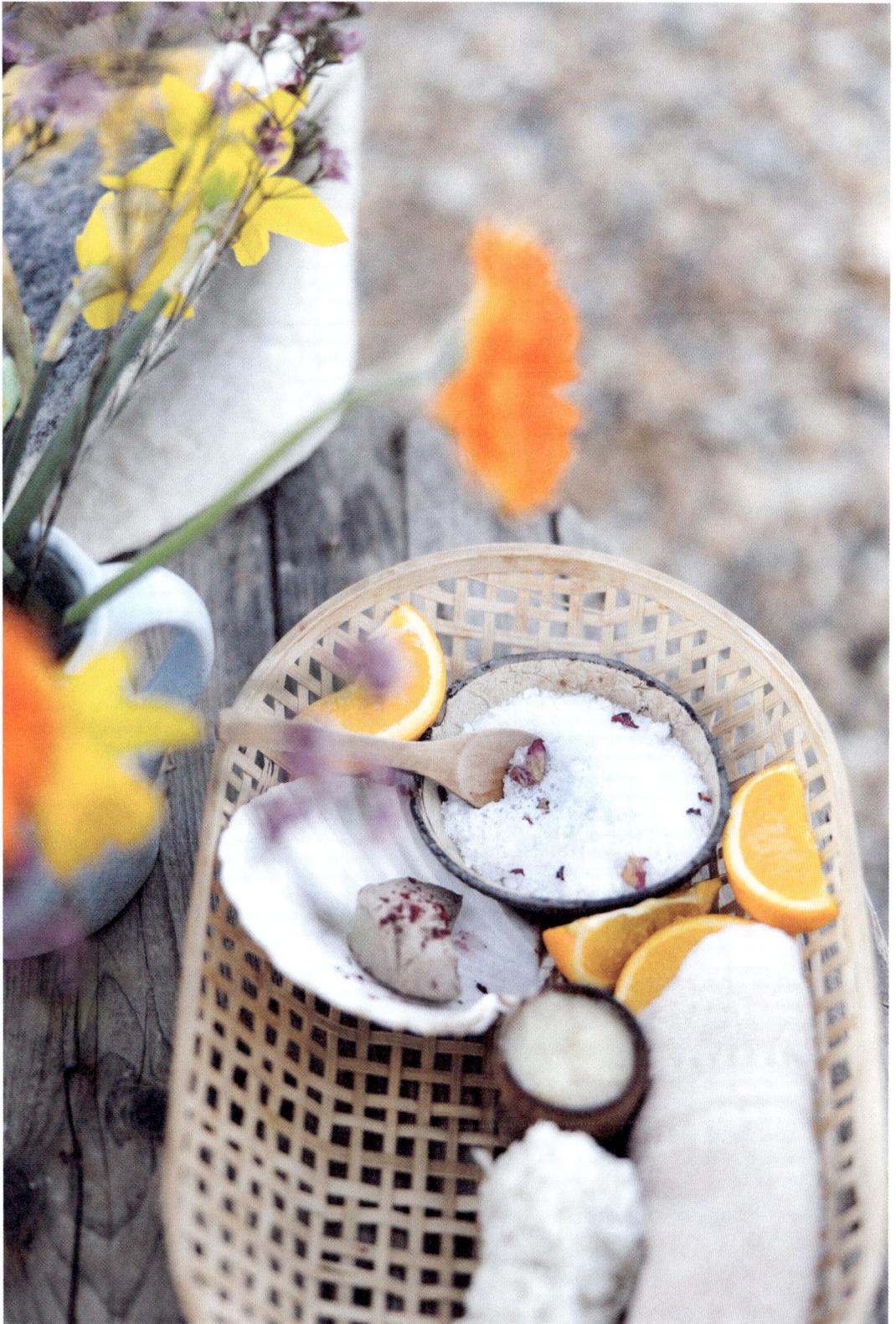

Cupping and bloodletting

As brutal as it sounds, bloodletting still happens in the sauna. While some find the idea of being cut to draw out sickness and boost the body's systems gross or frightening, others say it's cathartic and works wonders. The principles haven't changed for centuries. Until the 1850s, the belief that humours (four bodily fluids: blood, black bile, phlegm and yellow bile) determined our health was prevalent in Europe. The humours needed to be in balance. Too much black bile in the spleen would lead to melancholy; coldness was associated with too much phlegm; if you were pale, you were "white-blooded", and this white blood would need to be released. Bloodletting to get rid of obstructions or viscosity was used to treat almost everything.

Every village had a cupper who would work in the warm, antiseptic space of the sauna, using cow horns as cups, pressed against the warm skin, to bring blood to the surface. Even the healthy succumbed to the process, twice a year, in spring before the harvest and in autumn before winter, as a preventative measure. Today, silicone cups are used, and "wet" (blood) and "dry" cupping is recognized as a legitimate practice in many countries.

Beyond her academic interest in sauna, Dalva Lamminmäki is also a trained cupper. "Cupping is healthy because it takes oxygen out of the muscles and makes you produce new blood, which is always good," she says.

Treatments begin by making sure the patient is fully warm in the sauna, and then cups are placed over the hard muscle where the pain is. This brings the blood to the surface of the skin. Then tiny incisions are made to the skin, following the same points as acupuncture. "You don't feel anything, it's like a nail scratch." The tiny scratches and suction marks disappear after a week or so, and around 1.5 decilitres of blood is lost – more if the blood is full of oxygen. Wet cupping is used to treat many athletes, and one of the most common ailments is "ice elbow" ("frozen shoulder" in English). Dalva says: "New blood cells boost the entire system. It's simple. There's no magic involved." Cupping causes the body to release endorphins and heal itself naturally.

Cupping is licensed by the Finnish Health Authority and can lower blood pressure, help heal inflammation, improve the circulation of blood and fluids, balance hormonal functions and help the work of internal organs such as the kidneys. If you're taking blood thinners or cortisone, or have diabetes, low blood pressure or strong menstrual bleeding, you need to consult a professional before you start treatment.

Opposite: Traditional stove at Sahanlahti resort in Finland.

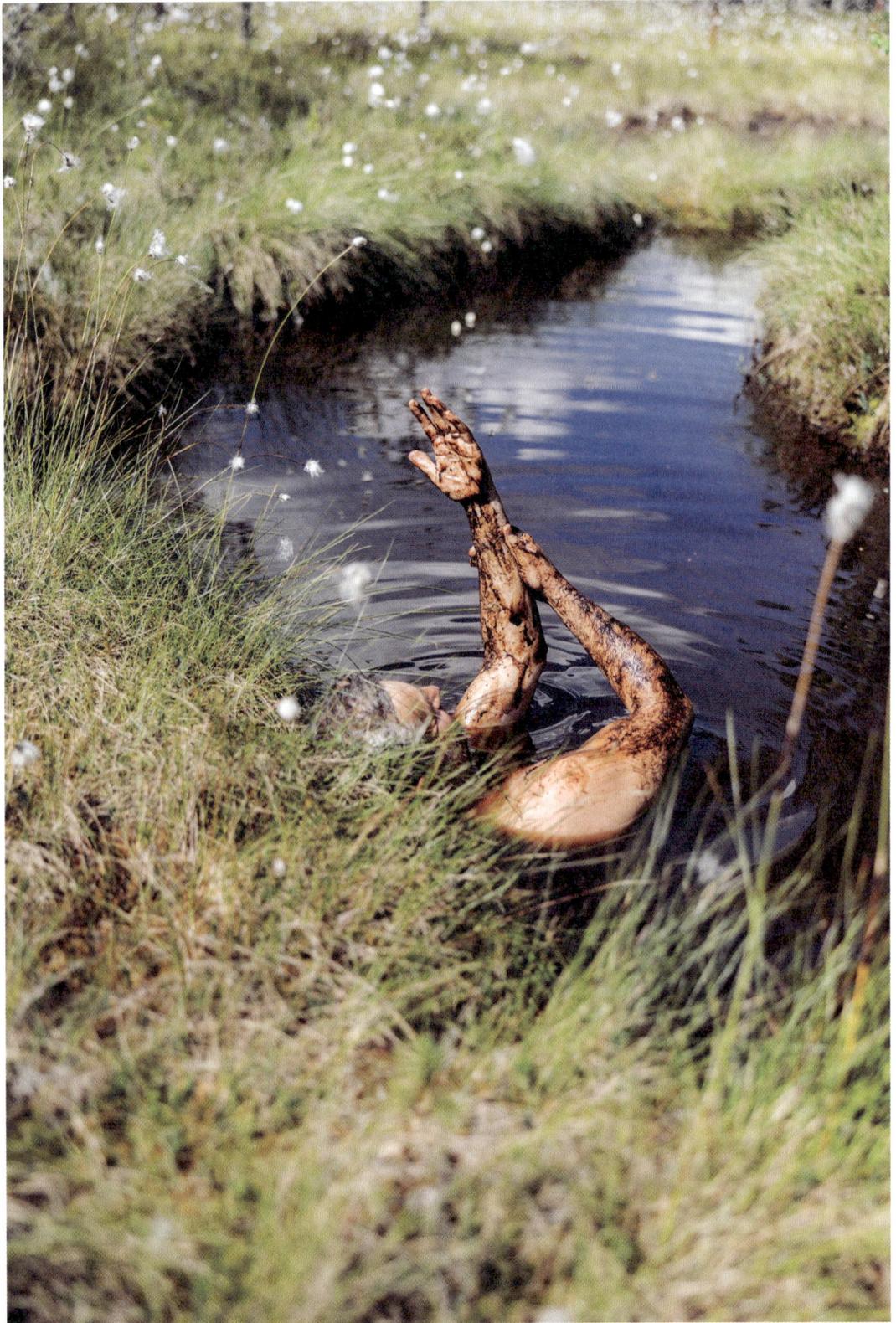

The power of peat

For centuries, the peat bogs and swamps of Northern Europe were seen as frightening, foreboding places; black quicksands where the wicked and the villainous would be sucked to murky depths. Shamans and witches were the only ones brave enough to inhabit such wild, unpredictable terrains, and enemies would be lured across them to their deaths. The ongoing discovery of "bog bodies" – cadavers dating back to the Iron Age – reveal that they were also mossy underworlds of black magic and human sacrifice.

As mummified bodies, complete with skin and internal organs, continue to be exhumed from the swamps of Scandinavia, Germany, the Netherlands and the UK, peat is being forensically scanned by scientists and doctors for its life-preserving qualities.

Not all peat bogs are the same, but when it comes to life-giving benefits, the "therapeutic layer" is the most precious. This is found at least one metre below the surface of the bog, and is rich in humic and fulvic acids, minerals and antioxidants which thrive in the absence of light, bacteria, fungi and oxygen. When it's harvested, this yellow, fulsome-smelling sterile peat is stored in airtight containers to preserve its star ingredients.

Humic and fulvic acids have a range of anti-inflammatory and antimicrobial properties that improve skin conditions and allergies, and ease pain and swelling. Anyone suffering from eczema and dryness, acne, psoriasis and dermatitis would do well to embalm themselves in this virgin peat. It can work wonders internally too, improving blood flow and easing inflammation and skeletal pain.

Finnish gynaecologist Leena Larva has spent 20 years researching the benefits of therapeutic peat. At Valkeakoski Health Village, her day spa near Tampere, she mixes high-grade "sterile" peat to a soft paste in a food processor and uses it in her signature Swamp Earth treatment. Sauna and cold immersions are an essential part of the ritual. After smearing themselves head-to-toe in the peaty paste, participants take a sauna for at least 20 minutes. The heat stimulates blood circulation and causes pores to open, which allows the peat to really penetrate the skin. Leena believes the addition of the sauna deepens the effects of the treatment. "Regular sessions stimulate the lymphatic system and make the skin really soft," says Leena, whose traditional area of expertise is aging, menopause and pelvic pain. "Over time, people say they feel and sleep better, and menopausal women say symptoms such as sweating, lack of libido and low energy are alleviated."

There are 10 million hectares of peat swamp in Finland, and the 5,000-year-old Lehtosuo peat swamp near the city of Ähtäri is one of the oldest and, according to the Geological Survey of Finland, one of the highest grades.

Here, on 10 hectares of virgin swamp, "peat entrepreneur" Heikki Ruha "lifts and sifts" virgin peat to produce Lehtopeat, a line of peat-based shampoos, soaps, body scrubs and wraps which are sold all over the world. Heikki also runs the onsite Suo Spa. Here, a DIY sauna and a wooden massage hut sit next to a natural spring rich in magnesium and manganese, copper and zinc. The spring is the colour of kombucha, tastes like an iron supplement and is fed by more than 25,000 litres of fresh water every day. Die-hards swear by it. "It took 5,000 years to make this swamp in a natural laboratory," laughs Heikki, before downing a pint-glass full of pond juice. Near the spring is a "fertility" plunge pool – located in a deep ditch, it has a greenish surface formed of sphagnum moss, believed to be rich in oestrogenic and antiseptic properties (sphagnum moss was "discovered" as a suitable dressing for wounds in the 1880s). When these properties are able to penetrate the skin, many believe they can boost fertility; visitors from as far as Japan come to soak in the pool's life-giving properties.

An hour away, Kammi-kylä (see Chapter 7) is a work in progress. Here, on four hectares of virgin swamp, Erkki Kalliomäki has created three saunas and a moat. And he's not done yet. He's in his mid-80s but looks 20 years younger – the life-giving properties of peat are clearly working for him. "I'm a friend of the swamp," says Erkki, whose complexion has a healthy, peaty-coloured tinge, "and I'm a total sauna freak." Along with the three saunas on the swamp, he has three at his home, and another that he built with friends. And he uses them all – a different sauna for every day of the week.

A totemic arch of fossilized wood signals the entrance to Erkki's empire; it's both foreboding and inviting – rather like the swamp itself. A dirt path leads past white fluffy heads of cotton grass humming with insects; an unusual stillness fills the air as the peat has soundproofed our footsteps and clatter. It's so quiet we can hear the wasps' beating wings. The saunas, draped in hairy moss, straw and twisted boughs, come into view, looking like they have risen from the swamp itself.

Kammi-kylä and Suo Spa are not for everyone. They are simple and unfussy, and you have to throw yourself into a marshy bog with insect companions and all that lies beneath. For those who don't want to be swaddled so intimately in swamp, Kiulu is a lakeside resort in Ahtäri offering a more "refined" peat experience. Its sleek, glass-fronted sauna offers views across rippling waters and dense forest, and there are hot showers and a range of Lehtopeat treatments and wraps available.

Previous and opposite: Peat bathing at Kammi-kylä swamp in Nummijärvi, Finland; peat has been used for centuries to treat a range of skin conditions. *Next*: Kiulu resort, Ähtäri, Finland.

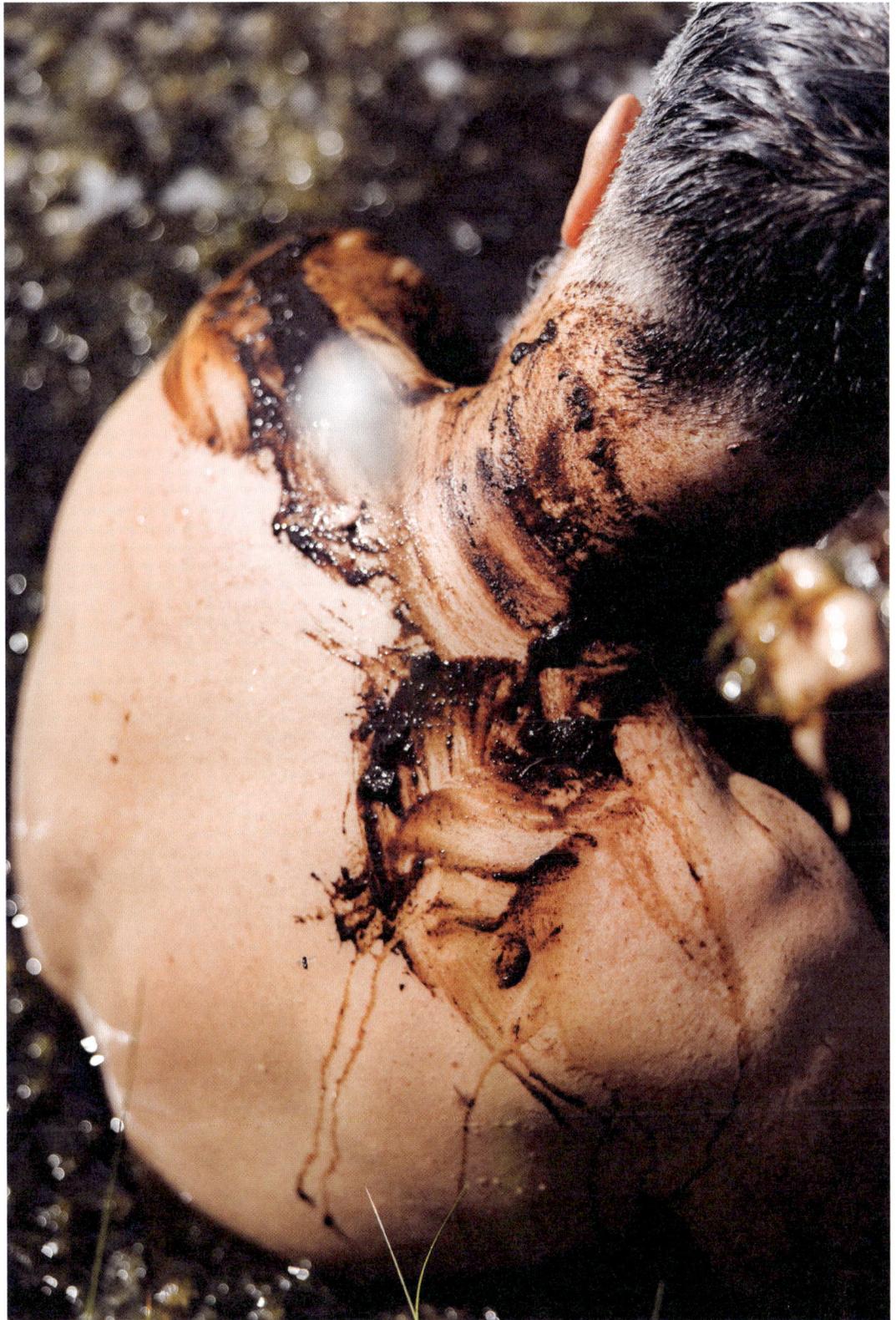

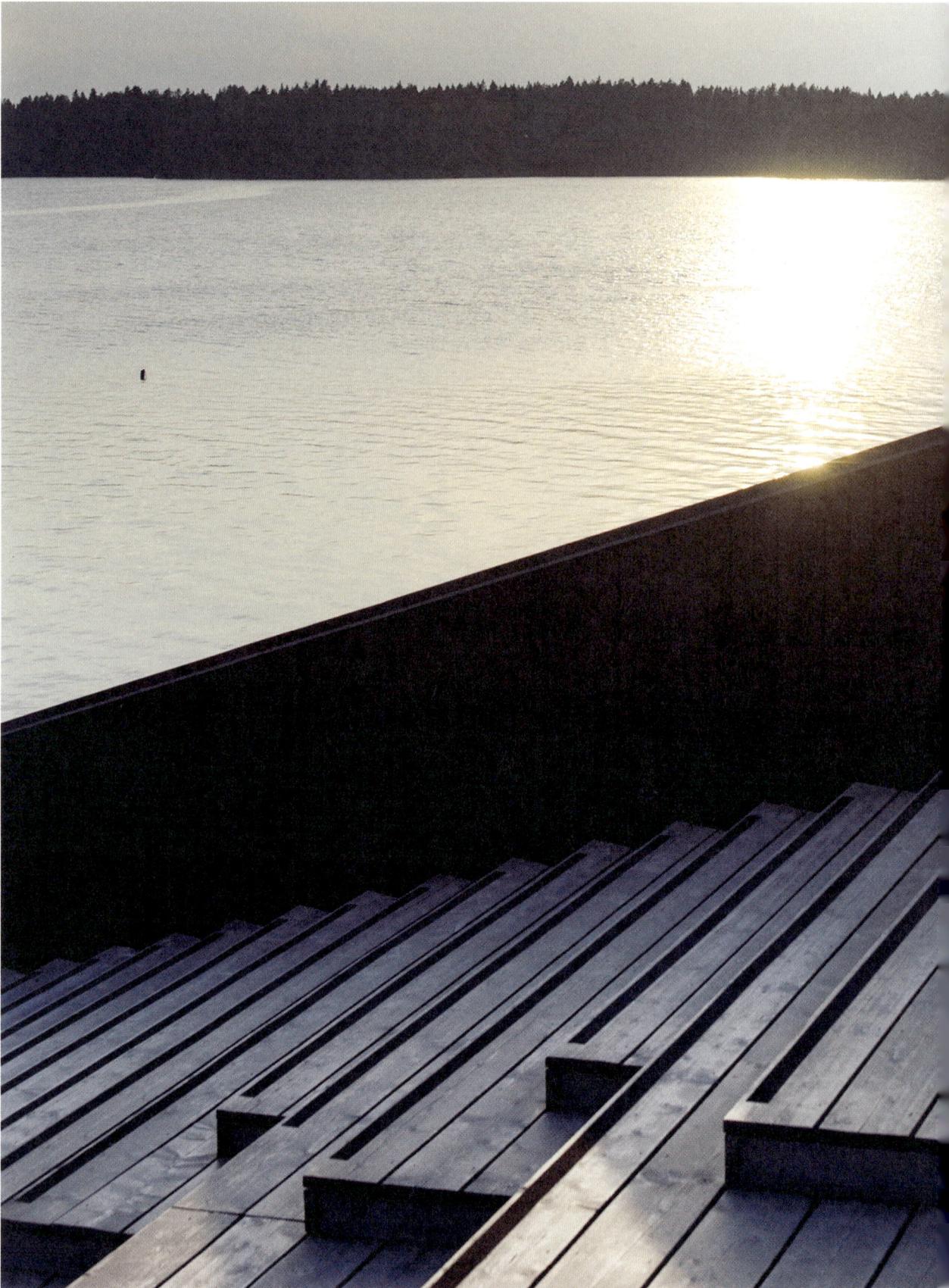

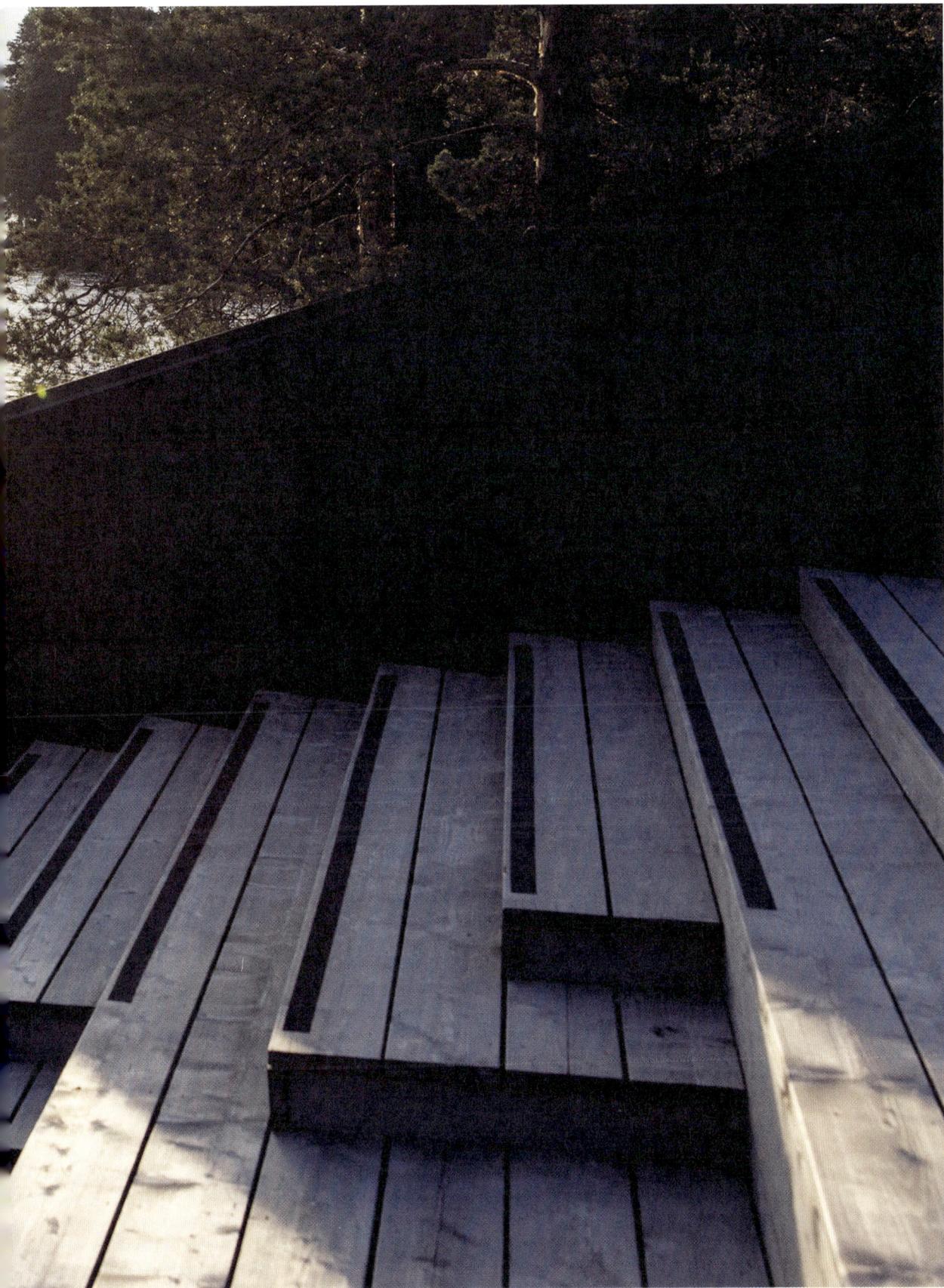

An introduction to *aufguss*

It is 4.30pm on a Monday afternoon in September 2022 and I am standing naked save for a sarong, queuing to watch a 15-minute performance in a huge event sauna somewhere in the Netherlands. Around 200 other, also naked, people are in front of me. Buffed-up performers dressed in special robes are twirling towels in a backstage VIP area like matadors preparing for a fight. The air is crackling with excitement. It's Day One of the annual Aufguss World Championship – essentially the Academy Awards, World Cup or, more closely, Eurovision Song Contest, of *aufguss*.

Auf what? *Aufguss* is the German word for "infusion", and is a wellness and purification ritual hosted in a sauna by an *aufguss* master who wafts deliciously aromatic steam with a towel in a graceful rhythmical dance over bathers. It lasts no longer than 15 minutes in temperatures upwards of 60°C and comes with a healthy dose of humour, pizzazz and Las Vegas kitsch. Performance-art-meets-musical-theatre in the steam.

There are several theories as to how *aufguss* developed, but the most common is that after World War Two, soldiers suffering from health complications and PTSD were offered sessions with a sauna master who would tell them stories to try to heal their wounds, both mental and physical. It isn't hard to see how this quickly became both cure and entertainment. The Japanese call it *Auf Goose*, and it's now so popular in Poland, the Czech Republic, Austria and Germany that "event" saunas big enough to host up to 200 people are in high demand.

The ninth World Championship is taking place at Thermen Bussloo – a spa complex an hour from Amsterdam which features a collection of saunas, plunge pools natural lakes and a "Mexican *cenote*". Naked guests play chess on white loungers and relax on lawns by neatly clipped bushes. But the new sauna theatre, with huge sauna stove, state-of-the-art light and sound systems and 4.5-metre-wide LED screen is a highlight. It offers even more opportunity for loud music, bizarre props (a computer? in a sauna?) and swift, between-the-scenes wardrobe changes.

Exuberant (fully clothed) MCs promise to take us to new worlds and unimagined dimensions and the frenzied clapping of the audience suggests they cannot wait. Enter the first participant, Norwegian solo performer, Jerome Richter. The lights dim and we all countdown from seven with the huge digital screen, "6, 5, 4" … the music blasts … "3, 2, 1" … and a very "drunk" pirate stumbles into the sauna with well-rehearsed Johnny Depp-style moves.

Music blares, lights fizz and the giant screen brings to us the tumbling waves of a violent Norwegian Sea. Jerome staggers and trips, spilling his bottle of "hooch" onto the sauna stones. It's his own homemade infusion and the smell of pine forests and salty seaweed carry on the billowing "sea mist". Jerome twirls and pirouettes, catching and throwing towels and wafting his heavenly scent all around the space. It invokes feelings that are cathartic, meditative, invigorated, sensual and joyful – sometimes all at once. Everyone inhales.

At the end of his tale of derring-do there's a standing ovation (brave when naked). We file out thirsty, sweaty and bewildered, and head for the nearest cold lake. We need to cool off before the next show; there's one every 45 minutes. For a week.

The World Championship is a far cry from the "classic" *aufguss* ritual, which is quiet, relaxing and sometimes spiritual. But "show" *aufguss* has a growing fan base. "I LOVE it," guffaws a German man in his 30s, who is here with friends for the whole week. "Normal sauna gets boring after a while," he explains, taking off his towel. A large group of Japanese men in sauna hats are grinning ear-to-ear. *Auf Goose* is HUGE in Japan. Japanese *Auf Goose* masters are known to practise their towel-twirling skills for three to four hours every day. Many of them are YouTube sensations. For the first time, a Japanese team is performing at this year's contest, and it's causing a buzz.

The next performance, the MCs enthuse, features a Big Reveal. Since we are all already naked, we're stumped. What more is left unseen? The screen lifts to a stage behind glass, where musicians in Goth-like costumes are playing guitars and violins. String instruments are next level; sauna gongs and drums suddenly seem like relics of the past. The crowd goes wild.

What makes a winning show? Participants are judged on their story, their acting, their choice of essential oils, costumes, music and special effects. But ultimately, it's sauna mastery that really counts; the steam must reach everyone and be distributed evenly via heat peaks and troughs. Propeller, Catch and Throw, and Throw and Catch Behind the Back are popular moves. It mustn't get too hot – 85 degrees is plenty – and accidentally dropping towels or props, or forgetting lines, loses points. It's intense and, rather like fringe theatre, unpredictable. It's also beautiful, bizarre and engaging. And it's easy to forget you're in sauna, which is good news for people who don't like saunas.

"Show" *aufguss* started in 2011 in Tyrol in northern Italy with just four *aufguss* masters.

Since then, it has exploded throughout Europe. Every sauna or spa hotel worth its salt scrub now offers it as a sauna "show", and for many spa hotels standard *aufguss* has become as essential as, well, essential oils. It's not usually compulsory to be naked like it is in Bussloo, but everyone must place their bottoms and feet on a towel to keep the sauna clean.

Aufguss camps, competitions and events are held all year round, and to reach a final you have to make it through many heats, either as a team or as a solo act. Step by step, performances have grown more complex and creative. The Italians brought fans, opera and ancient Rome; others brought *Hamlet*, Marie Curie and Patrick Swayze. In 2022, *aufguss* made it to Las Vegas, and the US and Canadian teams planned to join the 2023 World Championship.

Each ritual is unique and certain themes, such as war, violence and death are off-limits – it's meant to be a feel-good get-together. But the Czech Republic's interpretation of Quentin Tarantino's *Kill Bill* and the harrowing story of domestic abuse by a married Polish duo pushed those limits. Thirteen countries were taking part in the 2022 championship, their performance times decided by a lottery on the opening night. An early slot is best, when the sauna is still cool, while after lunch is the graveyard slot. No one wants a sauna on a full belly. Most acts are in English but include national themes. In kimonos, accompanied by dragon imagery, the Japanese team twirled their towels like samurai swordsmen. The Brits, who also debuted this year, wore Union Jacks and Welsh flags and performed to "London Calling" by The Clash.

Aufguss (in swimwear) is coming to the UK. The first domestic contest was held in April 2023 in Rudding Park Spa in Harrogate. But there are so many challenges, as British team leader and spa

owner Deborah Carr points out: "We need more large saunas, more stoves we can pour essential oils and water on to and an audience that understands that sauna is not an endurance test. With *aufguss* it can be fun – and it's good for you."

Before we head home, we watch Czech performer Sarah Matilda Ryskova give a performance about her career as a ballerina, the battle she faced with anorexia and her new-found happiness as a mother. She danced to non-stop applause and a few tears from a full house. The heat was intense, and with her grace and elegance and the heady aroma of bergamot and birch, it would have taken a hard heart not to be moved.

Aufguss ritual in SALT, Oslo, involves pouring water and essential oils on the rocks, then artfully wafting steam around with a towel and cooling bathers off with whisks and water.

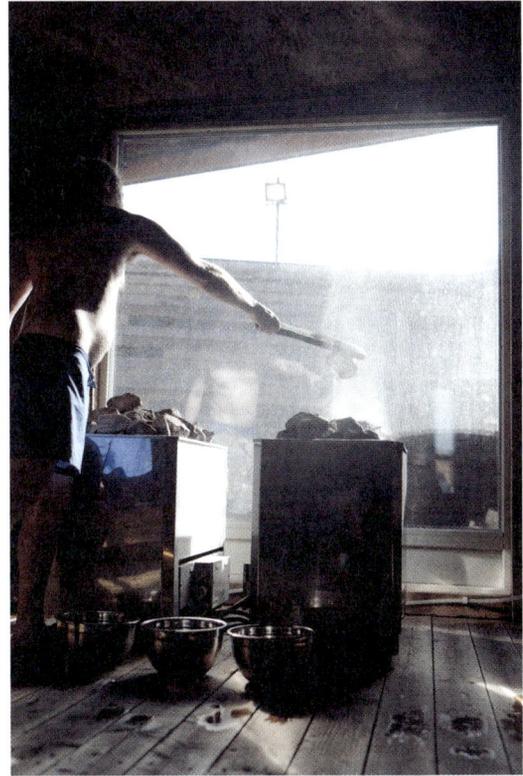

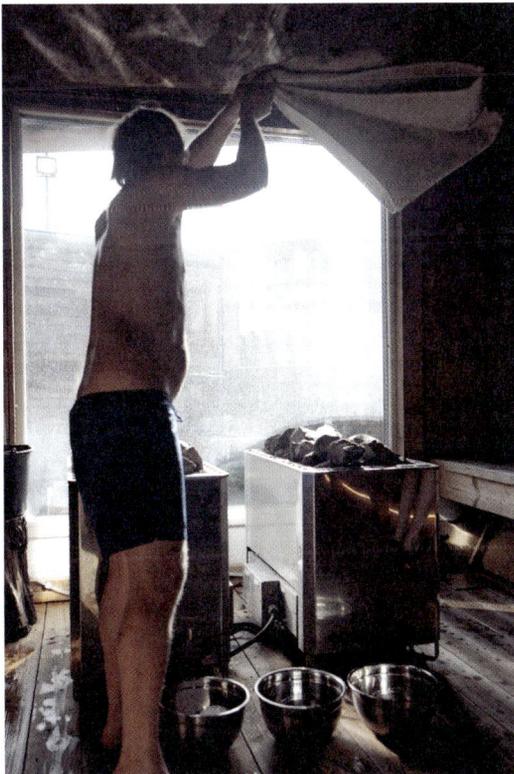

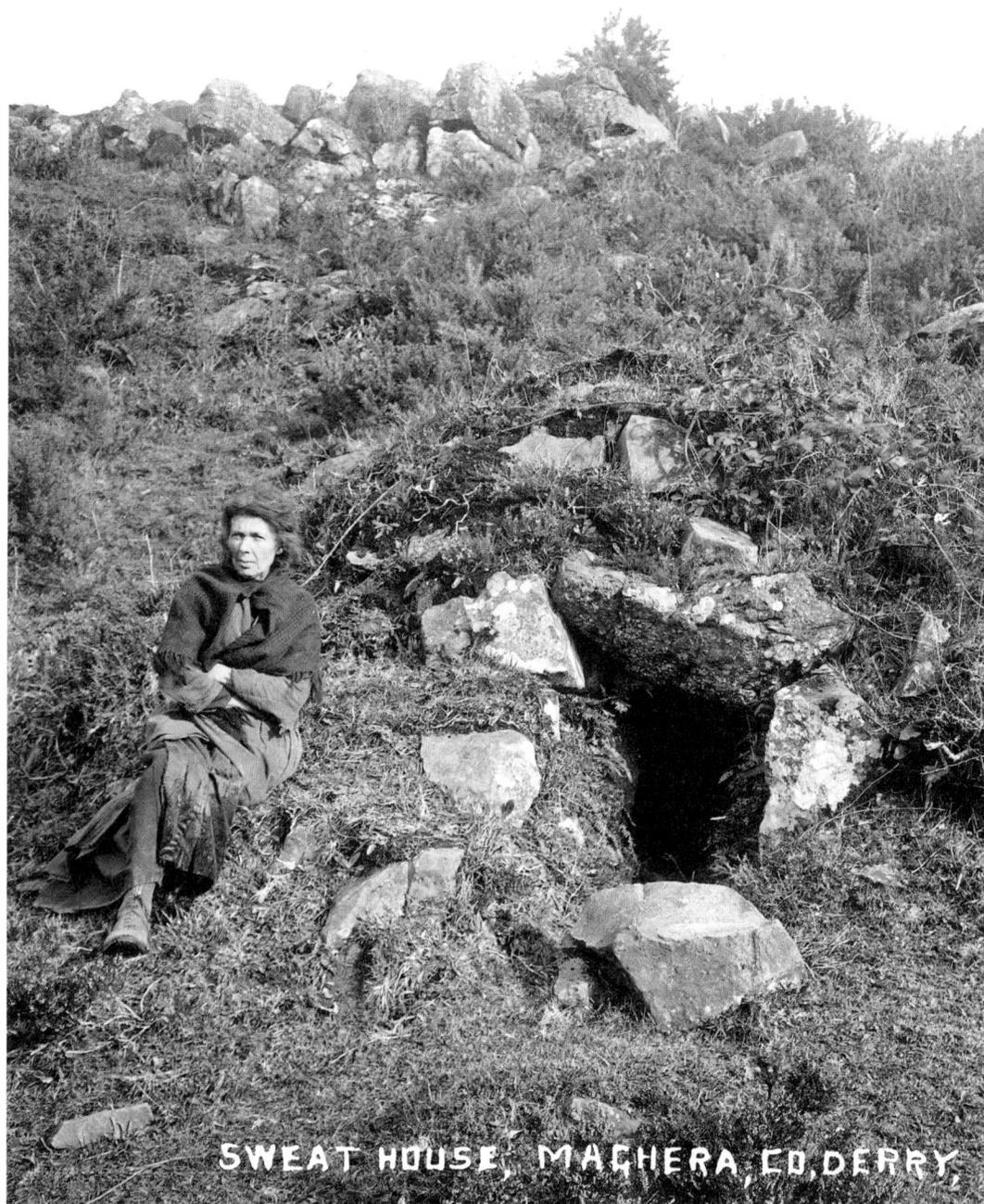

Sitting outside a sweat house in Maghera, County Derry, Ireland in the early twentieth century.

SWEAT HOUSE, MAGHERA, CO, DERRY,

INTERVIEW WITH A SWEAT LODGE MASTER

British-born Tim Jago has been hosting Celtic sweat lodge rituals in Scandinavia and beyond for more than 30 years.

How did you discover the Celtic sweat lodge?

When I was 19 I had made a huge mess of my life, and I ran away to the mountains in North Wales. Two women, who turned out to be the keepers of this tradition, took me in. I knew nothing about sweat lodges, but they put me in the sweat again *and* again and taught me how to do it. They themselves had been taught by an older man.

There were a lot of stone houses and a well-known tradition of sweat bathing in Ireland, so I went there a few times and found old guys who could tell me stories. If you go to the pub and buy enough beer, then lots of stories appear! Ha ha. You don't know whether they're true, but they tell you something their grandfather told them, and that their grandfather had told them, and so on. They would put wood on the fire and heat the hut like a baker's oven, put stuff on the floor and sit and sweat, for physical – and spiritual – healing.

Tell us about your sweat lodges.

I make a wooden frame and cover it in piles and piles of blankets until its totally dark and heatproof. It's about 4 to 5 metres in diameter and holds 15 to 20 people. I want to get people into nature, so I build it outside and, if possible, near a water source. I live in northern Sweden so I'm spoilt for choice of location.

Then we have a big fire, and heat stones the size of loaves of bread until they are glowing red hot. We bring half of them in along with a bucket of water and some aromatics – sage, lavender, frankincense or myrrh – and close the door. It's so dark you can wave your hand in front of your face and you can't see anything. And it's hot – somewhere between 70 and 90°C.

Who comes to your lodges?

Mostly people are interested in personal development, or neo-paganism or looking for a new experience. People who come to retreats tend to have something they would like to heal. Those who come to festivals are looking for an experience. People wear what they're comfortable in. Some are naked, some wear sarongs; I've even had a person in sweatpants. In some traditions you have to sit, but here everybody is lying down as we stay in there for three hours. There's no coming in and out, and no water to drink inside. People are also advised to fast up to three hours before joining, so the body is quite empty.

What happens in those three hours?

The ceremony is divided into two parts: death and rebirth. In the first part, I get everyone to relax and I tell a story. It's a guided meditation, which brings people in touch with different things; we reflect that life will have an end; we don't know when or how, and what the consequences of that will be. It's the space for people to stop and look at their own lives; to think about people they need to forgive; to reflect on the things they do that are a waste of time. They look at what are they holding on to, things that hold them back from dying a good death or living a good life. And we work past these layers.

Then the story goes into death. It's a traditional Welsh story, which I learned from my teachers, who got it from theirs; they say it goes back several generations. (It involves the story of the death of Wales's most famous poet, Taliesin, whose life as a simple servant changed dramatically through the power of rebirth, inspiration and transformation.)

Taliesin inhabits a revered place in Welsh history as a legendary bard born of myth and magic, whose words have survived throughout the centuries to the modern day. Much of what I know is word of mouth. In Celtic mythology there's a lot about reincarnation. There is no heaven or hell; when the whole body dies, part of it carries on to another life. We come back. I say, "Let's see if we can get in touch with that." In the dark and heat, your grip on reality softens and it allows things to happen fast as you don't have the normal defences. It's very intense.

What happens to people?
Three hours is a really long time in the dark. The storytelling is just one part. I'm only talking a third of the time. People can find resolution with old trauma or old relationships. They are working, and part of my job is to support them.

Do people start panicking?
Sometimes. If they are ready to leave, then of course they leave. But it's very rare that people get panicky or claustrophobic. It's the thing they are most are afraid of, but it doesn't happen much at all. When somewhere is completely dark you have no sense of how big it is. And we are there for a long time, so you reach a place where you have to give up trying to be in control. Surrender. Let go and let the process happen.

What about emotional outbursts?
Sometimes people cry, or talk about something painful or beautiful. It's rare for someone to shout. It's hard to describe, but it's a private space too. You're on your own journey.

If someone reveals a trauma, who helps them?
It could be me or it could be the group. Sometimes it's as simple as finding someone who has had a similar experience. And we have a phase where we talk about this stuff intentionally. If someone says they have been physically or emotionally or sexually abused, we say let's invite the perpetrators in and find a way to forgive them; then let them go and get them out of our lives. The first half of the journey is dying, in the second half I bring people back. They come out of the lodge reborn, then spend a bit of time drinking water and eating. This is a space to share anything, but many are very quiet. When you clear away all the crap that gets in the way of seeing clearly, you see the point in having a life.

What happens if you don't see the point of your life?
That's interesting. And it happens. It starts people off on powerful journeys. Six years ago, a woman who was management level in an advertising agency joined a ceremony. Afterwards, she slept for 12 hours. When she woke up, she came to me asking "Why am in I this job? And this relationship? There are no answers." Six months later she found the answers and started living a different life. Lots of people come back, some come four or five times a year. You can do a ceremony many times.

Is there anyone to whom you refuse entry?
Any age group is welcome; so far, the youngest person was 5, the oldest 86. A weak heart is not a problem, but beta blockers that slow the heart beat down are, as are diuretics and certain types of medication that prevent you from sweating. If someone looks dehydrated, I'll say no, and anyone who's been using drugs of any kind can't come in. Drugs are really not necessary.

Would you describe yourself as a shaman?
I have studied anatomy, physiology and alternative medicine, and I've held lodges in Sweden, Norway, Denmark and Wales. But I would not call myself a "shaman". I simply hold lodges and try to help when needed.

www.celticlodges.com

Opposite: Just like a sauna, a sweat lodge requires hot rocks heated by fire to provide a transformative state.

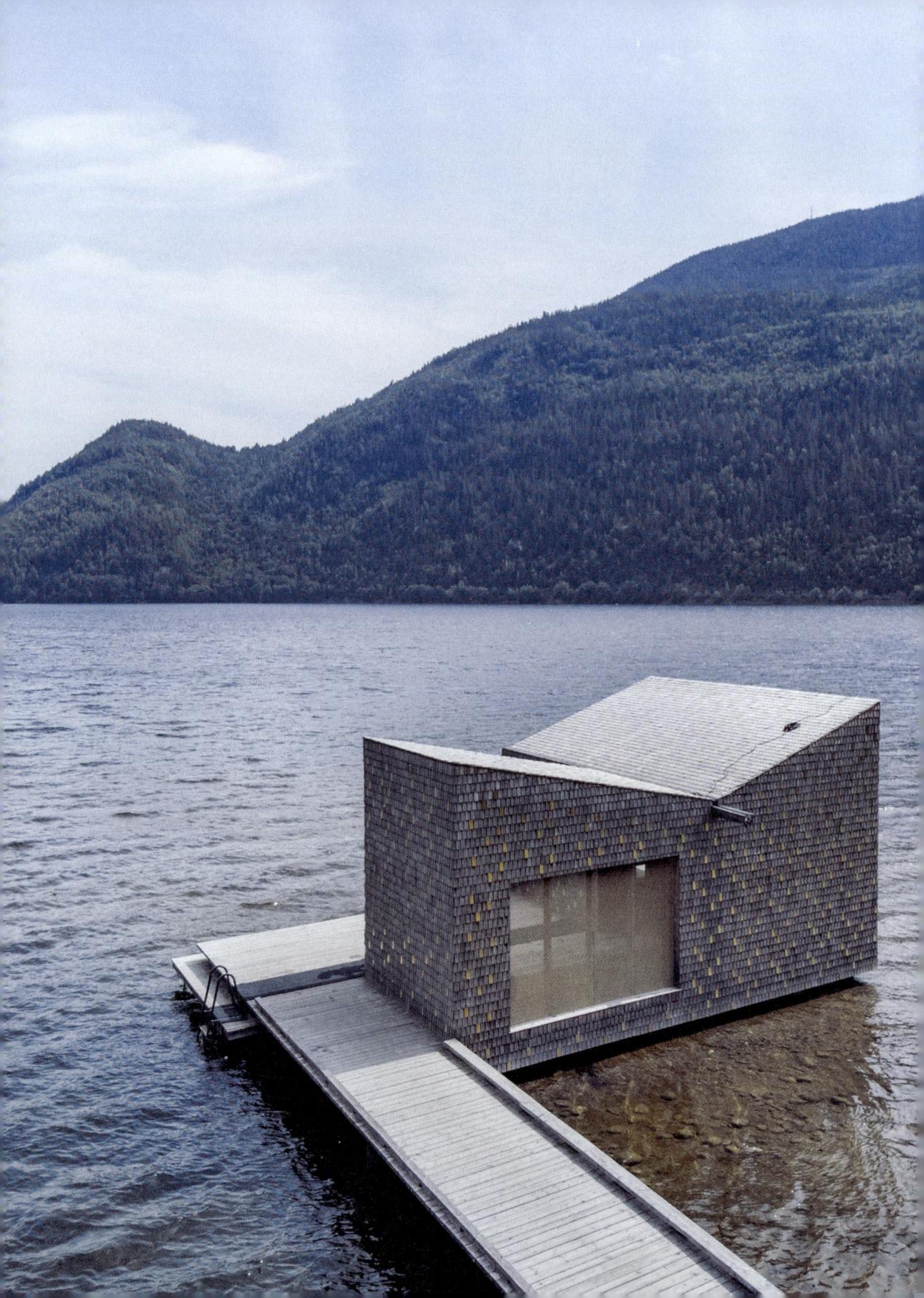

BEST BAKES

Places worth breaking a sweat for

"I felt my lungs inflate with the onrush of scenery - air, mountains, trees, people, I thought, 'This is what it is to be happy.'"

Sylvia Plath, *The Bell Jar*

Soria Moria,
Dalen, Norway.

Best overall experience

Ästad Vingård, Ästad, Sweden

Could there be a more sublime meeting point for gastronomy, wine and sauna than at Ästad Vingård? Here on a vineyard a 90-minute drive south of Gothenburg, wine lovers can savour a new breed of Swedish sparkling wine, gastronomes can indulge in a 17-course tasting menu based on local, seasonal ingredients and sweat bathers can indulge in eight saunas with a difference. In all three departments, Ästad Vingård excels.

Having started life as an organic dairy farm with a restaurant and rooms for overnight stays, it now has its own wine label (sold onsite only), Michelin-starred restaurant Äng, a 25-room hotel, cabin cottages and a luxurious spa. Surprise is key. Diners at are taken on a choreographed mystery tour around Äng's highly designed glasshouse between every dish, and sauna-goers get to sweat in different settings.

There's an underwater sauna; a sauna with a hammock; a sauna with a lake running through it; a fire sauna, where specially charcoalized wood feeds the fire. Naturally, lakes and heated pools accompany the mix. But that's not all. Each sauna has its own sounds and smells (and, coming soon, taste) inspired by the surrounding Åkulla Bokskogar nature reserves – think the gentle rustle of birds pecking among the leaves or the wind whistling across the lake, and the scents of freshly sawn timber and moist autumn leaves. These are designed to trigger memoires, provide an element of surprise and deepen the sensory experience. And they do.

astadvingard.se

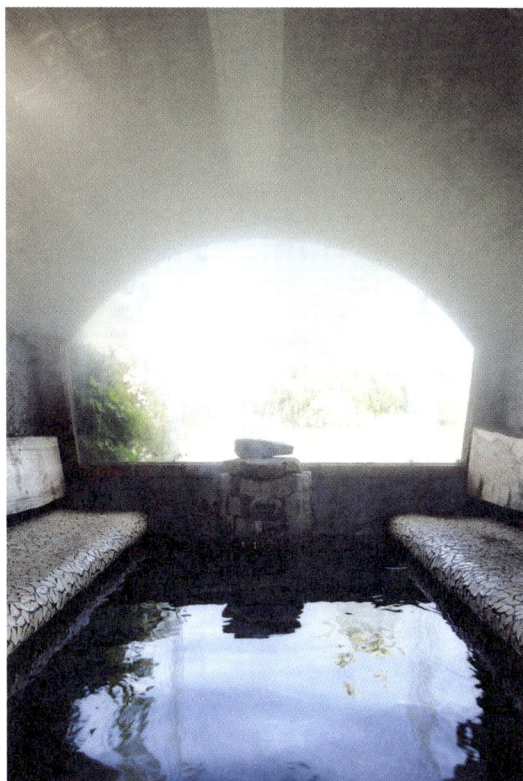

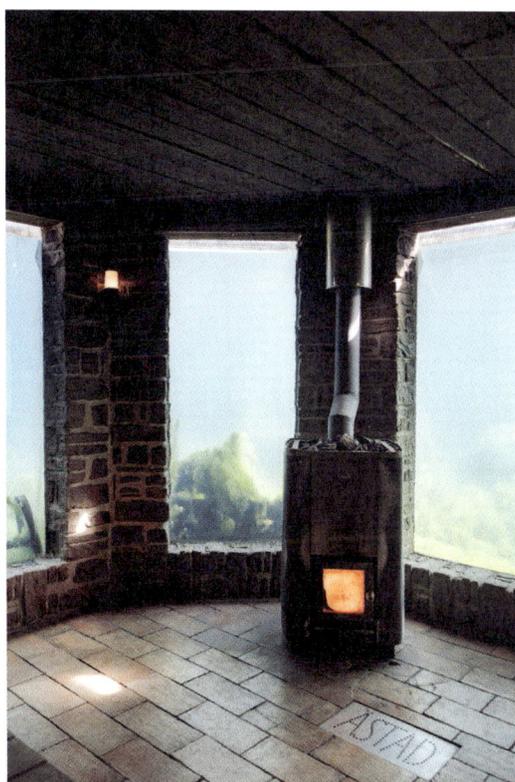

Best nature experience

Eldmølla, Vang i Valdres, Norway

Getting to Eldmølla is part of the adventure, especially in winter and spring when you have to navigate the last three kilometres on foot – sometimes more, depending on how heavy the snowfall in the Valdres Valley has been. Then it's a scramble through the snowdrifts, along a narrow walkway over a waterfall, and up a little ladder. When you finally hit the steam, almost 1,000 metres above the treeline, it's a joy like no other.

For the architecture students from the Norwegian University of Science and Technology in Trondheim, creating Eldmølla was a huge challenge. Over 10 days in midwinter, they battled temperatures of –20°C, shovelled snow and ice on skis and hauled materials in any way they could to fulfil their brief: to create a small sauna that would make the most of its surroundings.

Eldmølla means "fire grinder" in Norwegian, and the sauna design takes inspiration from local Kvernhus buildings – small mills from the Middle Ages used to grind grain. A bridge across the stream carries water into a bucket inside the five-square-metre sauna, which holds up to six and can be rented for a couple of hours at a time. For those who want to stay longer – and who wouldn't? – Knut (see "Badstufolk", Chapter 4) has built a cabin-for-rent nearby that sleeps up to ten.

Eldmølla is one of many saunas that Knut and his best friend and business partner Hallgrim have created in the area. In the nearest village of Vang, there's a lake sauna, a bakery sauna, a community sauna and Hallgrim's cabin sauna by the river. Thanks to the pair, Vang is gaining ground as a "sauna destination", and its annual sauna weekender offers workshops, talks, rituals, food and beer. And, of course, sweating.

eldmølla.no

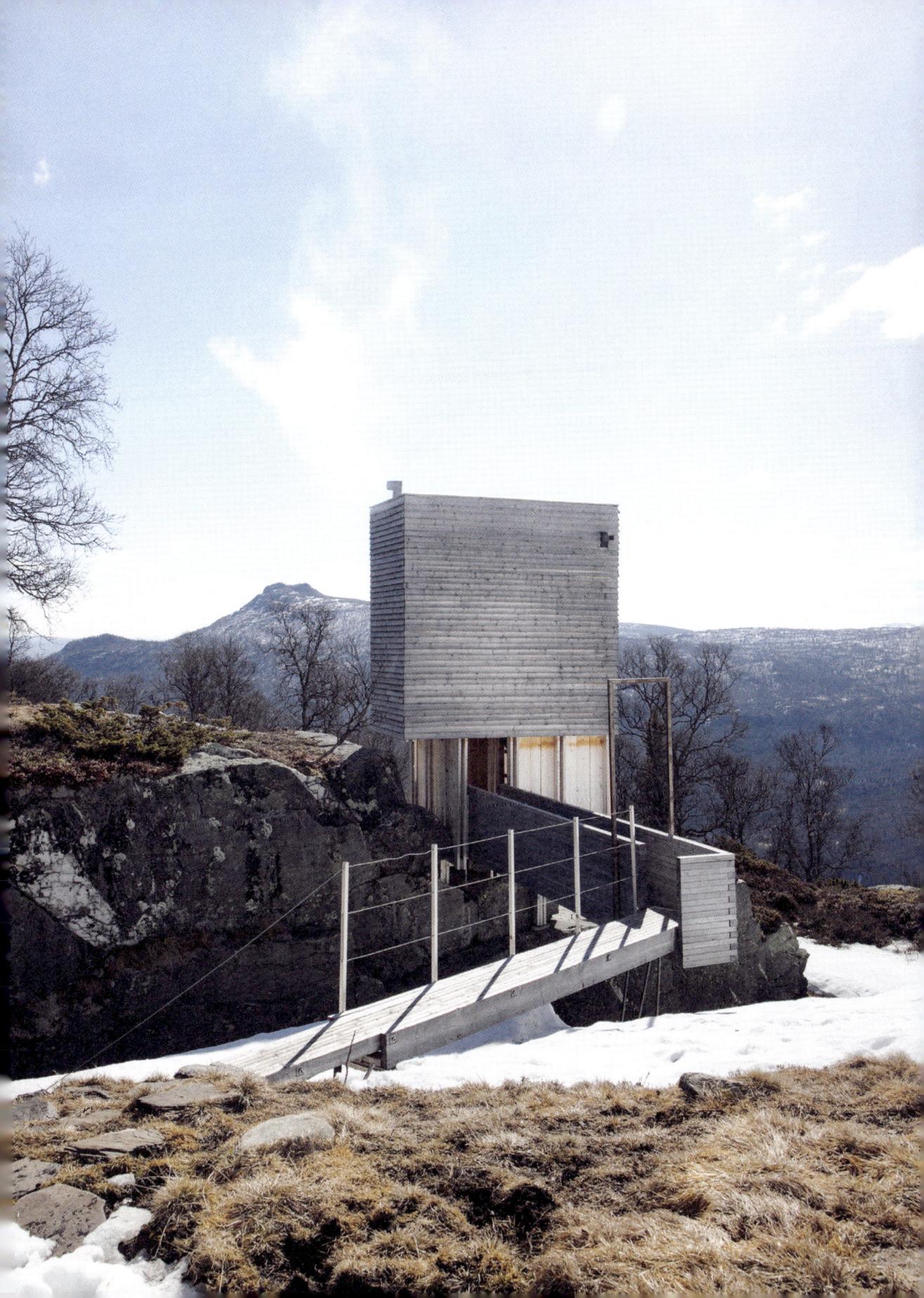

Best off-the-beaten track sauna

Kammi-kylä, Nummijärvi, Finland

There's no electricity or running water at Kammi-kylä; visitors scoop peat straight out of the bog with their hands, and wallow in the mineral-rich moat; but to sauna at Kammi-kylä is to bathe in a work of art. It's not just that the three saunas open onto a virgin peat bog rich in health-giving properties (see Chapter 6), or that there's a freshwater moat to swim in, or even that there's a dining room where (as long as you bring your own food and drink) you can stay for hours. It's more that to visit this surreal swamp complex two hours north of Tampere, is to experience the ethereal, wonderful world of octogenarian "swamp man" Erkki Kalliomäki.

Erkki spends almost every day at his three-hectare playground, building, carving, tinkering, and sauna bathing. His saunas look like dwellings from a different era, which in a sense they are, because everything is built with materials and relics salvaged from the mossy depths: hairy moss – "as waterproof as a goose's back"; grassy thatch, which Erkki burns with tar to keep critters and birds at bay; peat bricks hewn by hand.

A sculpture of charred wood from a fire a thousand years ago sits above a homemade rocking chair; sinister creatures with wood-knot eyes and birch-whisk tails are part of the decor, along with wood panelling, delicate carvings, antlers, horns, wooden thrones. And none of the walls are straight, which adds to the surrealism. Life on the bog shifts and slides in tandem with the unstable earth beneath.

The best time to visit Kammi-kylä is in summer or spring when the snow is not melting, turning the bog into a wavy sea. The two wood-fired saunas and the smoke sauna hold up to 15 people each and can be booked in advance. Every year, woodworkers from Wales to Taiwan, and tourists in search of a peat bath with a difference, come to indulge in Erkki's many talents. It's totally worth the trek.

nummijarvi.fi

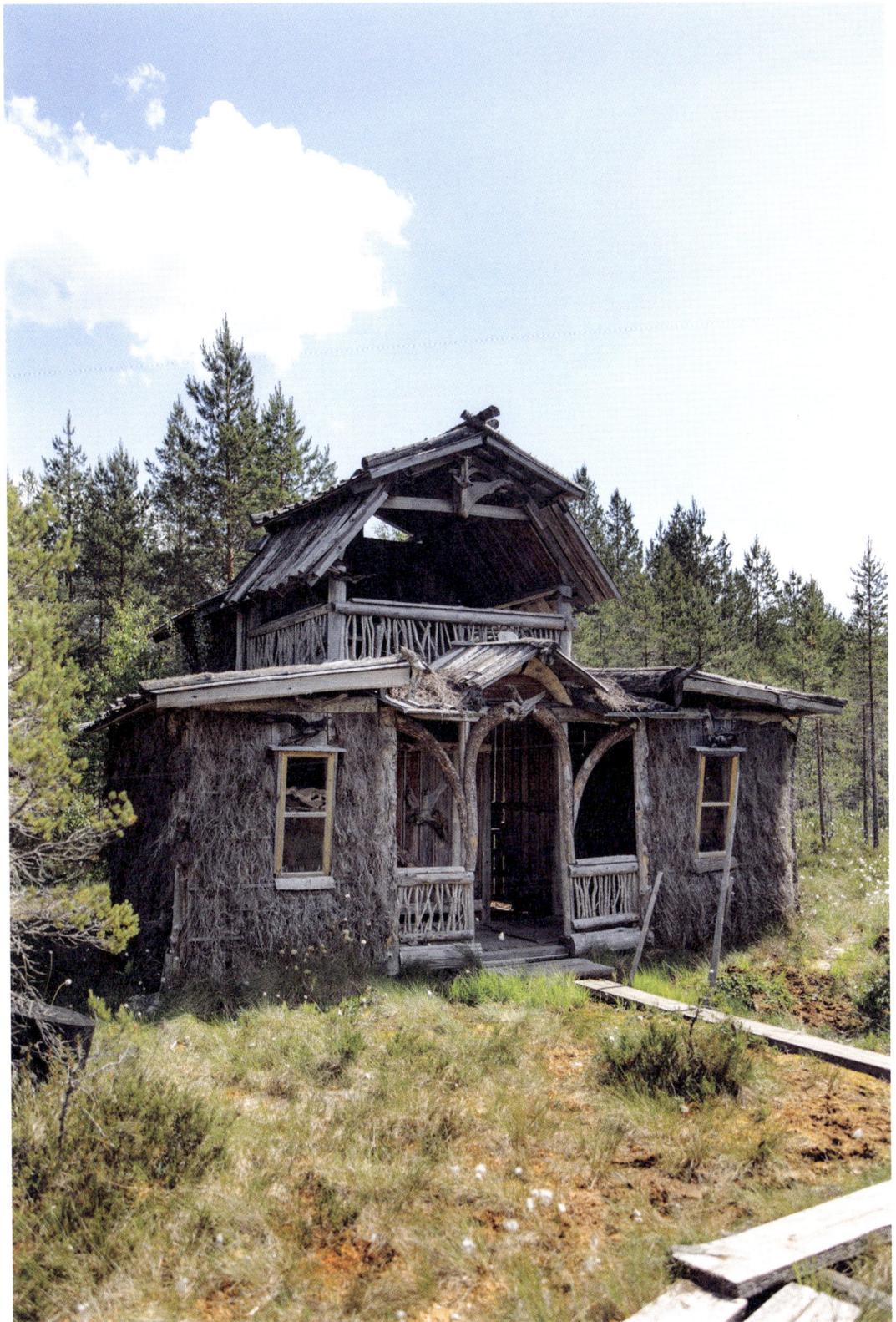

Best city sauna

Löyly, Helsinki, Finland

No trip to Helsinki is complete without a steam at Löyly. In the same way that every city wants its own Manhattan Highline, every city wants a Löyly – cool, unmissable and responsible for putting their neighbourhood on the tourist map. Löyly attracts more than 200,000 visitors a year, and is the youngest building in Finland to be listed as of historic importance, but don't let that put you off. Shaped like an upturned boat on the stony, once-unloved shore of the former industrial district of Hernesaari, it has ample terraces with sweeping views over the city and a generous number of showers and lockers so that it doesn't feel crowded.

It offers two wood-fired saunas and, best of all, a large double-height smoke sauna, which is rare in any city. It draws an international crowd; well-heeled office workers sip cocktails next to overheated tourists from the US and Japan, and no one leaves without sampling its famous salmon soup. Indoors and out, there's plenty of space to chill with a beer, socialize and watch the cruise ships chug into the harbour in the distance. In winter, bathers come to plunge into the ice hole that is cut into the sea.

Sauna tourism is now Finland's number one attraction, and Löyly has definitely helped it reach the top. Locals complain that tourists can't take the heat, and don't know how to pour water on the rocks properly, but they keep coming back anyway. Löyly is an institution. And it still feels Finnish; for that reason, it's a must.

loylyhelsinki.fi

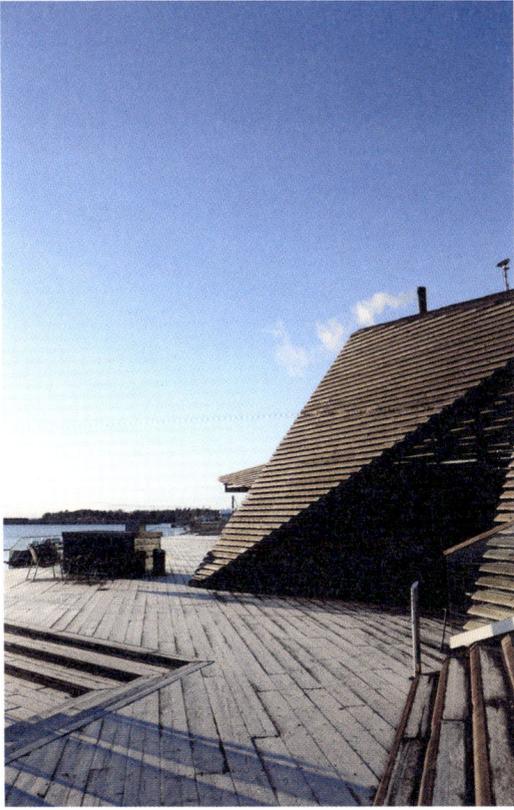

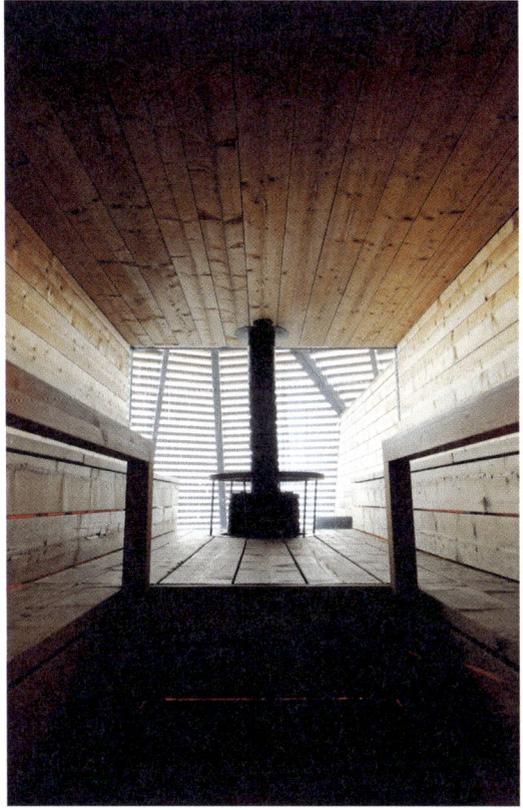

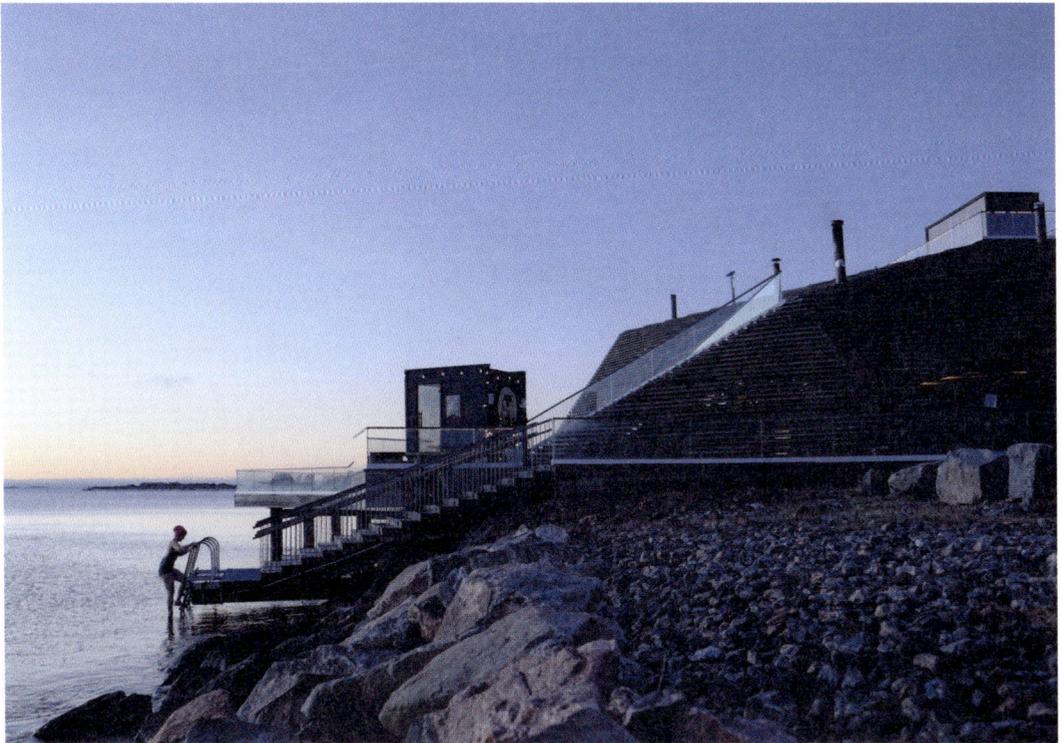

Best ritual

Mooska, Võrumaa, Estonia

Don't let rumours of viper poison, spells, ancestor worship and bloodletting put you off a visit to Mooska. Yes, these *can* be part of the mix at this smallholding in Võru County in south-eastern Estonia, but only if you want them. Mooska-owner Eda Veeroja has spent a lifetime acquiring knowledge of and practising ancient Estonian sauna customs, and she's eager to share them. Her rituals range from a three-hour guided session involving whisking, salt scrubs, honey wraps and essential oils based on local ingredients and beliefs, to specific rite-of-passage ceremonies – to mark a new job, say, or a graduation, a new baby, or a wedding. People suffering maladies, from thrombosis and arthritis to fertility problems and depression, come from all over the world to be treated by her healing hands.

Rosy-cheeked and approachable, Eda looks like a regular farmer on a regular Võru farm – not a feted healer that people travel a long way to see. There are no crystals or totems or New Age decor at Mooska, just three very old saunas chuffing merrily away around a glassy pond where bathers cool off.

Eda learned everything she knows from her mother and her grandmother. In 2014, she succeeded in having Võrumaa's smoke sauna tradition added to UNESCO's Representative List of the Intangible Cultural Heritage of Humanity, and she runs workshops and courses for those wanting to learn more. She also uses sauna therapy to treat deeper ailments – energy blocks, pain, psychological woes.

Nudity is not compulsory, but phones and alcohol are banned. Such modern-day distractions cloud the mind. At Mooska, it's about turning off the noise, turning up the heat and turning to the self, just for a while.

mooska.eu

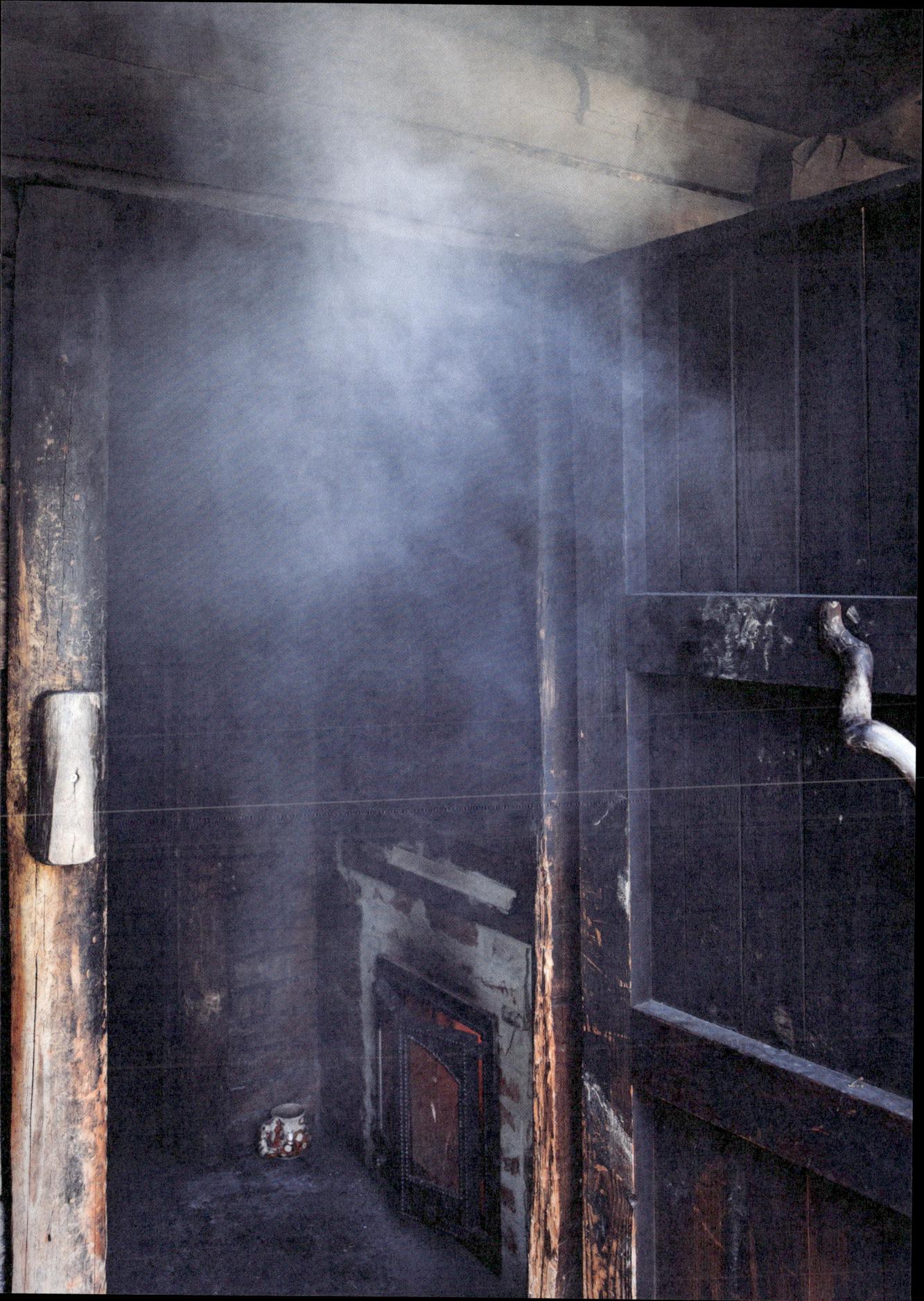

Best community sauna

Oslo Badstuforening, Oslo, Norway

As Mikkel Aaland writes in the Foreword of this book, a sauna needs three elements: the physical, the social and the spiritual. Oslo Badstuforening has them all (see Chapter 3). What started as an illegal sauna raft on the Oslo fjord in 2013, has grown into a sweat-bathing community of 7,000 members, a tourist attraction and a showcase of Norwegian architecture that lives up to its starry neighbours, the Munch Museum and the Oslo Opera House.

With a mission to "bring sauna to the people", the Oslo Sauna Association is brimming with novel ideas. Things move fast, saunas come and go, but good design is always a priority – from wooden Estonian "iglu" saunas to elegant architectural versions. "Skarven" has huge picture windows and a shape that echoes the beak of a cormorant; in 2021, it featured in a retrospective by Norwegian artist Sissel Tolaas at Oslo's Astrup Fearnley Museum of Modern Art. Tolaas invented a scent for the sauna and called it Liquid Money. Visitors to Skarven were invited to steam in the smell of filthy lucre before "purifying" themselves with a dip in the sea.

New additions to Oslo Badstuforening are a super sauna on a former ferry, with space to hold *aufguss* rituals, and Bademaschinen, a collection of red and yellow saunas that echo the Victorian "bathing machines" of old.

Aqua gymnastics are central to sauna life on the fjord, where restrictions are looser than in many other waterfront cities, and Oslo Badstuforening encourages its bathers to dive, jump and somersault as much as they want. It was set up by anarchists after all (see Chapter 3), and it doesn't want anyone to forget it.

oslobadstuforening.no

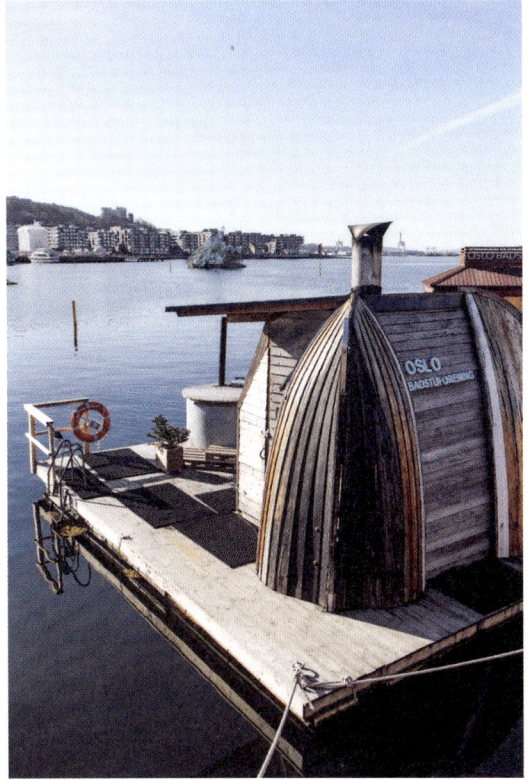
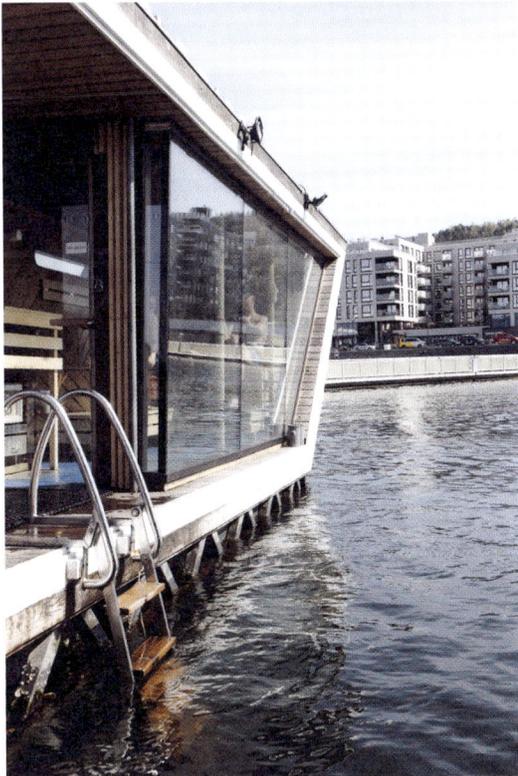

Best *löyly*

Rajaportti, Tampere, Finland

"A sauna stove is like a diva", says German artist Alex Lembke, "many things – rain, wind, the previous day's heat – will affect it." Alex runs thesaunaproject.net, a research project into Finnish sauna culture, and every day he heads to downtown Tampere and lights the fire at Rajaportti, the oldest community sauna in Finland. Here the stove is a *giant* diva. It weighs 1.5 tonnes, is two metres high and takes five or six hours to warm up. When the doors open to the public at lunchtime, women head down one side, men down the other. The main topic of conversation? The quality of the *löyly*.

Many believe Rajaportti has the best steam in Finland. This is partly because this historic sauna was built in 1906 and has thick walls, floors and ceiling, which absorb the heat, so it's never really cold even when it's not lit. It's a kind of heat that goes deep into the bones. And even if you don't really understand what good *löyly* is, at Rajaportti the steam feels different. And so do you.

But how do you recognise good *löyly* when you feel it? Alex, who has studied sauna culture for many years, explains: "Top quality *löyly* is a good balance between heat and humidity," he says. "It should hug you slowly and intimately. If you sit in the silence, close your eyes and wait for it, and then ask yourself: What is it doing to you? Where is it touching you first? Shoulders? Fingertips? Feet, maybe? A good *löyly* never hits you in the face. It's strong, but never aggressive. Then, after a while, when it has worked its magic, it releases its grip and slowly drifts away. It doesn't bite." And bad *löyly*? Well, that's a punch in the face.

Alex makes a comparison: "If you drink bad whisky all your life, you just don't know what good whisky tastes like. If someone shows it to you, then suddenly a new world opens."

Bathers at Rajaportti say the *löyly* has "dimension", that it's heavy, yet soft and comes from all directions. Go and try it. Feel it for yourself.

rajaportti.fi

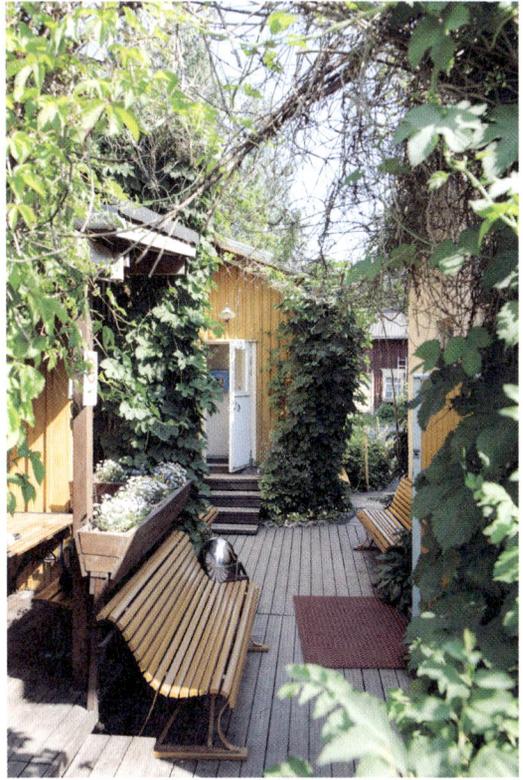

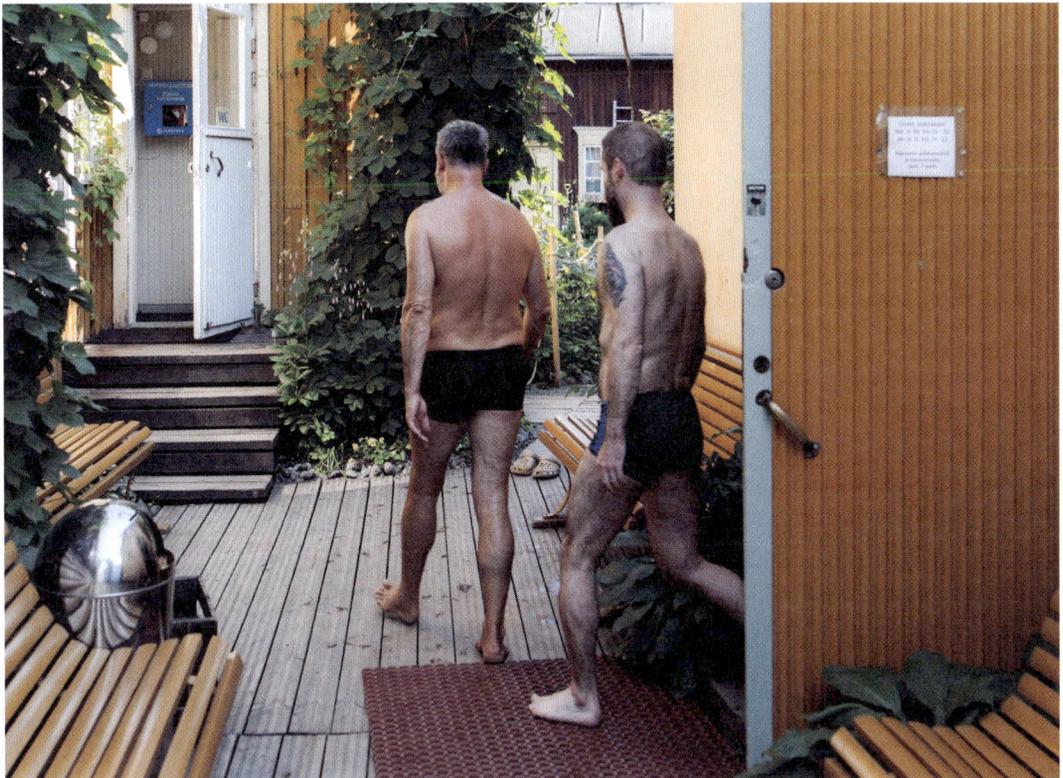

Best view

Soria Moria, Dalen, Norway

At the end of the nineteenth century, Dalen in southern Norway was a popular holiday resort. Royals and upper-class travellers would check into the Dalen Hotel to enjoy the untouched nature and landscapes. But the advent of sun-seeking foreign travel and the popularity of the fjords led to the demise of the region so famed for its wild beauty. Now, more than 100 years on, visitors are back – thanks, in part, to the Soria Moria sauna.

The sauna's distinctive shape is inspired by the rugged scenery that the aristocrats of old would come to admire; and its name comes from Soria Moria Castle, a Norwegian folktale in which a journey to a castle is a pauper's progression to happiness and success. It's one of six art projects entitled "Tales of the Waterway" promoting the Telemark Canal, once the country's major thoroughfare. Norwegian architects Feste created the space using local materials and techniques, among them a simple wood shingle façade that is interspersed with golden shingles, in reference to the contrast between the lavish guests of the Dalen Hotel (itself an architectural gem) and the poor, rural locals.

The waters of Lake Bandak are shallow at Dalen, so in order to give bathers a deeper experience in deeper waters, Soria Moria is built on stilts and accessed by a long gangplank connected to the shore. Blessed with beautiful natural surroundings, Norwegian saunas are sometimes known for prioritizing the view above all else, including the quality of the steam. Not so at Soria Moria. Here, sweating, swimming and soaking up the scenery are all in perfect balance.

visittelemark.com/dalen/things-to-do/soria-moria-sauna-p4614023

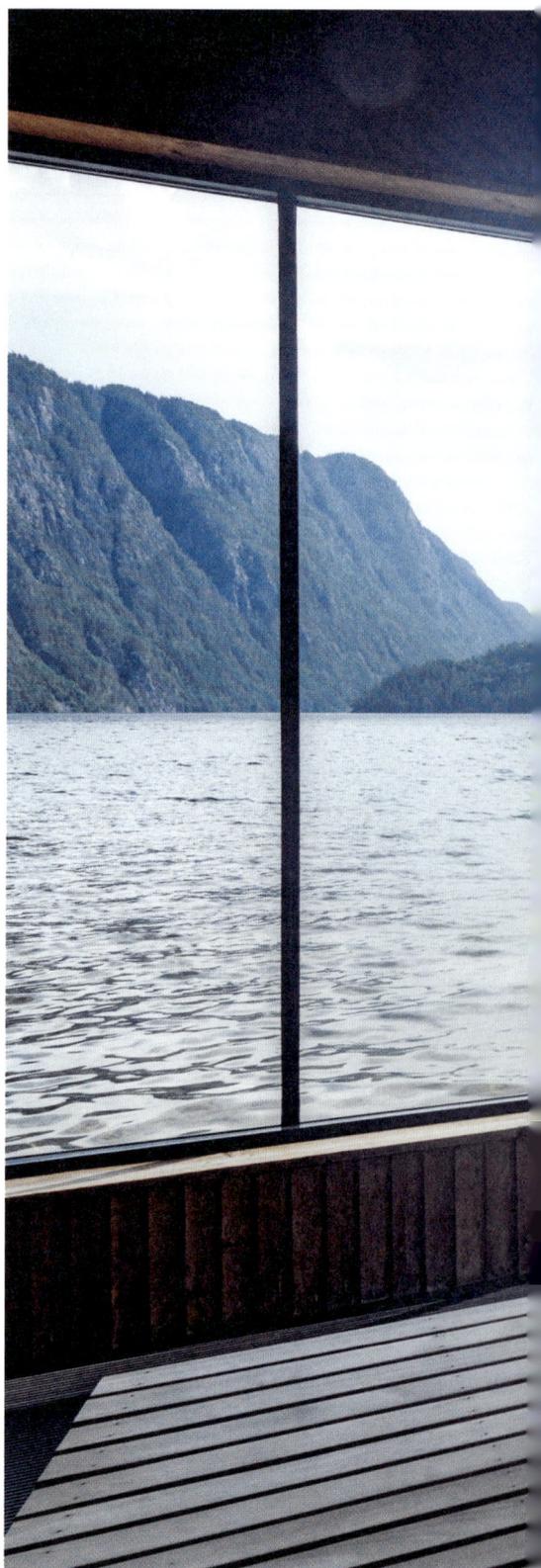

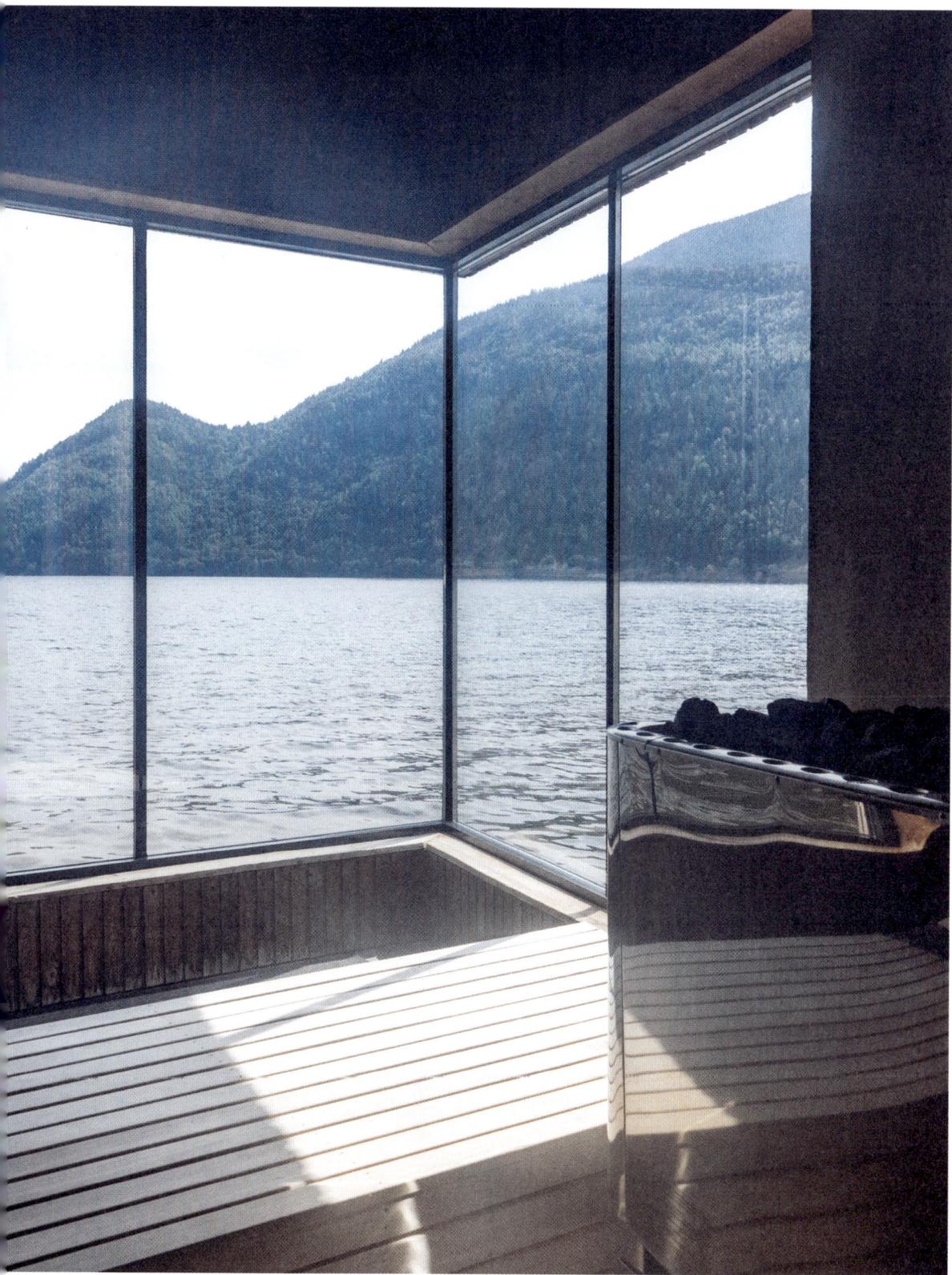

Best seafront sauna

Björholmens Marina, Björholmen, Sweden

Islands, islands and more islands. Such is the nature of Sweden's west coast, from Gothenburg to the border with Norway, that there are too many to count (8,000 is a popular number). And there are plenty of saunas too, but the one at Björholmens Marina on the island of Tjörn has a seafront like no other.

Hundreds of moss-soaked skerries, populated only by birds and passing swans, ensure that this stretch of Tjörn is sheltered from rampaging tides and perilous storms, making Björholmens Marina a popular pit-stop with yachties and tourists.

You don't have to be a guest at the nearby Björholmens Marina & Hotell to use the charming wood-fired sauna that sits on a jetty which drops into the calm and gentle waters of the North Sea. The sauna is open all year round, the restaurant services bathers with beers and snacks, and there is a sauna and Sunday brunch package. Tjörn, too, has plenty to offer. At the Pilane Sculpture Park, works by leading international artists, among them Jaume Plensa and Tony Cragg, punctuate the stone circles, graves and grazing sheep of what was once an ancient burial site.

Besides its islands, this region is famous for its pretty seaweed, which is harvested by hand in the fresh, salty waters around Varberg. For more than 200 years, the West Coast seaweed massage has been a popular treatment to heal and cleanse the skin. Bathers typically lie in wooden tubs filled with salt water and scalded seaweed, which release minerals and vitamins. This has not yet made it into the sauna, but there's still time.

bjorholmensmarina.se

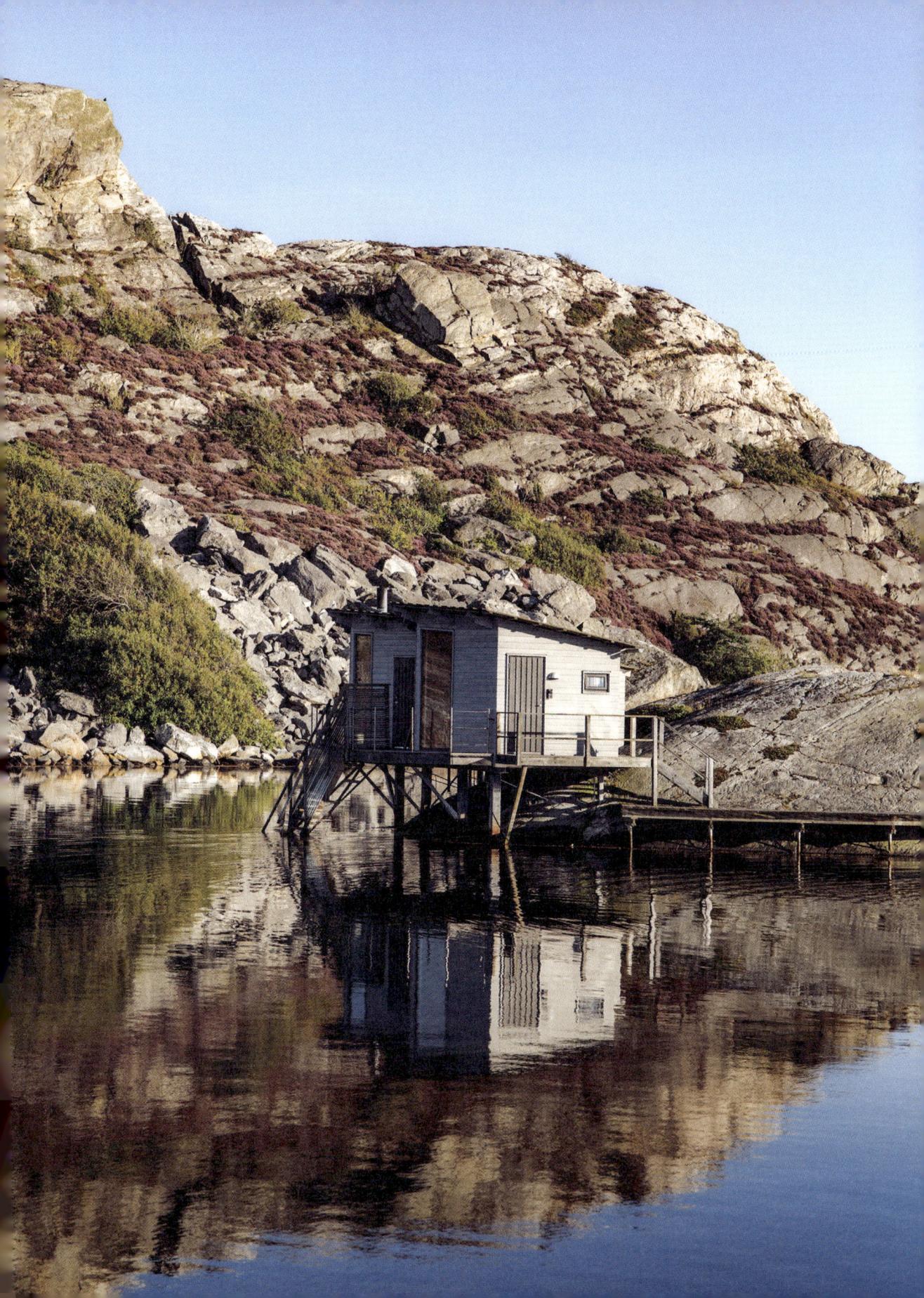

Best unique experience

Sipoonjoen Perinnesauna, Sipoo, Finland

Mostly, smoke saunas are the preserve of those lucky few who have access to a family relic near the summer cottage. With their propensity to burn down, they are not common in cities. Nor are they advisable for novices, for whom having a smoke sauna is like heading onto the motorway before you have learned to drive. All of which makes the Sipoonjoen Perinnesauna, 40 minutes outside Helsinki all the more special.

Tucked into the banks of the Sipoonjoki River the smoke sauna is a newly built cellar sauna. A ramshackle path leads down through a tall, thick pine forest, past a fire pit, to a smoky doorway covered in carvings of mythical creatures from the *Kalevala*, Finland's epic poem.

Stepping through the doorway into a windowless, candlelit interior is like stepping back centuries. Almost instantly, a smoky taste takes shape in the back of your throat, streaks of soot stick to your skin and you sweat – a lot, even if you never normally do. As is customary in Finland, bathers ask permission before they pour water onto the rocks, knowing that it will be intense, satisfying, and very, very hot. But that's what people go for, and there's a cold plunge and hot tub on the terrace outside when it's time to cool down.

Sipoonjoen's founders are on a mission to revive ancient sauna practices and rituals, and the simplicity of the setting feels authentic, unpretentious and open to everyone. If you book in advance, whisking, washing with leaves and private ceremonies involving ancestral wisdom are also possible.

saunotus.fi

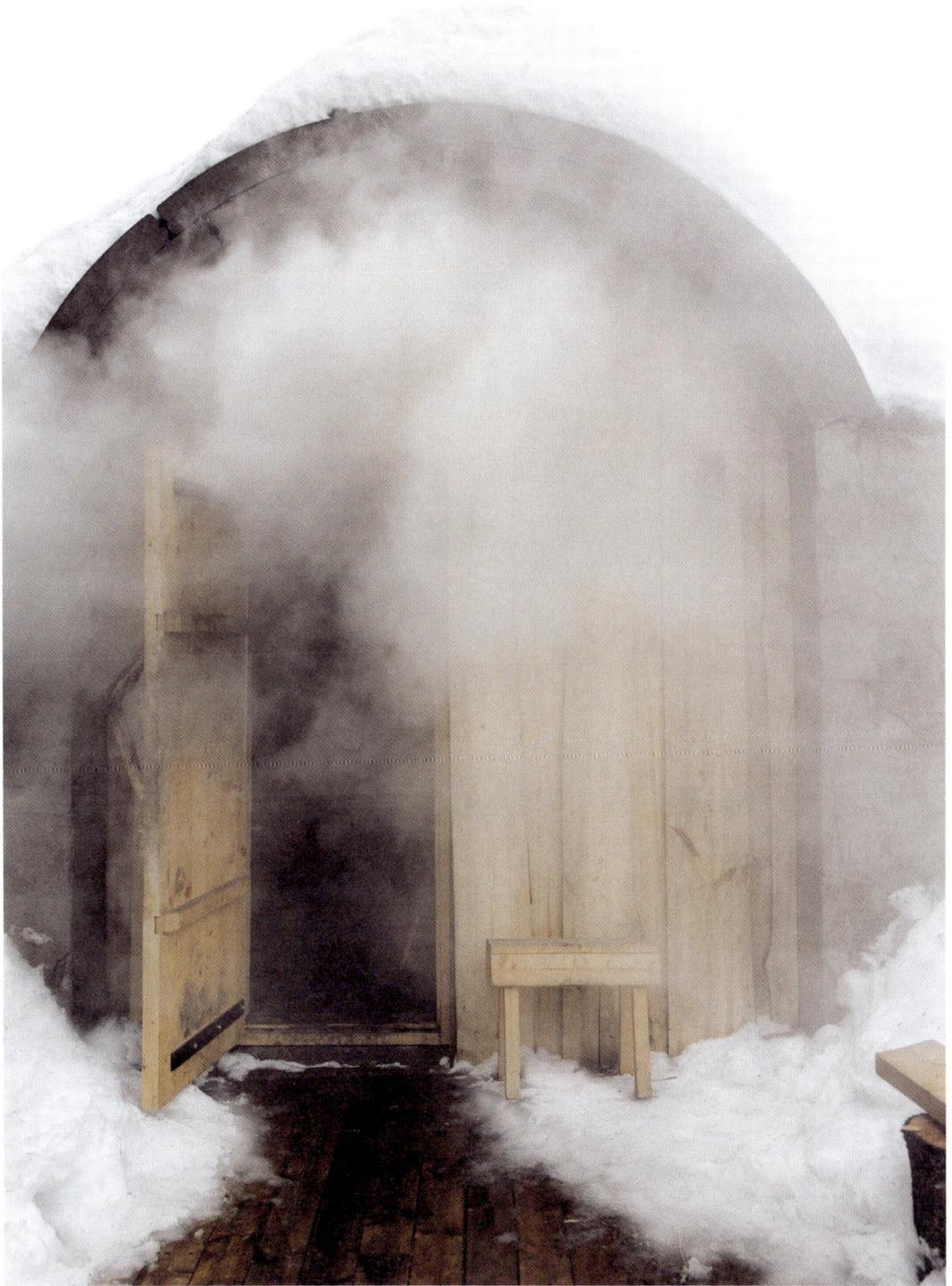

Resources
& References

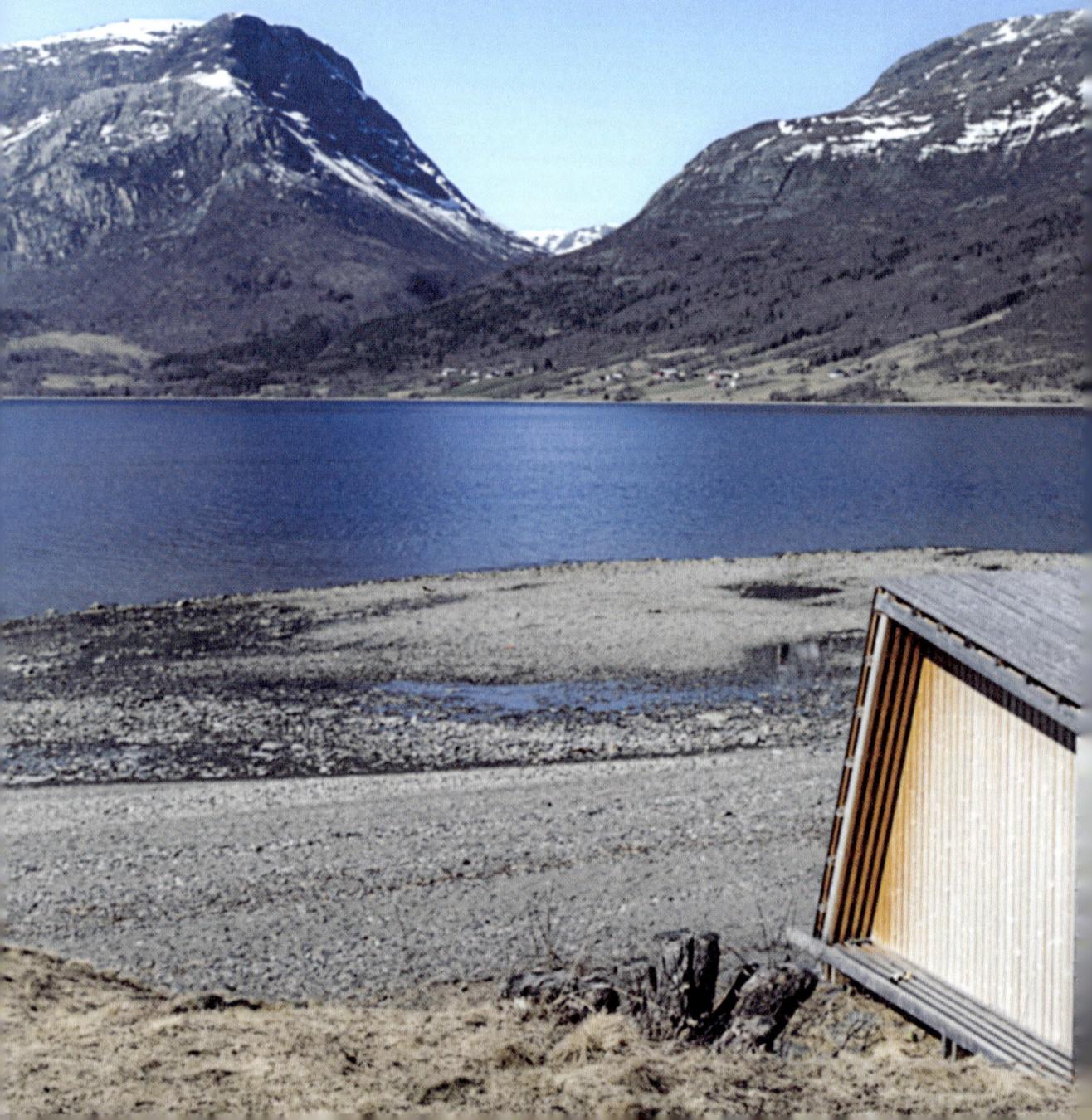